POSITIF 50 YEARS

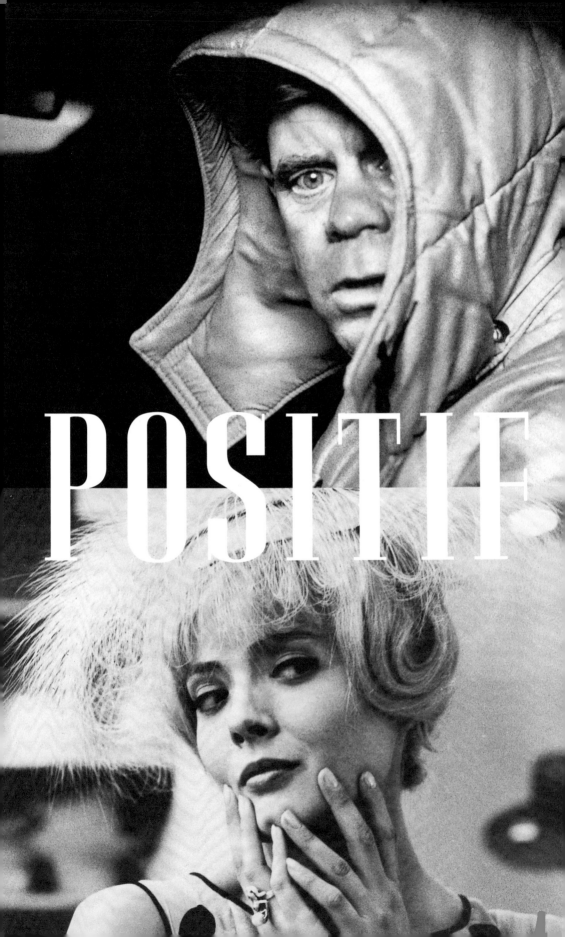

50 YEARS

Selections from the French Film Journal

Edited by Michel Ciment and Laurence Kardish

THE MUSEUM OF MODERN ART, NEW YORK

CONTENTS

1980s

1990s

Preface and Acknowledgments

Positif, a French film magazine published for the past fifty years, is virtually half as old as cinema itself. In its ardor and zeal for the new filmmakers it champions, in the maverick intelligence that informs its ideas about the work of these artists, and in the writings themselves—poetic, surprising, and illuminating—Positif both sustains and nourishes the culture of cinema.

A culture is a cohesive social system of belief and experience; a vibrant culture changes, adapts, and evolves continuously. Films alone do not make a culture resonant, but thinking, writing, and arguing about them, their makers, and their context do. With the disappearance of regularly published film magazines at once serious and popular on both sides of the Atlantic, and with the ascendance of the sound bite masquerading as criticism, writing about movies, especially in America, has become either the expression of a journalist's bias (hardly the basis for contemplation) or of an editor's interest in celebrity (which has nothing to do with the film itself). Since a culture reflects the ideas it generates, present critical anemia threatens to keep the wan body of American film appreciation bloodless. This book then, which presents a selection of French film criticism and comment, is offered as a transfusion, an antidote. It is also a celebration.

Positif was founded on an enthusiasm—still maintained after a half century—for cinema. In 1952 a group of articulate and voluble young filmgoers in Lyon led by Bernard Chardère, a humanities student himself, published the first edition of a new magazine with an optimistic name to share ideas about the movies. In France, cinema has never been simply a mode of entertainment but rather a source of engagement. Films are reflections of social mores and/or statements, covert or not, of political sensibilities, and/or expressions of the director's psychological makeup. The passions elicited by the cinema in France are those sparked by painting, music, literature, theater, and governance, and the inquiring writers of Positif, energized by the ideas the arts ignite, write about film with the same verve they write about other lively disciplines. The method of artmaking in 1952 was not as encompassing as it is in this new millennium, but in French public consciousness filmmaking has always been part of an artistic continuum. In virtually all the articles in this book there are comparisons, cascading and natural, between films and works in other mediums.

The Surrealistic inflection of Positif may give rise to some curious observations and peculiar connections, but the magazine suffers neither condescension nor cant. It assumes that its readers are as knowledgeable as its writers are about the Western canon, current international affairs, the history of cinema, and are as familiar with the films, the subjects of the essays, as they are. The tone of Positif is conversational rather than formal, and readers sense that the magazine's contributors consider them part of a group of friends sharing ideas about films, as they might in the informal atmosphere of a sidewalk café. Setting aside the absence of advertising, the magazine is indeed user friendly. Unlike other publications focusing on the front lines of film festivals, where a few privileged critics rhapsodize about films that may never reach a public, Positif champions films that can be seen in at least limited release in Paris,

if not France. Roger Tailleur's pioneering article on Robert Aldrich was written in 1956, when four of the director's earliest features had opened within a six-month period in Paris. Without being hortatory Tailleur explained why Aldrich was a major new talent.

In his introductory remarks, Michel Ciment, a veteran editor of *Positif*, describes the magazine's distinguishing aspects, including the communal editorial process. For this writer what is special about *Positif* is its recognition of Surrealism as integral to thinking about film. Surrealism reveals what sensibility hides: its basis is the image without ontology. The dream image does not exist in the real world; neither does the cinematic. Both are creations of the mind, asleep or awake, although many argue that going to the cinema requires a surrender equivalent to sleep. The writers of *Positif* acknowledge that cinema mimics dreams in a way that is beyond language—powerful and beautiful. Since a significant area of film appreciation cannot be expressed precisely, *Positif* allows for abundant lyricism, powerful allusions, and woolly associations.

It may be true that the essays chosen for this book reveal a fascination with America, or rather with the idea of America. If French cinema is the Academy—stable, correct, and perhaps majestic—American cinema appears to be in a constant state of re-invention, just like the art itself. America seems to be an engine, a locus of experimentation, pragmatic and ever primitive. It is as though America and its cinema remain unfinished: according to *Positif*, whether it be Robert Aldrich, Jerry Lewis, Roman Polanski, or Wim Wenders, these filmmakers participate in an effort to realize an evolving art in a young nation that may "belong" to Americans but can and should be claimed by anyone who wants to join the endeavor.

Choosing forty-four articles from over six thousand in *Positif*'s five hundred issues was a daunting task, and I am grateful to Michel Ciment for assuming the challenge of making the first important cut. He and I decided on a few guidelines, elaborated in the Editors' Note on page 13. We selected articles that referred to films that are, for the most part, available on video; we restricted texts to those written at the time of a film's release, or when a new filmmaker appeared, or a new genre emerged. We excluded interviews, revelatory and important as they are. These await another book. We decided to choose no more than two pieces by any one author.

Positif's dual strategies of being current and assuming an educated reader render articles vulnerable to time. What might have been evident to a contemporary reader may have become obscured in the intervening years. Moreover, what may have been common knowledge in Europe may have hardly been recognized in America. Not wanting the readers of this book to be stymied by references which have become arcane and yet wanting to respect *Positif*'s own high regard for its readers, this editor has tried to determine what required amplification and what did not. In Paul Louis Thirard's article on Marcel Ophuls's *The Sorrow and the Pity*, for instance, ORTF is identified as a French television network, but in Robert Benayoun's essay on Jerry Lewis the reference to Pico della Mirandola goes without comment. Being a French magazine, *Positif* at times refers to non-French films by their release titles in France; we have attempted to refer to all non-English films by their original titles, whatever their country of origin, and, where appropriate, by their American release titles. In Gérard Legrand's article on Orson Welles's *F for Fake*, Claude Chabrol's *La Décade prodigieuse* becomes *Ten Days' Wonder*. Since Legrand supposed his readers would know

that Chabrol made *La Decade prodigieuse*, we assume the same and did not take the liberty of adding the filmmaker's name to the translation.

Translating these texts required a particular talent. Not only did the translator need to know the story of modern cinema, and a fair amount about European and American society, but he or she had to have a facility for synthesis and philosophic consideration. We were fortunate in finding Kenneth Larose of Ottawa, Canada, who with his colleagues undertook this commission with determination, grace, and good humor.

This book would never have been possible without the dynamic participation of Michel Ciment, co-editor of this publication. I also express my gratitude to the Museum's Department of Publications and most particularly to Joanne Greenspun, who has patiently applied her keen and discriminating editorial skills to the many texts that crossed her desk; to Gina Rossi, Senior Book Designer, who created such a handsome volume; and to Christina Grillo, Assistant Production Manager, who oversaw the book's development. I am grateful to Michael Maegraith, Publisher, and Harriet Bee, Editorial Director, for their advice. Thanks are due to Florence Colombiani, Samantha Safran, and John Migliore for the invaluable research they undertook. My colleagues within the Department of Film and Media have been very supportive of this project: Mary Lea Bandy, Chief Curator; Jytte Jensen, Associate Curator; and Josh Siegel, Assistant Curator. My appreciation also goes to Jillian Slonim for her encouragement, as always.

This book is published on the occasion of a fifty-film exhibition entitled *Positif Champions: Fifty Years of Cinema* marking both the magazine's golden anniversary and its five-hundredth issue. The retrospective, co-curated by Michel Ciment, takes place from December 2002 through January 2003 at The Gramercy Theatre on East 23rd Street in Manhattan, where the daily exhibition program of the Department of Film and Media is temporarily located while The Museum of Modern Art's campus on West 53rd Street is being expanded. The exhibition focuses on films *Positif* helped discover, and includes not only many of the works discussed in this book but also films by artists like Theodoros Angelopoulos, Michel Deville, Miklós Jancsó, and Jerry Schatzberg, filmmakers absent here only for reasons of space, but whose works are regularly considered by the magazine. *Positif Champions* opens with the American premiere of a new French film, *Une Monde presque paisable* (*Almost Peaceful;* 2002), by Michel Deville, and an older American one, *The Errand Boy* (1961), directed and starring Jerry Lewis, which is due for reconsideration particularly in the light of Robert Benayoun's 1963 article in *Positif*, "Jerry Lewis: Man of the Year," appearing here in translation for the first time, like most of the other articles in this volume.

Laurence Kardish
Senior Curator
Department of Film and Media

For Your Pleasure: A Brief Overview of Fifty Years of *Positif*

A lthough the political, cultural, and cinematographic landscape may have changed considerably over the past fifty years, it is nevertheless an interesting exercise to enquire into the roots of *Positif*, its development and its eventual role as a thread running through several generations that made the magazine so distinctive even as it too changed with the times. It is a story about a group of friends who, drawn together by their love of cinema, would assemble every Sunday afternoon for three or four hours, over a period of five decades, to talk about the latest film news (and simply the news!), to discuss the content of the next issues, select a cover, read the articles submitted to the editors and vote on whether or not they would be published, and assign one or another of us the job of reviewing a film or developing future projects. Another thing that made us unique in the trade publication business was that there was no editor-in-chief, but rather a floating editorial committee consisting of members representing successive waves of contributors from its earliest days. Those who were involved in the first (or some of the first) issues thus found themselves alongside neophytes whose articles had been published barely a year earlier.

These successive strata, made necessary by a number of deaths and departures to engage in other types of work, created a continuity and an occasionally contradictory form of dialogue, all of which makes *Positif* a magazine that can be genuinely said to have a "spirit" or "tone" that evolved through successive accretions rather than having a policy of replacing one group with another. Like any opinion forum, *Positif* accepts articles from readers who feel that they are on the same wavelength as the editors and wish to join their ranks, at least those were the articles that drew the attention of the editors more than the more usual multi-photocopied pieces sent out like so many messages in bottles to a wide variety of publications.

The fact that the magazine was founded elsewhere than in Paris—in Lyon as it happens, by Bernard Chardère, who was later to become the curator of the Institut Lumière—also had an impact. It has always been characterized by an avoidance of an excessive focus on Paris, which would be a virtual guarantee that it would not be looked on favorably by the various media giants, even though, after its early years in Lyon, it moved to the center of filmmaking in France and ended up in Paris so that it could have better access to past and current world production.

To the original core group from Lyon (Bernard Chardère, Jacques Demeure, Paul Louis Thirard, and a few ephemeral contributors) were quickly added Roger Tailleur, Michel Pérez, and Louis Seguin, residents of the neighboring convalescent home of Saint-Hilaire-du-Touvet, who had established their own magazine, *Séquences*. Once in Paris, these young people (except Chardère) would meet Ado Kyrou, Robert Benayoun, and Gérard Legrand, former writers for *L'Âge du cinéma*, a Surrealist mouthpiece, thus adding another dimension to *Positif*. Other recruits from the provinces were the men of the Midi: Marcel Oms (the future host of "Confrontations," in Perpignan, and *Cahiers de la cinémathèque*); Raymond Borde, who founded the Cinémathèque de Toulouse, and Jean-Paul Török. Gérard Gozlan and Michèle Firk, early

oppositional Communists, through their militancy brought further commitment to the Left-leaning tendencies of all the editors.

What made *Positif* distinctive in the 1950s, which were heavily influenced by the Left, particularly in the cultural area through the domination of the Communist party and its fellow travelers, was its ability to merge a love of cinema in all its forms (particularly Hollywood movies) far from Stalinist puritanism, and at the same time become actively involved in political battles. Anyone who did not live through the period would find it difficult to imagine how deep and intense were the political differences elicited by the colonial wars, the still-powerful influence of the Church and its moral order, and the role played by censorship. Although one might criticize the magazine for having missed out on important filmmakers like Roberto Rossellini and Alfred Hitchcock, the editors at the time could well reply, as Jean-Paul Sartre might in another context, but with better reasons than he had: "We were wrong, but we were right to be wrong." For defenses of Rossellini and Hitchcock were to be found elsewhere, in the name of "grace" or other religious values, with an emphasis on "miracles" or "confessions." At the time, it appeared to be more important to defend various other values, hence the iconic names that frequently appeared on the covers of *Positif*: Jean Vigo, whose films were a turning point in the rebirth of French cinema, a cinema that was to be libertarian, poetic, rebellious; Luis Buñuel, totally faithful to himself, an ironic decrypter of bourgeois society; Akira Kurosawa, the spearhead of new Japanese cinema; Andrzej Wajda, a director who grasped the early warning sign of tremors in the loathed regimes of Eastern Europe; Michelangelo Antonioni, the creator of a modernity that would characterize the following decade; and lastly, John Huston, screenwriter, director, and rebellious individualist who overthrew the conventions of American cinema. For while *Positif* may have been one of two key champions of Hollywood movies (along with *Cahiers du cinéma*), it supported those films on the other side of the Atlantic that went against the silent majority or at least did not exalt the values of the Eisenhower era. It focused on the dreams incarnated in musical comedy (Vincente Minnelli, Stanley Donen), the pessimism of film noir, the radical criticism of Robert Aldrich or Orson Welles, the liberalism of people like Richard Brooks, the new look incarnated by Frank Tashlin or Stanley Kubrick, not to mention the anarchic delirium of the cartoons of Tex Avery and Chuck Jones.

This international aspect of the magazine, which was to grow dramatically in the 1960s with the worldwide explosion in new cinematography movements, was always reflected in the many talented new foreign contributors who, whether from within the editorial committee or not, brought their sympathetic but different sensibilities. There were the Iranians Hoveyda and Gaffary, the Italians Fofi, Volta, and Codelli, the Brazilian Paranagua, the Czech Král, the Swede Aghed, the Pole Michalek, the Swiss Buache, the English Elsaesser and Le Fanu, and the Mexican Perez-Turrent. That some of these were members of Surrealist groups in their respective countries demonstrates once again how important the Surrealist movement was to the magazine.

For at *Positif*, the cinema, while never separated from civic commitment, was also never dissociated from painting, literature, or the other arts. The auteur policy was thus always complemented by attention to the creative contributions of screenwriters, set designers, directors of photography, and musicians. The constant interest shown in animation, for example, came no doubt from familiarity with the plastic arts and comics. And that four publishers known for their literary output—Les Éditions

de Minuit, Éric Losfeld's Terrain Vague, POL, and, more recently, Jean-Michel Place—should have crossed paths with *Positif* ought not to be surprising. Nor should it surprise anyone that many of the contributors, past and present, are also poets, novelists, or essayists, ranging from Frédéric Vitoux to Jean-Philippe Domecq, Gérard Legrand to Emmanuel Carrère, Jean-Loup Bourget to Petr Král and Robert Benayoun.

The magazine was sometimes criticized for neglecting French cinema—a trumped-up charge if ever there was one. But undoubtedly in its international outlook its attitude could be seen to be more circumspect, with a desire to judge domestic production against that of other countries, without being too complacent, as so many were, or too reliant on cozy relationships within the industry. While *Positif*, from the very outset, may not have wholeheartedly embraced the total Nouvelle Vague package as a revolutionary phenomenon with a profusion of talents (many of whose careers were short-lived), the magazine had nothing but praise for François Truffaut's *Shoot the Piano Player* (*Tirez sur le pianiste*), Jacques Demy's *Lola*, Jacques Rivette's *Paris Belongs to Us* (*Paris nous appartient*), although Jean-Luc Godard remained a blind spot for *Positif*. The magazine was undoubtedly closer to the Left Bank filmmakers—Chris Marker, Alain Resnais, Agnès Varda, Georges Franju—and support was also needed for the individualists who did not have the benefit of the snobbery associated with influential groups: people like Claude Sautet, Michel Deville, Alain Cavalier, and others like Maurice Pialat.

Labels give people a feeling of security. *Positif* was upsetting to those who liked neat categories, and was distasteful to some because of its extreme freedom. Depending on whom one spoke to, it was either too theoretical or not theoretical enough. And then they were the intellectuals, the hair-splitters, who loved the labyrinths of *Last Year at Marienbad* and the speculations of Raúl Ruiz or the traps set by Peter Greenaway, but who just as readily defended the horror films produced by Hammer Films or Michael Powell's *Peeping Tom*, unanimously rejected when it was released by the "serious" press, as well as the golden age of Italian comedy neglected on both sides of the Alps! Supporters of the FLN (National Liberation Front) and signatories of the Manifesto of the 121 [a signed statement by 121 intellectuals affirming the right of conscripts not to have to fight in the Algerian war] also sang the praises of Anthony Mann's Westerns or Blake Edwards's comedies, "opiates of the people" both, but perhaps failed to notice automatically the virtues of Third World films! It is always dangerous to be out of sync with fashion, to explore the contours of future cinema, at the risk of being called elitist or for basking too readily in the pleasures of old films and being labeled retro.

The 1960s saw the triumph of critical unanimity. Fellow critics who up until now had not been highly politicized and even less curious about foreign cinema (apart from Hollywood) discovered ideological concerns and a genuine cinematic curiosity. In other words, they finally caught up to *Positif*. This incredible decade saw everything that was innovative in world cinema being defended: a rebirth in Poland with Roman Polanski and Jerzy Skolimowski; in Hungary with Miklós Jancsó, István Gaal, and István Szabó; in Russia with Andrei Tarkovsky, Otar Iosseliani, and Gleb Panfilov; in Italy with Marco Bellocchio, Bernardo Bertolucci, and Gian Franco Mingozzi; in Brazil with Glauber Rocha, Ruy Guerra, and Carlos Diegues; in Czechoslovakia with Milos Forman, Ivan Passer, and Véra Chytilova. *Positif* and *Cahiers* launched their "semaines de films inédits" (new cinema), which brought this desire for discovery to film programming. The late 1960s and early 1970s saw our sister publication

bogged down in Maoist preachings, after limiting the scope of its preserve to Godard-Gorin, Straub-Huillet, and *The Red Detachment of Women* (directed by Xie Jin), to make the most of the cultural revolution as they all read *Peking Information* in chorus to the glory of the work camps. *Positif*, although it welcomed the May 1968 movement and took part in it actively, held its course in the midst of the excessive zeal of the latecomers to the revolution, to the jibes of those all too willing to speechify about the virtues of the Red Guard. It was in this contaminated climate, exacerbated by the Vietnam war, that anti-Americanism became popular, a time during which *Positif* declined the invitation to criticize overseas filmmakers, particularly those who refused to proclaim the dominant values of their society and were busy rejuvenating Hollywood films in terms of both structure and story lines: people like Robert Altman, Monte Hellman, Martin Scorsese, Francis Ford Coppola, Bob Rafelson, Jerry Schatzberg, Sydney Pollack, Terrence Malick, and Brian De Palma.

At last there was calm after the storm. But while confrontations may have been less visible, there were equally necessary battles to be fought. It was the context that had changed. *Positif* was born in an era of deep and intense cinephilia, sustained by the extraordinary activity of the ciné-club movement. In every city – even small ones – classics of the cinema were regularly on view. The cultural fabric had given birth to a multitude of magazines. Some, in the 1950s and 1960s, were close to *Positif*, for example René Château's *La Méthode*, Francis Gendron and Jean-Louis Pays's *Miroir du cinéma*, Michel Caen and Jean-Claude Romer's *Midi-minuit fantastique*, or the defiant *Jeune Cinéma*, founded by Jean Delmas, which gave Jean-Pierre Jeancolas, Françoise Audé, and Hubert Niogret their start. It was around the film club Cinequa-non that I met Bernard Cohn, its guiding light, before we both went to *Positif* in the early 1960s, along with Bertrand Tavernier, the co-founder of *Nickel Odéon*, and began to write articles for it. Alas, these irreplaceable ciné-clubs, so important for culture, have been allowed to disappear, as the more-spectacular but less-important media and cultural trends made inroads. And television is doing a worse than ever job—the programming of non-Anglo-Saxon foreign films on the networks is hopeless. Nothing has replaced the in-depth work done in those years by the ciné-clubs. Distribution is worse than ever, and the rare independents who dare to stray from the beaten path become victims of media concentration and are unable to balance their books by selling films in their catalogues to the Malthusian world of television.

It is the perennial thirst for discovery that also explains the success of film festivals. The many festivals in France make it possible for local audiences to learn about areas of cinema from the past or present that are not generally well explored, for a short period every year, through a retrospective or a panorama. *Positif* has stuck more fiercely than ever to its high standards in this area. The space we give to the rediscovery of cinematic works and to historical aspects of film is, we feel, essential: insight into the current state of cinema and its future requires an exploration of its cultural legacy.

Our current editorial platform of curiosity, artistic choice, historical information, and critical analysis in the cinema appears to us to stem from a polemic attitude in response to the advertising overkill and ever-diminishing space given to cinema criticism in the general press. And recognition of aesthetic appreciation becomes all the more necessary at a time when the cultural pages of newspapers are gradually

being transformed into detailed box-office reports. Readers of film magazines can get all the information they want about box-office receipts in Los Angeles, New York, and Chicago! If a film does poorly in the US, it is a bad sign for how it will do in France, as if the quality of a film can be judged by how much money it makes. The speed with which information circulates levels the media playing field. To my knowledge, Truffaut, Benayoun, Tailleur, and Godard could not have cared less, when they were critics, about what New York or California reviewers thought about *The Night of the Hunter, Touch of Evil, The Left-Handed Gun,* or *The Barefoot Contessa.* So much the better for the French critics, because their ability to judge these films independently helped these films acquire their status today as classics!

But in recent years the landscape of cinema magazines has changed considerably. The monthlies have virtually all adopted the same magazine format: page layouts that allow zapping, a proliferation of short columns, fragmented summaries, an emphasis on "people" articles, schedules of events, top-ten ratings and critic's choice lists, financial information, films in production, whether or not accompanied by stories, etc. There has also been a great increase in the number of bimonthly, quarterly, and semiannual magazines, either devoted to theoretical studies or the history of cinema for a highly erudite public. *Positif,* a monthly available at newsstands and magazine shops persists, however, despite this general shift, in continuing to call itself a "cinema magazine," just as it always has, helping it to stand out from the rest even more today. With the explosion of information on the Internet and the arrival of new media (scrambled channels for Pay TV, DVD), we feel that it is necessary to make well-informed choices, and to sort through the flow of images carefully. *Positif* was thus among the first to detect the emergence of a new generation of French filmmakers in the 1990s, as well as the amazing output of Asian filmmakers. Like the first readers of fifty years ago, we leave it to the new readers of today to tell us whether this kind of contribution is essential and whether the enjoyment is mutual.

—*Michel Ciment*

Editors' Note

Selecting an anthology of forty-four articles from a total of five hundred issues, as a way of marking the fiftieth anniversary of a magazine, seemed like an impossible mission. We decided to make the selection somewhat cohesive by choosing only articles that illustrate those aspects of *Positif*'s criticism that are most relevant to present-day cinema and to introduce each text with brief remarks, written by Michel Ciment, who has been associated with *Positif* for close to four decades. The studies in this compilation are thus contemporary with the release of the films and indicative of the stand taken by the magazine as the history of cinema was being written.

This means that three key areas that made *Positif*'s reputation are missing from this collection. First to go were the long in-depth interviews, several examples of which may be found in English within the *Interviews* collection of books about directors published by the University Press of Mississippi. Then there are the special issues about the history of the seventh art. Third are the theoretical and polemical articles intended each month to stimulate discussion about the cinema. By thus circumscribing the types of material that would be included, we are, of course, aware that a number of important names among the magazine's stable of writers are missing, as well as certain directors that some writers at *Positif* considered extremely important.

revue

positif

mensuelle de cinéma

1950s

YOU'RE GOING TO SAY:

Not another film magazine (and yet another preface!) when so many others have fallen by the wayside . . . Doesn't it matter that the market you are breaking into has no more readers?

Decentralization is very nice when you're talking about it from Paris, but in a city where sponsors can't even support an undefeated soccer team . . .

What affiliations, what skills, what money? You are doomed to being ephemeral, so we won't buy you.

Why We Are Going to Fight

Bernard Chardère

Bernard Chardère, a literature student, founded *Positif* in Lyon at the age of twenty-two with the help of a number of friends. In his editorial in the first issue, he provides the broad outlines that the journal intends to cover over the coming years of film history in the making.

WE SAY:

You like the movies: you also know that film is an art. It took fifty years for the professors to admit it; in another half-century students will be writing theses that attempt to reconstruct lost masterpieces. But whose fault was it that they disappeared? It is up to us to do something against the merchants of the mediocre.

That is the role of a film magazine: apart from what it has of interest to each individual reader, it acts as a witness for us all, we the masses. To be sure, it is a minority mass, but "the minority is always right." What Henrik Ibsen meant to say was, "We'll always be right."

The "battle" is a specific one: the magazine *needs to last*. A film magazine becomes more important as time goes by. You may not have seen a particular film, and you may not have purchased the issue of *Positif* that discusses it, but you will see that film one day . . . Then a friend who happens to have a copy of our magazine borrowed from someone else will lend it in turn to you. We wish to remind you, however, that if you read this copy, borrowed from someone else, to get the information you need, we will be unable to survive. We hate to remind you of this so early **on**, but without your subscriptions we can do nothing.

WE DON'T WANT:

—To be a newsmagazine. Although our main office is in Lyon and no film news comes from anywhere but the first-run theaters in Paris, our team has enough people with access to the latest professional screenings who are able to keep up with the most-current projects. But *Positif* will not in any way attempt to be a film daily; we will have as much to say about Jean Renoir's *The Rules of the Game* (*La Règle du jeu*) as his *The River* (*Le Fleuve*) (let alone *The Golden Coach* [*Le Carrosse d'or*],which is based on Prosper Mérimée's novel *Le Carrosse du Saint-Sacrement*]). Not only that, but as a general rule, you need to screen a film more than once before you can talk about it. And although film-festival summaries are indispensable, and we have nothing against them, we would prefer to do something else.

— Be a retrospective magazine. We will not focus tenderly and exclusively on the silent era. When the cinema was silent, we were barely learning to speak, and when

Cover of first issue of *Positif*, May 1952

The Jazz Singer came out, most of us knew nothing about the movies. We like the masterpieces of 1920. But we also believe masterpieces are still being produced today and that it is important to say so, if only to make sure that there will be some tomorrow. We want to reach a broad public rather than a few circles of initiates (or people who believe they are). It is an ambitious dream, but the fact that *Diary of a Country Priest (Le Journal d'un curé de campagne)* was such a widespread success indicates that we ought not to despair over the taste of the "masses."

—A "youth magazine." While it is true that members of our team might be described as young, we refuse to focus on scandal, to wallow in anarchy, or to parade the flotsam and jetsam of a difficult puberty. Likewise, we will mistrust peremptory judgments, capital punishments, and mere summaries, just as we will be cautious about enthusiastic infatuations for the three random sublime minutes in an otherwise idiotic film; in other words, we will attempt to avoid all of the false audacity that does such a poor job of covering up inexperience and ignorance, to which we willingly admit.

WE WANT:
—Discoveries rather than rehashes, even subtle ones. Shedding light on the unknown John Huston is far more useful than trotting out the usual clichés about *The Devil's Envoy (Les Visiteurs du soir)* for the nth time.

—Interesting contributions, in particular from those who do not often get an opportunity to express themselves: the makers of films that we admire. Doesn't a single sentence from Jean Renoir have more resonance than a hundred books of exegesis?

—An improved layout: it will be what you make of it. It is your subscriptions and your friends' subscriptions that will make it possible to increase the number of pages, the number of photographs, and the quality of the paper.

—Last, we would not want to be unworthy of film criticism. Here we salute our elders: *Cahiers du cinéma*, on a solid footing in the wake of the sadly missed Jean-Georges Auriol, *Sight and Sound*, *Bianco e Nero* . . . However (more modestly perhaps), it is from *Raccords* that we would like to pick up the torch. Like Gavin Lambert's *Sequence* in England, the magazine published by our friend Gilles Jacob recently disappeared. And yet "no one died," and you will find a few names here soon . . . It is only natural that there is a link between us and Jacob's magazine. Rather than starting from scratch after a fade-out, *Positif* will hit the screen as a fade-in.

No. 1, May 1952

SWIMMING LIZARDS AND MONKEY BUSINESS

I f we were to ask John Huston what *The African Queen* was, he would no doubt say, as he tends to do, that it is "a nice little adventure film." It is an amazing adventure film, but then he did have Africa as a setting. True enough, his Africa has been completely stripped of its "wild splendor," without the prestige of huge wild beasts and with only the mosquitoes and leeches retaining their vicious reputation. Out of what usually makes us quiver and tremble, Huston amuses us from time to time along the way: swimming lizards and monkey pranks are what African exoticism has been reduced to. Huston renounces the dis-

The African Queen

Jacques Demeure and Michel Subiela

The third issue of *Positif* contained a number of articles about John Huston, followed by a number of special issues or features about major directors. The editors found that Huston was a model screenwriter-director who created his own universe within the restrictive framework of Hollywood production. He also took a critical stance toward the very conservative American society of the 1950s.

orientation normally imparted by exotic new surroundings and the facile prestige of a strange world seen eternally through the eyes of whoever gets off the boat. Reducing the scenery to its proper function, scaring filmgoers with leeches rather than lions, and giving the starring role to something other than the virgin forest shows a total disrespect for the rules of adventure films. But it also rejects the facile traditional formula, the most tried-and-true components of which are suspense, parallel editing, close-ups of the bad guy grimacing, and an enigmatic witch doctor.

Thus delimited, the world of Miss Rosie, Charlie Allnut, and *The African Queen* is not Tarzan's world.

ASPHALT JUNGLE—AFRICAN JUNGLE

An essential feature of Huston's films is the systematic obliteration of American mythology. In his previous films, he in turn debunked the Detective, the Gangster, and the Adventurer, and his methodical search for the men beneath the mask, with which the movies and literature are replete, appears to have led to *The African Queen*.

American civilization provides frameworks that generate archetypal characters. When they are placed outside of any civilization, removed from the asphalt jungle and conveyed to a healthy primitive setting, such characters run the risk of having a different but no less conventional attitude imposed upon them by a different environment. That is why in this film Huston never shows us an image in which the picturesque surroundings constitute the most important thing on the screen. The characters are always front and center, and they never expect anything from the landscape into which they have been dropped. That is why the colors are all somber: green and gray-blue backgrounds against which the deeply tanned faces stand out.

Why then did Huston believe that it was necessary to shoot this film in Africa itself, with all the inherent problems of filming there? Because he wanted to get back to a harsh but free lifestyle in touch with nature, of which Robert Flaherty (who was its friend) showed us the grandeur, a primitive universe that American novelists nostalgically attempted to re-create.

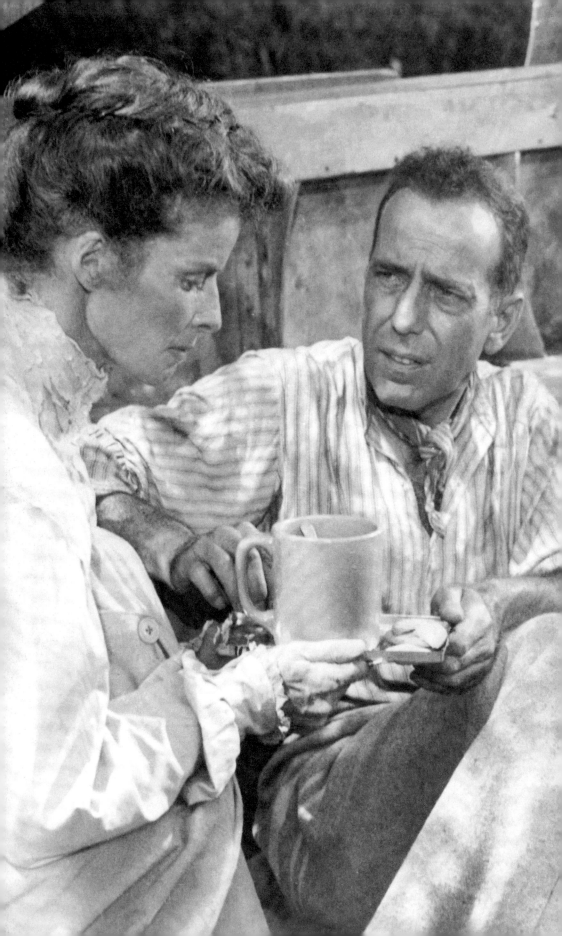

HYMNS FOR BLACKS

There is no place for the greed of *The Maltese Falcon* or *The Asphalt Jungle* in a place where gold and diamonds mean nothing, where civilized people feel ill at ease, encumbered by their quaint clothes. Their transplanted rites look ridiculous, and the film begins in a setting worthy of Charlie Chaplin, with a misfit of a priest trying to sing hymns for the local blacks. Rosie's simple prayer on *The African Queen*, trapped in the swamps, has more power than all of these religious artifices, perhaps because the small boat, so perfectly in harmony with the region through which it traveled, drew strength from the shorelines along which it sailed and from the river it descended. It is less a machine than an old familiar beast of burden persuaded gruffly but gently to keep going.

The African Queen guides Rosie and Charlie in their unlikely adventure.

THE STUBBORNNESS OF THE ABSURD

The plot goes from one twist and turn to another, thanks to the strokes of luck that happen every time their escapade appears to be coming to an untimely end. When, after so much useless effort, Rosie (Katharine Hepburn) and Charlie (Humphrey Bogart) give up on the idea of ever getting *The African Queen* out of the swamps, not knowing that they are only a few meters away from the lake, we can only recall the ridiculous failures of some of Huston's earlier heroes. Ditto when they get married beneath a mast that they are supposed to be hanged from. But the rain saves their small boat and pushes it all the way to the lake and guides the boat *The Louisa* toward the wreck full of torpedoes. And the most ridiculous of all is reserved for the "civilized people," the sniper blinded by a ray of sunlight, the German sailors who do not know how to swim. In other words, everything appears to be conspiring in favor of the couple on *The African Queen*, so stubbornly that it approaches the absurd, and they escape the fate of the characters in Huston's earlier films.

This absurd play of external forces prevents us from feeling that Rosie and Charlie are heroes and even destroys the very idea that what they are involved in constitutes an exploit. How can you believe that someone is a heroine when she is unable to size up the danger involved in the rapids ahead? How can a chance torpedo-launching be considered an exploit? Is it possible to consider people heroes when they get involved unconsciously and see their efforts move beyond their control and yet succeed in spite of them?[1]

A BOAT BUILT FOR TWO

What we have here are not heroes but a man and a woman. The two of them, alone on a river whose banks we never get to know, are constantly on screen. Huston focuses all of the interest on a small boat. The small amount of space they have to move around in led him to use close shots constantly, but he did not use many extreme close-ups because they isolate the characters too much from their frame of reference, and this might well have interrupted the climate of tenderness that is so specific to this film.

The bedroom that traditionally isolates lovers from the rest of the world is here replaced by this leaky old tub called *The African Queen*. But the tone between the lovers is the same, and Huston reveals himself to be a "master of intimacy," who is able, with unexpected poetry, to reinvent the couple: She and He.

Katharine Hepburn and Humphrey Bogart in John Huston's *The African Queen*. 1951

GIRL SCOUT AND STRONG DRINK

"She" is over forty. After she wasted many years playing the harmonium among the natives and preparing tea for her brother preacher, his death at the time of World War I released her from her Puritan constraints. But her parasol and large hat still indisputably make her look like a Girl Scout, an accomplished product of the traditional English education system. Her patriotism and her sporting attitude lead her to drag poor Allnut and his old boat into attacking a German gunboat. But this meant having to sail down a river full of rapids; as her dress and skirts become increasingly tattered, she leaves behind her British dignity and her aversion to strong drink. On the other hand, she gains the exaltation that comes from dangers overcome and learns more about the opposite sex. This evolution is made clear through the expressive medium shots of Rosie at the end of so many scenes, which are often indicative of her ever-changing view of life. It took Hepburn's talents and face to render these subtle "punctuations" that condition the viewer's feelings for "He."

SISYPHUS IN LONG JOHNS

"He" is not much older, but the fact that he has been navigating on the rivers of Africa has taken away any veneer of civilization. The only thing that remains from his Canadian background is his long johns. There is never the slightest trace of patriotism. For example, he almost forgot to tell the minister that World War II had begun when he visited him. When he got there, he disrupted Sunday Mass and the traditional tea ceremony with his rumbling stomach (a deep sound never before heard in the movies). But these noises that sound out of place in the world of good manners disappear as the adventure continues its course, no doubt because Rosie, as she gets closer to Charlie, no longer finds it worth objecting to. It is through her eyes that we see Allnut transformed from a grotesque caricature into a feeling human being. Rosie's attitude and feelings become ours, and the only person who needs to express himself is Allnut; we can feel that he is trying to meet her halfway, by shaving, attempting to clean himself up a bit, and turning *The African Queen* into something of a home.

Far from the towns that he is used to visiting, Bogart seems to discover true courage and sincerity.

RAPIDS AND LEECHES

This courage is genuine insofar as it is a slow and deep victory over oneself—the very opposite of an exploit. It is always easier to go down the rapids enthusiastically than it is to suffer from mosquito bites and leeches in an attempt to remove a boat from the slimy mud of the swamps. The difference in the timing in each of these two episodes shows clearly that Huston prizes tenacity over skill, and that he feels it is more important to decide upon and then stick to something than it is to succeed.

As for the courage that comes to the surface in the heat of the action, Rosie and Allnut have it to the same degree, giving rise to a form of equality between them.

A REMARKABLE LOVE STORY

It is this equality, and even more so the intimate tone of Huston's approach, that makes *The African Queen*, despite the characters' ages and the location, a remarkable love story. Even more surprising given Huston's slim history of dealing with love stories, his characters needed love, but this need was never met, either because there

was no one there to meet it or because the relationship had failed.

It is here in a surprising climate of good health, sensuality, and tenderness that the sexual doings of our forty-year-olds take place, without *The African Queen* ever beginning to resemble anything like a Venetian gondola.

And as the Puritanism disappears, Huston pushes the traditional device of American eroticism—frustration—to caricature. Tempted during the inevitable bath scene by Hepburn's bare foot, the onlooker is bewildered to learn that many petticoats remain to be removed before anything like an Esther Williams revealing bathing suit will be seen. Of what use could these outdated dainty items be to people who have found a sense of joy in natural living? The love they have discovered is without artifice. In their contact with one another, he loses his overly rough edges, and she her excessive reserve, as they achieve perfect harmony in this "great love" that is their strength. This strength leads them to be willing to make sacrifices for one another, and to aggression toward "others." Charlie abandons his old boat for Rosie, making *The African Queen* the only victim we can feel sorry for in the whole story; and when they are in danger, each wants to run the risk alone. This is the first scene in which the strange household they have established shows that their union has been strengthened. And this union is something they affirm violently when faced with the last civilized people they may ever meet when, only a hairbreadth away from death, they somehow turn marriage into a form of protest.

Thus out of something that could have turned into a saga of patriotism, Huston has made a personal adventure. Thanks to a string of good luck, Charlie can still hum his corny old "Pimlico Sailor" tune. After the German gunboat goes down, the only trace left on the lake is the two "newlyweds" swimming toward shore. At the end of this absurd odyssey, it is easy to imagine Sisyphus in domestic bliss.

1. The novel *The African Queen*, by C. S. Forester, underwent many significant changes in the adaptation by James Agee and John Huston, particularly in the denouement. In the novel, Rosie and Charlie are chivalrously spared by the German commander, who admires their courage. In a state of extreme weakness, they owe their release to the attack by English ships, which the German gunboat resists heroically. Saved by their victorious compatriots, they decide, on Rosie's initiative, to have the nearest English consul marry them. The ending has Charlie thinking about his wife of twenty years, whom he left behind in England, and about whom he had not thought for a long time.

No. 3, July–August 1952

The African Queen. 1951. USA. Directed by John Huston. Written by James Agee and Huston with Peter Viertel, based on the novel by C. S. Forester. Produced by Sam Spiegel. Cinematography by Jack Cardiff. Music by Allan Gray. With Katharine Hepburn (Rose Sayer), Humphrey Bogart (Charlie Allnut), Robert Morley (Rev. Samuel Sayer), Peter Bull (Captain of *The Luisa*), Theodore Bikel (First Officer of *The Luisa*), Walter Gotell (Second Officer of *The Luisa*), and Gerald Onn (Officer of *The Luisa*). 103 min.

as it not Montesquieu who said, "The secret of writing well is to skip the
intermediate ideas"? This is also the essence of true cinema: editing,
ellipse, juxtaposition. That is the way to obtain the most reliable effects:
out of the shock of two images comes emotion, whereas a commentary (or a dialogue
in counterpoint), though apparently cool and "outside," adds somehow to this emo-
tion through a feigned neutrality. See Luis Buñuel's *Land without Bread* (*Las Hurdes*).

This process of "commentary" might well be said to belong to the era that
developed it to perfection—the eighteenth century. Voltaire, at the same time as
he was telling us what was going on, commented on it in a series of short, incisive,

Robert Hamer's *Kind Hearts and Coronets*
Bernard Chardère

Positif's interest in British cinema has never flagged, disputing François Truffaut's
famous comment to the effect that the two terms were incompatible. Before salut-
ing the birth of Free Cinema in the late 1950s, the journal celebrated the singular
originality of the films made at Ealing Studios by Robert Hamer and Alexander
Mackendrick.

perfect sentences, one after the other. There are never any apparent rebuffs, flights
of fancy, or efforts to wax lyrical. Everything endlessly repeats itself, the flames
crackle and converge without the author ever abandoning a tone more appropriate
to a report. This kind of commentary never weighs things down because it is never
developed further. It adds raw facts and brief comments together without any tran-
sition. The humor—and strength— of this style stem from the accumulation of un-
expected relationships. See the succession of sequences in Jean Renoir's *The Rules of
the Game* (*La Règle du jeu*).

This could be the definition of a specific form: that of the tale or the story. It is
essentially literary, essentially cursive. Transposing it to the cinema would involve
spending most of the time on the script, meticulously preparing it and breaking it
down into parts. Only then would images be developed to illustrate the text, mean-
ing—to the greatest extent possible—contrasting with it. Taken to the limit, this would
involve the projection of still images: we would end up with paintings by Mackie be-
ing commented on by songs from *The Threepenny Opera*, or, better yet, pictures from
Pierre Kast's *Images du Larousse* projected one after the other on the screen.

But we do not wish to condemn the successes in the name of moving images.
However, such successes are difficult . . . It takes a Charlie Chaplin to know how to
stick to static shots most of the time—and to make *Monsieur Verdoux* . . .

What I had in mind as I wrote the above was *Kind Hearts and Coronets*, Robert Hamer's
English film produced in 1949 by Michael Balcon.[1] Hamer made another excellent
film as well, *It Always Rains on Sunday*. But on the other side of the English Channel
they noticed that it went a little too far, much farther than the well-known and much
loved, structured, and polished "humor."

It was Nino Frank, I think, who wrote that he would believe in English humor
when it could make fun of the royal family, the Commonwealth, and the House of
Commons . . .

It must be admitted that one of the best English stories is the removal of the
Stone of Scone, a story that does not appear to be very popular there, and that a

Alec Guinness in Robert Hamer's *Kind Hearts and Coronets*. 1949

nation that begins to grow delirious two years before the accession to the throne of a queen, in 1953, strikes us as singularly lacking in humor. Unless, of course, this "humor" is simply a discreet way of dealing with embarrassing questions without ever confronting the taboos. There is no doubt whatever that laughter among friends has nothing in common with the victorious and all-conquering (would we dare to say progressive?) laughter of the freethinkers of the eighteenth century making a clean sweep of things.

The fact remains that although Hamer's film involved a degree of confusion,[2] it is absolutely harmless today. What we have here is a masterpiece, one that is completely out of step with the run-of-the-mill "English comedy film"; not only would it be impossible to remake it, but it could not even be imitated.

The story is that of a young man, the last in line to inherit a dukedom, who, by various means, does in the seven descendants in the line above him one by one. And he does so with considerable elegance, very gently, to please his mother (who died of sorrow when the family title was lost). A triumph of filial love. But at the point of achieving his goal, and about to marry the noble wife of his first victim, he is accused of murdering a childhood friend—the only murder he did not commit. A failure of human justice. Condemned to die, he is saved in extremis by his mistress, the wife of his childhood friend and a childhood friend herself, who loved him more and more as he got closer to his goal, and guessed everything. The end of the film, which is literally genial, leaves us in some uncertainty about our hero's future conduct: there is one woman too many, not to mention the fact that he left his diary on the prison table.

Hamer likes *The Rules of the Game* and harks back to it by choosing a piece by Mozart, and also in having an enjoyable scene with a poacher. He likes *Monsieur Verdoux*—the similarity of the themes is obvious, and he salutes Chaplin's best film with an exquisite stream of smoke (the ashes of the first in line . . .) billowing above a wall at the end of a field while, in the foreground, the attendant and the widow talk about the deceased. Just as Monsieur Verdoux gathered roses in front of his crematoria.

But Hamer is too discreet to show an open influence. "Black humor" is meaningless, but he would underscore the humor ("I like your sense of humor," says Sibella to her friend) and darkness ("He finds it difficult to kill people who aren't even his friends"). He dispenses subtle pleasures (the funeral bell sounding *before* the hero ties up the boat used to drag the two victims to their death) and the first truth, which we too often forget ("As in all good families, the stupidest was given over to religion"). At times sensitive (recalling Tennyson; his wonderful sets and costumes), and sometimes harsh (the tense scene between the duke and his mistress, very Maupassant: "We deserve one another..."). Knowing how to be directly sensual ("I want to shout when he touches me". . . says Sibella speaking of her husband . . . We note that the filmmaker has perhaps discovered the best way of showing a kiss—in a close-up of the woman's face *before* . . . And the choice of actor, with the curious timid and harsh voice, "Lou-is"—all these small minor details that make it perfect) or skillfully bawdy (the two friends stretch out on a sofa in front of the hearth—collapse on the white wedding dress) Hamer thought of everything, and made everything work.

It certainly deserves to be called a masterpiece. We could go on for ten pages and still not exhaust all the resonances: the social satire, the customs and mores, the comedy and the maliciousness. No detail has been left to chance. Each word is care-

fully weighed; there is not one word too many; each scene is meticulously prepared, and none could possibly have been structured or executed better. Once the script had been completed, the film was, of course, finished (as with René Clair) but still to be discovered were the transitions to the image, the choices involved in deciding how to illustrate the content. Never has the word "mise-en-scène" been more accurate! With a faultless script, all the angles sharp, and all the loose ends taken care of, Hamer came up with a series of appropriately linked sequences that varied in terms of pacing...

Throughout, the story is narrated by the hero, who tells us his past. He is interesting enough to hold our attention, but sufficiently outside (cf. Renoir as Octave in *The Rules of the Game*) to tell us his thoughts as things go along, in a detached but believable manner. And, paradoxically, isn't a film like this made for subtitles, sentences from a tale that fit so well under the precise images of some magic lantern?

Hamer has given us a "lesson" in a genre that we would be wrong to believe, you can take it from me, to be essentially French. It would not be particularly interesting to attempt to derive inspiration directly from something that is never a model to be followed, but that somehow remains a remarkable success. Perhaps, one might at least recall the tone?

In any event, just in case, check out your family tree and make sure that you see this film (it is, after all, a masterpiece). As Thomas De Quincey put it so well, "Enough has been given to morality; now come Taste and the Fine Arts."

1. Screenplay by Robert Hamer and John Dighton (based on Roy Horniman's *Israel Rank*). There is an interesting interview with Hamer in the December 1951 issue of *Sight and Sound*. See also Lindsay Anderson's article in issue no. 9 of *Sequence*.

2. It could be compared to Claude Autant-Lara's *The Red Inn* (*L'Auberge rouge*). The skillful Alec Guinness would, no doubt, like Fernandel, have been out of his depth.

No. 9, Autumn 1953

Kind Hearts and Coronets. 1949. UK. Directed by Robert Hamer. Written by Hamer and John Dighton, from the novel *Israel Rank* by Roy Horniman. Produced by Michael Balcon. Cinematography by Douglas Slocombe. Music by Wolfgang Mozart. With Dennis Price (Louis Mazzini), Joan Greenwood (Sibella), Valerie Hobson (Edith), Alec Guinness (Ascoyne d'Ascoyne/Henry d'Ascoyne/Canon d'Ascoyne/Admiral d'Ascoyne/General d'Ascoyne/Lady Agatha d'Ascoyne/Lord d'Ascoyne/Ethelbert/the Old Duke), Audrey Fildes (Mrs. Mazzini), John Penrose (Lionel), Miles Malleson (Hangman), and Clive Morton (Prison governor). 106 min.

M aurice Burnan's name and works are now well-known. He won festival awards for *Terrible* and *The Window Seat (Le Coin fenêtre)*, but now that he is internationally famous, people seem to have forgotten his beginnings. The studies that have appeared quickly gloss over his works prior to 1945 and, more seriously, neglect his cinematographic training, even though it is colorful and instructive.

The Early Films of Maurice Burnan

Paul Louis Thirard

Like any serious publication since the 1920s, *Positif* considered directors, or at least the best of the directors, as the "auteurs" of their films, but did so without the excesses of a "party line" that treated the latest work of every filmmaker as the pinnacle of his career (e.g., *The Countess from Hong Kong* for Charlie Chaplin or Jean Renoir's *Le Petit Théâtre de Jean Renoir*). Through his fabrication of the imaginary director Maurice Burnan, Paul Louis Thirard cast an ironic glance at the excesses some people would go to in creating and canonizing an auteur. In later issues of *Positif,* many people wrote in to contribute to the hoax, including film historian Georges Sadoul and writer Boris Vian. Later, the very serious *Films in Review* included in its filmography for Jean Gabin an imaginary film attributed to Burnan!

And yet, there is no doubt whatsoever that his present status owes much to *March to the Sea, Terrible, The Window Seat,* and *The Best Circles (Le Beau Monde),* but in this article, I would like to shed some light on his early days.

Maurice Burnan was born in 1899 at La Ferté-sous-Jouarre. In 1925, after a solid education culminating in a degree in literature, he began working for the periodical *L'Intransigeant,* where he wrote many different types of articles: popular culture, literary criticism, and movie criticism on occasion. It was not long before he met some of the pioneers of the day, the future "greats" of the cinema.

We will return in a short while to the screenplays he wrote at the time; one thing that deserves immediate mention is the curious story behind his first film, *Bread and Cocoa (Le Tartine de cacao)*

Burnan spent a great deal of time with the Surrealists; he befriended René Clair, Jean Cocteau, and Louis Delluc. In 1926 he shot his short subject, *Bread and Cocoa,* with the help of a few volunteer technicians and a borrowed camera. This short subject is still shown frequently at film-club screenings. It is perhaps the most staggering of any film shot at the time, and, God knows, we can still remember the bird putting on its yellow gloves to eat the head of the bound slave, the toy car full of shiny knickknacks . . . The film was very successful in film circles, but surprised those who knew Burnan; indeed, at the time, his great intellect was known more for his rather violent irony than for any lyrical esotericism. As for the efforts of his friends, he often spoke about them with amused indulgence. A number of critics claimed that the film was a hoax.

In 1946, in *La Revue du cinéma,* André Bazin, after seeing a retrospective screening of the film, wrote a remarkable article from which the following passage is excerpted: "In *Bread and Cocoa,* Burnan, at a single stroke, went much farther than any of his friends. Whereas *Entr'acte* was no more than entertainment, and *Un Chien andalou* nothing more than 'a passionate call to murder,' but one that left us alone in the middle of a disoriented world, Burnan's film achieved the difficult symbiosis between a form of

Maurice Burnan. *Bread and Cocoa.* 1926

anarchistic (and liberating) terrorism, and at the same time affirmed properly human values, as demonstrated by the magnificent image of the sword, which remained in the middle of the screen for ten seconds, alone and immobile."

It was only after the appearance of this laudatory article that Burnan resigned himself to admitting publicly that he had always considered the film a hoax, and that he had developed it off the top of his head, with no purpose other than to stun his audience. He added, rather perfidiously, that where Mr. Bazin was concerned, he seemed to have achieved just that.

But this is merely a colorful story. More instructive for us is a study of the many screenplays written by Burnan between 1923 and 1927. *A Definite Crime (Un Crime défini)*, directed by Julien Duvivier, and then *To You, Darling (A toi, darling)*, directed by Marcel L'Herbier, are among the most important of these. Glimpses of what was to become Burnan's universe could already be seen in these silent films: irony and bitterness, cynicism and laughter, films that are basically extremely desperate but bubbly and sparkling on the surface, like champagne.

After 1927, weary of his disputes with Léon Poirier over a script that Burnan claimed was ignored when the movie was being shot, our maker temporarily abandoned screenwriting. After that, he could be seen in a few films as an extra or playing bit parts: you may recognize him as the deathly pale chimney sweep in Jacobsky's *The Man in the Pale Fedora (L'Homme au feutre blême)*. He also plays the toothless tramp eating sausage in the doorway as Henri Garat and Claire Juvy say goodbye to one another in the final sequence of the heartrending *Nini Peau d'Chien*, by Jacques Feyder [music-hall song by Aristide Briand, which has since become a rugby song].

The year is 1932. The talkies. Burnan's first serious commercial film passed almost unnoticed. It must be admitted, though, that his *Legionnaire from Nowhere (Légionnaire du bled)*, although it contained some striking cinematographic passages for someone who had previously been a screenwriter, is somewhat difficult to watch today. Furthermore, Burnan, though he knew how to frame a scene, was not very good at directing actors. He had written the script himself but had, no doubt, lost his directorial touch. His lack of experience in writing dialogue for talking pictures did the rest.

Not at all discouraged by this failure, Burnan began to study seriously how to direct actors. His next film, *Station 503 (Poste 503)*, was a box-office success that is still considered a masterpiece, but it is rarely shown nowadays, even at ciné-clubs. However, one film they do show frequently is *Bread and Cocoa*.

Station 503 began as a script by Henri Fouquié. It was adapted by Burnan himself in collaboration with Jacques Coirrat and Henri Jeanson. Jeanson also wrote the dialogue.

Everyone remembers this magnificent love story in a godforsaken place, this modern Romeo and Juliet, and the majestic camera work of Rudolf Maté; Pierre Brasseur was a sensation, as were Robert Campi and Nikita Bottine in the role of the fortune-teller.

After achieving such perfection, Burnan's films were rather uneven by comparison until 1939, although none can be said to be indifferent: *Forbidden Passage (Passage interdit;* 1935), which was saved by Jacques Prévert's dialogue and Jean Gabin's brilliant interpretation; *My Pretty Girl (Ma Jolie Belle;* 1937), an unpretentious musical comedy in which a few scenes dear to our director come to the surface once again; *Words in the Air (Propos en l'air;* 1938) and, lastly, *Suite in D Major (Suite en Ré)*, interrupted by the war, which was never finished: the censors made it clear that they would not look favor-

ably on a film in which a prostitute says "shit" to a general in front of a subway station from which large numbers of mocking workers are exiting.

After being blacklisted by the Vichy government, Burnan took advantage of his forced vacation during the four years of the occupation to study the art of film in depth. He published two highly engaging theoretical works: *Semi-Exposed Film Stock* (*Pellicule demi-vierge;* Grasset, 1941) and *While Turning the Crank* (*En tournant la menivelle;* Gallimard, 1943).

The productive period that began in 1945 was marked by a total renewal for Burnan. We now rank Burnan alongside Robert Bresson and Jean Renoir; we have difficulty recalling the surprise with which the public, in 1946, greeted *March to the Sea* (*La Marche à la mer*). The rigor and austerity of the film were absolutely faithful to the story by Jorge Borges, with its many close-ups and sober acting, with some playing a role in a metaphysical tragedy for the first time (the mystical Raymond Bussières was quite a revelation); all of this taken together resulted in a completely new tone.

Bazin (who was the first to laugh at the bafflement of the 1926 film) wrote that "the future, the avant-garde, is now inner cinema," but Pierre Laroche spoke of the "renaissance of boring cinema," whereas Lo Duca demonstrated "the resurgence of Burnanian themes" masked by a different form.

And since then we have realized that it was not an isolated success, like *Station 503* in 1934. We have since seen *Terrible*, *The Window Seat*, and lastly, *The Best Circles*, which *Positif* reviewed in an earlier issue.[1] But it was, was it not, instructive to examine the background of this auteur, who is now in the pantheon, and to look at the slow progress of an emerging genius?

BIBLIOGRAPHY

It will be useful to refer to the two books written by Burnan mentioned in the text. In my view, the best work about Burnan is Jean Quéval's *Maurice Burnan;* however, as with most works, he says virtually nothing about the period prior to 1945. But then the book was published before the release of *The Best Circles*. For information about this film, there was a very detailed study in *Cinéaste*, issue number 4. There are three articles in that issue, by Bazin, A.-J. Cauliez, and Maurice Schérer, along with a taped interview, several photographs, an extract from the screenplay, etc.

FILMOGRAPHY

1926 – *Bread and Cocoa*	1939 – *Suite in D Major* (unfinished)
1932 – *The Legionnaire from Nowhere*	1946 – *March to the Sea*
1934 – *Station 503*	1948 – *Terrible*
1935 – *Forbidden Passage*	1951 – *The Window Seat*
1937 – *My Pretty Girl*	1954 – *The Best Circles*
1938 – *Words in the Air*	

1. Cf. the relevant analysis of this film by B. Chardère (February-March 1954). But when will we finally get to see *The Best Circles* on our screens?

No. 13, March–April 1955

I n only six months in Paris, with four films, a director suddenly appeared out of nowhere. At the beginning of the year he was totally unknown; he is now one of the most talked-about directors, of whom much is now expected. Just before the fall of 1955, his latest film was accepted for a festival, where it won the top award. The speed of this birth-ascension-recognition demands the epithet "unique," particularly when legitimacy is backed up by indisputable and uncommon qualities.

And yet *Apache* did not hint at such confidence or such a fast rise in the director's destiny. The film, which was remarkable mainly for the new way the subject was treated, was—except for a few moments—directed in no more than

The Advént of Robert Aldrich

Roger Tailleur

Roger Tailleur, a leading postwar French critic who wrote monographs about Michelangelo Antonioni and Elia Kazan, pays tribute to the early films of Robert Aldrich, who was considered by *Positif* to be one of the most interesting of the new Hollywood filmmakers, along with Richard Brooks and Frank Tashlin.

a workmanlike manner. *World for Ransom*, released in the same month (in the United States), loosened up the director's reserve, leading to two extremely successful films: *Vera Cruz* and *Kiss Me Deadly*. There is no longer any doubt that the cinema is now considerably enriched by a born filmmaker of exceptional temperament, a new master of the camera, as Jean Renoir or Luchino Visconti were when they were young, as King Vidor was in his later years, or as Jules Dassin and Orson Welles are still.

MASSAI

When we look back now on *Apache*, in light of the films that followed it, we are tempted to try to find traces of the sense of humor (Massai's escape in a train full of deportees, for example, or his arrival in St. Louis, in a white man's city, a sequence that Aldrich worked on lovingly) that were to affirm themselves and become more subtle in the director's future works. There were also some signs of cruelty and violence, as in the initial relationship between Massai (Burt Lancaster) and the Indian woman Nalinle (Jean Peters), in the solitary war conducted by Massai, a war of lightning bolts, explosions, fires, and death that rained down all over the place in Lancaster's brutal, nervous, and short-lived deeds.

The initial relationship between Massai and Nalinle, before love has had time to do its work, and the film are revisited later. For the longest time, Massai is afraid of love, afraid of the woman who can soften a single man and destroy his will: "I am a warrior," he defends himself, "and a warrior is worthless without hate." Then he weakens, but warns her: "All whites, all Indians are my enemies. I can only kill them all, and one day they will kill me." And she replies, "So we will live together until then."

A CONCENTRATION CAMP WESTERN

The way Aldrich tells the story, the duel between freedom and slavery in the film is reduced to its most rigorous expression. This virtuoso champing at the bit plays an extremely austere game for an hour and a half. I spoke of freedom, but all we see here of freedom are its final bursts. This is a Western that lacks space, where the rarefied air is virtually cut off from the rest of the world; there is constant anxiety over the trap that is always set to spring. Massai wakes up in an open cart that he had found the night before as a place where he could hide; his first impression was one

Burt Lancaster and Gary Cooper in Robert Aldrich's *Vera Cruz.* 1954

of being smothered, and his eyes shone with terror. It is a shot in which an almost unbearable feeling of claustrophobia is expressed, reminiscent of Edward Dmytryk's films. The editing is fast, taut, spare, with rapid dissolves (they lengthen considerably in Aldrich's *The Big Knife*, Stevens-style), single backward tracking shots that pan slowly to take in all kinds of action, and shots that group two or three faces or portions of faces in the frame, the way John Huston does it. This film, which was made at a time when CinemaScope was in vogue, protests against the invention; only once does the camera seem to want to run off its rails, following Massai as he leaves Nalinle. But when Massai stops to wait for his companion, the camera halts not long after, as if regretfully, and then revolves around the Indian to include the Indian woman in the frame. Everything I have to say about the film is contained in that one shot. The death of freedom is expressed in Aldrich's technique through every imaginable means: from the departure of the train containing the deportees from the Apache reserve, we see the station platform receding, and then the door of the car closes before our eyes and a blind is drawn; the fade-out is effective gradually and dramatically, with no artifice. There is another suffocating shot: that of Massai asleep in the tent of the traitor Santos, where three or four men struggle to put handcuffs on him. Needless to say, Lancaster fights desperately in the midst of this cluster of men, as he does in most of his films (*The Crimson Pirate*, *Vera Cruz*, *The Kentuckian*, etc.), but this time in vain.

Even in the love that ties him to Nalinle, there is a feeling of compromised freedom for which she reproaches herself incessantly. Massai is a symbol. The only thing on earth that speaks to him as an equal is the snowy peak in the mountains of his country, to which he promises to return as he gets on the train at the beginning of the film, fixing his eagle's gaze on it, his icy stare, more blue than any Indian gaze has ever been.

THE SINGAPORE GESTURE

World for Ransom, which Aldrich also produced—together with Bernard Tabakin—is initially more revealing, not so much of the director's style, which was still developing, as his aspirations and also his influences, and his desire to sublimate a tested genre—the exotic adventure film—by using an innovative technique that itself would become one of the stars of the movie.

Created on the strength of the popularity of the "China Smith" series, which he had directed for television with the same lead actor, Dan Duryea, Aldrich plays the game; his film is indeed an adventure film, and exotic too. The constant references to his being a master of genre are doubly satisfying: genre and master, because in the lighting of these wet and foggy nocturnal streets, and even more in the smoky, damp interiors reeking of life and the unusual sets, much is owed to Josef von Sternberg. To highlight the unusual nature of some of the sets, and to add to the rococo subtext in which a minor decorative motif can suddenly, through its position in the foreground, act as a poetic filter, the camera often slides behind the decorative iron gates, the grilled manhole covers, the iron bedsteads and screens, beyond which the characters occasionally appear to be living a mysterious life of underwater fauna.

The same influence can be seen in the eroticism of *World for Ransom*. One sequence opens with a close-up of a manhole cover being raised; the absence of any spatial references prevents us from guessing whether what we are looking at is a tiny snuffbox or an enormous cistern being opened. A woman comes out, an "Oriental

dancer," carried away by the sinuous and lascivious rhythm of her dance, like a jack-in-the-box, except that we remember that "the devil is a woman." A little later, Frennessey (Marian Carr) appears, wearing a top hat, a suit, a tie with her hair pulled back. Her enormous eyes are poignant because she is lost in a man's get-up; in our memory, Marlene has barely had time to triumph over Elina Labourdette (oh, how easily) when the apparition disappears: we get an establishing shot of the smoke-filled dive, and then nothing. The scene is so abnormally brief that we are convinced there has been a cut.

Aldrich's Singapore is reminiscent of von Sternberg's Shanghai in another way: in both films, the opening and closing scenes return us to the same location with the same characters: the bustle in the street, at night, in the eternal city horrendously indifferent to the hero's destiny. (In Aldrich's street, we are once again in front of the neon sign of a club called The Golden Poppy. Poppy! Is this supposed to be a reference? But of course we all know what poppies are used for.)

MIKE I (CALLAHAN)

The little rejected Malaysian prostitute of *World for Ransom*, who concludes that "love is a white bird that no one can buy," is yet another contribution to the unusual poetry of the film, an auctioneer's poetry in some of the dialogue, which is reasonably appropriate given the sets and some of the items on display (the branch and flowers of the plum tree) along with Aldrich's special effects, the following of which is the best example: "I have known many women, but you are the only one who matters. You stand straight, in shining gold and light, on the black mountain of memory."[1]

Mike Callahan (Dan Duryea), whose words these are, seems far removed from Massai. He is not mistrustful of women but shows blind confidence, based on a similar misunderstanding of the opposite sex. Dan Duryea loves Marian Carr, but having had to separate from her, he ends up finding that she has married his best friend, Julian March (Patric Knowles). Dan loves Marian more than ever, hopes that she will return to him, and that is why he will return to save her husband's life yet again, at the risk of his own. The failure of his mission reveals the futility of his hopes. Marian tells him that before meeting Patric, she had to engage in a profession frowned upon by morality and the American cinema. This is too much for what little strength remains in Mike. So much for his "confidence" and for his "great" love. It is through him that a very narrow and American conception of love is satirized; Mike's faithful feelings, desperately pure, prove to be more fragile than those of the husband, Julian, who is superficially frivolous, but very understanding: "I loved him because he loved me for what I am." Julian is English, and not only debauched, but a traitor as well. Mike cannot love like that. He is the hero; he is American. He also turns down, in the first and final scenes, the little prostitute's offers.[2]

HUSTON MEETS HIS MATCH

But *World for Ransom* has even more merits than this. The exotic adventures described above take place in Singapore, where the Occidental and Oriental (dialogue) worlds meet. The plot is as follows: gangsters kidnap an atomic scientist and threaten to turn him over to the Russians if the Westerners are unwilling to pay five million dollars ransom for him. The scientist, of course, will be freed by the hero and turned over to the English, with only a few lives lost. It was not enough for Aldrich to have the hero act for very personal motives (he wanted to save the husband in order to

win the woman's heart again), an important alibi; he had to describe the official success of his mission with a sustained and humorous derision that prevents his film from having even the slightest taint of propaganda in connection with the facts being described. Humor keeps surfacing everywhere in the story (Duryea disguised as a rickshaw driver). He is always there, ready to do his destructive work when the enemy forces are present: the caricatured portrayal of the governor (played by the late Nigel Bruce); the reception for the adventurer (Gene Lockhart) at the governor's; Dan Duryea finding Major Bone (Reginald Denny) near his jeep, and telling him in a very civil manner to follow him, and then, directing operations, because his government spent less time making a good soldier of him than the British government spent making Denny an acceptable policeman (dialogue). When the "victory" is won (and the friend killed), Duryea rejects the role of hero and exits stage left while the English soldiers try to smash down a virtually open door with a battering ram.

Thus out of a powerful anti-Communist subject, Aldrich manages to make a film that is anything but patriotic or anti-Communist. I would even go so far as to say Nekrasovian [Nikolai Nekrasov was a Russian poet known for his writings on the life and sufferings of the peasantry]. Let the scientist stay in the Western world, where he can continue to spend the five million dollars that were so dearly saved on his everyday work; a fat lot of good that will do the world!

This salutary humor and derision are something Aldrich found in Huston's work. For Huston, nothing matters except the inner fulfillment of man, whether for himself alone or in love (*The African Queen*), and he lambastes any other expedients (whether for wealth in *The Maltese Falcon*, *The Treasure of the Sierra Madre*, *The Asphalt Jungle*, or *Beat the Devil*, or false causes, as in *The Red Badge of Courage*, *The African Queen*, or *Key Largo*) and then can only be aroused by just revolutions, as in *We Were Strangers*. It's too bad for them that the myopic critics were unable to learn from the binoculars that Aldrich forced upon them to lengthen their view, and missed out on the opportunity to lose their aversion to Huston's work.

Much of Aldrich's already brilliant future can be seen in *World for Ransom* alone. A young filmmaker naturally chooses his masters, and Aldrich's were clearly von Sternberg and Huston. What is he lacking from here on? Personal talents? Aldrich has these by the score. Certainly enough to be the equal of his models: one might even be justified in preferring *World for Ransom* to *Beat the Devil*, for example, and certainly to *Macao*, not a real von Sternberg to be sure, but his name is in the credits.

ERIN VERSUS TRANE

Whether or not they are the result of script coincidences, there are a number of familiar scenes and characters that reappear in *Vera Cruz*, reconstructed, finished characters and themes to which the director returns and which he improves upon. Like Massai, Joe Erin (Burt Lancaster) says, "I have no friends," and repeats this until the very end. His attitude toward women never moves from his basic hostility toward human beings generally. We have already encountered many loners who are unable to trust others or help those in need, and who are always guided strictly by their own self-interest (only last year we had James Stewart in *The Far Country* and his refrain, "I'm not interested"); Joe Erin depicts a man who could not be more firm, fixed, and incapable of changing. Ben Trane (Gary Cooper), embittered by recent events, with a thirst for adventure, claims that his only little soft spot is for horses. After a few justified instances of mistrust which are overcome (the wallet),

a woman converts him to some form of humanity and some feeling for his fellow man, for love and Juarez. For here, women are not something males fight over in futile triangles. "To each his own," says Joe Erin. "Let's have some fun." What we are talking about here is more basic, because it is not so much choosing a partner as an ethic: cunning and duplicity or allowing for the possibility of sincerity and love. For the characters, and their director, the important thing is to have things turn out well.

Though Aldrich's heroes manage regularly to find love, one out of every two films, one out of every two heroes, they are much less happy in friendships. I don't know whether this has anything to do with Aldrich's own experience, but one situation in *World for Ransom* turns up again in *Vera Cruz*, and yet again somewhat modified in *Kiss Me Deadly*. Two men, one of whom has saved the other's life, find themselves— or believe that they are—bound by this act that leads to unshakable attachment, both for the rescued and the rescuer. This kind of friendship, "for life, to death," is found in adventure novels. One day they find themselves face to face at gunpoint, devastated because one of them has to kill the other, taking the life he had saved.[3] What makes the friendship between Trane and Erin affecting, so much so that it moves the latter to tears, is that we hope to find him somewhat torn, at least enough to obtain a final good deed from Erin. His disappointment in this regard is total. Trane nurtured this hope from the day he had considered it a declaration of friendship—and Erin's only weakness. The explanation of the "story of his life" is, namely, the death of Ace Hanna. At the last minute, Trane revealed that he had based everything on a lie, pure invention, "I will end up believing that the story of Ace Hanna is true after all."

NO LONGER STRANGERS

The story in *Vera Cruz* is accompanied by a discreet commentary on revolutions. A number of American vultures begin to circle over a turn-of-the-century Mexico, where barefoot people who do not go bare-headed (always the sombrero) attempt to rid themselves of some highly undesirable French occupants. Two of the Americans have barely returned from the Civil War, with the black man Ballard (Archie Savage) still dressed in the blue uniform of the Union soldiers and Trane as an ex-Confederate officer. Their friendship does not come easily. Ballard is the first to oppose the rape of Nina (Sarita Montiel) by the simian Pittsburgh (Charles Buchinsky); after he is killed by Erin, Trane decides that he has had enough; it symbolizes the Union, and the elder sister of all the small pan-American revolutions that Hollywood unfailingly shows us. South of the Rio Grande, one after another tyrant falters, taken from power by people who rebel. The United States, which after a few years of secession got back into line once and for all with the God of all revolutions, with Karl Marx as well, contemplates these various movements with a benevolent gaze that stems from a satisfied conscience, peace and order at home, and the happiness of peoples who no longer have histories.

But Trane's role modifies and strays somewhat from this traditional pattern, and I am stubborn enough to think that this is the take of the writers and particularly of Aldrich himself. Beaten in a number of ways (a Southerner, ruined by the war) and unable to find satisfaction in the experience of combat, Trane makes honorable amends by choosing a good cause, one that will win. Here we have Huston properly understood. This is the work of a filmmaker who knows his art, and not of critics who don't.

WELL DONE!

Aldrich is too knowledgeable about his art to have allowed overly tempting influences to have followed him to Mexico; von Sternberg in Singapore was perhaps a misstep by a youthful director, as well as a mark of good taste and respect. On the way to Vera Cruz, Aldrich encountered neither Eisenstein, nor Orozco, nor Villa, nor Zapata, nor even the lesser Figueroa. The Aztec pyramids seen along the way are not framed in a tortured manner. The sombrero, mentioned earlier in passing, plays less of a starring role than the black-and-white hats of Burt Lancaster and Gary Cooper, the colors of their respective souls, with Lancaster's black hat in particular at the center of the lovely panning shot along the battlements. The local colors, which we thought were black and white, with good contrast, were actually done in Technicolor.[4] In this country, which has been depicted in color as almost virgin territory, cinematographically speaking, Aldrich in the end relied on no one but himself and his own resources.

The structure of *Vera Cruz* is brilliant, taut, spectacular, and told through incessant flashbacks to history from the beginning to the end of the film. Anyone who would call these reminiscences would have to be mischievous indeed. Humor and horror appear in brief episodes because one is never given enough time to pause and revel in it. Everything is broken down into acts, which are ultimately accounts of the loyalties and deceits that arise at various times in the dialogue. One either lies or tells the truth, one speaks little or a lot, and the acts take stock of who does what. You might call it cinema.

EXEUNT

A cinema less primary than this last sentence could bring it out. And yet, it is to the theater that I would go to search for some of the more elegant features of the style of *Vera Cruz*, even though Aldrich, if I am not mistaken, never worked in the theater. There is a theatrical perspective that one would certainly not find shocking on the screen at a time when it is no longer considered a paradox to point out that William Shakespeare's cutting is more cinematic than Joseph Mankiewicz's. This perspective is not only to be found in some of the sets with a large cast and rather stereotyped in execution (the market square, the celebration at Maximilian's), as in the abundance of enclosed places, such as certain scenes that are unusual in a Western: the fortress in the first part, the locked-up village of the ambush, the natural circus of the second circling, the final battle with the various different rooms and zones to be crossed, the scene of the duel between Erin and Trane. I see it mainly, although this detail is as discreet as it is elegant, in the manner in which the characters effect their exits, the place, the sequence, or sometimes even the way the shot is positioned. This small, special, ritualistic theatrical moment (the exit) is visible when the character is spoiled by the director, or the inveterate ham actor—with a word or a pirouette of some kind—leaves. I am not thinking, in *Vera Cruz*, of Donnegan's (Ernest Borgnine's) exit when he is punched and kicked out of the saloon; nor, in *World for Ransom*, of Dan Duryea using his elbows to pull himself through the window of his room. At such moments, one finds frequently enough that surprise is combined with violence in good films. Here we have Gary Cooper and Burt Lancaster being spoiled by Robert Aldrich, the amused perfectionist. It is frequently side by side, after comically exchanging glances, that they walk off screen: to follow the countess; after recovering their weapons on her advice; the evening that the

gold is discovered, etc. In the midst of battle, they appear together at the top of a wall, jump with their arms out and land on their feet, bending their knees to break the shock, as if on parade or in a ballet. No doubt Aldrich thought that this artifice would help to make people believe in the friendship between Erin and Trane, and in their parallel destinies. On two or three occasions, Cooper exits alone, with Lancaster immobile behind him, slightly later, time enough for him to understand laboriously: "I don't mind being hanged." And, of course, at the end, Cooper, alone, makes the nicest exit: after throwing Lancaster's weapon into the dust (for the second time), he gets up and, walking beneath the countess's balcony, where she is a silent spectator, he raises his hand to his hat.

Similarly, Aldrich shows his heroes face to face in profile in extreme close-up: against the door of the coach, with the countess standing in the background; leaving the saloon, after Borgnine, etc. It is shots like these that may be inspired from the black-and-red, very lovely, Goyaesque film posters.

For Aldrich's talent is also characterized by a terribly visible elegance that clearly satisfies both the mind and the senses, and communicates enthusiasm, but that also hides behind details of an imperceptible subtlety, an impalpable sobriety within the greater riches, with a great detail of modesty at the heart of stories that are full of noise and frenzy.

MIKE II (HAMMER)

Kiss Me Deadly is one stage further along the way to a mastery of his craft, and one step downward toward despair in the world he describes.

As an American filmmaker, Aldrich works within well-defined genres, this time the thriller. But Aldrich being who he is, his film is only seventy percent thriller, twenty percent horror film, with a touch (ten percent) of science fiction, all of which are genres that resemble one another to some extent. *Kiss Me Deadly* is in the first rank of film noir masterpieces, a genre which had been in eclipse for a good while. It is on an equal footing with the best films of Huston, Welles, Dassin, and Otto Preminger. Based on a Mickey Spillane novel, which I am told is much inferior to the film, *Kiss Me Deadly* is the story of a private detective who toils amid some mysterious and long-invisible gangsters, strictly episodic policemen, and an enormous amount of loot, the nature and location of which are unknown, with all of these factors frenetically put into action in pursuit of one or other of them. We find ourselves in this very particular class of thriller, a crime film with a private detective and a romantic streak running through it, a trick used to remarkable effect by Raymond Chandler before Spillane (and also a few vaguely plagiarized and British-looking pale imitations). However, the master, the Aristotle of this type of noir, is Dashiell Hammett.

Mike Hammer (Ralph Meeker), Spillane's Sam Spade, works—like Philip Marlowe—in Hollywood. He seems to earn a good living, has a secretary-mistress, and an apartment-cum-office, all very comfortable. His taste for fast cars, telephone tape recorders, and a number of actions that smack of studied sadism, gives his character a veneer of dandyism. He and his secretary Velda (Maxine Cooper) are a little like a pimp and a prostitute, both working closely together to dupe the clients, with him in charge of the female game and her the male, and both members of we are not sure what union. The masterful scene in which Hammer appears with the police would have pleased the highly realistic Hammett, who could never allow himself to

do such a thing, as he himself was an ex-private detective. We can only dream about a purely documentary film, the subject of which is about the everyday villainous activities of the detective, this voyeur who spies on private lives. In any event, Aldrich does not here hide his contempt for his film's hero. Mike Hammer is midway between Erin and Trane, avaricious, cruel, and amoral like the former, and yet capable of some degree of sadness, late like all sorrow, but which generates an impulsive and disinterested desire for vengeance. He is also a complete bastard, and Aldrich unflappably paints a picture of him. Christina (Cloris Leachman), the mysterious character on display, with secrets too burdensome to reveal, and a spiritual granddaughter of the pre-Raphaelite poetess, sizes him up perfectly, "You are bad, and incapable of giving anything." And Velda, who knows something about such things, confirms, "You're behaving like a cop."

Whereas Humphrey Bogart, in the films noirs mentioned above, could not prevent himself in any of his roles from looking intelligent, all Ralph Meeker is asked to do is clench his jaw, harden his gaze, fix his grin even wider, hit harder, act as charming as he can, in a worrisome, barbarous, and perverse manner, a style that suits *Kiss Me Deadly* that has decided he is a hero. Let's look at Hammer's methods: he asks questions, preferably by slapping whomever he is speaking to, without any preamble, then appears not to listen to the answer, wanders around the room looking bored, and then goes off in an absentminded quest for information.

With women, Hammer never appears to be in a hurry, true to a well-entrenched tradition in the genre; he rebuffs any nymphomaniacs he encounters along the way, occasionally attempting to instill a sprig of morality by teaching them to spell the word "no," and boringly accepts wet kisses on his neck. But sometimes, when his desire gets the better of him, in between two Greek girls, he calls his always available secretary and gives her gluttonous kisses that business talk is never allowed to interrupt. And then one day, after sending her to her probable death, he slows his pursuit enough to free her, but then perhaps that was only so she could help him, riddled with lead, from a corner that may have become too tight even for him. And yet Mike Hammer is not always such an awkward customer. Didn't he stop to pick up Christina in his car, didn't he help her get through the police barricade, on the other side of which she was to meet some ghosts?

DREAMLIKE CRITICISM

The ghosts of film noir are the many secondary characters encountered on the screen in an hour and a half, who, together with the bizarre and varied places we find them in, turn the modern thriller into a compressed form of serials, which in former times used to have twelve or twenty-four episodes. Aldrich disposes of these characters masterfully in two words, two gestures, sometimes fewer. A list of them would sound like a Surrealist poem, a procession of night and death: a collector of abstract art in his apartment-cum-museum, a girl running barefoot on a road at night, a suave-sounding chief of the FBI, an Italian mover, a few killers—two faces from *Vera Cruz*, a Greek mechanic with a booming voice,[5] a noisy blonde girl on a bed in a hotel room, a black manager in his gym, looking a little purple from overexertion, a disfigured reporter hiding out in a room, a doctor in a morgue dissecting bodies, other killers and other girls[6] around a billionaire's pool, a bel canto singer in a sordid apartment, the deceitful secretary at the Hollywood Athletic Club, a truck driver having dinner with his family at home, the female singer in a black nightclub, a few black cops.

On the screen, the poem is the film itself, black and gray, brutal and blaring (a hysterical soundtrack, full of panting, shouting, punches, and explosions), a nightmare. For one of the keys to the film is the resolutely dreamlike nature of the story, which is the most obvious—and darkest—source of its violent poetry.

Just as a Christina Rossetti poem gives the key to the mystery of the plot, *Kiss Me Deadly* contains its own key in its poetic form.

It's not this woman being pursued at the beginning of the film, running along the white line in the middle of the road, attempting to flee we know not what, the night perhaps; could she not be every one of us, a victim of a nightmare? An ongoing nightmare that will, from this point on in the film, victimize Mike Hammer, buffeted and roving. He is barely conscious: when he asks Nick how he is doing, the answer is, "I don't know yet." He is practically amnesic: we remember that his tortured and sick memory only reminds him rather late about the existence of the letter Christina left for him with the mechanic ("Remember me," words that contain all the irony of the film). The chaotic travels he gets through with considerable difficulty are a faithful reflection of his inner chaos: masochism—beaten, battered, tied up to a bed, given a Pentothal injection, and burned by radioactive rays; powerlessness—on the ground, he can't even raise his head to identify his attackers; he suffers the insults of the cops without saying a word; here we see him with Lily (Gaby Rodgers), Friday, even Velda.

And just in case, having failed to understand, you still remain stupidly "wide awake." Aldrich piles irony upon irony: one after another, we get a close-up of an eye with a scar above it, Caligari staircases, the thematic shots of the door handle and lock opening onto a room with large square black-and-white tiles, in this gratuitous and irrational increase in fear (Hammer, entering his home, squeezed against the wall) or violence (the fight in the street), these visual ellipses in which, in addition to the horror of what we see, we experience the horror of what we imagine: Dr. Soberin's (Albert Dekker's) legs, Christina's tortured howling, the shot that kills Sugar Smallhouse (Jack Lambert) in the bathhouse, and the loot that we never get to see, and that we will never learn anything about.

ROBERT ALDRICH

Enough said. Let us leave to the palm readers and psychoanalysts the task of explaining Mike Hammer, through *Kiss Me Deadly*, and while they are at it, they can have a go at Mickey Spillane too. Robert Aldrich, who no doubt is mistrustful of any dubious promiscuities, chose instead to change to another world. From his own, he has used his attentive lucidity as well as the richness of his own unconscious to place his characters in a dream, a magnificently illustrated dream behind glass, where we are allowed to contemplate them. Aldrich is indifferent toward his creature and perhaps even as sadistic as the creature himself![7]

His filmic world is a hard one, a world of frenzied egoism and solitude carefully chosen and defended, with an excess of purity in a pestilential universe. But if all Aldrich ever did was give his own version of a jungle in which the law of the land was that of an eye for an eye, it would rather lessen the scope of his work. I don't know what form of fate may have befallen him in his love life, and which may lead him to have everyone kill off the person he loves, whether friends or lovers. In the end, all I see is the hero's hara-kiri, the character who likes himself too much and dies of it. Sophocles's play *Oedipus Rex* could well lend itself to such an interpretation, but then, of course, *The Big Knife* ends with the hero's suicide.

In terms of structure, *Kiss Me Deadly* achieves a certain flamboyance: a profusion and variety of ideas, exuberant creativeness, and a formal beauty, sensual, like the true geniuses of baroque lyricism, Orson Welles or King Vidor, a King Vidor who still wanted to play with his camera. *Sight and Sound's* use of the word "hysterical" to describe him, with intent to relegate him to the rank of bombastic birdbrains like Elia Kazan, is thus particularly unfair. There may be hysteria, but it is used intelligently, and is a hyperbolic form of a language that is consistently cinematographic.

THE WOUND AND THE KNIFE

In the credits for *The Big Knife*, Robert Aldrich is listed for the first time as the sole producer, and hence the only man in charge. In passing, I note that these credits confirm my theory of a sealed window, which I mentioned in connection with *Kiss Me Deadly*, a window that separates the creator from his world: a series of posters appears against a black background over the image of a tormented Charles Castle (Jack Palance), and then the screen shatters like a dirty mirror borrowed from Max Ophuls, and then against an immaculate background we read the name of the producer-director. This is a matter of Aldrich affirming himself as a moralist and critic; it is not an autobiographical effort to put on display a not particularly tidy conscience the way the people do these days.

Once again we are in the jungle where, we are told, the problem is to survive. The economic and social data are clearer here because Clifford Odets took care of this; the moral consequences are all the more desperate as a result. Aldrich's characters do well with Odets's terminology, as defined by his spokesman Hank Teagle (Wesley Addy), the Irish writer: in Joe Erin and Mike Hammer, we recognize two realists to keep Smiley Coy (Wendell Corey) company. Then Trane, Massai, and Marion Castle (Ida Lupino) are "idealists"; two other characters whose ambiguity does not last: the philistine Stanley Hoff (Rod Steiger), a faux-idealist, and Charles Castle, a faux-realist, seem to make a situation more complex than it is. For here, as always, Manicheism is the only way to guarantee morality. Charlie, who had faith (the New Deal, etc.), and lost it, and who is pompously called "the valiant knight of lost causes," is really nothing more than a new portrait of Trane hesitating between the gold and the Revolution.

But by finding himself once more, Charles Castle loses his life. Pinned alive through his wound by the big knife, he becomes the usual hightoned-timorous-awshucks prototype of the American screen (Korean soldiers, New York dockworkers, Knights of the Round Table, who knows?), for after all this, better dead standing than alive on one's knees. But in this death, one must see more than the "example" identified by Teagle and the only way out of the scandal or slavery; it is the only way not to lose Marion, and also the only way to make her happy with someone else. This time an excess of love kills.

ALDRICH'S INFLUENCES

Somewhere in *The Big Knife*, Marion, the pure one, Aldrich's alter ego, gives a list of those producers-directors who represent, against the Hoffs, "the honor of Hollywood." It is highly unlikely, because of the dates, that the names given were in Odets's play, which was written around 1950 (the answer is sure to be found elsewhere). No doubt this was Aldrich listing his "personal beacons." Of this constellation—seven in all—two or three names appear to be very dubious for both philosophical and other

reasons. Nevertheless, their influences may appear to varying degrees in *The Big Knife*.

Huston, Billy Wilder, Stanley Kramer: scathing social satire, often generous, but tending sometimes toward cynicism and nihilism.

For a long time, William Wyler and George Stevens seemed to be in the former group, but the growing indifference of the contents of their films and the excessive paralytic care lavished on style have separated them from the former group. Of Stevens, all we can see in Aldrich's films are some very slow dissolves that do not have the same effect as the admirable ones used in Stevens's *A Place in the Sun*. From Wyler, Aldrich momentarily found his predilection for "film theater": almost a single set, with characters walking around one another, considerable depth of field, long shots, faces tightly framed in the foreground on a section of the screen.

Mankiewicz, a talkative maker because he had nothing to say; of course, *The Big Knife* says a great deal, because it is a play, but it speaks better; there is also some misogyny to be found, but only in secondary characters.

To end with, Kazan is, regrettably, the person to whom the structure of *The Big Knife* owes the most: music reminiscent in patches of Leonard Bernstein; angle shots at the beginning—and also at the end when watching a film of Charlie Chaplin boxing, and Marion says, "That's a good film"; there are a few images that are somewhat overly tortured; three actors (Jack Palance, Nick Dennis, Rod Steiger) who hug and touch one another to death. Compared to Rod Steiger, actors like James Dean, Vic Morrow, and Vince Edwards have a style that is highly original. Rod Steiger appears to be the Marlon Brando of television, and it was very clever to have had them play the roles of two brothers in *On The Waterfront*. Everything about Brando is to be found there in Steiger: the voice, the look, the corpulence, the sunglasses of *The Wild One*, Marc Antony's speech to the Romans (the hallmark blackmail is here), verbal outbursts, and terrifying silences, the little clicking of lips. It's very embarrassing.

SHAKESPEARE AND PASSION

But Aldrich breathes into it and it works, it moves along and we are taken in and overwhelmed. Aldrich succeeds in the prodigious feat of making a film with tricks borrowed from Kazan. He gets the best from his actors, particularly Jack Palance, exploring each square centimeter of his highly dramatized sets, in which every object has its proper place: cushions, telephones, pens, backscratchers, lampshades, and record players are not haphazardly scattered about, but waltz in the hands of the heroes. There is a Georges Rouault artwork on the wall and a metal panel representing the masks of comedy and tragedy, acting as mirrors for one another. Palance moves about from one piece of furniture to another, climbs a few stairs to stand above whoever he is speaking with, then hurtles down the stairs again, spreading his arms, crucified, joins hands with his wife for prayer, places himself in front of the circular panel with serrated edges and is framed with a crown of thorns, acting like Christ in front of Rouault's clown. This particular Rouault is a Christ in front of which Palance plays the clown, because here, as in Rouault's work, Christ and clown are interchangeable. Anything is allowed to keep the film moving at a frenzied pace. Nothing is ever "too fortissimo." Aldrich found nothing better to put passion into his film than to relate the Passion. No particular value is to be assigned to this reference, and it is only useful insofar as it can unsettle things still further. There is nothing but emotion, suffering. We bathe in tears, in the blood of a successful tragedy. Like the Roman soldier, the devoted and deceived friend comes to spit in the face

of the New Deal Messiah leveled by the Hollywood Inquisition. As I was saying, we bathe in successive waves throughout the final sequence, in barely discolored blood; at the end of this film, which is as dry as Smiley Coy's eye,[8] we have the old agent Everett Sloane bursting into tears, and, in close-up, the face of Buddy in tears; here is the captivating image of an oozing ceiling, with Nick coming back sobbing from the wet bathroom. And finally Marion, crying, streaming tears after tightly holding fast to the lifeless body of her husband, and in a final tracking shot from high to low, the camera separates itself from the characters, leaving them to debate desperately in their walled-up enclosure, where Marion cries for help like a drowning woman.

Another apt reference to dramatic heights is to Shakespeare. Odets had called the man who baptized the faithful friend Horatio rather than Hank, and he was not afraid at the end of the first scene in *The Country Girl* of mixing his own words with the words of *King Lear*. Aldrich rewards him in the final shot by having Ida Lupino, dazed, mechanically drying the water streaming from her hands like Lady Macbeth.

That then is *The Big Knife*. It is weighed down neither with prejudices nor caution. It is sometimes weighed down somewhat by the director's considerable culture. Nevertheless, it forges ahead, achieves its goals, moves, rebels, and satisfies. In it Aldrich also affirms some of the lesser qualities that belong to him alone because they cannot be imitated: the unity of tone within a film, the rare sense of dramatic values, the precious social values, an intelligent and clear-thinking head, a good heart and on the left, a positive outlook.

1. Translated from the French, which was used in the dubbed version of the film.

2. The turning point is typical of Raoul Walsh's *Battle Cry*, an almost exhaustive account of wartime romance. A soldier falls in love with a young girl he meets regularly on a ferryboat. When he finds out that she is really a prostitute, he becomes desperate. She realizes that she loves him, finds an "honorable" job in another city, and writes him. He doesn't reply, until an experienced and wise sergeant tells him that if he is really a big man, he will know what he has to do. The soldier replies to the letters. To be as broad-minded as this, of course, the character had to be an intellectual.

3. In *Vera Cruz*, Joe Erin had saved Trane from his attackers in the saloon, but it was to pay him back for not having hung him for being a horse thief (Trane, pointing his weapon at Erin, and then throwing it in the dust, the killing done and erased). They were even. Everything began with Trane saving Erin by hauling him into his saddle during the Juarez ambush in the small village, a gesture that earned him Erin's confidence.

4. The process used, Superscope, is not CinemaScope, although it is as wide, but taller, so much so that it is almost the same as the classic aspect ratio. This makes it possible for the distributors to use all sorts of options in terms of how to carve up the image, and they have taken advantage of it. *Vera Cruz* was thus the first film to be shown in a different way in every theater, and every time you see it, you might be viewing a slightly different film. I hope one day to encounter a theater operator of good taste to discover Sarita Montiel off in a corner of the final shot of *Vera Cruz*.

5. But who is not Ado Kyrou.

6. Including Marion Carr (Friday), making her debut in *World for Ransom*, and seen since in James Edward Grant's *Ring of Fear*, with Mickey Spillane himself playing a role, and Fred F. Sears's *Cell 2455—Death Row*.

7. We can only hope that Aldrich kills off Mike Hammer at the end of *Kiss Me Deadly*.

8. Much earlier in *The Big Knife*, the tears of Hoff and Dixie Evans (Shelley Winters) were shed, but the first tears were really crocodile tears; the others, though largely tributary of drunkenness, prefigure the final flood.

No. 16, May 1956

I n an earlier issue of *Positif*, I mentioned how much Andrzej Wajda's first film had surprised and enchanted me. Four out of five of our magazine's writers were present that evening at the cinémathèque where, without fanfare and an audience of, at most, twenty people, the masterpiece *A Generation* (*Pokolenie*) was screened, and at the end we looked at one another the way people do at a moment of rare discovery. It was something that had to be talked about, proclaimed. For us, a director had been born—a very unusual event—but there was much apprehension too. At a time when phony values, flashy intellectual tramps, concierges who buy

Kanal (They Loved Life)
Ado Kyrou

In Eastern Europe, Polish cinema was the first to show signs of an aesthetic and moral thaw after ten years of stifling Stalinism. Sensitive as always to left-wing libertarian ideas, *Positif* paid tribute to Andrzej Wajda's emergence by devoting three covers in a row to his first three films. Ado Kyrou, a Greek Surrealist who had fought in the Civil War and was the author of a famous book entitled *Le Surréalisme au cinéma*, and a great admirer of Luis Buñuel, was among the first to champion Wajda in Western Europe.

their clothes at Nina Ricci, people with mannerisms who have nothing to say, window dressers for big stores in the provinces with formal airs, are praised to the skies, at a time when the films of the Santis' are snubbed for suggesting . . .—follow me here — it is dangerous to affirm "we have a rare bird." Enthusiasm and a lack of caution won out, and we all agreed: "Wajda is important."

With hope and apprehension we waited for the second film by this young Pole. Was he what we imagined? Or was *A Generation* a propitious accident of the sort that often happens in the cinema? Not having been to Cannes, I read all the reviews of *Kanal* (also called *They Loved Life*). We weren't wrong. The festival audience in their Sunday best understood the film straightaway, the beautiful dresses of the old pretentious women muddied by the cruel beauty of the gutters. The lovers of elegance were overwhelmed by this film in which the most brilliant production values are never gratuitous but *always* part of a subject that is both momentous and horrible.

That is, between the lines, what the critics told me. Since then, I have met and talked with Wajda and I have seen *Kanal*—unfortunately, only once.

Thus calmly and deliberately, I state: Wajda stands beside Luis Buñuel and Ingmar Bergman. He is in the line that goes from Louis Feuillade to Frank Borzage, and from Jean Vigo to Georges Franju. First, he is the only young European to have the guts to tackle subjects worthy of *Land without Bread* (*Las Hurdes*) and *The Young and the Damned* (*Los Olvidados*), and this in an era of intellectual sloth and laziness, effeminate salons and simplistic psychology. It is, I assure you, very important.

The action of *Kanal* is set during the final days of the tragic uprising of the Polish people against the Nazis. A group of forty-three fighters has been battling in Warsaw for several weeks. The men are becoming tired, and the movement, which began as a vigorous push for freedom, has already become hopeless, a horribly murderous fight. One of the most significant scenes in the film tells us that confidence has evaporated. Nevertheless, these combatants engage in the most terrifying battles simply to survive, because they believe in life, to their dying breath.

To better understand the reactions of these men and women, to properly grasp the attention that Wajda pays them, we must understand that this is not an army of the sort with which we are unfortunately all too familiar. Volunteers, motivated only

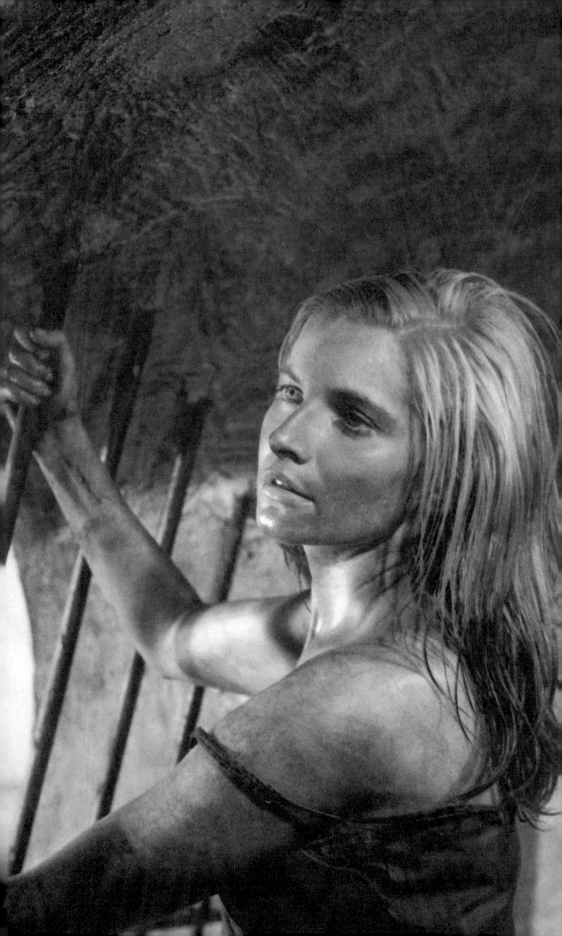

by their immense desire for freedom and joy, by their terrible hatred of Nazism, take up arms but without uniforms and retaining their individual status—which never happens in a regular army—while never ceasing to be soldiers for a freely chosen cause. Thus, this people's army, which includes all ages, even children, and all levels of society, which very much reminds us of the glorious brigades of the Spanish civil war, is composed of individuals whose profession is not to bear arms or to risk death at any moment. This army, obedient only to the orders of liberty, is the marvelous fighting group which must rise up every time fascism rears its ugly head.

In this particular case all these elements are exacerbated by the certainty that it will all come to nothing. Hope can only be personal, but life is such a precious thing, especially when you know that tomorrow or even today is so precarious. Happiness also exists, the instinct for conversation being so strong that people will try anything to escape death.

Surrounded by Nazi tanks, bombed day and night by Stukas, the little group is forced to use the sewers to get back to the city center, which is calm for the moment although already in ruins. Three-quarters of *Kanal* concerns the nightmarish odyssey of these men through the sewers, while above ground the Germans lie in wait at the exit points.

The first part of the film—the shortest—takes place in full daylight. The sunlight is blinding, the paving stones hot, and the street fighting bright but hopeless. Even the blood seems clean. It is with calm, serious purpose that, in the surrounding whiteness of the sun, our group contemplates the coming battle which means the end for all. Taking refuge in an abandoned middle-class house, they enjoy a few hours' respite to live a little and behave like ordinary people who do not know they are about to die. A composer plays the piano, a romantic young woman believes she has found true love, a kid plays with a revolver like a kid, others sleep, shave, and talk about this and that. During this wait, we get to know the main characters. The word that comes to mind is "normal" but since this doesn't tell us anything, I will try to explain myself: the characters *live*, they *are*, the camera looks at them and one gets the impression that they are surprised by it [the camera]. The extremely careful camera movements catch not only the acting, but also, and most importantly, those casual first looks that subtly characterize people, the strange detail that is *life*, the apparently offhand glance. That is why all these characters are right and believable, because they are true, not superficially, but in depth, in time, and in space, in life which is neither simplified nor lacking in the unexpected.

Wajda's vision is poetic.

From the violent charm, set against the realistic pictures, we move to the ordinariness of daily life transformed by the absurd decor of the bourgeois house in which the fighters are sheltered, and finally to the dark poetry and horror of the sewers where the heroes will meet their end.

Their entry into the sewers is incredible. The group is ordered to escape through the "Kanal," and they obey without enthusiasm, but at the entrance to the sewers hundreds of people wanting to flee Nazi barbarism have gathered. In an impressive melee, in an atmosphere of terror and panic, the forty-three men, women, and children go underground into stench, silence, dampness, and darkness. The nightmare march begins, interspersed with the cries of those who believe that there are gases in the underground tunnels. Bodies float on the black, sticky water; the walls sweat terror.

Teresa Izewska in Andrzej Wajda's *Kanal (They Loved Life)*. 1956

There, all of Wajda's characters will meet their truth. Fear and the will to live do battle, and sometimes death will not seem like defeat since—and here we encounter the depth of Wajda's vision—love can be a great victory, even in the sewers.

In connection with *A Generation* I wrote that the most important thing Wajda brings to the fight for life and freedom is the joy of love. In *Kanal* this is expressed even more violently since the action takes place in a horrible environment under frightful conditions.

It would be tiresome to follow each of the characters through the sewers, especially since the only possible criticism of *Kanal* is that the action is too fragmented, the editing occasionally sloppy; but could it have been otherwise?

I won't comment further—for the moment, at least, until I have had the opportunity to see the film several times—on the composer going crazy, on the person in charge of the group who prefers suicide to saving only himself, and all the others, heroes in spite of themselves in a dull adventure, so that I can spend more time looking at the two love stories a little more closely.

The protagonists in the first are a boastful warrior, a courageous "nice guy" who wears the uniform because "it looks good," and a young girl, naive and romantic and for whom fighting and love are a dream, full of charm. She believes in it, and simply wants to live a few hours of love, all the more because it is certain that they will have only a few hours to live. In the sewers, the real personality of the young man, whose main characteristic is revealed as a lack of sincerity, and the girl commits suicide in the polluted water. He, crazy with fright, wanting more than anything else to get back to his comfortable middle-class home, oblivious to everything that made his armor of heroism, jumps into the lion's jaws. He goes to meet the firing squad and, as though drunk from panic, shaking on wobbly legs, allows himself to be executed, stunned by the reality of what he had not imagined possible.

It is a story of a failed love, because it was unrequited. The loveboat fails because the man did not want to love, or could not.

The second love story is sublime. The woman, provocative and self-confident and with many boyfriends, is the only one who perfectly understands the maze of the sewers, since she had been using this route for a long time as the liaison between the headquarters and our group. The young man, Jacques, is a sincere and honest fighter, similar to the hero of *A Generation*, alert and always trying to find his own life, uneasy but a real man in every way. He had been badly injured a few hours before going into the sewers. He loves her desperately, but without really wanting to say so; he is tormented and jealous in the face of the uninhibited airs of the young woman, whose lovely nickname is Daisy.

Guiding, protecting, and looking after him, she prefers to stay with the man she loves rather than take over as head of the group, since she loves him with a really crazy passion, and her attitude is that of modern youth torn by contradictory desires. She has within herself all the revolutionary romanticism of Lya Lys in *L'Age d'or*, all the sincerity of a little girl and her first love, but her terrible shyness causes her to adopt the false attitudes of skepticism and of doubting everything.

One sequence—the most beautiful in the film—seems to me to be especially typical. Jacques, feverish and bleeding, can no longer see clearly. He can barely distinguish, under an electric light, something written on the wall of the sewer, "I love Jacques!" We, as viewers, know that Daisy had written it herself during one of her underground trips. There, sheltered from the world, she felt free to proclaim her

true self. Jacques asks her what is written and she replies, "I love Jean," afraid of looking ridiculous by admitting what a false world would have us take for weakness. She could escape, alone, but Jacques cannot follow her along the slippery passage. She stays with him. They end up in the sunshine, but an impenetrable grille keeps them prisoners in the sewers. She talks to him gently, makes him feel the warmth and the fresh air, and they lie in the sun, behind these bars that mean their death.

It must not be thought that Wajda takes pleasure in the idea of death. On the contrary, his whole film is an affirmation of life. In one of the early sequences, the young woman who commits suicide later says, "It's easier to die when you're in love," and another character replies, "Enough of your platitudes."

For Wajda, as for any free man, it is easier, and certainly better, to live while in love. But we are caught in an era when it is as difficult to live as to love, and even at the risk of our lives we must fight to attain freedom in life and love.

That is why *Kanal* is a horrific film: because it is neither bathed in blissful optimism nor false pessimism, because it sees both cruelty and the absurd, because it draws from this an immense joie de vivre. Like Buñuel, Wajda is a thinking man who describes reality while trying to change mankind and the world, drawing miracles from atrocities. And Wajda tells it all with a talent that leaves us gasping. The technique no longer exists and the actors no longer exist because the technique *is* the film and because the actors *are* the characters. It is pure poetry.

While hoping that *Kanal* will soon hit the screens in Paris, I repeat: Wajda is the essential filmmaker, the filmmaker of tomorrow.

No. 25–26, Autumn 1957

Kanal (They Loved Life) (Ils aimaient la vie). 1956. Poland. Directed by Andrzej Wajda. Written by Jersy Stefan Stawinski. Produced by Stanislaw Adler. Cinematography by Jersy Lipman. Music by Jan Krenz. With Teresa Izewska, Tadeusz Janczar, Wienczylaw Glinski, and Wladyslaw Sheybal. In Polish. 95 min.

1960s

With *Hiroshima*, Alain Resnais has begun a new stage. Here the expression of time plays a role that is as important as it is in Orson Welles's *Citizen Kane*. But instead of being a way to reveal the secrets of a specific person, time itself becomes the leading character in a film in which human beings and events, however cruel or serious they may be, are nothing more than pretexts. More specifically, Resnais wishes to give the audience a specific problem having to do with time, and to give us a specific idea of time, and not simply tell us a story or give us an account. What then is this problem?

Hiroshima, mon amour

Bernard Pingaud

I – Clearly, it is the problem of memory and forgetting. The idea is to show us that memory is a form of forgetting, and that forgetting can only be complete once memory itself has totally accomplished its work.

Note that this is not an isolated problem in Resnais's film production. You will no doubt recall the film *Les Statues meurent*

When the new generation of young French filmmakers appeared in the late 1950s, *Positif* sided with those of the Left Bank—Alain Resnais, Agnès Varda, Chris Marker, Georges Franju, Alain Cavalier, Claude Sautet, Louis Malle —who were compared favorably, because of their political ideas and the places they met, to the filmmakers of the *Cahiers du cinéma* school, whose offices and opinions were located on the Right Bank. Bernard Pingaud, a well-known essayist and novelist, analyzed the first feature film of Alain Resnais, who was to become one of the magazine's favorite directors.

aussi (*Statues also Die*), whose subject was the deliberate or involuntary forgetting of primitive civilizations. You no doubt remember Resnais's *Guernica*, an art film about a painting commemorating a dramatic event. You remember *Nuit et Brouillard* (*Night and Fog*), in which color images of a peaceful, forgetful present are used in counterpoint to black-and-white images of past atrocities. And then, of course, *All the Memory of the World* (*Toute la mémoire du monde*), so aptly named, which methodically describes the cemetery where the great works of the past sleep and which is called a library.

All of these films were documentaries. Resnais used various excuses to attack the problem of the external. With *Hiroshima*, he addresses the problem of the internal and claims to be showing us how someone experiences forgetting.

I say "he" but, in fact, this film has two makers. Some critics are alleged to have contrasted Marguerite Duras's contribution with that of Resnais; I believe, on the contrary, that they are inseparable, and what is perhaps most important and original about *Hiroshima* is that the makers wanted to tell the story and do, in fact, tell it through images and speech. It would be difficult to imagine a silent *Hiroshima*. The dialogue is never really explanatory, but rather a key component of the story.

II – There is no need, I think, to remind you of the facts of the film. From the standpoint that interests us, it can be represented by a triangle. Two of the angles are past events: the heroine's youthful romance in Nevers and the bombing of Hiroshima. The third angle is the present, to which the other two are linked: a young French actress in Hiroshima falls in love—at the very spot where she has come to see the traces of the bombing and evoke her memory in a film—with a Japanese man whose whole family died when the city burned and who, fourteen years later, places her in the same impossible situation in which she had found herself before with a German soldier. The whole structure of the film consists of having her delve into the situation, both through

Emmanuelle Riva in Alain Resnais's *Hiroshima, mon amour*. 1959

the reconstructed Hiroshima and the German who is revived in the Japanese man, so that she can understand it and release herself from it.

It is obvious then that the film could only have been constructed as an extended flashback. But the expression here is quite wrong. There is nothing explanatory or psychological about the flashback. The story proper could well have done without it. Resnais is not interested in showing the reasons for anyone's current behavior, and the very anecdote the film uses as a pretext is of no interest to him. What matters is the relationship of the present to the past, a relationship that is expressed in the ambiguity of remembering and forgetting. In reality there is, therefore, no return to the past, but rather the opposite, with the past resuming its place in the present and giving it deep and true meaning. Between the past and now, the heroine's memories do not give rise to a causal link, but rather superimpose two situations, reveal their identity, and show that even those that we thought were unique and irretrievable could be repeated.

From this, there are two consequences: the analogy between the classical flashback and the process used by Resnais could only be superficial. We need to study, from the point of view adopted by the film's director, how he was able to reinvigorate this classical technique. In addition, isolating the flashback from the rest of the film (as one can usually do without causing any damage) would be altogether artificial here: the gradual impregnation of the present by the past means that even when we are not at Nevers, there is a problem in expressing time. In addition to the pictorial flashbacks, there are flashbacks through words, allusions, interferences. Most of all, we get an image of time, its density, its quality, and how it influences the whole film, including scenes that are purely retrospective.

It is, therefore, only for the purpose of the analysis that I will set a number of retrospective episodes aside, and then say a few words about how Resnais, by imposing an unusual pace on his film, succeeds in going beyond the elementary time of immediate cinema.

III – There are two flashbacks in *Hiroshima*, one because we need to return to the bombing and the second to Nevers. Between these two events, these two situations, there is a major difference: neither the heroine nor her Japanese lover experiences the bombing. All they can know about it is secondhand, through the imprint on the memories of others. On the other hand, what happened in Nevers was experienced by the young woman. She (Emmanuelle Riva) tells her lover (Eiji Okada) at dawn as they are parting for the first time that she dreams all the time of Nevers, but never thinks about it. For the bombing, the very opposite occurs: we think about it but never dream about it. The story will show us that these two complementary situations are both evidence of the same tragic inadequacy, and that they are both images of forgetfulness. In both instances, it is only through the present, the present whose existence, density, and richness can do away with them that past events can loom up and take shape.

The first part of the film is dedicated to evoking the bombing. You remember the first images. We begin with the most closed and densest present imaginable: the embrace. You also remember the lovers' first words: "You saw nothing at Hiroshima."— "I saw everything, I am sure of it." These two lines are essential to understand what follows. The young Frenchwoman, who has always cried about what happened at Hiroshima and who is obsessed by this tragic event, has seen everything that can

be seen. She is, moreover, there (no matter how inconsequentially) to ensure that such an event can never happen again. And yet she has seen nothing because all she has seen is the reconstitution of the bombing, and she knows that it will happen again because it is already being gradually forgotten and life continues on the razed ground of the rebuilt city. Hiroshima's tragic past is thus shown to us in the form of a documentary that describes its present. What is a documentary? It is precisely the most fragile form of memory. Fragile because the documentary shows us places the way we could see them, but in a way that we have not. It is a kind of derivative or substitute vision. Furthermore, while the documentary—in this film and in *Night and Fog*, for example—can evoke past events through the physical traces left in the collective memory in the form of monuments, museums, and official records, it is merely illustrating the inadequacy of such a derivative memory, of learned memory in a more tragic manner.

The Japanese man is therefore right to repeat obstinately these words that strike us as mysterious, "You have seen nothing," which mean not that what the heroine has seen is nothing, but simply that what she has seen cannot in any way compare with the event itself, an event about which no one can ever know anything except what it has left behind. Memory consists of traces in the present from the past. It thus belongs only to the present: the more it is faithful and accurate, the more it brings out the elusive nature of this past, and the more it emphasizes the distance separating it from the present where it is now deployed, and this distance is precisely what is called forgetting.

This does not mean that memory is useless. On the contrary, it is very useful to see, and the heroine says specifically that "looking is something that can be learned." One must, in fact, look at the past to understand forgetting, and forgetting is, as the rest of the film will show us, the desperate and desolate condition of life itself.

Duras's dialogue does not need any comments. "I know forgetfulness," says the young Frenchwoman, and when the Japanese man denies this, she emphatically says, "Like you, I have a good memory. I have tried to battle with all my strength, to have one inconsolable memory, to fight the horror of no longer understanding why I have this recollection. Like you, I have forgotten. Why deny the obvious need for memory?"

If further evidence of this pathetic and theatrical nature of memory were needed, for it is never more than a reconstitution of the past, we would find it in another scene that complements the flashback. That is the shooting of the film. It is, of course, laudable to make films about Hiroshima and peace, but such films, compared to the event they claim to be commemorating and that they wish to prevent ever occurring again, are presented as a form of clowning around. The sequence in which we see the filmmakers shooting Japanese people holding placards, among whom are characters made up as bomb victims, is a satire of the documentary, and through the documentary, of memory itself.

IV – While there may be something of the illusion of memory, there is a truth about forgetting. That is what the symmetrical episode of Nevers will demonstrate. Hiroshima and Nevers are primarily linked factually. For the heroine, the death of her German lover in Nevers represents (subjectively and not, of course, in terms of the impersonal historical experience) a major disaster precisely comparable to that of Hiroshima. It is a death, an end, something for which there is no afterward. And yet, there was

an after: after is forgetting and forgetting culminates in repetition. Just as forgetting Hiroshima, which is inevitable because the survivors need to carry on, makes the possibility of other Hiroshimas real, just as the repetition, fifteen years after her youthful affair, of an impossible love with the Japanese man, which marks the depth and the need to forget. And just as the young woman was able to get the impression that she was reliving the event by visiting museums, hospitals, and the ruins of the destroyed city—"The illusion is so perfect," she says, "that the tourists cry"—just as she is fooled into thinking of the German when she looks at the Japanese man.

Thus begins, in the very middle of the Hiroshima episode, the flashback to Nevers. At the beginning of the film, when we see the images of the city in which the heroine is walking around, the sentence, "You are killing me, you are doing me some good" (which serves as the second leitmotiv) is about both the German and the Japanese man, more precisely, the Lover, yesterday's lover, today's lover, and she is asking for the impossible: to distort, to mark her physically so that the perfect moment of love can be once and for all fixed in her flesh just as the traces of the bombing have been fixed in the flesh of the survivors and the very soil of the city.

There are three features that basically distinguish between the story as a flash forward, as invented by Resnais, and the traditional explanatory or psychological flashback. The first and most obvious difference is playing with the chronology: past events do not resurface in the order in which they happened, but in the order in which the narrator chooses to refer to them. It is the meaning of today and not yesterday's date that determines their appearance. The heroine also speaks of the present; she even goes so far as to confuse the Japanese man with the German as if it were the latter who was telling his own story. Thus the past and the present and the deliberate confusion of the two are characteristic of this subjective form of retrospection. There is a constant back and forth between the two that is comparable to a diver searching through a shipwreck. The events surface gradually from the depths in which forgetfulness has buried them and, naturally, the most serious, the most weighty, those buried deepest, come to the surface last. The second and less-obvious feature, but perhaps the more important of the two, is that throughout the story, we never leave Hiroshima. We see fragmentary images of Nevers but we never hear, or hear only in the distance in very brief passages, sounds from Nevers. The soundtrack that accompanies the story consists of sounds and noises from Hiroshima. We are locked with the heroine into this eternal present moment that is made up of several superimposed histories, which constitute (in opposition to clock time, the time of others) subjective time. This flashback is neither an explanation, nor does it have anything to do with knowledge; it should rather be compared to psychoanalytic treatment, with the Japanese man playing the role of the doctor who says almost nothing, and who is content to move his client forward when she hesitates or to stop her when she is moving off in the wrong direction. Since it is treatment, the flashback should also be a lesson; that is why he does not stop once after all the previous facts are known but returns to them again, in the final part of the film, to shed light on a future that is being organized around him.

The explanatory flashback would normally outline the stages in the love affair in Nevers: first meetings, first conversations, a clandestine rendezvous, the decision to run away together and, finally, death. Resnais instead begins, not with the death itself, but what we might describe as a fragmentary image of the death

which, the moment it occurs, is neither recognized as such nor accepted. It is the image of the Japanese man's hand on the sheet that suddenly leads to the reappearance, unexpectedly, of the image of another hand on the pier at Nevers.

The reminder, as vague as it is brutal, stops there. But the mechanism that he has triggered begins to operate from that moment on. It involves bringing this death back to the surface by reliving the exact conditions under which it occurred. You no doubt remember how Resnais got you there. The lengthy confession scene in the café on the riverbank goes through gradually deeper levels. To begin with, the heroine simply sketches out what happened. She relates the before and after. We first see happy images, with her running to her assignations. Then the punitive images: she is in the basement, forever condemned to hide, threatened by madness. The somber images appear immediately in response to the clear ones: the punishment is appropriate to the illicit pleasure that preceded it. That is why the masochistic memory (perhaps all memory is masochistic because it tries to remain stuck in the head of anyone remembering a horrible truth: time heals everything and you can survive everything), the true memory of a particular place and time is not merely there for the pleasure of being related but for understanding. And perhaps without knowing, memory, to fool itself, lingers over punishment and is a defining state, a fictitious death: it is what the young woman calls eternity, symbolized by the static scene during which she looks at the cat.

At this point, we have not yet reached the forgetting stage, and are rather at the stage where even the possibility of forgetting is denied, where it seems that nothing can ever change—an eternal present, huge, crushing.

But memory cannot maintain the illusion for long. As it is a real memory, it knows that there is an after, and it speaks precisely to relate this after. It must therefore admit that at a certain point, the young girl began to live again: "You come out of eternity," she says. She opens her eyes and we watch her awakening, which is one of the most beautiful moments in the film. She wanders around her room with a strange smile on her lips, as if coming out of a dream. She recognizes familiar objects one by one, she *remembers*. I know of no other filmmaker who has ever been able to express the physical reality of memory with such force, giving a name, a shape, to the things she discovers. Remember the phrase from the beginning of the film: "Looking is something that can be learned." To look, one already needs a degree of perspective. This perspective toward things and oneself, this awakening, is the beginning of the process of forgetting.

But forget what? The question takes us back once again. Memory, as soon as this reference to forgetting is made, is caught out. It notices that it has not said everything. It did not say something that it knows is obscure, that it still refuses to look at but which is essential. This means that the pilgrimage is not yet over. We need to dive in once again. This second attempt brings to light the two most dramatic scenes in the story, and they are the key, the tonsure scene and the death scene, of which memory has already given us a few isolated fragments (the hand, the house where the gunshot was fired, the body stretched out seen from a high angle). The death of the German is the climax of this retrospective effort. It makes us understand after the fact what is meant by the enigmatic words spoken by the Japanese man; when the young woman asked him why he was so interested in Nevers, he answered, "You became what you are in Nevers, it is in Nevers that I almost lost you."

It is true that the heroine became what she is in Nevers, precisely because she almost got lost there. At this moment in which she no longer identifies only the Japanese man and the German man, but also herself, with death, the interminable death of her lover, on whom she is lying, the heroine fails to lose herself in the eternal and empty present of a death in the world that has no past and no future. And as the past and the present coincide, it is not only in the past that she almost lost herself, but when she speaks now she is virtually lost.

The unexpected slap from the Japanese man snaps her out of her hypnotic state. It gets time moving again. Resnais symbolizes this resumption of time with the ball that falls in the cave and rolls, and the young girl picks it up and then holds it in her fingers with surprise.

The story of Nevers is over then. We watch the nocturnal departure of the heroine on her bicycle and her arrival in Paris on the very day that the news of the bombing of Hiroshima is announced. In a flash, the link to the present is made.

After the two symmetrical and successive returns back and forth between Hiroshima and Nevers, the meaning of the film becomes clear. It is not a love story or a story about two loves or about a bombing, but rather a story about forgetting. "I will remember you the way one forgets love itself; I will think of this story in the same way I think about the horror of forgetting." This conclusion is echoed by the comments made by the heroine when she looks at herself in the mirror above the sink a moment later, "You think you know, and then no, never." To "know" what happened in Nevers she had to relate it. The story is what gives meaning to the events. But if she was able to recount the story, it is because the story was "tellable." And if it was a story that could be told, that is precisely because it is present in memory as something that had been forgotten. As the young Frenchwoman says, "You see, it was possible to tell our story," to which she adds immediately, "Look at how I am forgetting."

V – If the flashback has no more than explanatory value, that would be the end of the matter. But we shall see that this is not the case, that it is prolonged and becomes stronger and more meaningful extended into the future. Before discussing this, however, I would like to make a comment about the second aspect of Resnais's treatment of time: the qualitative aspect. In Resnais, as in Michelangelo Antonioni (remember the feeling of expectation experienced throughout The Cry [Il Grido]), the pacing of the story elicits in the audience a temporal sensation that is independent of the images themselves. As Resnais's problem is an ambiguous one, constructed out of two antinomies that perpetually refer back to one another (memory and forgetting—the passionate period and the bombing, and the empty time of everyday life), the pacing will function at two rates, alternating moments of rest with moments of participation.

Very roughly speaking, we could say that when things are slow it is a sign of peace, a sign of life continuing, and that the speedier and more mobile pace signals passion, happiness, and also the tragic. Thus the procession in the scene in which the film is being made accelerates for no apparent reason when the Japanese man tries to get his mistress to go with him. This speeding up marks the acceleration of the young woman's time frame, and the panic that she begins to experience. Likewise, in the Nevers story, there is a contrast between the present state of affairs (the

immobility of the people at the café and the slowness of the river) and the living and passionate moment in the past: the scenes between the young girl and the German always show her speeding toward him, whether on foot or on her bicycle.

But things are not so simple. As the situation that Resnais would like us to imagine is ambiguity itself, there is also the reverse pacing. Fixity is the eternal present, the moment of passion or horror (the scene with the cat)— and the regular, monotonous, indifferent movement—is life mired in forgetfulness. Thus at the end of her long meditation on forgetting, the young woman says, "The night never ends in Hiroshima."

Throughout the third part of the film, which follows the Nevers story, the emphasis is placed precisely on this slow, interminable aspect of forgetfulness. Because one does not forget all at once. It is only the awareness of forgetting—memory—which is sudden, like a snapshot. We suddenly discover that we have forgotten; but the forgetting itself took a long time. The time we enter from the end of the young woman's story, more precisely the scene at the sink, is the time when forgetfulness begins.

VI – You no doubt recall the series of repeated scenes of the characters walking slowly through the city and the parking-lot entrance (under a porch, at the train station, at the movie theater), during which the Japanese man keeps popping up behind the young woman. These scenes make the audience smile. They are barely believable and border on parody. That precisely is the kind of tragic parody that Alain Resnais and Marguerite Duras wanted to show us, the parody of a love that is condemned to fall apart, to be forgotten.

But why is this love condemned? Here we are in Nevers. The strange, trance-like nature of these strolls stems from the fact that the makers of this film, after showing us a present that is buried in the past (Hiroshima's past, Nevers' past), they now show us a time that is being gnawed at by the future. They accomplish this not merely by using a rhythmic process—the slow ceremony of a breakup, inevitable but always postponed—but also a form of "return," a particularly daring and new approach because it consists of projecting images of the past into the future. Just now the heroine was identifying her present with Nevers. Now Nevers symbolizes the future; this, it seems to me, is the meaning of the lyrical monologue that accompanies her solitary walk through the streets of Hiroshima, during which we are shown new images of Nevers, images that this time include more characters and that are no more than a symbolic setting in which all the plays of life can be performed. During these scenes, when the two cities coincide, the words she speaks to the dead German—who is also the Japanese man—shift imperceptibly from the past to the future: "I waited for you with unlimited patience, calmly." But soon after: "Time will pass. There won't be anything left for us to do. Everything will disappear. We won't even be able to say what would keep us together." Here is the echo of what she says about Hiroshima: "The horror of no longer understanding the why of this memory." This is when the young woman decides once and for all to leave, and she tells the Japanese man. She says, "It is impossible to stay and impossible to leave." But this impossibility shows that the departure is necessary and fated. It is impossible, as we saw with the cat, to stop time and the night, or to fall into it, and enclose oneself in it, without at the same time losing oneself in it and, as soon as one realizes that this has happened, the slow degradation of forgetfulness begins.

VII – There is one final step in this difficult elucidation of the past in the light of the present: the parting. The final sequences of the film show us a dual separation that symbolically constitutes only one: the heroine leaving Japan but also Nevers. A final flashback shows us the city where she lived, the story of her youth, from a standpoint that will never occur again: "Threepenny story, I consign you to forgetfulness." At the same time, she begins to condemn the Japanese man to being forgotten. You no doubt noticed that from the moment the breaking-up process begins, the two are physically separated: at the train station by the old woman, at the cabaret by the other Japanese man. It is at the station that she begins to look at her lover from afar, the same way she looks at Nevers, and she realizes that he is already no longer there: "As with him, forgetting begins with your eyes, your voice. He will gradually triumph over all of you." At the cabaret, the parting is even more clear-cut because the scene between her and the second Japanese man, right before the eyes of her lover, repeats the scene that must have occurred twenty-four hours before when she met the first Japanese man. Another has symbolically taken his place and in the look of the lover who up until then did not really believe it, we see a gradual fear of this separation: "I will forget you, look at how I am forgetting you already."

At that moment, things have come full circle, with the future and the past closing in on the present, sticking closely to this pure time, open to an empty future. We have literally reached "the end of the roll" and our own physical weariness translates this impression of the interminable emptiness, which is the very image of time that Duras and Resnais wanted to leave us with.

One conclusion is clear: *Hiroshima, mon amour* demonstrates that a self-conscious cinema can rival the more complete and freer stories of Romanesque art. Whatever minor criticisms we have of the makers' film, whether about aspects of dialogue, editing, or the subject matter of the film itself, it is fair to say that *Hiroshima* is a major step forward in the art of cinematographic narration.

The process parallels current developments in the novel. From this standpoint, I see nothing wrong in calling *Hiroshima* an experimental film. It is experimental because, for the first time, film directors, like novelists, are attempting to shift interest away from the story and from characters—i.e., from the content of the story—to the narrative itself, and the very structure of the film is designed to express a special form of time. The only criticism I would be tempted to make is that perhaps they underscored this too clearly. Imagine how annoyed many members of the audience might be over this didactic aspect of the story. But to shift the focus like this, a way had to be found to force them to distance themselves somewhat from the story. This means that an audience does not get caught up in *Hiroshima* in the same way as it might David Lean's *Brief Encounter* or even *The Cry*. The telling of the story itself is interposed between the audience and the story. We are not affected directly: the ceremonious and incantatory dialogue (this long recitation) contributes, no less than gestures, camera movements, and editing, to a deliberate impression of artificiality. We may in the future begin to find this approach natural. Today, it still seems rather deliberate and somewhat forced, like the novels of Alain Robbe-Grillet, Jean Cayrol, Claude Simon, or Nathalie Sarraute.

I have just mentioned the names of a few novelists who are, it is generally agreed, "avant-garde." *Hiroshima* resembles their books, not only in terms of general structure but also its themes. The dual pacing that governs the succession of images

(movement and fixity, avoidance and fascination) are commonly found in today's novels. Cayrol says, "I write the way one walks." Walking, the natural image of movement, plays an essential role in Cayrol, Butor, Robbe-Grillet, or in a book like Henri Thomas's *La Nuit de Londres*: all their characters are unable to stay in one place, pushed forward by some obscure motive that may be nothing more than the forward movement of the story itself. Cayrol's *L'Espace d'une nuit* is constructed entirely around a movement of this type.

But in the new novels being written today, there is also fascination with the immobile and the nostalgia of fixity. The most typical example is perhaps Robbe-Grillet's novel *La Jalousie*, which expresses a point of view that tries to ignore time. Or then again there is Simon's *Le Vent*, which bears the revealing subtitle "Tentative de description d'un rétable baroque" [An attempt to describe a baroque altarpiece]. The story consists of a succession of immobile tableaux that the reader is asked to contemplate and describe in detail the way one looks at museum pieces.

The synthesis of movement and fixity is expressed in *repetition*. Repetition is perhaps the most characteristic form of time in the modern novel. The idea is that of a movement that turns back on itself, that literally annihilates itself by going nowhere. In Simon, where it takes the form of a whirlwind, and in Robbe-Grillet, who is obsessed with the labyrinth, repetition plays a role no less important than it does in *Hiroshima*. In a discussion about the novel, philosopher Jean Hyppolite gave the following rationale for this dread: "Repetition is the symbol of necessity. The necessary object is the one that has no meaning, that refers only to itself." In Resnais and Duras, repetition, as we have seen, serves to illustrate forgetfulness. When a situation repeats itself, it means that there has not been a decisive or eternal moment. The reappearance of a moment that we had believed was eternal makes its initial disappearance something that can be felt, and expresses it. The initial event is only completely eliminated when the second puts it back in its place, locates it in the past, and that is when the second is to disappear at the same time. This, reduced to its abstract structure, is *Hiroshima*.

Can we draw a more general lesson from this conception of time? The meaning of the film is, to tell the truth, very ambiguous. Somber from the standpoint of the heroine, who believes in the repetition of war and the impossibility of love, the outlook appears brighter for the Japanese man, who, we are led to believe, is taking effective action to prevent another Hiroshima. While we may have generally emphasized Resnais's pessimism, that is perhaps because the whole film, or almost the whole film, is seen through the eyes of the young woman. Indeed, the idea of time revealed in *Hiroshima* is a reasonably accurate reflection of the crisis of the idea of history in a world that has experienced a cataclysm. Previously, the historical dialectic was seen as a progressive development, often difficult but fundamentally happy, because it had meaning, and this meaning made the bleaker periods something that could be lived with. The thesis and antithesis were always transcended and preserved in a later synthesis. Here there is no longer a synthesis. No doubt the present moment rejects and transcends the past moment, but it does not preserve it in any true or even ambiguous way. It preserves it loosely by neglecting it. Thus we can never be sure that the present has drawn a lesson from the past, or that mistakes will not repeat themselves. History has no meaning other than what can be assigned to it by an obstinate will, always defeated in the breach by forgetfulness.

And yet a degree of hope remains. It is of course to be expected that certain of these basic, collective, or individual events will be forgotten, even though they engage one's whole being and seem to destroy it irremediably. But this mutilation, this evasion, this sacrifice, the conditions of our survival, are the price we must pay for freedom. The movement of existence, its capacity to receive and renew, and its *openness*, all have their cost. Why must one remember? Why must one look? Because memory, which puts the past in its place and allows us to escape from its fascination, obviates the need to treat our present as a past and to lock ourselves in it obstinately, because memory makes it possible for us to continue to believe in the possible: memory is the key to forgetting, but a man who is unable to forget would also be unable to have a future.

No. 35, July–August 1960

Hiroshima, mon amour. 1959. France/Japan. Directed by Alain Resnais. Written by Marguerite Duras. Produced by Sacha Kamenka, Shirakawa Takeo, and Samy Halfon. Cinematography by Sacha Vierny and Michio Takahashi. Music by Giovanni Fusco and Georges Delerue. With Emmanuelle Riva (She), Eiji Okada (He), Bernard Fresson (The German), Stella Dassas (The Mother), and Pierre Barbaud (The Father). In French. 91 min.

From the very first sequence, and even the very first shot, we know that we are about to see a film directed by someone who has taken his ideas to the limit, someone who refuses to be locked into a genre, crushed by a production system, the very opposite of the cowardly and anonymous cinema being churned out by the British studios. It is a dynamite film, the sort of film after which you feel the way you felt after seeing Robert Aldrich's *Kiss Me Deadly* or Orson Welles's *The Lady from Shanghai*, because you have just witnessed the destruction of a world, a rotten society, physically and morally falling apart. Such works are awkward, and we call them exercises in style so as not to get too upset.

David Graham (Michael Redgrave) arrives in London one morning twenty-four hours before the scheduled execution of his son, Alec (Alec McCowen), who has been convicted of murder. He had been unable to attend the trial because he was

Time without Pity
Bertrand Tavernier

Positif was among those who helped rediscover Joseph Losey, who was living in exile in London after being blacklisted and forced to leave the United States. In the following text, the young Bertrand Tavernier extols *Time without Pity*, Losey's first film to gain a cult following in France. This article, the first by Tavernier to appear in the magazine, is also prophetic because his own first film, *The Clockmaker (L'Horloger de Saint-Paul)*, was about a similar theme: the relationship between a father and his son.

undergoing treatment for alcoholism in a Canadian clinic. Convinced of his son's innocence, and wanting to regain his respect, he decides to try to find evidence that will put a halt to the workings of the justice system. The audience knows who is guilty, having seen the murder in the first—admirable—sequence, a murder committed by Robert Stanford (Leo McKern), a rich industrialist. Once engaged in this race against the clock, Losey could easily have fallen into all sorts of traps. Not only did he avoid them, but he somehow managed to combine a precise and dry, almost mathematical, demonstration with the wildest poetry and the most deeply moving lyricism.

Everything relating to the unfolding of the detective-story plot, from the clock-like precision of a watch movement that keeps its pace on target, is admirable, both in terms of how the scenes are linked together, how the characters crisscross and find one another, and the evidence of Alec's innocence, which appears to become clearer and clearer, particularly now that David, who, although he has completed treatment, is always on the edge of a relapse, "sees" things with new eyes, noticing lies and injustices with blinding clarity. All of this is uncomfortable for people accustomed to living in a bourgeois society that serves their selfish desires and their baseness. The results of the investigation are important, but no more so than the changes Graham causes for all the people he encounters, right up to the end of the film, the final and surprising dramatic turn of events, a brutal scene in which we see the other side of the remarkable opening scene. The whole film is thus built around this to-and-fro, this search for reversal, this use of opposites. The first part of the film follows Graham visiting everyone likely to be able to provide him with interesting information. Then his growing suspicions suddenly become a certainty in his mind. In the second part, we revisit the same places and the same people in almost the exact same order, but this time the lighting has changed, and every parallel scene becomes the other side of the coin. Not only did the characters lie, and not only

must their attitude change radically, but the things around them, the places they live and work in, and the roles they play are shown and "used" systematically in a manner contrary to their initial appearance. It is as if finding the evidence of Alec's innocence was causing the world to crumble, replacing it with its very antithesis (somewhat the way this occurs in Ray Bradbury's short stories in *The October Country* and Fredric Brown in *What Mad Universe*). Mirrors, following a well-known law of optics, reflect reality by reversing the image laterally, a fact that is of particular importance in this context.

A man's innocence affects the whole world, particularly when people are only too happy to allow the man to serve as a scapegoat, because it means that one doesn't have to go after a more dangerous enemy. The detective film has fallen apart and what we have now is a modern political film of the kind only Americans have made, a film that clearly refers to Marxist theories, not so much because of the argument against the death penalty, the attacks against the press, or even its condemnation of the incompetence of the justice system, not to mention bad faith, but particularly the way Losey describes all these characters to us. These people, who are alone and alienated in their solitude by a society that is crushing them, and which they have stopped opposing, are the vanquished ones, almost cowards by now. This solitude is killing them; they need help (a word that returns often in the film). Finding none, they turn toward other things: David's alcoholism, Stanford's race cars, Mrs. Harker's (Renee Houston's) drugs, and even Brian's (Paul Daneman's) homosexuality. Some are happy in their selfish lies, and satisfied with them even though they are pitiful; these are the ones who refuse to help David, the troublemaker. Others take advantage of the circumstances to free themselves, whether by refusing to continue to hide the fact that they are lying, or through love, which enables them to rise above this society: the love scene between Alec Graham and Honor Stanford (Ann Todd) is one of the most beautiful in the film. It is also the only moment when the filmmaker allows a break, a peaceful moment.

This admirably described social world is an almost virgin England. Nowhere, except perhaps in Jules Dassin's *Night and the City* or Michelangelo Antonioni's third sketch in *The Vanquished*, have we seen such a lively England, free of gentlemen, respectable old ladies, an England which is often poor and sad, with grimy apartments and welcoming but gloomy pubs. When we see Stanford's apartment, with the staircase, the etchings, the park with the Mercedes, the pitiful music hall, and the prison, these two or three shots are enough to set the scene. Losey's film is not afraid of ugliness, and he keeps his eyes on the world, even if what is shown is hurtful, and the truth always hurts.

Time without Pity does not advocate either resignation or nonviolence, but rather appears to be a destructive work: the only way for truth to triumph is through violence; while awaiting the final victory, the battle involves love, friendship, and solidarity. The direction is clearly on the right track when we recall Losey's political ideas (and we hope to see again very soon *The Prowler, The Lawless, The Sleeping Tiger,* and *The Big Night*): his direction of actors is clearly the work of someone who knows how to shape and modulate; it is less like the work of Elia Kazan than Bertolt Brecht, whose play *Galileo Galilei* Losey directed in the theater with Charles Laughton. Redgrave and Daneman are directed with total rigor right down to the slightest details of movement. Losey either pushes them toward one another or the very opposite depending on what he wants and what is needed (the direction is particularly

Ann Todd and Leo McKern in Joseph Losey's *Time without Pity.* 1957

sensitive in the second scene between David and Alec). It is impossible to say of Leo McKern whether he is "acting well" or not, because his performance goes well beyond mere acting. He simply is, and that's all. The enormous and powerful virulence in the satire reminds us of Orson Welles. Through Welles, we feel the presence of his Shakespearean cinema, overflowing with physical strength and sparkling health. But Losey is noteworthy in the sense that his direction never aims at virtuosity, and there is no attempt to be flashy, not one metaphysical tracking shot. Here technique and screenplay are inseparable. Very few directors could achieve what Losey has done.

No. 35, July–August 1960

Time without Pity. 1957. UK. Directed by Joseph Losey. Written by Ben Barzman. Produced by John Arnold and Anthony Simmons. Cinematography by Frederick Francis. Music by Tristram Cary. With Michael Redgrave (David Graham), Ann Todd (Honor Stanford), Leo McKern (Robert Stanford), Peter Cushing (Jeremy Clayton), Alec McCowen (Alec Graham), Renee Houston (Mrs. Harker), and Paul Daneman (Brian Stanford). 90 min.

The X certificate was introduced in 1951 to replace the former H certificate, which had been applied only to horror films.

I n Great Britain a horror film is best viewed in a small town in Wessex, Winton-chester, Casterbridge, Melchester, or Wimborne, after a hard morning's work on the trail of a gentle heroine fatale through streets that the Victorian era has frozen into a facade of si-lence bordering the

Horror Pictures (I)

Jean-Paul Török

most feminine and luxuriant wooded countryside. You en-ter a room, as some people enter a cathedral, that is generally empty at this time of the af-ternoon, its old-fashioned neo-Eliz-

"Proper" criticism has nothing but contempt for formulaic films, whether they are horror films, fantasy films, or Italian historical epics. *Positif*, whose Surrealistic leanings had always led it to reject the hierarchy between popular culture and high art, defended these forms of cinema, which had been neglected by the aesthetes and intellectuals. Thus Jean-Paul Török sprang to the defense of Mario Bava, *Peeping Tom*, and, in this article, Hammer Films.

abethan architecture indistinguishable from that of a hospital or museum, except perhaps for the gaudy posters (showing vampire's blood or mummy green) crossed out by the famous X certificate. After a double-bill interrupted at intermission time for five-o'clock tea, you will leave at nightfall and will, naturally, after such a double-bill, be only mildly surprised to see red post-office trucks delivering enormous boxes strapped onto creaking dollies to the houses of single women just as vampires prepare to open their eyes to the splendors of the night, when Peeping Tom deploys the sharp shutter blade of his lethal camera.

There is in the heart of Wimborne a small town with buildings no more than two to three feet high, an exact replica of the town itself, the tallest structures being the church steeples, which are as tall as a man, from which recorded organ music plays continuously. It is a Lilliputian town through which visitors can walk among the various houses reproduced down to the most trifling details (such as items in shop win-dows) and where the only movie theater every week displays a postcard-sized poster of the movie that is playing, because the person in charge of the miniature town is fanatical about absolute fidelity to the original. A glance inside this miniature cin-ema theater is unfortunately impossible, and we will have to remain content with dreaming about the strange films projected to a public, which I imagine consists of little moviegoers with very special tastes of a particularly furtive nature. Can there be a better introduction than the imaginary to the marvels of English cinema?

SCIENCE FICTION

The homeland of H. G. Wells, Wyndham Lewis, and T. E. B. Clarke has produced only a limited number of science-fiction films. For example, there is Maurice Elvey's 1928 film *High Treason*, in which Ado Kyrou remembers having seen an army of women subjected to very special kinds of assault, and W. C. Menzies's 1936 *Things to Come*, based on the novel by Wells, which is remarkable for its admirable sets. In 1950 it was through a comedy based on English humor that science-fiction themes were reintroduced: that of the android, in *The Perfect Woman*, in which Bernard Knowles re-lates in a jocular tone the relationship between a scientist and his creature, representing

the ideal woman, while Val Guest made his start, in a genre that he was to specialize in for a while, with *Mr. Drake's Duck*, the history of a duck that lays uranium eggs, a science fantasy whose satire is not far removed from that of Alexander Mackendrick's 1951 film *The Man in the White Suit*. In 1954 David MacDonald directed the delicious *Devil Girl from Mars*, whose plot line is not far from *Dans l'espace avec vous* because we see a captivating Martian woman come to earth to ravish various specimens of the male sex. The following year we had Val Guest's *The Quatermass Xperiment* (US title *The Creeping Unknown*), based on a television show by Nigel Kneale and produced by Hammer Films. The Monster is a plausible scientific ploy, the idea of the spaceman turned into a creature by an extraplanetary disease, and is not simply a skillful plagiarism of similar American films, as some have claimed.

The emphasis is not so much on scientific fabrication as on the pure horror that can stem equally well from close attention to detail or the intensity of suspense that does not go beyond the plausible. The eventual killing of the monster in Westminster is more closely akin to the kind of gothic fantasy found in Howard Lovecraft's novels. But the science-fiction film closest to Lovecraft is definitely *Quatermass 2*, directed by Guest once again as an adaptation from the popular Kneale series as a sequel to the successful *The Quatermass Xperiment*. The film will remain a footnote in the history of cinema because of François Truffaut's attempt to start an argument about science-fiction movies by citing Guest's film. It was a bad argument, as it happens, because *Quatermass 2* is an excellent demonstration of how unimportant direction can be when the script is intelligent and well constructed. Even though this account of an invasion of repugnant extraterrestrials in combat with a scientist leading a handful of men is related by Guest with his usual sluggishness and lack of conviction, the story is too well told not to be believable. There are no great catastrophes on a planetary scale, no H-bomb or napalm, no trace of inner romance, but a horror story distilled through a sequence of minor facts and small details that successfully suggest the unspeakable without destroying it.

With these two films, Guest and his crew created a style of science fiction that is close to Neorealism, that pays close attention to the furtive reality of horror and is revealed in the accurate rendering of everyday life to make it perceptible. The next Guest film—*The Abominable Snowman*—did not follow through on this promising beginning, and is only of interest because of the extraordinary presence of Peter Cushing, a film whose sole ambition is to generate money from the profitable Abominable Snowman myth, as Sir Edmund Hillary would later do. The grandiloquent sermon of Paul Dickson's *Satellite in the Sky* (1957) and Robert Day's *First Man into Space* 1958, a remake or plagiarized version of *The Quatermass Xperiment*, are the last on the list of British science-fiction films. It is not very useful to add *The Mouse that Roared* by American director Jack Arnold.

THE FANTASTIC

There is a fantasy film period in English cinema, beginning in 1945 with the sublime *Dead of Night* and including Michael Powell and Emeric Pressburger's *A Matter of Life and Death* (US title *Stairway to Heaven;* 1946), Albert Lewin's *Pandora and the Flying Dutchman* (1951), Ken Annakin's *Miranda* (1948), Terence Young's *Corridor of Mirrors* (1948), and Thorold Dickinson's *The Queen of Spades* (1949). The main merit of the magazine *L'Age du cinéma* (*Age of Cinema*) was to publish lovingly written studies of these films. More recently, Paramount distributed important films like *Three Cases of Murder* (1954),

Christopher Lee in Terence Fisher's *Horror of Dracula*. 1958

a compilation film in which the first segment, *In The Picture*, directed by Wendy Toye, was a masterpiece because of its eerie and cruel description of the strange world beyond certain paintings. Sidney Gilliat's 1957 *She Played with Fire* had, in addition to the lovely Arlene Dahl, a short dream sequence in which the dreamer first enters a castle, then enters a painting depicting the castle, and then the castle painted in the picture, etc. Muriel Box's *A Passionate Stranger* (1958), in both black and white and Technicolor, blends a dream about an imaginary love story with reality. These films relate much more to the strange or the marvelous than to pure horror. The first English film to rely almost entirely on quasi-physical horror effects was Ivan Barnett's terrifying 1949 version of *The Fall of the House of Usher*. The first vampire to appear on British screens was in John Gilling's 1952 comedy *Mother Riley Meets the Vampire* (US title *Vampire over London*).

THE HORROR TRADITION

In 1957 attendance at British cinemas was down, and producers were looking for a new formula to attract the public. They discovered the commercial potential of horror films when the extraordinary American film *I Was a Teenage Werewolf* was a great hit in London, generating $2 million in only eleven months. Hammer Films immediately set to work on a Frankenstein film and a Dracula film. Indeed, the popularity of horror films in Britain was the result of the renewed popularity of the genre in the United States, which in turn resulted from the immense success on television of reruns of films from the 1930s. After *I Was a Teenage Werewolf*, the Americans made *I Was a Teenage Frankenstein*, *Frankenstein's Daughter*, *Frankenstein's Castle*, and then, a science-fiction movie that added science fiction as another dimension, *Frankenstein 1970*, not to mention the sublime *I Married a Monster from Outer Space*. Under an agreement with Universal-International, Hammer obtained the rights for all subjects owned by the American company. With producer James Carreras and director Terence Fisher, they assembled a team of screenwriters and technicians who would, in various facilities built in Bray, develop the Frankenstein and Dracula series of films, in addition to *The Hound of the Baskervilles*, based on the Sir Arthur Conan Doyle story, and *The Mummy* and *The Stranglers of Bombay*. They also planned remakes of *The Phantom of the Opera*, *The Invisible Man*, and—why not?—*Caligari*, not to mention *And Frankenstein Created Woman*, with Brigitte Bardot, which unfortunately was never made.

No. 39, May 1961

I t is a curious fact that while no country other than Great Britain has produced so many mystery, gothic, and horror stories, the English cinema has rarely exploited the genre and instead has left it to the American cinema to develop traditional fantasy themes. Take Frankenstein, for example: we all know the tale about a fantasy-story competition organized on the shores of Lake Geneva by Percy Bysshe Shelley, his wife, Mary, Lord Byron, and Dr. Polidori [Byron's physician], and that it was Mary, barely twenty, who won by coming up with the short story of

Horror Pictures (II)

Frankenstein, whereas Polidori wrote a fragment called *The Vampire*. In the United States, where monsters were much more popular than ghosts, Hollywood took hold of the Frankenstein creature in 1931, at the same time that English director James Whale

immortalized him on the screen. From this time on, the Frankenstein era remained the exclusive property of the American studios, and it took until 1957, and *The Curse of Frankenstein*, for the monster to return to his native land. James Carreras and Terence Fisher pretended to ignore the numerous American versions and took the myth back to its source. *The Curse of Frankenstein* returned to Mary Shelley's original story. That was their first innovation, a remarkable enough accomplishment given how far the monster had degenerated. *Frankenstein* was made fashionable for a teenage public more used to rock 'n' roll singers and surprise parties.

Returning Frankenstein to a gothic context and carefully reconstructing the atmosphere of the period were the chief accomplishments of Fisher's team. The producer's bright idea was to give a first-run budget and distribution to a subject more typical of a B movie. On the large screen, with color used effectively for the first time in a horror film, it became possible to heighten effects and do a better job of frightening people. In contrast to the warmly colored, comfortable interiors, the autumn woodlands and flesh tones were genuinely cadaverous, and the dissection experiments truly bloody, in an admirably scientific atmosphere of a laboratory full of brightly colored bubbling liquids. Straying from the commonly held view that to be truly effective, horror should simply suggest things, Fisher instead lingered over macabre details, with many cutaway shots of brains covered in bloody foam or eyeballs out of their sockets, fearlessly using extreme bad taste to make even the most blasé member of the audience have a purely physical reaction. This healthy and effective use of shocking effects was to make Fisher the master of what has been described in Britain as "The New British Horror Film School."

Fisher, who was born in 1904, began working as a director in 1948, making many films about a wide variety of subjects, most of which were B series for home consumption or television. His many thrillers include *The Stranger Came Home*, which was distributed in Paris in 1957 under the title *Meurtres sans empreintes*. But it would clearly be pushing things too far to argue, as some have, that the revelation of English horror film makes Fisher an auteur. Much more familiar to the English is the concept of a team making films together. Screenwriter Jimmy Sangster, cameraman Jack Asher, and all of Carreras's contributors played a role in this success story. It is also impossible to overemphasize the importance of the actors. *The Curse of Frankenstein* introduced Peter Cushing in the role of the baron and Christopher Lee as the creature. Cushing, with his impassive, icy beauty and sovereign elegance, was ideal for the role of the "inspired" scientist who shows disdain for the common sense and down-to-earth arguments of his fellow scientists, caught up in his visionary pride. He sacrifices his best friend to science, shows open contempt for women, and refuses to share the results of his discoveries with his contemporaries, devoting himself wholly to his research. Lee, with an admirable makeup job, showing a maniacal concern for morbid realism, gave us a creature who could make us forget Boris Karloff's hallucinatory mask.

Following his successful treatment of the Frankenstein theme, Fisher and his team then moved on to Dracula. These two inseparable great horror myths—and it needs to be emphasized for those blasé people who claim that these myths are not original that we have not heard their last—are perfectly complementary. The Frankenstein creature is a corpse without a soul, a mechanical physiological object that elicits both distaste and pity. Frankenstein proves that matter and death must triumph and cannot be questioned by man's pride and defiance. This assemblage of corpses

can only give the appearance of life and will only be able to avoid decomposition for a while. Dracula, on the other hand, is the victory of life and eroticism unto death. In the vampire Dracula, the liberating aggression of the life force (Eros) is directly opposed to the triumph of death in Frankenstein's masochistic passivity.

Fisher's *Dracula* (US title *Horror of Dracula*) is no doubt the best vampire film since F. W. Murnau's *Nosferatu*, the only one to consciously appeal to the well-known effectiveness of eroticism. The adaptation is faithful to Bram Stoker's novel. Added to Peter Cushing and Christopher Lee—Hammer Films showing a willingness to make every sacrifice—is the famous theater actor Michael Gough. With the sets as meticulous as those described in gothic novels, the characters sumptuously dressed, no expense spared in the direction, and, to be sure, an abundance of pretty women (Melissa Stribling, Carol Marsh, and Valerie Gaunt in the role of the female vampire: we know how beautiful English women are when they are vampires), the masterful coordination of all these elements made *Dracula* wildly successful. Fisher's predilection for bloody details is even more exaggerated: stakes through the vampire's chest, accelerated decomposition of bodies. Lee, wearing very little makeup in the role of Dracula, radiated a fascinating and romantic beauty to which perhaps only Conrad Veidt could be compared. To their great delight, he attacked young women not only to make them his victims, but also his equals. Never had the vampire's bite been compared so consciously to the sexual act. Fascinated young women lock themselves in their room, change into their nightgowns for the night, open their windows wide, lie down on the bed, and, like an offering, await the arrival of the vampire as they would a lover. Fisher, with exemplary seriousness, is clearly on the side of the vampires in their battle against their enemies. In fact, the most cruel deeds do not involve Dracula giving his consenting victims unparalleled pleasure, but rather Dr. Van Helsing (Peter Cushing), who breaks into tombs, pierces bodies, and deliberately uses the cross as a form of torture, in the most terrifying manner ever seen on the screen.

The Revenge of Frankenstein is, after *Dracula*, Fisher's finest film. It definitely constitutes a rehabilitation of the baron and ends in his total victory. To further add to the desirable confusion of cinematographic genre, one must not be afraid to assert that *The Revenge of Frankenstein* is also quite simply one of the best films in recent years. This horror film completely revives the genre, and it is also a masterpiece of poetry and humor. The humor is certainly present in the cast—Michael Gwynn and distinguished Shakespearean actor Richard Wordsworth—who are allowed to shine. Baron Frankenstein, played once again by Cushing, who has escaped the hanging to which he had been condemned at the end of the previous film by having the priest executed in his place, is continuing his experiments in another city and would have succeeded remarkably if the unforeseeable had not entered the scene once again. After the operation, his creature appears once again as a normal man, one who is even reasonably attractive. The horror stems from the fact that when the brain starts to deteriorate after a shock, the body begins to deteriorate at the same time and starts to resemble the former body of the crippled and limping hunchback, who in the hope of possessing a more robust carnal exterior, and for the love of a woman, had entrusted his brain to Frankenstein. The baron was lynched by the mob but, before dying, ordered his assistant to place his brain in the attractive body of a fresh corpse, and this time the experiment was a perfect success. The end of the film shows Baron Frankenstein *redivivus*, mixing brilliantly with elegant society people in a foreign city, ready to resume his experiments. This constitutes total emancipation

from the "Frankenstein complex" through the liberating use of humor. It is one of the rare contemporary works that is capable of opening new pathways in psychoanalysis, in particular with respect to the phenomenon of transference. The doctor's laboratory and his experiments reach an extreme level of complexity that calls for the poetic use of Raymond Roussel's marvelous machines. How can one ever forget the pair of eyes floating in the murky liquid of an aquarium, which, when hooked up to a complex system of wires, organs, and more or less electrical motors, *lives*, with its worrisome gaze turning in the room toward the visitor's footsteps?

In 1959, with Cushing and Lee yet again, Fisher made *The Hound of the Baskervilles*, based on the famous novel by Sir Arthur Conan Doyle, and *The Mummy*, staring the very beautiful Yvonne Furneaux. *The Mummy* is the resurrection of a Hollywood scene in Victorian England. Wrapped tightly in the bandages of the grand priest Kharis, Lee could hardly perform to the best of his ability, and this mummy released only an abstract form of terror. However, the reconstruction of an admirably colored Victorian atmosphere gives the film an old-fashioned look that bathed, with secret menace, the face of Furneaux playing the reincarnation of the princess Anaka.

With *The Stranglers of Bombay*, Fisher explores the India of 1826, with a sect of stranglers killing thousands of travelers. The subject this time was based on an original script, and it worked because of the many dead bodies and scenes of violence, in the same way that John Gilling's *The Flesh and the Fiends*, another horror film based on historical events rather than legend, worked. *The Brides of Dracula* returned to the traditional genre. Peter Cushing, still playing the valiant vampire scourge, is joined by a new Dracula played by David Peel, in addition to the revered monster of English theater, Martita Hunt, in a role tailor-made for her as the vampire mother turned into a vampire by her son. The first half hour of *The Brides of Dracula* is a true nightmare, the perfectly executed slow discovery of horror pursuing the inevitable Frenchwoman (here played by Yvonne Monlaur), who is always led astray by the malicious screenwriter in the world of British monsters. For anyone slightly late in discovering English horror movies, it would be easy to consider *The Brides of Dracula* a masterpiece. However, the film's production budget was not what it might have been, and the script itself has too few terror scenes to make up for the slow-moving plot development. Nevertheless, minor details and bright ideas (young women, very ugly when alive, become remarkably beautiful after being turned into vampires), and using the shadow cast by the vanes of a windmill as the final weapon to knock down the vampire, makes the film more than interesting for anyone wanting to remember what a nightmare is like. A thought in passing: why do vampires dare to appear in films with an X certificate? Or is it that the English simply want to prevent them from entering dark rooms as members of the audience?

Fisher's recent films explore the remaining monsters: the werewolf, the Phantom of the Opera, and the invisible man. They in turn conquer British screens. The setting of *The Curse of the Werewolf* is a late-eighteenth-century castle in Spain. The cast includes Clifford Evans, Oliver Reed, Catherine Feller, and Yvonne Romain (another Yvonne, still French). The traditional horror-film repertory is now conscientiously brought before us by the English studios, and cinephiles too young to have seen the American films of the 1930s when they were released, will, through Fisher's remake, have access to a brand new, admirably designed, museum of horrors. Nevertheless, Fisher and his team are not really geniuses or even original. There is a lack of pretension and a keen awareness of the limits of a genre in which an overly intellectual approach

or a surfeit of gimmicks can spoil the whole endeavor, as can a self-satisfied aesthetic or the need for rational explanation. Any vain desires to bring the stories up to date must be rejected in favor of faithfulness to the original and efficiency. No cumbersome transpositions, hasty attempts to follow fashion, no jazz music, sports cars, or Caravelle or Comet jet planes. All of Fisher's films are set in the late nineteenth century, in this striking Victorian era, the era of nonsense and the ghost story, and the English golden age of the occult and the irrational.

A SHORT HISTORY OF HORROR

Sordid and bloody accounts from the crime pages have also produced their legends, and a number of particularly ghastly criminals have left us memorable and hallucinatory images alongside the great mythic monsters of horror. Jack the Ripper, whose terrible deeds were certainly real, has for a long time been a figure in the mythology of horror. The film *Jack the Ripper* (1959), by Robert S. Baker and Monty Berman, appears to have no purpose other than to elicit from the audience an initial reaction of disgust. A frenzied accumulation of sordid details, the premeditated meeting of particularly ugly and repugnant actors, a string of scantily dressed girls unpleasant enough to look at, provides nothing much for the eye to enjoy, and one may well ask with some concern for what audience this film was intended. This mechanical spectacle of horror, which aims very low in wanting to provoke nausea and disgust, creates no horror whatsoever. It is nevertheless difficult to avoid being taken in by an admitted fascination with the heavily suggestive deviant sexual violence in the film, just as it is difficult to enter into, without feeling discomfort, the sick and deviant eroticism of a work like John Gilling's *Mania*, whose evocative title is fanatically realistic and exerts an attraction that is not far removed from necrophilia. On the other hand, the climate of the fantastic, typical of Frankenstein and Dracula, gives their behavior a salutary gratuity and opens wide the doors to humor and poetry to allow for free play of the imagination. The pleasures of *Mania*, are comparable (shameful because it is certainly less than aesthetic) to the joys experienced by people who like to watch executions. *Mania* is an account of a famous case in Great Britain, that of the resurrectionists (or grave diggers), who supplied subjects for dissection to the famous surgeon Robert Knox, causing a scandal and leading to a trial that made the headlines in Edinburgh in 1820. Robert Louis Stevenson used the facts to write a fantastic tale entitled *The Body Snatcher*. For his film, which is a model of historical reconstruction, Gilling patiently exhumed the past. His meticulousness is striking; but it fades in the shadow of a morbid interest in the macabre, the corruption of the flesh, and the sadistic pleasure of transgressing the inviolability of death. With *Jack the Ripper* and *Mania*, the boundary between horror and the pathological is barely perceptible. Neither film has any visible aesthetic merits, and no alibi is possible. In the history of the horror film, *Mania* is important because it reveals the mechanics of the pleasure we derive from it.

HORROR IN THE NEWS

The character of the sex maniac, of which Jack the Ripper is the most famous historical incarnation, haunts the quiet streets of small villages in the English counties to this day. A mother would never for anything in the world leave her children alone at home out of fear that a lecher might enter, a fear reinforced by reading the news columns in the gutter press. Great Britain has always held the record for sexual

assaults and crime, and the character of the Peeping Tom or of the voyeur is familiar enough that a film could be devoted to it. I will not say anything more about Michael Powell's excellent film except to note that *Peeping Tom* opened the door for contemporary horror films. It has always been extremely difficult to set a horror film in the present. Doing so strained credibility and made it difficult for the story to be effective. The solution has always been to substitute for the imaginary creature, who is only at ease in the distant past where everything becomes possible again, a hero of our own kind whose monstrous nature is the result of sexual dysfunction. The voyeur, the obsessed murderer in Arthur Crabtree's *Horrors of the Black Museum*, committed a string of fiendish crimes with an amazingly refined range of murderous methods. The most innocent objects were to become the weapons of pitiless cruelty in the expert hands of Michael Gough, who had an aesthetic appreciation of killing as one of the fine arts.

Sidney Hayers's 1960 *Circus of Horrors* develops a very skillful screenplay by George Baxt, whose point of departure resembles Georges Franju's *Eyes without a Face* (*Yeux sans visage*). A plastic surgeon attempts to reshape the burned face of a pretty girl, but the experiment fails and he is forced to run away to the continent to hide his identity. In order to be able to continue his experiments in peace, he buys a circus and uses it as a cover. Plundering the seedier neighborhoods of big cities, he collects a large number of lost young women, seriously disfigured either by a birth defect or an accident. He operates on them and gives them beautiful faces. In exchange, he asks them to stay with him and become stars in his circus, which is soon populated with numerous pretty girls and becomes a great international hit. The doctor's triumph would have been complete, and his rehabilitation a success if the genial man had not been such a lover of female beauty. Like Pygmalion, he fell too violently in love with his most recent creation, causing his earlier favorites to become jealous, and thereby creating all sorts of complications. To get out of his difficulty, he commits a string of murders by rigging the circus acts and killing the women he had operated on one after the other. However, the police eventually became alerted to this series of "accidents." When the circus returned to England (as a benefit for the mentally ill), a return trip that was to celebrate his dual triumph as a surgeon and circus manager, everything ends tragically; just as he is about to be arrested by the police, he is killed by one of his patients who had gone crazy because of a botched operation. The Dr. Schüler character, played by Anton Diffring, resembles those created by Peter Cushing, but with an obsession for women that one would look for in vain in the latter. The plot line is a lovely poetic idea: re-creating the faces of the women on whom he operates, he attempts to make them look like famous portraits; thus Yvonne Monlaur, wearing a sea-green dress, looks just like someone out of a Degas painting.

We must now close our review of horror films from across the Channel at this arbitrary point of *Circus of Horrors*. We will return to the topic soon. Horror has become a new motion picture genre in Great Britain, one that is well defined and that has its own rules and its own styles. There is a great deal of talk about Free Cinema. But through its power of suggestion, its frenetic pace, its invitation to travel to the world of dark and wondrous things and imaginary eroticism, is not English horror cinema the real Free Cinema?

No. 40, July 1961

L et's begin by placing the film on a pedestal within my own personal rankings: *Cleo from 5 to 7* (*Cleo de 5 à 7*) is, in my view, the best French film since Alain Resnais's *Hiroshima, mon amour*, Pierre Kast's *Le Bel Age*, and Jacques Becker's *The Hole* (*Le Trou*).

There is nothing more admirable than intellect sprinkled with sensibility, except perhaps for sensibility guided by intellect. There is nothing rarer than a mind smit-ten in equal measure with rigor and fancy, ex-cept for a temperament that is both hyperin-stinctive and extra-lucid at the same time. Agnès Varda is the harmony of her opposites, and per-haps the most complete

Cleo: From Here to Eternity
Roger Tailleur

Alain Resnais edited *La Pointe courte*, Agnès Varda's first film. Like her, he was a photographer who loved the seductiveness of words. Here we have another representative of the Left Bank being extolled by Roger Tailleur in this essay about Varda's second film, which is clearly one of her masterpieces.

of our filmmakers, if she does not find herself too limited by her sex (nothing could be less certain than this, as it happens). *Cleo* is thus both the freest of films and the film that is the greater prisoner of constraints, the most natural and the most for-mal, the most realistic and the most precious, the most moving to see and the most pleasant to watch. With so much felicity in terms of expression, one thing is clear: at least once in her life, Varda, to use her own words, had to go slightly pinkish. It brought her good luck.[1]

Varda, who is the maker of *La Pointe courte*, which once annoyed us, but which in the new version has been resynchronized and could well fill us with shame, in retrospect—and who also made three marvelous short films, is not the smallest jewel in the new French cinematic crown. She is a wonderful representative of that cin-ema, on an equal footing with Resnais and Chris Marker, not to mention Armand Gatti, Kast, and Jean-Claude Bonnardot. A strange family perhaps? All one need do, however, is glance at their respective filmographies, in which they give advice to one another, comment on one another's work, share editors, composers, and pho-tographers, and view their films, with their occasional lighthearted reciprocal winks at one another, which are remarkable primarily for the boldness of their subjects and structures, to see that beyond the varied receptions given to these films—alongside one hit surrounded by bitter controversy, three films banned outright and a few box-office failures—what we get with these makers is not a noisy and well-organized gang. Nor is it a union bent on intimidation in an attempt to gain prestige, but a genuine Centre National de la Recherche Cinématographique [National Center for Cinema Research], in which nomads talk back to the stay-at-homes and the most esoteric experimentation is nicely counterbalanced by the most strictly structured affirmations of talent.

This then is an effort to place Varda, to "condition" her as she likes to say, and with respect to *Cleo*, to point out the narrative research, the time limitations, the vital concerns, the elegant tone and surface, and, two by two, the humor and the anxiety, the gravity and the poetry.

WHAT

What is the subject of *Cleo*? A woman knows that she is going to die; more precisely, she may die and she believes she is going to die. She is a young and very beautiful

Corinne Marchand in Agnès Varda's *Cleo from 5 to 7.* 1962

woman. For a period of ninety minutes, from the time (5 P.M.) she consults a not very reassuring fortune-teller, until 6:30 P.M., when a doctor in only a few words gives her rather a optimistic outlook (about which we can doubt its total sincerity) based on the results of a medical analysis, ninety minutes then until, like a macabre hero obsessed with a minor matter, she can think of nothing else: the scandal, her death. Her secretary Angèle (Dominique Davray) her lover, the musicians with whom she rehearses a few songs at 5:30 P.M. (according to Varda, "she is a not very well-known singer"), a girlfriend, Dorothée (Dorothée Blank), who is a sculptor's model, whom she visits at ten minutes to six, a young man by the name of Antoine (Antoine Bourseiller), who approaches her a quarter of an hour later in Montsouris Park and accompanies her to the Salpêtrière Hospital, no one manages to really get between Cleo (Corinne Marchand) and her uncontrollable obsession. No one, except Antoine, at the very end, only a few moments before the doctor appears, a suddenly rather futile oracle.

Death is everywhere on the route followed by Cleo that afternoon: it is the pale mask of the fortune-teller; an old white-haired woman caught suddenly in a low-angle shot like a dead woman in a Carl Dreyer film (the best ones are *They Caught the Ferry* and *Vampyr*); it is the many seductions of a millinery ("The black one suits me very well," says Cleo, trying on several hats); it is the African masks in the antique shop windows on the rue Guénégaud, which all remind us that "statues die too" and that the censors are in charge of the funeral; a funeral encountered in Montparnasse, as it happens; it is the irony of a sign saying "Here's to good health"; it is a short, macabre, burlesque film, seen on the fly, or the unfortunate words used in conversation: "The dead, we no longer know who they are," says Dorothée while sorting out the street names on the signs. "If you are arrested, you are unlikely to die," says a taxi driver. "Today," says Antoine, "the sun leaves Gemini and enters Cancer." Far from remaining an abstract leitmotiv, thought digs deeply into Cleo's flesh, like a splinter, and any scene that is even slightly abnormal, provided that it suggests physical pain or visceral acrobatics, causes revulsion and leaves one on the edge of nausea.

A frog swallower, a sidewalk acupuncturist, a bullet hole in a café window in settlement of some mysterious scores, almost make her faint: "I feel turned inside out." After seeing the first African mask, she sticks her head out of the taxi window for a breath of fresh air. Some news on the radio about the difficult convalescence of her well-known fellow singer Edith Piaf, a story told to her by the woman taxi driver about some of her run-ins with difficult customers, and a discussion of women parachutists, chill her with horror. In the climate that reigns because of such an obsession, superstition grows. But Cleo, who seeks answers in the cards and gets upset over a broken mirror, is not alone in wanting to propitiate the decrees of providence. Her friends, on the other hand, see her sensitivity to fate as a way for them to be thoughtful and considerate toward her. "No nines on Tuesday," says and repeats Angèle, the secretary, "you don't want any bad luck, do you?" "Not this taxi, it has an unlucky number," adds Angèle ten seconds later. Dorothée, who goes away for a moment, tells her to "think of something else; count sailors' hats." And Varda herself quietly breaks down her story into a prologue and thirteen chapters, and then so arranges things that everything goes smoothly for her heroine as soon as she returns. Dorothée's attentive generosity by giving her the hat she wanted, a little black fur hat that she had chosen in spite of Angèle's protests.

Such an abundance of references to death and signs of death would, of course, be unbearable if Varda believed even slightly in symbolism. But she is definitely an absolute realist instead. Jean-Luc Godard, after incorporating into his film *Breathless* a scene about a car accident that Jean-Paul Belmondo had briefly witnessed, was able to say about his film, among many other verbose auto-referential glosses, that he was focused on the obsession of death; that was his explanation, supposedly resulting for all practical purposes from a feverish bout of "inspiration." Varda, who, as we have just seen, can also deal with fate, remains lucid when artistic creation is under discussion, and she is not particularly interested in sharing her credits with chance or any other obscure forces of divination. Just as Varda's *L'Opéra Mouffe* was the diary of a pregnant woman, *Cleo* is the diary of someone who is really ill, not just imagining it, and who is afraid of dying. In the magazine *Témoignage Chrétien* (April 3, 1959), Varda explained: "How we perceive a pregnant woman is conditioned by, and hence altered by, her circumstances. She unconsciously *chooses* to notice what precisely this means, such as her seeing old men whereas you, in the same street, would have mainly seen children, houses, or cafés . . . My cinema is thus expressionistic; it distorts the world, it shows it from a particular standpoint." And in speaking of *Cleo*, in an interview with the magazine *L'Express* (June 29, 1961): "At the beginning, I wanted to travel around Paris, but Paris seen by someone who looked at things in a special way. Why not the point of view of someone who is going to die? Why not a woman? . . . What always interests me is the way of apprehending reality." "Conditioned," "particular standpoint," "special way"— could this be the woman's version of the "documented point of view" so dear to Jean Vigo? In any event, there is a big difference between being unaware of all of the details in something that has been studied extensively and being unaware of something because of a touch of laziness or lack of preparation, and between impulses that have been investigated and retransmitted and impulses that go around in circles.

This realistic vision, in an extremely and immediately concrete manner, which alternately shows us Cleo and what her "take" on the world selects from it, is like a lengthy balancing act not only of shots and reverse angle shots, because the shots of Cleo are no less subjective than the others, but subjective in a very variable manner in terms of their level of reference to the heroine herself. Cleo, in effect, meets people who size her up just as she sizes them up, and each of the thirteen chapters includes a proper name in the title (Cleo five times, followed by Angèle, Bob, Dorothée, and Antoine). In a short preamble to the film, the maker explained the meaning of her titles: "The shooting, directing, and even the 'color' of each chapter is intended to characterize the take or perspective of each person, and when it is Cleo who 'sees,' she idealizes her character (for example, Angèle 'sees,' in static shots, simple, clear, and realistic images. Cleo 'sees' in sinuous movements, framed images against pale, vague backgrounds)." This Marienbadism [a reference to Alain Resnais's film *Last Year at Marienbad*] of the film is, we hasten to add, not as systematic as these words would appear to indicate. First of all, if it were absolutely necessary to be aware of the shifts in point of view from one chapter to the next, then the titles would be enough to let us know immediately who was taking over. But the powerful realism imposes a form of consistency and fluidity of tone on the film that initially makes the audience unaware of all these shifts in discourse.

Were it not for the preamble, I would have noticed nothing, and would have believed straightforwardly that the chapter titles were only there to structure the

story, place us in time, and introduce the characters. I would have been wrong; for example, the sequence with the visiting lover is not entitled "José" but "Cleo." Having thought about these matters, for it was necessary to do so, let us not argue with Varda about her long tracking shots in Chapter IV, titled "Angèle," and admit that many of the chapters, strictly from the directorial standpoint, are admirably designed in terms of point of view: Chapter VI, for example, which is crazy and full of gags and camera movements, and worthy in every respect of the unbridled fantasies of the composer Bob (Michel Legrand); Chapter V is stylish, fussy, and full of Cleo's simpering; Chapter VIII ("Some Others") is full of abrupt changes, fragmented impressions, and documentary one-sidedness. More often, and more simply, the characters have chapters in which, in terms of dialogue and their presence on the screen, they are "the star": Angèle in Chapter II because it is full of her fond chattering; Raoul (José-Luis de Villalonga) in Chapter X because the location is the movie theater where he works as a projectionist, and where he says, "No illness can win out if you can stop to laugh for a moment" before projecting a short comedy; Antoine in Chapter XII because he is there, dealing with war and love; and lastly, Chapter XIII, "Cleo and Antoine," because for the first time Cleo agrees to talk.

Whatever may be the levels of subjectivity for the various episodes, and our corresponding perceptive acuity, the different "visions" on view remain, with two exceptions, purely retinal: what we see is something that anybody can see—only the points of view change. The only two times the imperturbably concrete gaze of the film blinks are at 5:05 P.M. as Cleo is leaving the fortune-teller's, when the same shot is used three times in a fast-cutting sequence showing her face moving jerkily forward, a rather well-rendered impression of going down a staircase in medium tempo; and at 5:50 P.M., when walking down the street, she thinks of different people, and we are given, in overexposed flashes, shots of the fortune-teller, the frog swallower, the lover, Angèle, and Cleo herself tearing out her false hair, etc., overly obvious points of view cut in time with the equally insistent objectivity of the metronome heard earlier during the credits. At these two moments, when the inner eye takes over for the physical eye, the Marienbadism of which we just spoke triumphs.

But the triumph is short-lived. Cleo's victory is elsewhere: in a close co-existence between the objective and the subjective, in which the best of one person can live on good terms with the best of the other, without either detracting from or feeling undermined by the other, just as in Michelangelo Antonioni's films the apparent wrapping hides artifices (commentary, subjective camera, interior monologues, etc.) but whose intimate substance reflects an incomparable level of subjectivity.

WHERE AND WHEN

To accomplish this, Varda uses a multiplicity of objective reference points, so much so that her film has more self-imposed limitations than any other imaginable. She decided to follow Cleo everywhere for ninety minutes straight, without ever allowing an ellipsis to remove the heroine either from the time she really lives in or the places she is going through. This is a unique challenge because earlier famous movies filmed in "absolute time" (Robert Wise's *The Set-Up*, Alfred Hitchcock's *Rope*, and Fred Zinnemann's *High Noon*) compromise their temporal continuity, and sometimes their spatial continuity, by centering on different characters. But she meets the challenge, with only two brief exceptions, the famous two exceptions that prove the rule: at 5:04 P.M. the fortune-teller shuts the door on Cleo and tells her husband (?),

who is in the next room, "I saw cancer in her hand"; and at 5:31 P.M., when the two musicians in the wings put on a special farce they have invented just for Cleo. With the exception of these few seconds, we are always with Cleo; whether or not she is in the frame, she is in the scene. What is on the screen is what she is living or what she is seeing. There are also details of all kinds, and to our unaccustomed eyes, they appear to be obsessive.

When we hop into a taxi on rue de Rivoli to go to rue Huyghens, we are clearly driving down rue Vavin, which is very close to Studio-Parnasse. When we reach Parc Montsouris by avenue Montsouris, we cut through avenue Reille exactly at the place where we find, if not a statue of Ado Kyrou, then at least his ghost. The number 67 bus that takes us from Parc Montsouris to the Hôpital de la Pitié runs to Verlaine Station and, a little farther along, crosses Place d'Italie. You have to give two tickets to the attendant, just as four new francs were paid for the trip in the first taxi. When the radio in the taxi says that it is 5:22 P.M., they're not kidding; you could set your watch by it. And these highly vaunted ninety minutes are not off in eternity somewhere; they were lived once, only once, once and for all. What were you doing on June 21, 1961, the first official day of summer, the longest day of the year? At about 6 P.M., at the very moment Cleo was in stitches watching her little burlesque film, I was entering the Elysée Cinéma to again watch *Man of the West*, with Gary Cooper, who, as it happens, had died of cancer the previous month. Marcel Achard, the Claude Chabrol of the previous generation, who was sitting one row behind me, could readily confirm it, at least if his personal papers are in as good shape as mine. But I think the twenty-first was a Wednesday, whereas *Cleo*, as we are reminded in the incident concerning the black hat, took place on a Tuesday. So, was it the twentieth or the twenty-first? Who is right, my calendar or the nice but talkative Antoine, the harbinger of summer whose omniscience did not prevent him from getting Flora and Ceres mixed up? Perhaps the news bulletin on the radio in the taxi could tell us.

We could hear talk of the coming Tour de France, the peasant problems in Brittany, labor accidents, and lastly, slowly, poised in the monotone voice of a speaker, of the decidedly interminable Algerian war. Poor French cinema, poor little sterilized cinema, where screening a straightforward newscast in the silence of a dark room constitutes an innovative and audacious event, and we are surprised when we hear it and fear in the darkness the probable presence of the censor. Later, after this breach has been well and truly opened, Antoine, the soldier on leave, will, without raising his voice, say how much he hates dying for nothing, before preparing to take the ship back there again. (In writing this, I suddenly think that *Cleo* is like a new and very French remake of Tay Garnett's *Trade Winds*, in which two people, one of whom is a murder suspect, have a brief interlude of love.) The realm "which belongs to everyone" is once again brilliant in the sequences and shots in which Agnès gets to give herself over happily to documentary: the Avedonian tracking shots in a hat shop; two more in a sculptor's studio; the Dôme Café sketched masterfully; a quick psychoanalysis of Godard using the Dr. Mack Sennett method; and, on the soundtrack, thanks to Antoine's lengthy discussions, worthy of Jean Giraudoux, with a thousand useful and informative details about the trees and hospitals of Paris, love of the kind that young girls do not experience, mythology, and other delectable etceteras.

The structure of the story is no less rigorous and accurate than the reality itself. Allow me to speak here about musical structure. *Cleo* begins with an overture (a

French overture, in the style of *Carmen*, the purist would say) in which everything is said, gathered together, summarized, with a main theme and secondary themes. While playing with her tarot cards, the fortune-teller talks to Cleo about her life, barely sidestepping the topic of death. She speaks to her about a lover who will not marry her, of a young man she will meet, a departure, a trip, a serious illness that she takes too seriously, and just before the final card, number thirteen, she tells Cleo in tears: "It is not death, but a deep transformation of your whole being." Here the opening comes to an end, and the credits appear. Later, in Chapter II, in the form of an anecdote told by Angèle, one theme reappears: Angèle speaks about a peasant from the Causses in southeastern France who, after being told by his doctors that he would die, leaves on a long trip—not the final voyage—to the Mediterranean and returns hale and hearty to his small village, where his wife, the unlucky Penelope, had been killed in an accident while he was away. The theme is also paraphrased, always with philosophical counterpoint, in the small burlesque film: Godard, because of his dark glasses, sees as falsely as the overly simple vision of *Breathless* would indicate. He thinks that Anna, his wife, is black; she is crushed and disappears into a horrible hearse, etc. Then when he tosses his dark glasses into the river and gets rid of the systematic myopia of his black ideas and visions, he rediscovers Anna, blonde again. "Ah, I was seeing everything black because of my glasses," says the subtitle, "Damned dark glasses!"

WHY

The main theme, which I have not spoken about much thus far, is that all fixed patterns kill, through words. What lies at the heart of *Cleo* is less the obsession with death than the possibility of breaking the circle, not so much of death, but change. "The profound transformation of the being," as the old woman said, a way of putting an end to a hackneyed monologue, superstition, and of taking off blinders and dark glasses, getting out of oneself to move toward others, or at least toward one another. We can follow the stages of this almost imperceptible but continuous passage from being self-centered to being more communicative in the dialogue, and even better in the faces of others, depending on whether we are met with a Sphinx of indifference or a reassuring Pythias. Almost as much as in *L'Opéra Mouffe*, where faces had a haunting presence, *Cleo* has a constellation of human faces.

After seeing Carl Dreyer's film *The Passion of Joan of Arc*, the customers wait at the fortune-teller's in lighting that is worthy of a perfect morning for executions; we have Cleo looking for her face, from the bottom of the staircase, crying in front of her reflection, "Being ugly is death; I am ten times more alive than others," and crying once again at the café, with her face against the mirror. We have the overly professional attentiveness of the owner and a waiter ("So, little lady, what's wrong?"), indifference erected into a system, propped up with reasons, justifications, etc., of the lover, the fleeting curiosity of passersby in the street, the crowd at the Dôme Café in small but well-partitioned islands, and we have Cleo in front of another mirror, in a Chinese restaurant: "Everybody is looking at me and I am looking only at myself," in reply to Dorothée after she asks her about her illness: "It's in the stomach; at least you can't see it, no one suspects a thing," and then admitting to Antoine: "I'm surprised by everything, people's faces and mine alongside." Depicting this perpetual ballet of faces, this incessant interplay of stares and looks, amounts to a film that describes in detail people looking at one another and watching one another

look at one another; on the one hand, there are mirror images, because for Cleo another face is simply another mirror, but one that distorts more, is more worrisome, and, with a little luck, as in a refracted portrait of Dorian Gray, there is the opportunity to see one's own death at work (as Cocteau said); at other times it is like swordplay, where Cleo's best option to counter the aggression of the other person's gaze is to refuse to pick up her foil.

But Cleo is going to change. Cleo the spoiled child, Cleo the stuck-up young woman, Cleo pouting, the stormy Cleo, who plays with her body but does not give her heart, Cleo for whom the song titles "L'Allumeuse" ("The Vamp"), then "La Menteuse" ("The Liar"), and then "Moi, je joue" ("I play the game") are so well suited, Cleo is going to change. The place is a garden full of birdsong, waterfalls, and lunar landscapes, and another garden, which resembles the park surrounding a castle in bygone days. In this map of the Tender [an allegorical country in which diverse ways of love have been imagined], where Eden can be found again, covered in sneakers, from *Du côté de la côte*, the old platform buses operate without danger. Varda insists on making the instrument Antoine, almost the first person to come along, thinking perhaps of this lovely inspired poem by René Char called "L'Amour":

To be
The first to come along.

We would like the first people to come along to be just like him. For a half hour, Antoine makes one of these speeches of loving friendship and growing complicity, the way one might imagine them, perfect and forever, only with one's eyes shut in the darkness, on the brink of a sleep that will not come. Unflaggingly, the skillful Antoine Bourseiller, a kind and contagious character, speaks in his serious-amused, humble-assured, and sententious-pleasant manner. For twenty minutes we get a broad and steadily ascending movement that constitutes one of the two or three most beautiful love scenes in all of cinema. There is a scene in which love is discussed, but only indirectly, in which the phrase "I love you," and the kiss are left unshown, without ever once bringing to mind the concepts of discretion or sobriety, these vulgar critical appendages, because everything is done with such wonderful naturalness. As the scene progresses, Cleo ceases to be a tyrannical subject and can stand outside of herself; what this means is that she wants to be an object only insofar as she becomes part of a couple. As Antoine is about to get off the bus, she calls him back by saying, "But you're with me!" He calmly replies, "You're with me, too." And then we get the offer of a flower, holding hands, an exchange of addresses, a "Thanks Florence, thanks Cleo," and they start to talk about the future together, leading this exemplary duo to a remarkably modest and particularly moving *climax*. At the same time, Cleo, one by one, discards the final remains of her fear. She, who is afraid of everything, from elevators to birds, and who cultivates melodrama ("With her, you've got drama and company," says Angèle, and Antoine finds the label that sticks, "You are a melomaniac, you love schmaltz") still flinches when she sees the "Hospital" sign, and the absence of a doctor gets on her nerves. And when the doctor is gone, she comes toward us with Antoine, the two leaning against one another, giving him her *first* smile, not very confident yet, and her first gaze. They are as naked beside one another as the couples in *L'Opéra Mouffe* and *Du côté de la côte*. "It seems to me that I'm no longer afraid. I seem to be happy"—the apologue of the peasant from the Causses has come to an end. Card number thirteen has been turned over,

and the voyage is beginning for Cleo; Roger Vailland's novel *La Fête* would say that she is no longer a woman who complains, who accepts, who mopes, who stays within; she is a woman who goes outward. Damned dark glasses!

HOW

While the above analysis isolates some of the key features of this teeming film that cry out for comment, it says far too little about the charm, poetry, and emotion, in short, those vast areas of the ineffable dealt with in *Cleo*. Vaunting the iron glove without a word about the velvet hand, praising the rigorous harmony and construction while neglecting comments about the sets because one is afraid of entering the temple, is a little like reviewing a musical by talking about the tracking shots, measuring the camera angles, and quoting from a few lyrics, and leaving it at that. It amounts to an appropriate assessment of the depth, which is valuable and admirable, but with a blind eye to the style and elegance.

Varda's weapons of seduction are many. Through the dialogue, the beauty of her images, the beauty of her heroine, and the inventive richness of her direction, she is style, as Georges-Louis Buffon was unable to define it: style is woman. These dialogues are a mixture of tirades, facile and deliberate wordplay, such as maxims, declamations, preciosity, proverbs from Khrushchev; in short, she has taken many things that are recognizably negative, magnified them here in using a natural tone and mixing them together, and, with a mathematical law, has come up with the undeniable sign of talent. In commenting on the search by Varda and her cameraman, Jean Rabier, for the spontaneous, it would be an understatement to say that the results they have produced are at least as felicitous as those of Raoul Coutard, and they never forget one essential fact that people who haul cameras around can easily forget: the meaning of the formal.

Varda is perhaps the only filmmaker in the world able to make a Venetian film (*La Mélangite*, God, François Truffault, Carlo Ponti, and a few others willing) as beautiful as *Othello* and *Sait-on jamais . . .* combined. The sets of *Cleo*, whether on location or designed by Bernard Evein, are also one of its strengths. The heroine's apartment is an enormous white rococo waiting room in which cats wander around. Cleo in a satin negligee moves from a trapeze to a swing to a fabulous bed that one can only imagine the director of *La Pointe courte* checked and fussed over for every scallop, every astragal, from the canopy to the twisted bedposts, and even to the bedspread. If we must, in at least one respect, demonstrate strict impartiality and mention the weaknesses of a film that is not perfect (but then has one ever loved a perfect woman? It must be very boring), then it would have to be about the sometimes loose acting, particularly in the minor roles. But the simplicity of Dorothée Blank, the humor of Michel Legrand, and, of course, Antoine Bourseiller and Corinne Marchand quickly sweep away any vague desires to comment on the acting. Never has light humor been carried off with as much grace as by Marchand, a doll sculpted out of flesh, a large-sized baby doll. The chorus girl of *Lola* has become the most beautiful of moping women, a heroine of Baldung Grien who triumphs in her battle with the skeleton. She also sings songs that the dialogue tells us rightly have words (written by Varda) that are pretty, and the melodies (by Legrand) are equally up to the mark. Legrand also composed the music for the film, which is both tender and funny, from which I would like to be able to detach what could be called the first movement, an adagio, from his Montsouris Symphony (Lola's entrance in a taxi). Hoping that my

next visit to Raoul Vidal will enable me to buy the 33 LP on which all of that needs to be recorded, I will now comment on the final song, in which Cleo sings about her solitude and her fear, and bursts into tears in an unexpected and unproductive cathartic experience. A circular tracking shot is followed by a dolly forward that stops on the pure and fragile alabaster of Cleo's face, wet with tears, as we listen to her wail:

And if you should come too late
They will have buried me,
Alone, ugly, and deathly pale,
Without you, without you, without you.

It is one of the high points of the film, a moment of pure beauty, and proof that along with a few of the other reasons I have already mentioned, Varda is wrong when she says that she does not think she would be good at musicals, and yet realism, for over ten years now, has been an element of musicals.

And here we are, from close-ups to tracking, speaking about direction. *Cleo*'s direction, and I hope this has stood out clearly from everything I have said, teems with big and small ideas, not to mention brief, long, serious, far-fetched, ambitious, and slight ideas, sometimes yielding sublime images, images that can transfigure a work, when—it is not the case here—the urgent need is felt. One could come up with a long list of innovations, without repeating oneself once, innovations that everyone else is looking for and that are clearly on display here. And what great innovations they are: these iron bars in the Luxembourg Gardens, for example, as the taxi radio blares "Free the Bretons!"; the matches that the vamp spreads out one by one to the rhythm "He loves me . . . a little . . . a lot"; the pastiche of Brahms that salutes the entrance of Villalonga; the amazing dolly back from the doctor's car, to the end, literally leaving the couple where they are, like a *deus ex machina*, and then rising at alarming speed into the arches, its mission accomplished; Cleo's distraction-indiscretion in a café when she hears a word in Angèle's story, and jumps when she hears the same word in the conversation of a couple nearby, leaving us to choose between the story about the peasant and the lover's tiff, both of which can be heard with equal volume; the poetic "word," which is worthy of Cocteau's *Orphée*, and which appears on screen superbly. Angèle is worried about Cleo's tears after the last song, "What a state she puts herself in!" while in the meantime, Cleo disappears behind a dark curtain. Cut to another shot, a fade-out—but it's not a fade-out after all—and the curtain that now fills the frame of the screen is pulled back violently by Cleo, who comes forward completely dressed in mourning attire: "I am dressed in black."

The two sublime shots, which I have kept for the end, are the following: the first is indescribable because nothing in the technical execution draws attention to it (it is both a static shot, of Cleo and Antoine facing one another on the bus platform, and a tracking shot, because the bus is moving down the road) and particularly because, isolated from the dramatic, emotional, and amorous continuity, it does not mean much. Quite simply, we have Cleo and Antoine face to face not saying a word. In the previous shot, he gave her a flower; immobile, he looks at Cleo, who looks back at him almost furtively, several times, brushing back her windblown hair with the hand that holds the flower. Varda has filmed the first spark of love, a serious and

silent conflagration. The second shot is the one in the hospital garden, when Cleo, who has just given her speech to Antoine, is suddenly full of plans: "What shall we do? Shall we stay? Go to the restaurant? Do you want to eat on a terrace?" and then she calms down: "We have all kinds of time," whereas the camera, in an extreme long shot, isolates the couple, immobile on the bench in the middle of the garden, in a moment of serene silence, out of time.

As in love, a sense of propriety and even avarice is essential; the best films give one the desire, which of course is doomed, to prepare an exhaustive inventory. Doomed because only the many mediocre films should elicit a mania for inventories: a vicious circle, but a delicious circle. At least, as Marker says, "I have counted my riches." I am thinking again of this unique moment, the end result of one hundred minutes of fear. Prior to this moment, we had Cleo Victoire, singer, from 5 to 7 P.M. on the twentieth or twenty-first of June 1961. Now it is Florence and Cleopatra, *from here to eternity.*

No. 44, March 1962

1. Rosiguer: marcher dans la m . . . (cf. *Express,* June 29, 1961).

Cleo from 5 to 7 (Cleo de 5 à 7). 1962. France/Italy. Written and directed by Agnès Varda. Produced by Georges de Beauregard and Carlo Ponti. Cinematography by Jean Rabier. Music by Michel Legrand. With Corinne Marchand (Cléo), Antoine Bourseiller (Antoine), Dorothée Blank (Dorothée), Michel Legrand (Bob, the Pianist), Dominique Davray (Angèle), and José-Luis de Villalonga (Cléo's Lover). Also with Jean-Luc Godard, Anna Karina, Eddie Constantine, Sami Frey, Danièle Delorme, Jean-Claude Brialy, Yves Robert, Alan Scott, Robert Postec, and Lucienne Marchand. In French. 90 min.

If you have a stick, I will give you one.
If you do not, I will take it away.

—*Zen proverb*

Anything can happen. Just ask Heraclitus, Leonardo da Vinci, Pico della Mirandola, Madame du Barry, P. T. Barnum, Jack the Ripper, Henry Clay, and a roofer with a stutter in Cincinnati, Ohio, whose name I can't remember. The French critical establishment, five years after *Positif*, has finally recognized Jerry Lewis's genius.[1] In awarding the prize for best foreign film in 1962 to *The Ladies' Man*, the Nouvelle Critique jury gave the thumbs up to this overdue recognition and forced the hand of a number of old grouches for whom humor is still nothing more than a perfidious way to fight the flu.[2]

In *The Errand Boy*, Jerry Lewis, in a short sentimental interlude, tells a puppet how, after being born in New Jersey, he went to Hollywood and tried to fashion a career there. Then, in a thinly veiled reference to his own experience, he argued that creators ought to be more intuitive and refuse analysis. The key phrase in this strange scene is, "I like liking you." Coming from a character as visibly smitten as Joseph

Jerry Lewis: Man of the Year
Robert Benayoun

Jerry Lewis has been a bone of contention between Anglo-Saxon and French critics. Robert Benayoun was the first to pay tribute to the director of *The Nutty Professor*. Benayoun, who was part of the Surrealist group and the author of works on Alain Resnais, John Huston, Woody Allen, and Tex Avery, published this overview in *Positif* before writing a book about the American comedian entitled *Bonjour Mr. Lewis*.

Levitch [Lewis's real name], there is nothing surprising in it. However, its audacity is noteworthy. Having long become accustomed to the most disparaging comments from critics, this boy with a heart of gold, convinced (he would explain this later to a journalist for *McCalls*) that laughter is a form of therapy, refuses to be satisfied with a rational appreciation of his work, and demands, if you will, that people *go to him* with hands outstretched.

Last October Jerry Lewis explained to *Variety* not only why his twenty-seven films had *all*, without a single exception, been enormous box-office hits, but also why the movie industry as a whole was on the wrong track. "It has stopped using these three very simple words: I like you." Lewis seems to be obsessive about this idea, but if we flatly ignore his suggestion and analyze his work point by point, we reach the same conclusion: we have to like Jerry Lewis.

In *The Errand Boy*, Jerry's name, Morty S. Tashman, is an obvious reference. Now that he is a director, he is paying his debt to Frank Tashlin, who in a lengthy interview published in *Esquire* by Peter Bogdanovich,[3] tells us that Lewis considers him his spiritual father. In the interview, Jerry, who has often been called a megalomaniac, reveals his deep modesty. Now everything would appear to indicate that when working under the direction of Norman Taurog or Don McGuire, Jerry, helped by his screenwriters Simmons and Lear, was already writing his own material. And Tashlin himself, exhausted by crazy sessions with an elusive, annoying, and irresistible actor, but one who was able to do his scenes in a single take, said during the shooting of *It's Only Money*: "A director gets no credit for a film with Lewis in it."

Jerry Lewis the director never enters a set without a specially designed fanfare literally exploding and synchronizing his arrival with carefully timed drum rolls. All at once, as in a child's dream (or in a film by Orson Welles), he becomes the complete master of a magical world that could be called Lewisland. On the stage, two rows of chairs are reserved for children who want to watch their big brother Jerry shooting; every technician has a coffee cup with his name on it (a little like the dwarfs in *Snow White*), and he wears a polo shirt bearing a caricature of the chief. The chief (as the huge sign at the entrance to his box says) hands out gifts and demerit points, sends memos, jokes with the technical team in the middle of shooting, turns up inappropriately in a crazy Indian costume, and perches with satisfaction at the top of a gigantic crane where another sign tells us that it is *Jerry's toy*. (This mania for signs does not stop there. At the studio door there is a sign that says: *This set is open. You are welcome to enter.* At the entrance to his splendid $350,000 mansion, which used to belong to the late Louis B. Mayer, there is a plaque that says: *Our house is open to the sun, friends, guests, and God.* On Jerry's desk is another plaque with the words: *I will only be in this world once.* Another idiosyncrasy is to hand out to the people he works with small bronze plaques engraved with sentimental statements of friendship and fidelity.)

From his earliest roles, Jerry was a closet director, very keen on technical matters and on the very latest equipment. He founded Ron-Gar Productions (Ronnie and Gary are two of his sons), and with close friends like Tony Curtis and Janet Leigh, he shot numerous pastiches of highly successful films such as *From Here to Eternity*. Everyone who has seen his burlesque short films at his lush Bel-Air villa says that the director in him was coming to the surface years before *The Bellboy*. Now Lewis's clowning on the stage can no longer hide his technical and professional skills. Jerry has a well-equipped editing room adjacent to his office, and he has invented two special technical control systems, one of which consists of four television sets synchronized with his cameras so that he can see his own rushes almost immediately, and a set of sixty microphones located around the studio, a device that cuts out several hours of sound adjustments for the many scenes in a film.

Tashlin isn't kidding when he says that Jerry is "an electronics genius." The comedian's life is literally haunted by gadgets. Jerry has a telephone in every single one of his fourteen cars, his house has microphones and tape recorders everywhere, he has an ingenious intercom system, all of which make it possible for the over-active Lewis to talk any hour of the day or night to residents of Los Angeles and the San Fernando Valley through his private radio station, KJPL, interviewing his children or unexpectedly discussing politics with some of his visitors. And, of course, the most spectacular symbol of Hollywood wealth is the $15,000 hearing aid developed by brilliant electronic engineers at Jerry's behest for his deaf spaniel Chips.

In Tashlin's *It's Only Money*, Jerry visits the model home of an electronics genius. This home (which could be the home of Joseph Levitch in Bel-Air) contains complex remote-control devices, hidden television sets, remote-control vacuum cleaners and lawn mowers, and, in particular, an advanced high-fidelity system used in an astounding way: if recordings of trains are played, the house begins to shake, signals light up, smoke fills the room, and the conductor, like a ghost, comes into view to punch your ticket (a gag that I unhesitatingly attribute to Jerry himself because it is so typical of him, even though the screenplay is by John Fenton Murray). Jerry, when he launches into a subject with which he is familiar, goes on at

85

Jerry Lewis in his film *The Errand Boy*. 1961

length about electronics, mixing technical jargon with onomatopoeia, and miming explanations with a marvelous form of double-talk.

On the lavish set of *The Ladies' Man*, full of cameras, microphones, and floodlights, one cannot only interpret the mechanical dream of our filmmaker, but also identify the exact framework for his directorial activity. The film set happens to coincide with the actual shooting (the stage goes no further). In the Wellesian sense of the word, it is a wonderful electric train set, which Lewis puts in our hands before he even uses it himself.

It could be said that Jerry's directorial ambitions are becoming increasingly important in his career. Comic actors usually want more than anything else to play a tragic role: this was the case for Ed Wynn, Groucho Marx, and many others. But Jerry, apart from a television experiment (in which he played *The Jazz Singer*, no doubt tempted by the Jewish facet of the subject), does not want to become a tragedian. People have, to no avail, offered him roles in *The Last Angry Man* and *What Makes Sammy Run?* Ernest Borgnine and Yul Brynner have requested him as a partner, and Shirley Booth wanted him to direct her. "I refused these offers," said Jerry, "because there are 5,000 dramatic actors who could play these roles better than I can, but no one who can play the kind of roles that suit me."[4]

In 1959, after eleven years with Hal Wallis, Jerry signed a new contract between his own company and Paramount, giving the latter exclusive rights for seven years over all Lewis productions, and over seven films in which Lewis would star. Jerry will therefore act in at least one film per year for Paramount (directed by someone like Tashlin or Norman Taurog), and he will produce another film each year, which he himself will direct. Needless to say, this will do nothing to slow his usual pace, which includes two months a year doing nightclubs in Las Vegas, and three weeks in Chicago, along with two major television shows a year, and the task of directing a school for young comics, to whom he automatically gives a start in his films and television programs. One might just as well say that Jerry has signed a contract with us to guarantee his presence on the screen, a form of laugh insurance that we are very happy to have so early in the year.

When we did a survey of Jerry's eccentricities, caprices, and clowning, we tended to avoid the essentially serious side of his ambitions, and the systematic development of his work. Having begun to direct almost by accident (Paramount needed to produce a summer film out of nothing, whereas Jerry wanted to release *Cinderfella* at Christmas), he proved that he was up to the task by improvising on the spot at the Fontainebleau Hotel in Florida—where he was supposed to be resting—a feature film without a story and virtually without words, on a $900,000 budget. It went on to earn $8 million. It was a tour de force, but for Jerry it was simply an introduction or a homage to the purest form of the gag, a *Ziegfeld Follies* of silent slapstick.

With *The Ladies' Man*, his efforts reached a peak: by building an enormous dollhouse seen in cross section to give us an entomological overview of a matriarchal anthill, Jerry found the plastic equivalent of an Asmodeic glance, a vision of a demiurge seeing through solid walls, one that also shows supreme disdain for the various narrative clichés that allowed him in a single shot to show us the secret of his set, to place his cards on the table, and demonstrate how he was going to run his show and, from that point onward, surprise us over and over again.

The Errand Boy operates on a different principle. Jerry, deciding at the outset that every gag has, of course, been used at least once before, decides to make us guess

what his gags are going to be. Everything happens in the wings, and all we see is the before followed by the after. We never see Jerry fall into a swimming pool that had been trying to entice him for some time. But after a lengthy underwater scene showing him pirouetting around a frogman with the effortlessness of Esther Williams, we learn that all he is trying to do is drown himself. We do not see Jerry at the controls in a dubbing room, but we see a copy of the film that the distraught moguls are screening. We do not see Jerry taking the boss's convertible Cadillac through a car wash (with Mrs. Boss in it), but we see, emerging from the car wash, a screeching and hissing matron who remains so abstractly in character in her bit part that she never complains. All of this takes place in an almost generalized silence and at a fairly slow pace. *The Errand Boy*, with the exception of a few pratfalls, is a film of murmurs, whispers in the hallways, and minor surprises like the candies in a jar. Of all the styles that were current coin during the slapstick period, in this film Jerry appears to have revealed his secret predilection for what is called the slow burn, which is a patient and stoical attitude as a character is subjected to one indignity after another. (The slow burn was perfected and used for over thirty years by an actor by the name of Edgar Kennedy, who even appeared in a number of Laurel and Hardy films as they acted out their scenes of destruction.)[5]

In a masterful sequence in the film, Jerry goes up in a packed elevator, stuck side by side (face to face) with a number of masticating, drooling, or twitching strangers. The oppressive immobility of these people leads to a series of nauseating incidents (we are already aware of Lewis's sadistic-anal complex, like the forced meal in *The Ladies' Man*). A toothpick goes from mouth to mouth, and cigars and sneezes are a prelude to the explosion (this too is off-camera) of a large piece of bubble gum. Jerry's slow burn is part of a dismayed fatalism, a polite stupor, filled with the gentleness of the Schlemiel of Jewish tradition.

When such scenes are followed by a noisy seismic disaster that destroys the harmony of a smooth cozy world, we are watching a true cataclysm. With Lewis there is something unreal about clumsiness. Things have a way of becoming rebellious in his hands. Let me relate the following anecdote from the comedian's official biography. Jerry's first job, working in a drugstore at the age of eleven, ended in the following disaster: he stuck a fork into a toaster with such energy that he blew all the fuses in the building and plunged the store into darkness, allowing fifty customers to leave without paying their bill. In a number of his films (including *Artists and Models*), Jerry gets into trouble with a water fountain, this typically American display. In *The Errand Boy*, the water tank empties all at once in front of him in an abominable glug, like a single gigantic sob, leaving him frustrated, with his sadly empty cup in his hand. A little later, an enormous bottle of champagne that he is holding explodes a frosty Niagara over the studio bosses and floods the stage.

But most of the time in *The Errand Boy*, as in *The Bellboy*, we are dealing with discreet vignettes, in a loop, that do not link up to other episodes. This "soft humor" is accompanied most frequently by the use of unlikely names (W. C. Fields and Groucho had a soft spot for such names). When he has to introduce Mr. Babe Wosenthal to Mr. Wabenlatnee or Mr. Vermendnitting, Morty S. Tashman has a great deal of difficulty remaining as serious as his peers.[6] Furthermore, the increasingly controlled precision of his gestures becomes musical in structure. In each of his films, Jerry mimes a scene accompanied by an orchestra: here, it is a round-table conference in which each intervention, each gesture, and in particular each word

used has an identifiable musical form. I saw Jerry Lewis at Birdland in New York introducing Count Basie and his orchestra; in fact, he conducted the orchestra for two straight hours, during which every note that he had learned by heart (Basie was in the film *Cinderfella*) inspired silent talk that was as eloquent as the illegible scribbles of Saul Steinberg.

Without a doubt, *The Errand Boy* is a cut above Tashlin. All one needs to do is compare this film, which is completely focused on Hollywood, with *Hollywood or Bust*. In the Tashlin film, Jerry arrives in Hollywood as a sixteenth-century sailor and discovers the natives, their magic, and their unbelievable customs. In *Hollywood or Bust*, Jerry achieved his goal without any resistance, but Hollywood does not blow up. We never get into the sanctum. It is true that we make a quick visit to a number of sets, one after another (in a rather hilarious scene no less), but only, so to speak, in passing. But in *The Errand Boy*, we see Hollywood from the inside, from the point of view we mentioned earlier, that of a young man from New Jersey who is crazy about movies and who manages to get himself involved in the machinery.

We first see Hollywood from above, as we might view it in a James A. Fitzpatrick documentary, but the architecture has no soul, it is no more than a string of empty shells that confirm the impression of emptiness that all visitors to the Mecca of film take away with them. The name of the studio, Paramutual, is obviously derivative; it is desertlike and abandoned. By playing the role of a gofer (who turns out to be a spy hired by management to find out about certain mysterious things "missing"), Jerry is in a situation in which he can explore behind the scenes of a myth, and wander through corridors about which we know nothing, because all we see is the final product: a few sequences of films that we are shown and only afterward learn what lies behind them, however cruelly deceptive this may be. Even the titles of the films, like *Hot Heat, Tall Pain*, are fortuitous pastiches that refer to dreary undertakings whose laborious production efforts are shown unsparingly, but by the time the big premiere comes along, they become monuments of glamour. From the screenplay onward (in which tons of multicolored paper are sorted through laboriously by a horde of bored typists), through endless fiddling with the sound track, Jerry deals with (and sabotages in spite of himself) every phase of the production process. We see him pushing a train of trash containers, demolishing a time clock, ruining the 1925 musical number as well as a sophisticated scene being shot in a living room by a Viennese director ("I do it all mit musik," says Sig Ruman), rummaging around in the prop room, where the armor is alive and men who look like dummies hang from hooks. Finally, we see him making a complete disaster out of the birthday celebrations for a big sentimental star, looking all the world like Lana Turner, who commits suicide as the cameras roll in a scene reminiscent of a Douglas Sirk tearjerker.

All of this is related by an ambitious but awkward young man who can turn an accident into howling laughter, and who, like Jerry himself, ends up owning the studio, rendering unto Caesar that which is Caesar's. *The Errand Boy*, which is the story of a man thinking about himself after experiencing both ends of the process, is a very curious form of split personality: Jerry alternates between the calm and the frenetic, allusion and big gags, good taste and incredible vulgarity (for example, only Jerry could carry off a joke about scratching somebody's back a little too low, a joke that he uses often). I have argued elsewhere that there are two men inside Jerry, but this is proved incontrovertibly in his next film, *The Nutty Professor*, which simply amounts to an extremely loose adaptation of Robert Louis Stevenson's *Dr. Jekyll and Mr. Hyde*.

In 1959 Jerry Lewis told Isabella Taves of *Look* magazine that you can't get anything from a book that you can't get directly from people. He added that he had only read one book in his life—*Courtroom* by Quentin Reynolds. I am ashamed to come up short in the culture department, but I must admit that I have never read this masterpiece; I do know, however, that it is a biography of Judge Samuel Liebowitz, who sent Jerry a signed copy. And yet, in 1958, Jerry told Helen Eustis of *McCalls* that he liked to read everything he could get his hands on about psychoanalysis. Let us then treat with circumspection any attempts to gauge the intellectual baggage of a man who, although he might not buy suitcases full of books like W. C. Fields, in all likelihood enthusiastically reads everything that has anything to do with his concerns of the moment. I suspect that he is a gleaner and a skimmer, someone who likes to consult. And his recent aside to Bogdanovich must not be forgotten, first asking him if he had read *The Catcher in the Rye*, and then telling him that he, Jerry, was a guy like Holden Caulfield. A predilection for J. D. Salinger does not indicate a lack of culture or confused perceptions. The author of *Franny and Zooey* is the most subtle and refined of contemporary American writers. And I am sure that Lewis's Bel-Air library contains much more than just scripts and albums full of press clippings.[7] He is truly self-taught, was never educated, and learned everything from his lawyers, impresarios, doctors, directors, and technicians, and he is well aware of his shortcomings: "Of course, education is very important, but if you didn't get one, you can learn everything you need with a little observation."

And to all the clever people out there, may we remind you that Jerry became a producer and director by marketing the very handicaps that have been held against him throughout his life. The person who began as "The id" (idiot) and then "Ug" (the ugly guy) was able, with his almost diabolical intellect, to build out of these insulting nicknames a very personal mythology, a comic style, and a small business empire. So people came to realize that the comedian was making very good use indeed of his gray matter (much better than poor Michel Capdenac) and that he could occasionally make himself very seductive to women. We know what the late Marilyn Monroe thought about him ("I think he's sexy"), and one of his female admirers wrote him a letter saying, "Each time I see you on the screen, I want to take you in my arms and burp you."

This comment contains just the right amount of dynamism, psychological truth, and innocent bad taste to have led Jerry to be unduly flattered.

I would not want to end this article without highlighting Jerry's unique form of kindness, his fraternal adoration of children (he is young at heart), and this light touch of spleen which, while it never spills over into pathos, reveals to precisely the right degree the fact that he is always worried. When he leaves home every morning to go to the studio, Jerry admits that he feels a moment of terror: "I get the feeling that they won't be there at the same place and in the same way when I return in the evening." When Jerry falls asleep in *The Errand Boy*, while contemplating the awkward frolicking of a small clown in rags, we are miles away from Charlie Chaplin's sentimentality. Jerry is not trying to tell us that he is a poor entertainer, a clown who likes daisies crying underneath his happy makeup, a gypsy pierrot who has met Friedrich Nietzsche, rubbed elbows with Bernard Shaw, and dreads getting old without his daily ration of applause. No, he looks at what is no more than a sketch of himself as he would like us to see him, without seeking to understand where that knot in the solar plexus comes from, that feeling that separates

us from robots. The scene is brief, but important to him, and I believe it is irreplaceable. It fits perfectly into a complex of destruction, social iconoclasm, and antimatriarchal rebellion. Jerry, who is a stranger in the world he lives in, can only understand it through his destructive awkwardness, that gift he has of provoking objects and places into rebellion.

But his personality remains sentimental and also close to burlesque. Jerry enjoys playing a poor defenseless orphan (call him Little Orphan Jerry), a found child, a naive person exploited by his peers and his best friends. He always has a sad little story to tell, whether he has lost his goldfish or his fiancée has left him, and he dreams of marrying into a large family so that he can have "instant kin."[8] It is in compensation for this almost fatal handicap that he wants, with all his innocence, to annihilate the world around him, with our full consent, of course. This basic innocence also allows him to be in very bad taste. Innocence is never vulgar. And from no one else would we accept all these scenes of stuffing his face, double entendres, and embarrassing mistakes that Jerry uses so freely. We grant him the pleasure principle because his infantile behavior allows him to transgress every taboo.

In a televised debate in September 1959, Jerry, speaking to an audience of young people (on the program "Youth Wants to Know") said unexpectedly that obscenity was an essential element in all honest descriptions of a character. This is a thought that very surprisingly corroborates the statement by Havelock Ellis to the effect that obscenity is a permanent feature of social life, and that it responded to a deep inner need. Adults need obscene literature just as much as children need fairy tales, as a way of reducing the oppressive pressure of convention.

Jerry Lewis gives both adults and children an obscene fairy tale in which he is both Cinderella and Prince Charming, a paradoxical achievement to which I can find nothing similar in the whole history of comedy.

1. See *Positif*, no. 29: "Simple Simon ou anti-James Dean" was the first overview in France of Jerry's work, but it was in May 1956, in *Demain*, that I published the first article on Jerry Lewis's comedy. This kind of detail would not be of the slightest interest except for the fact that the exact same number of years later, in April 1962 in *Paris-Presse*, my colleague Michel Aubriant was still describing him in *The Ladies' Man* as "a tiresome buffoon."

2. A special note for Michel Capdenac. This ridiculous person, whose face has the relief of someone from Beauce [an ancient district in north central France] that has clearly gone mental, is to my knowledge the only member of a jury to spend his time disparaging the votes of his fellow jury members and to sing in a superb falsetto the couplet of someone no one is listening to. In the January 17, 1963, *Lettres françaises*, this person, who no longer even deserves a collectable gift of one of my so highly prized insulting letters, speaks about the "galloping stupidity" of Jerry Lewis. As the wit said, "[No humorist laughs at his own wheeze.] A snuff box has no right to sneeze."

3. Peter Bogdanovich, "Mr. Lewis is a Pussy Cat" (*Esquire*, November 1962). In the long list of known interviews with Jerry Lewis, the one by Bogdanovich is without a doubt the most brilliant piece of journalism I know.

4. Interview in *Newsweek*, December 29, 1958.

5. Until now, Jerry had reserved the use of the slow burn for actors who specialized in victim roles, such as Fred Clark, Sig Ruman, or even Peter Lorre. In *The Ladies' Man*, he came up with a masterly slow burn scene for Buddy Lester during which the irascible gangster's hat is slowly pummeled. The transfer of the slow burn to his own character represents for him a considerable effort toward sobriety and confirms his thoroughgoing familiarity with "dead time," when laughter builds up simply because of sheer expectation.

6. The S. in Morty S. Tashman means scared, because, as Morty says with touching frankness, I am a big coward.

7. I used my magnifying glass to examine closely an immense photograph of Jerry Lewis's office. Among the many books I recognized, in addition to *Harpo Speaks!* by Harpo Marx, is a large book about yoga right beside an oversized book about baseball!

8. Just like instant coffee. An instant family—dehydrated, powdered —ready to serve.

No. 50, March 1963

The Bellboy. 1960. USA. Written, produced, and directed by Jerry Lewis. Cinematography by Haskell B. Boggs. Film editing by Stanley E. Johnson. Music by Walter Scharf. With Jerry Lewis (Stanley), Alex Gerry (Manager), Bob Clayton (Bell Captain), Sonnie Sands (Bellboy), Eddie Shaeffer (Bellboy), Herkie Styles (Bellboy), David Landfield (Bellboy), Bill Richmond as "Stan Laurel" (The Man in Black), and Larry Best (The Apple Man). 72 min.

The Ladies' Man. 1961. USA. Written, produced, and directed by Jerry Lewis and Bill Richmond. Cinematography by W. Wallace Kelley. Film editing by Stanley Johnson. Music by Harry Warren and Jack Brooks. With Jerry Lewis (Herbert Heebert), Helen Traubel (Helen Wellenmelon), Pat Stanley (Fay), Kathleen Freeman (Katie), George Raft (George Raft), Harry James (Harry James), Hope Holiday (Miss Anxious), and Vic Damone (Herby). 100 min.

The Errand Boy. 1961. USA. Directed by Jerry Lewis. Written by Lewis and Bill Richmond. Cinematography by W. Wallace Kelley. Film editing by Stanley Johnson. Music by Walter Scharf. With Jerry Lewis (Morty S. Tashman), Brian Donlevy (Mr. T. P.), Howard McNear (Dexter Sneak), Robert Ivers (Second Director), and Dick Wesson (The A.D.). 92 min.

Twenty years ago, when Luis Buñuel was being rediscovered after *The Young and the Damned* (*Los Olvidados*), what people anticipated most in any of his films was the dream sequence. In such sequences, the audience often saw no more than a basic form of Surrealism, which it found superficially satisfactory; but for the director it was a very serious part of his technique that followed precise coordinates, from the obsessive surreal sequences of *The Young and the Damned* to the maternal fears of *Mexican Bus Ride* (*Subida al Cielo*) or the paternalistic obsession of *Robinson Crusoe*. Dreams propped up the story, and Oedipus was indeed

The Periphery of Dreams: Luis Buñuel's *Belle de Jour*

Louis Seguin

In its very first issue, *Positif* paid tribute to Luis Buñuel when *The Young and the Damned* (*Los Olvidados*) was released. The Spanish filmmaker, who was close to the Surrealists, would become a point of reference for the editors of the magazine. *Belle de Jour*, which was turned down by the Cannes Film Festival (before winning the Lion d'or in Venice), was given a lukewarm reception by the critics. This article by Louis Seguin demonstrates the importance of a film that some felt had been a concession to commercialism by the great filmmaker, and goes on to show that it was consistent with Buñuel's other works.

the king in terms of influence here. And then, scornful of his methods, Buñuel abandoned his dream sequences. A film as deliberately structured around obsession as *The Criminal Life of Archibaldo de la Cruz* (*Ensayo de un Crimen*) contained no dreams other than his heroes' symbolic outlets, and it took until *The Exterminating Angel* (*El Ángel Exterminador*) for dreams to resurface in the elementary and allusive form of a gag, visually stunning and a hundred times more satisfying than all of Salvador Dali's artifices.

From this standpoint, Buñuel's place in cinema history is highly original. Neither the magical lyricism of *Peter Ibbetson*, nor the charming everyday possibilities depicted in *Tom, Dick, and Harry*, or the psychoanalytical pretensions of the kind found in *Spellbound* are up to the mark. His inspiration, which is neither explanatory nor exalted, rejects both psychologism and scholarly distinctions between dreams, daydreams, and visions, which are not useful from the creative standpoint. He keeps them at the level of a poetic reversal that sheds more intense light on the story; this reversal is always isolated and buried in the heart of the narrative.

Then suddenly, following *Simon of the Desert* (*Simón del Desierto*), which was woven out of mirages and apparitions, comes *Belle de Jour*, with dreams making their reappearance in Buñuel's world, masterfully pervasive at first but quickly becoming as insidious as they are imprecise. As diluted in the mental landscape as a supporter of Mao, dreams now swim through the story like a fish in water, no longer merely shooting the rapids, but swimming a sinuous path through the whole river in a pattern that is as indiscernible as it is unpredictable.

At first glance, the structure of the story is perfectly clear. The adventure of Séverine (Catherine Deneuve), the young wife of a surgeon, who seeks in the forbidden territory of a brothel the thrills that she has not found in her rather drab married life, consists of six daydreams, all based on rather masochistic erotic themes, and two evocations of the past. The six are sandwiched between seven episodes of

Iska Khan and Catherine Deneuve in Luis Buñuel's *Belle de Jour.* 1967

"real life." But what we need now is to analyze the whole film, even though the end result will certainly be unreasonable.

Let's review the film. It begins with Séverine's fantasy of being whipped and then handed over to two lusty and bestial coachmen. The daydream is interrupted by the voice of her husband, Pierre (Jean Sorel), who asks her, "What are you thinking of?" which brings her back to the drab reality of their bedroom. After an interlude at a ski resort, where we are introduced to the pervert Henri Husson (Michel Piccoli) and we return to Paris, where the mistress of this degenerate man informs Séverine that one of their female friends, Henriette, is working as a prostitute. Séverine goes home, troubled, and drops and breaks a vase and knocks over a perfume bottle. Séverine's first childhood memory is of a particularly uncouth workman fondling her, and clearly giving her pleasure, as a female voice, probably her mother's, calls out, "Séverine, come quickly!" Following a discussion with Pierre, who, at her request, describes how things work at the brothel, as well as another meeting with Husson who, apparently innocently, gives her the address of a clandestine brothel, Séverine goes there and, after some hesitation, climbs the stairs. Her second childhood memory is the day of her First Communion when she refused to take the Host by holding her lips tightly together. She rings a bell at the house of "Anaïs" (Geneviève Page), the assumed name of the madam of the brothel, and agrees to go and work there every day from two to five P.M.

After attempting to keep herself from the path of perdition by going and fetching her husband at the hospital, she returns to Anaïs's place as agreed and, after being threatened by Anaïs and her brutal client Mr. Adolphe (Francis Blanche), turns her first trick. She goes home, pretends to be ill, and, lying on her bed, has her second daydream. In the Camargue, with cowbells clanging, she sees herself in a white dress tied to a post as greenish mud is thrown at her by Husson with the approval of her husband. She returns to the brothel a week later, and Anaïs agrees to have her back, in spite of her failure to return as agreed. She takes part in a masochistic performance in which a famous gynecologist is the main participant, and submits to an enormous Korean who subjects her to indecent behavior that remains rather mysterious because of a major cut in the film.[1] Exhausted on her bed, her face radiant with pleasure, she imagines a third adventure, the most important.

A funereal, polite, and mysterious duke (Georges Marchal) invites her to his château to take part in what he calls a form of religious ceremony. Dressed in a transparent black veil, she plays the role of the beloved daughter he comes to kill in a macabre and incestuous improvisation. She is then tossed outside into the rain by a valet. At home again, she gives herself to her husband with renewed tenderness. Husson comes to visit her. She has someone tell him that she is not there. The fourth daydream has her in the bar of the winter resort, where we were at the beginning. She and Husson are hiding under a table with a broken bottle and a small envelope full of asphodel (the flower of death) to engage in the mysterious occupation called "writing a letter."

Then, for the first time, Séverine is no longer at the center of the action. In the Biarritz building on the Champs-Élysées, two gangsters, Hyppolite (Francisco Rabal) and his young protégé Marcel (Pierre Clementi), attack and rob a bank runner. With the money, they go to Anaïs's establishment, and a strange kind of love develops between the heroine and the young thug. Séverine leaves for the seashore with Pierre, but quickly returns to Paris and Anaïs. One day she comes face to face

with Husson, a regular at the establishment. After sizing her up, he refuses to have her. Fifth daydream: two horse-drawn carriages transporting Pierre and Husson in an autumnal park where they fight a duel. Séverine, tied to a tree, with a bullet through her head, turns out to be the only victim.

She tells Anaïs that she is leaving, giving Marcel's tyrannical and pervasive passion as a pretext. The young man, with Hippolyte's help, discovers her address and comes to find her. She succeeds in sending him away, but the thug waits for Pierre in the street, shoots him down, and is himself killed by the police. Pierre becomes paralyzed as a result of his injuries. Husson visits the cripple and, to free him of any perfectly natural feelings of inferiority, tells him the whole truth. Séverine sees the tears in her husband's eyes. She sits facing him. Sixth and final imaginary episodes: Pierre gets up, as if nothing had happened or as if his paralysis had simply been feigned for strangers. Séverine goes to the window and out onto the balcony. The coach from the beginning of the film travels through the same park, empty.

At this stage, the story can be understood from an almost linear interpretation, which would make it rather ordinary, in fact as ordinary as Joseph Kessel's outdated psychological novel on which the story is based. Séverine's fictional adventures belong to the family of mental phenomena that the overly reasonable Pierre talks about when he advises his friend Husson to go and talk to a psychiatrist about his obsessions. At most, we might be tempted, in a very minor way, to perform an analysis similar to the interesting but dated quest in *Gradiva* [*Jensen's Delusions and Dreams in Gradiva* is Sigmund Freud's first published analysis of a literary work] if it were not for two obstacles that immediately get in the way. First of all, Séverine's daydreams have nothing enigmatic about them. There is nothing secret about them to anyone who is the slightest bit perspicacious. They are straightforward erotic fantasies. And, secondly, closer consideration of the story gradually causes the dividing line between dreams and reality to crumble.

And yet the links between daydreams and reality appear to follow a set pattern. These links are more often than not based on sound. Her husband's voice at the beginning brings Séverine back to reality. In response to "Séverine, what are you thinking of?" she does not know what to say except to give the obviously ambiguous answer, "I was thinking of you." Other voices, the mumbling of a priest, calls from her mother, and other sounds, bells and cowbells, perform a similar function. A second formal link, often juxtaposed with the first, is less obviously solid: Séverine's face in close-up, which often signals the beginning of a dream sequence, and sometimes ends them, except, if I recall correctly, in the two flashbacks. But this structure is so flexible that the reference to the duel, for example, follows a long shot in which Deneuve is seen from behind.

Furthermore, on at least two occasions, the very coherence of the daydream and the clarity with which it can be distinguished from the real are very vague. The first is the very long scene with the necrophilic duke, the longest and best constructed of the supposed daydreams. While Séverine's other ramblings, or nearly all, may appear slightly irrational, this episode is perfectly logical, and one is very much tempted to consider it as something extra on the part of the heroine, like a marginal adventure, in which a few signs and a few scenes sow only a slight amount of doubt. The ambiguity of the film's ending is something else again. The classical links, shots of faces and the sounds of bells are there, to be sure, but for the first time the dream

sequence is set in the same location as the real episode it follows. There is no spatial discontinuity to underscore any change in register. Secondly, this daydream completely contradicts an earlier statement by Séverine reassuring her paralyzed husband, "Since you are . . . since you had your accident, I have stopped having dreams." Finally, the daydream itself splits in two with a dream inside a dream. The first is Pierre getting better again. Whereas everything would indicate that he is condemned to his paralysis with little hope for recovery, aggravated by the mental pain that he cannot even express, except for a few tears, here we see him suddenly rise from his wheelchair, as if nothing had happened, exchanging pleasantries with his wife and pouring himself a drink. The bell sound changes in tone and becomes reminiscent, but clearer and multiplied, of the sounds of the carriage at the beginning of the film. Séverine goes out onto the balcony, but, and the idea is as simple as it is admirable, the next shot shows her face against a green background, which is totally unexpected in an urban landscape. Indeed, down below, the street has been replaced by a path through the forest with the carriage coming through it.

The logical decomposition of *Belle de Jour*, which is begun by the uncertainty over the episode with the duke and the layered dénouement of the daydream, is sustained by a different kind of food, the highly varied themes whose unpredictable repetition helps to further confuse matters. Some belong strictly to the imaginary. This is the case for the park, the carriage, and the coachmen, the same ones who appear at the beginning, at the end, and at the duke's. This is also true of the obsession with the cat, which returns in each of the first three daydreams. At the worse moment of the flagellation to which she is being subjected, Séverine begs her husband not to let go of the cats. Pierre asks Husson whether in the Camargue people give names to bulls the way people name their cats. The duke refers to one of his cats, who was called Belle de l'Ombre, and, at the most pathetic point in his macabre comedy, is interrupted by his valet knocking on the door to ask him whether he should let the cats in, and receives the following angry answer, "Go to hell, you and your cats." Other repetitions are found in both the real and the imaginary, and there may be a logical explanation for them. This stems from the structure of the interpretation to be given by the fireplace in which Séverine burns her underwear when she returns from her first experience as a prostitute, and we see it once again, almost identically, at the beginning of a shot when the story of the duke begins, but even more surprising, breaking out of the structure, it returns a third time when Séverine, dressed in black, is at the bedside of her immobile husband.

This obsession with fire, which we find even in the Camargue, when a wood fire cannot heat a pot of soup, and this proliferation of fireplaces is linked extremely well with another presence that haunts the whole film: autumn. From the beginning of the film to the end, the coach travels on a carpet of dead leaves. These same leaves build up in the Jardins du Luxembourg, where Séverine spends a brief moment of respite before ringing Anaïs's doorbell. It is fall once again, with its admirable sadness and the "black sun" that the duke will speak about when he meets the young woman in the Bois de Boulogne as the leaves are turning yellow. His château appears in a red and gold park setting. Just before the end, when we see this key park for the final time, an overlay superimposes autumn trees on a panoramic shot of city buildings. The rain, pouring down the tile roofs and flooding the countryside into which Séverine is tossed from the duke's château, a rain that is occasionally transformed into water pouring down the glass walls of a bathroom, contributes once again, in a final thread, to com-

plete the veil of chill and death that envelops the whole film, without making any further distinctions between the real and the unreal, a malevolent and marvelous fog.

There is also a final repetition that is essential to the definitive triggering of this slide toward calculated confusion. The sounds of bells, doorbells, tiny bells, and cowbells are introduced in a number of supposedly dreamed scenes, but this theme of ringing bells, muted by all kinds of tinkling sounds, possibly ice in a glass, is heard at least twice in the strictly real world. As Séverine walks back and forth over and over again in front of the Jean-de-Saumur housing development where Anaïs has her establishment, the clear sound of a bicycle bell can be heard above the general din of the street. Later, fascinated by the brutal strength emanating from her Asian partner, as Séverine feels his muscles, a bell is suddenly heard vibrating in the hand of this Hercules, and we don't know where he got it from—his torso is bare and his arms are extended—as if by the magic of an hallucination, signaling the bestial delights to come.

These few breaches are enough to mix the waters of the real and the imaginary. While, as we saw, at least one of the dreamed episodes has a high reality coefficient, there are numerous details that gnaw away at what is given to us as real. For example, many characters push the limits of verisimilitude and border on caricature. The prostitute that Séverine sees go by in front of the housing development is the very kind of whore we could readily imagine. The gangsters are so archetypical that in all likelihood they couldn't walk ten paces down the street without being arrested, and their very morphology is exactly the way a petit bourgeois would imagine them.

A number of coincidences are also rather simplistic, seen from a normal standpoint; for example, having Pierre show interest "for no reason" in a vehicle for the disabled that resembles the one he finds himself in after he is immobilized by the injuries inflicted upon him by Marcel. The erotic climate is also too polarized to be honest. The Anaïs character, the dominatrix toward whom Séverine is drawn by a kind of lesbian passion, behaves with the daughter of her servant, of whom she is the godmother, just like the classic teacher in sadomasochistic literature. Some sentences are totally "misplaced" and loaded with sexual meaning for Séverine, as when Husson says, "God, what punishments I have missed!" when three pretty girls go by.

The direction transforms ordinary details and takes them to the limits of the unknown, cherries in the eau-de-vie offered by Anaïs to the debutante, and Séverine's mishaps when she breaks a vase or knocks over a bottle of perfume, without being able to attribute her awkwardness simply to the trouble arising out of the revelation that her woman friend has just told her. These gestures are apparently unnecessary and unnecessarily dramatic, except to create a fleeting malaise, that of the prostitute who suddenly decided that it is dark and that she should light a lamp, or a host of other unusual and more calculated details, such as the lacquered box with the mysterious and strident contents that scares one of the prostitutes but fascinates Séverine, the masochist. In the case that contains the ordinary props of his humiliating farce, like the striped vest and enormous whip, the professor (François Maistre) has other instruments whose purpose is less obvious. The same is true for a cap which he hesitates for a moment to put on, but which could well serve as a sphygmomanometer and a nickel-plated obstetrics device. And what is the meaning of the metallic sound that we hear in the washroom that the client prepares to enter? The insistence with which Buñuel frames and reframes everything that has to do

with feet or shoes cannot be explained simply in terms of his personal opinions about fetishism. The shoes of Francis Blanche, the boots and socks of Pierre Clementi, and the pumps that Catherine Deneuve takes out of the shoebox just before the tragic events occur, also contain their small ration of the unusual.

When the time comes to determine where the imaginary begins and the real ends, all interpretations are possible, from the most linear and ordinary to the most absolute, worthy of Jorge Borges, which is Michel Aubriant's interpretation, namely, that the film is nothing more than the dream of a young woman who, in 1967, has just read Kessel—an interesting point of view in that it gives due regard to the congenial distortion inflicted by Buñuel on the novel, but a limited one because it sticks too closely to classical psychology. According to Eric Losfeld, it is also possible to determine which scenes are supposed to be dreamed and which are real, or conversely, which real episode has been dreamed, because all the brothel scenes are part of a vague and indistinct world.

In short, and this is not its least important virtue, everyone in viewing *Belle de Jour* can choose among an infinity of possible films. I will content myself with admiring the similarity between Séverine and the likeable hero of my favorite comic strip, *Peanuts*. People who read the strip will realize that Snoopy enjoys embellishing his status as a dog by taking on a wide variety of fictitious personalities, leading him to act out every animal in creation, from the vulture to the tyrannosaurus, and a felicitous selection of human heroes. Of the later, his preferred hero is the flying ace who, during World War I, takes off almost every morning at dawn to seek out his implacable enemy, the Red Baron. Snoopy's doghouse becomes his airplane, a Sopwith Camel, upon which, wearing a leather flying helmet and goggles with a scarf around his neck, he leaves on the most perilous missions. Nothing so far in any of that is more than a normal imagination involved in game-playing. But then suddenly, during a purely mental bit of air combat, the doghouse is suddenly riddled with bullet holes. Has Snoopy been shot down behind German lines? Here he is moving about in a war landscape with ruins and trenches that are absolutely lifelike. The boundaries are everywhere and nowhere, and the only approach to be adopted to avoid losing a truth that is seductive in ways that cannot be analyzed by the assurances and deductions of psychology is to consider the story as a whole, without looking for false or overly ordinary reasons to explain the methodical use of the actors and what has been invented, of the here and elsewhere, of the now and what never happened!

Seeking rational justifications for his tale would remove all of Buñuel's impact. His debts to André Breton and Freud are sufficiently large and conscious enough for us not to want to do him the disservice of reducing his imagination to "a parenthesis, like the night," to quote from Breton's *Manifeste du surréalisme*. The explosion of reality that he foments and puts on the screen is testimony to admirable physical health, or aesthetics, if one prefers, and mental health as well.

As his film career progresses, and his work becomes more organized and matures, what strikes one first is the perpetual and systematic use of the gag. The *Exterminating Angel*, *Simon of the Desert*, and indeed *Belle de Jour* are films in which, like Christ in *Une Girafe*, we burst out laughing.[2] Until his most recent films, this predilection of his showed clearly only in his regular use of provocation, in the dénouements, whether with the pineapples in *Nazarin* or the card game in *Viridiana*, or equally in the cathe-

dral in *The Exterminating Angel*, the nightclub in *Simon of the Desert*, or the miraculous cure in *Belle de Jour*. Other scenes were similarly inspired, not so much the pleasant exchanges on the set, but rather things like the professor's line, "No, not now" to the prostitute who, forgetting her role, wants to whip him too early for his fantasy to work properly, in addition to other episodes that are clearly the result of his direction alone, and which accordingly are harder for an audience to grasp, no doubt because they are more intellectual. The themes mentioned above, like the cats, often contribute to this merriment, seasoned by various spices, such as the Asian's mysterious box, or the problematic operations involved in making the coffin shake with the duke sprawled underneath it, and like the table in the bar under which Deneuve and Piccoli take refuge to develop their mysterious correspondence. Or like the sequence in the Camargue, the bells sounding the Angelus drown out for a moment the sounds of the flocks; or Pierre and Husson striking exactly the same poses as those in the painting so dear to Dali. Buñuel does allow himself private jokes. Like Hitchcock, he appears in his own film, and seated on the terrace of the Ermenonville Building, looks in a rather perplexed manner at Marchal. Buñuel even makes puns, for example, when Husson sends roses and, incongruously, both Maistre and Clementi have the same instinct of wanting to adjust their dentures.

Such a strong sense of intellectual pleasure, and an equally strong level of mental health, would not be possible without just as much moral strength, which in turn draws upon the various components of his vigor or the very shape of his enthusiasm. The flagellation scene at the beginning evokes, for good reason, the threat of the cats replacing the threat of the dogs, Justine's involvement with the young Count de Bressac, and the location chosen and the very circumstances of their misfortune. Mardore is right in his article in the *Nouvel Observateur* to refer us back to the Marquis de Sade's opinion about prostitution, even though he is wrong to limit himself to de Sade alone. This is easy to explain, however, because throughout *Belle de Jour* Buñuel continually affirms his repeated and necessary combat against Christian morality. Séverine, and this is a part of, but only a part of, her masochistic spell, thinks only of remorse and expiation. While she finds the spectacle of the professor repugnant and asks, "How can one fall so low?" as he engages in pleasures not so different from her own, it is not so much because his perversion seems ridiculous as because he appears to accept it and enjoy it fully and methodically. Like Leopold Bloom in the Circe episode of *Ulysses*, he lets himself go, dizzyingly, without any attempt to hold himself back, and Séverine refuses to allow such complete abandon. When Marcel, to retaliate for her absence, wants to whip her with a belt, she does not allow him to strike her face, partly out of vanity because it would leave a mark, and because then she would be forced to admit and proclaim her vice. To believe that Buñuel is placing sexual perversion on trial would be to make a serious mistake. The only thing he condemns is shame. That an unfulfilled young woman should go and seek more solid and more lively pleasures elsewhere—what could be more natural? He is, with Husson, the most moral character in the film, when he contemptuously responds to his friend Pierre's suggestions about therapy. In the Camargue, the bulls have names, like cats: "Most of them are called remorse, except the last one, which is called atonement." "I know that I will have to atone for something," Séverine says as well, to Husson once again, when they meet at Anaïs's brothel. And to care for her paralyzed husband, she will once again put on the repenting sinner's black dress.

Are we to think during the dénouement that, like Archibaldo, Séverine decides once and for all to rid herself of the things that haunt her, as the scene with the empty coach driving by would appear to be asking us to do, or at least give up the feeling of guilt that goes back to her First Communion, during which she refused to take the Host because she had enjoyed allowing herself to be fondled by the workman? It would be difficult to come up with an overly optimistic conclusion, but one thing remains certain, and that is that Luis Buñuel is not prepared to atone for anything.

1. Eight minutes were cut from the film by the producers themselves.
2. Editor's note: *Une Girafe,* written jointly by Buñuel and Pierre Unik, was published in *Le Surréalisme au service de la révolution,* no. 6 (Paris, 1933).

No. 87, September 1967

Belle de Jour. 1967. France/Italy. Directed by Luis Buñuel. Written by Buñuel and Jean-Claude Carrière, based on the novel by Joseph Kessel. Produced by Robert and Raymond Hakim. Cinematography by Sacha Vierny. With Catherine Deneuve (Séverine), Jean Sorel (Pierre), Michel Piccoli (Henri Husson), Geneviève Page (Anaïs), Francisco Rabal (Hyppolite), Pierre Clementi (Marcel), and Georges Marchal (The Duke). In French. 100 min.

Ira Levin followed a tried-and-true formula when he wrote a book entitled *Rosemary's Baby*, which had entirely predictable results. *Rosemary's Baby* was written to be a best-seller and for adaptation to film without any insurmountable problems. The subject was sure to fascinate modern America now that witches, warlocks, and likeable monsters had gained a faithful following after the "rebirth" of horror film. Furthermore, the outrageousness of the "psychedelic" era and the extremes restored to fashion by "camp" gave renewed popularity to unsettling, even monstrous creatures, the traveling sideshow, the freak. *Rosemary's Baby* was to attract not only the traditional hor-

Rosemary's Baby

Michel Pérez

Even though he had completed only a few early short films, Roman Polanski was interviewed by *Positif*, which considered him, along with Jerzy Skolimowski, the major discovery in the second wave of Polish cinema. His first American film confirmed that he was someone Hollywood had been unable to tame.

ror fan; it also had to win over snobs, unprejudiced intellectuals, and followers of the various undergrounds. Better still, the long, suspenseful nine-month pregnancy of the ill-fated Rosemary was tailormade to captivate the fans of Hitchcockian thrillers titillated by female anguish. (Some American women, chattering in their Easter bonnets and trembling at the torments of the heroines of *Suspicion* and *Shadow of a Doubt*, may well have had a more disquieting time, perhaps still quaking in their seats.) As for the exceptional and very precise length of the suspense, its very nature likely engrossed the entire female audience. Rosemary's concerns are no doubt familiar to all women who have experienced, or one day will experience, or fear they might never experience, the pangs of labor.

Rosemary's Baby was the biggest box-office hit of the year [1968] in the United States, to the consternation or anger of a few particularly intransigent Catholic leagues, a circumstance which did not detract in the least from the film's prestige. On the contrary, as a certain well-timed Vatican encyclical made her all the more topical, Rosemary became the heroine of the year, the little American mama, the mother of a people in turmoil.

To ensure his goal, Levin realized from the start that he had to avoid the fantasy common to the art of scaring people and steer clear of mind-numbing wonder and fantasy. He had to sacrifice the easy impact of irrationality, avoid contrived effects, and restrain himself from creating point blank too unusual and weird an atmosphere. There would be no exquisite apparitions and no doors bursting open to reveal visions of hell in *Rosemary's Baby*. On the contrary, the story would unfold in a setting portrayed with meticulous realism. Rosemary would not inhabit a "neverland" swathed in fog and dotted with old Victorian and neo-Gothic buildings, the usual haunts of creatures of satanic persuasion. Rosemary would be completely foreign to the gothic world; she would live in New York, in 1966 (the director insisted); none of the material particulars of her everyday existence escape attention. The Ira Levin reader is swamped with domestic details. We are told about the programs Rosemary watches on television, the novels she reads, the plays she sees at the theater (*The Fantasticks*, a musical version of *Romanesques* by Edmond Rostand and of no especially diabolical bent). We know the brand of fruit juice she drinks and the recipes for the meals she cooks for her husband. More than one page in *Rosemary's Baby* suspiciously resembles the columns of the major women's magazines. This stew

for the amateur sociologist spares no detail about the tastes and preferences of this average American woman, an urbanite eager to keep up with the latest styles. Rosemary would come to bitterly regret her mildly snobbish tendencies. For longing to live in an antiquated, admirably romantic building (undoubtedly on the advice of some article in *Harper's Bazaar*), she would become mother of the devil.

Leaving aside the usual trappings of the horror genre, Levin is obliged to exaggerate the realism of his portrayal and include a host of trifling but true facts. Quickly we find ourselves hunting for symbols, peering around every corner for the peculiar—even an innocuous package of Pall Mall cigarettes seems ambiguous. The humblest instruments of household life appear imbued with some evil force; Rosemary lives in a universe of inveigling gadgets, off-putting powders, and miracle products much deadlier than any evil potion. Her neighbors advise her to forego pills and tablets in favor of their healthy, natural mixtures, infusions, decoctions of herbs and plants, sometimes exotic but at least we know what's in them. Here are people who know about life, who have lived all over the world. All that Rosemary knows is one large American city; they have been everywhere. Every day they receive loads of mail from the five continents. They are vivacious and energetic. You might even suspect them of still enjoying the intimate pleasures of married life. Rosemary makes love like a robot. She says, "Let's make love," and her husband responds, "Uh-huh." They undress and that's that. Her deep, natural desire to have a child emerges in a frenzy of orders placed with the large department stores at the first glimmer of hope. A layette, baby scale, and disposable diapers are added to her daily shopping list along with detergent. The child is a good excuse for cheerful overspending, liberation from the guilt of buying manufactured goods shopped for and purchased in what seems like a race toward happiness.

Rosemary's quaint neighbors believe in talismans, grow herbs in their window boxes (used by every shrewd witch to ward off evil spirits), and throw parties where the sounds of strange music and noises like incantations seep through the walls. These wonderful, odd people, whose generosity and burning desire to share in the lives of younger couples, soon raise in Rosemary suspicions of the vilest intentions. These two old darlings, disarming in their kindness and thoughtfulness, suddenly seem part of an infinitely more real world, closer to the essential nature and realities of earthly life in the depersonalized, inhuman New York inhabited by our heroine. They seem more real because they are older whereas youth has become artificial, a commodity, a key piece in the productivity and consumerism game. Their occult activities and satanic beliefs have given them a playful spirit in a world where play is systematized, planned, and dictated by advertising, radio, and the endless focus on youth, sports, tourism, and culture. The rites they practice, undoubtedly quite harmless, give them a telluric sensibility denied the city dweller, an erotic sensibility that our era of sexual "liberation" increasingly sees slipping away. Suddenly, the prestigious character portrayed by Jules Michelet in his *Sorcière* comes to mind, and we wonder if Ira Levin, more inspired than Benjamin Christensen in the last part of his *Witchcraft through the Ages*, is simply writing the last chapter in the reincarnation of witches throughout history.

The reason we are dwelling at such length on the novel that led to Roman Polanski's film is that the filmmaker translated it word for word, overlooking none of the writer's instructions, content to delete a few of the repetitions and insistent descriptions that film makes unnecessary. Therefore, the film version of *Rosemary's Baby*

John Cassavetes and Mia Farrow in Roman Polanski's *Rosemary's Baby*. 1968

evokes the same thoughts as the book, especially since Polanski often avoids jump cuts, careful to mark the passage of time by changing minute details of the set, showing the accumulation of various objects acquired gradually by his heroine, her many wardrobe changes, etc. This unconditional loyalty to the written word is certainly quite new for Hollywood, where it could well be taken for the audacity of a European intellectual. And it is indeed a European reaction—fascination with the power of a story, respect for the work of another—and it may reflect a thoroughly European talent for immediately translating the sudden changes in a novel into images without altering their literary arrangement in the least.

From Polanski, we sense the pleasure that we all share to some degree on our continent in the specifically Anglo-Saxon art of telling scary tales. Three of his films more or less directly belong to the category of thriller cinema: *Repulsion*, a psychological thriller whose distant origins can be traced back to Daphne du Maurier (the heroine of *Repulsion*, although executioner rather than victim, is nevertheless spiritually akin to *Rebecca*); *The Fearless Vampire Killers*, more a good-natured spoof on American vampires than a rendition of the fantastic folklore of Central Europe; and lastly *Rosemary*, who is indeed a traditional victim, her woes served up unsparingly for public enjoyment.

The Anglo-Saxon writer creates fear from a given situation developed according to the same strict standards and rich inventiveness as a dramatic author of the old school. With the initial premise, or the specific idea of the point of fall clear (and here the author's work is highly reminiscent of the poem whose first or last verse is "heaven-sent," a providential gift given only to the worthy), there remains only the problem of form, with logical and dramatic development of the situation closely linked to the technique of the story, so closely tied that, when properly used, it naturally creates the desired feeling of fear. After the decision is made to tell the tragic story of a pregnancy with a potentially catastrophic outcome, the only thing left is to let the various stages of the pregnancy unfold with a maximum of realistic precautions; there is no need to even hint about any unusual pathological complications. Each mundane incident takes on a double meaning, and we search everywhere for warning signs of the final crisis (when the fantastic finally erupts onto the scene), delighted to see our fears confirmed during the crucial moments of the story. *Rosemary's Baby*, which ends precisely where other horror films begin (not until the final frames are we enjoined to believe in the supernatural, rather than in the first fifteen minutes) is much more in keeping with Hitchcockian melodrama than the cinema of magic or clever fools. Yet Hitchcock himself would probably have foregone Levin's subject because of its fantasy overtones.

Clearly, the devil and witchcraft hold little fascination for the director of *The Fearless Vampire Killers*, and he uses them strictly as easy entertainment for the audience and for his own delight. His *Rosemary* seems like a brilliant exercise in style, quite understandably appealing to a young filmmaker trying to prove his worth to the Hollywood machinery, fabricating a "suspense" which, more than any other dramatic form, demands using every trick in the book. However, we are still left feeling a little annoyed at seeing the devil and all his pomp and works treated with such a lack of deference.

It is not so much the memory of a strict Christian upbringing that causes us such reverence for the devil and his minions, but much more the long noon-midnight tradition. Devils, witches, and vampires are creatures who deserve some respect, and

the writers of second-rate horror films, though they may throw together their work, never allow us to doubt the existence of their familiar specters. Polanski does not share their peace of mind, cloaking himself in a very convenient ambiguity, leaving the viewer free to imagine that his unhappy new mother seems a bit daft, and that the final scene of his film could well be nothing more than a postpartum delusion.

Rosemary voices her uncertainties, and then her painful certainty, like the two characters who came from the sea and walked the streets of a small Polish city carrying their icebox.[1] However, the ice inside the box reflected unexpected things that made for good cinema. Rosemary's pallid face often reflects quite expected things that make for very good cinema. Polanski does not relinquish his personality to Hollywood; he proves that he can achieve dazzling success where many European filmmakers of his generation failed. He made a commercial film of which he did not have to feel ashamed and over which he was absolute master. He has proven that a person can enter the Hollywood system without being devoured. All very good, but is it in his interest to repeat the experience? A genre film like *Rosemary's Baby* assumes some degree of cunning in the person who carries it off, as if it were a game. He enlists his strong will while subtly distancing himself from what is admittedly a huge subject. He preserves intellectual quality by avoiding the temptation to engage in romantic excess. He gives the studio everything it needs to assure that the film is a commercial success by maintaining the deceptive appearance of a fashionable mythology. That is all fine and good, but will Hollywood accept anything else but practical exercises of this kind from a young European filmmaker, or will Polanski's future career be one long succession of rites of passage? We strongly hope he can avoid this pitfall, not to mention the wrath of California's witches who, as we all know, are many in number and omnipotent in power.

1. Editor's note: This is a reference to Polanski's film *Two Men and a Wardrobe.*

No. 102, February 1969

Rosemary's Baby. 1968. Written and directed by Roman Polanski, based on the novel by Ira Levin. Produced by William Castle. Cinematography by William A. Fraker. Music by Christopher Komeda. With Mia Farrow (Rosemary Woodhouse), John Cassavetes (Guy Woodhouse), Ruth Gordon (Minnie Castevet), Sidney Blackmer (Roman Castevet), Maurice Evans (Hutch), Ralph Bellamy (Dr. Sapirstein), and Charles Grodin (Dr. Hill). 137 min.

Par ordre du Commissariat gé...
aux questions Juives:
L'entrée des Juifs dans l...
Salles de l'Hôtel des Vent...
est interdite d'une manie...
absolue.
~

1970s

The history of this film is well known, and we will dwell on it here only briefly. *The Sorrow and the Pity* (*Le Chagrin et la pitié*) is a 1969 Rencontre (Swiss) production directed by Marcel Ophuls with André Harris and Alain de Sédouy, formerly the managers of "Zoom," a program on the French television network that changed its name in May 1968 to outside-Office de Radiodiffusion Télévision française. ORTF wanted nothing to do with the film, a video success in other common market countries (except Italy at the time of this article). In France the film first appeared on the relatively private screen of Saint-Séverin in the Latin Quarter and then, given its surprise success (its four-hour, thirty-minute length seemed to make it unmarketable), in a theater on the Champs-Elysées, where it was a big hit.

The Sorrow and the Pity
Paul Louis Thirard

The 1960s and early 1970s were a fertile period for political thinking in the cinema. *The Sorrow and the Pity* seemed not only to be a documentary masterpiece but also a film that could change the way a country viewed its history. In the controversy that followed, *Positif* sided with Marcel Ophuls, who, for the first time, tore down the mythology created by De Gaulle and the Communist party to the effect that France had been mainly against collaboration during the war. Along with Raymond Depardon, Frederick Wiseman, and Chris Marker, Ophuls remains among the documentary filmmakers rated most highly by the magazine.

The film explores the Occupation and Resistance, centered on Clermont-Ferrand, with a brilliant montage of conversations with various people—high-profile politicians and ordinary people—and period documents, primarily French, German, or English news.

Thus far, this history has been instructive. We might be inclined to view it as a mundane confirmation of the accepted idea that film allows more freedom than television, which seems unquestionable in some regard. Even at a mechanical level (elementary but still important), a completed film requires a seal of approval; otherwise it might trigger a media backlash. Yet for this program, ORTF didn't bother with the formalities, and the film is quite "unfettered." The big screen also allows more freedom than the small screen because of television taboos on sex and violence. Even politics, sometimes: Marin Karmitz may well have managed to make and distribute *Comrades* (*Camarades*), but it is difficult to imagine how he could have done it on television. Often, then, censorship and various contradictions allow film more "latitude" than television. But is this the case here despite appearances? The answer is not so clear: the film was indeed made for a European television audience, and was aired on European television. The ORTF's decision to sideline it was more a glitch than a matter of incompatibility. Merely portraying it as a "cinematic film" suddenly caused film critics everywhere to begin discovering the radical novelty, the sensational boldness of the subject. Would it therefore be all that paradoxical to consider *The Sorrow and the Pity* an example of television's superiority over film when it comes to taking a fairly serious look at certain burning issues? Or should it be seen as a genuine separation, because film critics don't watch television? Or rather, does the same film get a different reception, with different feedback, depending on whether it appears on video or on the big screen? Suppose that ORTF had purchased and broadcast the film. Would it have aroused more interest than a good television program, such as one of the best episodes of "Zoom"? I admit that I have no answer; however, I refuse to view Ophuls's film as an example of the greater freedom of film compared to television.

Marcel Ophuls. *The Sorrow and the Pity.* 1971

The obvious interest in *The Sorrow and the Pity* is not a direct offshoot of its basic political premise, which comes across quite plainly and makes no attempt to be "revolutionary." It exists within the boundaries of solid European liberalism, and its ideals probably lean toward those of the English parliamentary system. Instead, as Louis Seguin[1] wrote, its appeal resides much more in the portrait that the bourgeoisie paints of itself, with its dark sides, its collaborators, its heroes, and its great politicians. When Seguin writes: "Despite appearances, nothing about it relates to the superstitions surrounding real-life film—the live miracle where reality serves itself up with delicious simplicity, where people's secrets are laid bare and the nature of their actions are pure and unadulterated. Here, revelation is the product of artifice." Seguin is quite correct. Here artifice is by no means insulting. Let's consider this statement as we examine the film somewhat more closely.

A recorded conversation always involves a sort of game between the journalist conducting the interview and the person being interviewed. A quick viewing of the Ophuls film gives us the impression that he is more or less sympathetic to some of the people interviewed—those who sided with the Resistance, for example—while he harasses others—the woman who supported Marshall Pétain or the hosiery vendor who made a point of telling us that he was not Jewish. We also sense that this game often gives an advantage to those more familiar with audiovisual techniques, who never run the risk of being "caught." For example, among the politicians interviewed, those who "came off" the best—PMF [Pierre Mendès-France], Sir Anthony Eden, Emmanuel d'Astier de la Vigerie, and Jacques Duclos—have some experience with televised political debates, while Count René de Chambrun or Georges Lamirand were more easily "caught." They are also among the people visibly less sympathetic to the filmmakers and to us, the audience. Consider what Count Christian de la Mazière had to say. Normally, we would expect him to be among the harassed, too, but he is not. At first, I thought it was because he might have had some professional experience in journalism and television interviews. In fact, the reason he was not cornered or taken off guard like other collaborators is that he had previously arranged to script the conversation himself. This is just to show that everything in the film is "artifice," in other words, not by chance, controlled, staged, and deliberate. Everyone knows that PMF is no easy joker. So it was surprising to see him smiling, relaxed, humorously telling about his escape, almost like Mr. Hulot in *Traffic*. We are all familiar with stories of the English secret agent: the commentary by Denis Rake—with the eminent endorsement of Colonel Buckmaster—adds the "sensational" side of the character and his mission; in short, the film is composed according to the rules of performance, polished to generate interest, entertain, and captivate. James Hadley Chase's novel *Cade* uses the myth of the amiable photographer who manages to "capture" the "truth" of a subject; pure fabrication. Here, there are no impostors, no one claims that the deep "truth" of Chambrun lies in his sidelong glance to us after his docile "good man" tells about all that he owed to Pierre Laval.

If we go along, if we approve, if we agree, it's because of a wager, an underlying trust. "[Jean Giraudoux] wrote somewhere that a butcher who sells you veal isn't forced to deliver it in the shape of a calf. We are content to eat the veal. And if the butcher delivered it shaped like a kitten, a bagpipe, or an alligator, we might congratulate him for his inventiveness. . . . The only reason we might be suspicious of these various forms is if we suspected their essence. If Giraudoux had us eat cow, everything would fall apart." These lines were written by someone who had reflected

on the issue, and who wrote for Chris Marker at the time. A while later, Marker, in *Letter from Siberia* (*Lettre de Sibérie*), slipped in a few savory variations on objectivity. We know that Ophuls's camera is not a neutral, objective, or infallible witness: we know it only takes a bit of patience and skill to capture a given attitude in a given person, and that this attitude "in itself" is meaningless. We accept the artifice out of trust: we consent to "go along" with it as we would with any other film. Or rather, not entirely: this act of faith is much more evident in a fiction film, with actors, sets, etc. It is less critical in a report that does not address "substantial topics." For example, when Denis Sanders filmed the Elvis Presley show for MGM in Las Vegas, I expected him to show me a singer whom I enjoy seeing in action, but I didn't much care whether a given scene shown on screen really happened, or was staged for filming.

All of this might seem like breaking down open doors, but there are still a lot of people who don't realize it. On the whole, the language of film today is just that, "artifice": the public gives its trust, the filmmaker arranges the various elements in an artificial structure in order to present something to the public, which accepts it (otherwise it fails). Another kind of cinema may be possible, but not yet effective. *The Sorrow and the Pity* belongs to a long filmmaking tradition that also includes Marker, what Jean-Luc Godard calls "capitalist" cinema, which he denounces in the first part of his film *Pravda*. What is annoying is to see a blockhead (Delfeil de Ton) speak well of Ophuls's film (bravo), to exalt the last minutes of Ralph Nelson's *Soldier Blue* (a prime and also more crude example of artifice: the nervous shock of the "Italian atrocities" used to advance the cause of Indians and peace in Vietnam), to treat Arthur Penn's *Little Big Man* as a rotten film, and to divide film into pre- or post-Godard categories—without realizing that everything he praised is directly pre-Godard, just like what he rejects. To repeat Giraudoux's metaphor, quoted by Marker, whether the butcher gives us veal in the shape of a little calf makes no more difference to the value of the meat than if it were shaped differently: it still comes down to a matter of trust.

One problem remains, however awkwardly posed by certain staunch defenders of live film. If, fundamentally, such film is no different and is based on no other mechanisms than "fiction" film or the traditional documentary, is there not at least some methodological merit in assigning classifications, to identify structures and decipher similarities? It is at least interesting to try. Imagine a scale where, at one end, we find an abstract, ornate, animated drawing of concrete music (?) and then, successively, depending on the *apparent* degree of realism, we move on to the figurative, animated drawing, the musical film, the ordinary fiction film with actors and sets. Then appear natural sets, non-professional actors, the disappearance of a story line, documentary, films made using archival footage and newsreels.

This would not get us very far. It may be more effective to try a subjective sorting: to group together a number of films that seem to share something in common, and then examine whether we can identify something less subjective. A first series might include most of Marker's films, and *The Fall of the Romanov Dynasty*, *Primary*, *To Arms, We Are Fascists*, films by William Klein, Pierre Perrault, etc. Then, it might boil down to this: a heavy reliance on material that poses (from an utterly naive standpoint) as more "real" than fiction, that challenges outright artifice: a news item or report, rather than sets and actors, without necessarily laying claim to "realism" or being a "copy of reality," yet playing with this inherent characteristic of the material. But it also takes something more than a report or retrospective journalism; it

takes something like a theme or a thesis. I would not include in this group a film by François Reichenbach, or *Eddie Sachs in Indianapolis* (*Eddie Sachs à Indianapolis*). It might work in the alternative category—leaving out the "Elvis" show, but what about *Woodstock*? And why would I let *Primary* pass but not *Eddie Sachs*? I would have to check with the competition whether Esther Shub left any writings: we know that she studied under Dziga Vertov, and although his films leave me cold, I'm a fan of *The Fall of the Romanov Dynasty*, which, by the director's own admission, inspired *We Are Fascists*.

Enough said on the matter here. In connection with Marcel Ophuls's film, I simply wanted to deflate a few stubborn illusions about "direct cinema" and try to determine where to look for a definition or a study of that particular category of film. Secondly, I also wanted to note humbly the weakness inherent in any film criticism applied to television.

N.B. We should mention a few of the limitations of Ophuls's film. Naturally, it is not unreasonable that no one spoke of food vouchers, bicycle taxis, or wooden soles. Or even of Mayol de Luppé. However, granted that a certain degree of self-censorship is necessary (not *everything* could be included; this or that had to be cut), two oversights are more significant. First of all, almost nothing was said about the local Gestapo, except for one allusion to the German captain. Also, there was a surprising "blank" about the Battle of Mont Mouchet, where many in the Resistance under Gaspar's command were decimated. This is taken to such an extreme that the only mention of Mont Mouchet is by the English! Perhaps this memory calls to mind certain remarks by the underground forces complaining about the lack of officers, structure, and so on.

1. *La Quinzaine Littéraire*, May 1–15, 1971.

No. 128, June 1971

The Sorrow and the Pity (Le Chagrin et la pitié). 1971. France/Germany/Switzerland. Directed by Marcel Ophuls. Written by Ophuls and André Harris. Produced by Harris and Alain de Sedouy. Cinematography by André Gazut and Jürgen Thieme. Interviews with Emmanuel d'Astier de la Vigerie, Georges Bidault, Charles Braun (French witnesses), Sir Anthony Eden, General Sir Edward Spears, Maurice Buckmaster (English witnesses), Matheus Bleibinger, Dr. Elmar Michel, and Dr. Paul Schmidt (German witnesses). In French, German, and English. 270 min.

La Dolce Vita was an admirable exploration of a dying world, a sumptuous and baroque fresco of decadent civilizations seeking to recover lost certainties and prejudices in an occasionally lucid form of desperation. Unlike Luchino Visconti, who projects all of his morbid obsessions and splendid antiquated excesses onto an anachronistic social class (the nobility) that is condemned to die or that is already threatened and reprehensible (the reigning upper-middle class), Fellini projects his fantasies on everything within his grasp: aristocrats, artists, the bourgeoisie, clerics, and even workers. In short, he universalizes his feeling of things falling apart in a more confused (or more sincere) manner than that of the direc-

Federico Fellini after *The Clowns*
Frédéric Vitoux

Positif maintained close ties with the Italian cinema, with several regulars such as Goffredo Fofi and Lorenzo Codelli, who are natives of that country. Along with Michelangelo Antonioni, Federico Fellini was, of all the famous filmmakers from the peninsula, the most regularly defended in the pages of the magazine. Admiration for his work did not diminish in his second period, which was far from unanimously well received by the critics.

tor Visconti in his *The Leopard* (*Il Gattopardo*) and *Senso*. Once again, *La Dolce Vita* was a strong statement about the death throes of the Western world rather than those of any particular sociological group – a despairing acknowledgment in the eyes of an Italian who is too perceptive to want to perpetuate the spiritual values of his civilization, and yet who refuses the hope engendered by the philosophy of history and promises of endless progress.

After prophesying the end of his civilization, Fellini naturally took it to the next level and went on to predict the death of the artist and the loss of his inspiration. Because a particular world was condemned to die, the artist, whose role it is to explain and record that world, could only disappear in turn. The film *8 1/2* (*Otto e Mezzo*) marked an obsessive and subjective return to the apparent death throes of the creator, whose sources of inspiration became engulfed in the unnatural hideousness of a serene and irrational despair. *La Dolce Vita* was a film by a solitary moralist; *8 1/2* revealed someone turning inward on himself, like an artist whose grip on reality has been taken away from him, and whose wretched fantasies and nervous energy intensify to the point of delirium; in short, his inner world becomes as necessary to him as it is gratuitous.

We could begin to see how the Fellini story was unfolding. Just as the artist appeared to be withdrawing, after dismissing both his public and himself, he achieved a prodigious mastery of structure and appearance. This remarkable inventor of forms was faced with the following dilemma: to repeat himself or remain silent. But he did so in a breathtaking way. It was not difficult to see that with Fellini a real film and a dreamed film were not so different from one another, because he was able so effortlessly, accurately, and powerfully, from the depths of his memory, to put on the screen grotesque and lovable silhouettes hovering around the hero, not to mention his outrageous sets, and the unleashed ramblings of a wild imagination.

There is a fairly widespread view at the moment that every great artist has only one work, after which all he does is repeat himself. But Fellini seemed to recognize from the outset, in the very core of his films, that it was impossible for him to repeat himself yet again—an impossibility that he then restated in a Felliniesque paradox! Indeed, in his captivating and uneven career, in which similar qualities can be found in his passionate *The White Sheik* (*Lo Sceicco bianco*), *The Young and the Passionate*

(*I Vitelloni*), and *The Swindle* (*Il Bidone*) and in the heartbreaking *Nights of Cabiria* (*Le Notti di Cabiria*) and *La Strada*, he specifically relates the two streams of his work to the decadence of the world, and the powerlessness of art once it becomes detached from the values that underpin it and link it to society. It is, of course, a Felliniesque form of mockery that gives us a director at the height of his art who is called upon to condemn the very essence of his art thus far!

Juliet of the Spirits (*Giulietta degli Spiriti*), like 8 1/2, exhibited this escape through a headlong flight into subjectivity. But this time the director's fantasies were not so much a reflection of the artist's creation; rather, they borrowed their subject matter from the banal worries of a menopausal bourgeoisie worried about its conjugal future. Hence this painful split between the sumptuous cinematographic visions on show and the alibi on which they rest, a split that is in keeping with the failure of the film.

Then came *Fellini Satyricon*, an admirable retelling of *La Dolce Vita*. For the most part it was about decadence once again, but with a strangely deliberate pace, as if all of Fellini's compositional efforts were spent on creating balances within the frame of the screen rather than imposing the dizzying dynamics of glorious but unwarranted behavior. It is as if all the nightmare silhouettes from this reinvented Rome (which does not mean that they are not accurate, although they certainly strain credibility) got bogged down little by little in some kind of mud on screen as if in a two-dimensional universe. *La Dolce Vita* was a painting of the world after God. As Giuseppe Lo Duca put it so well, "This Christ flying over Rome in the opening scene of *La Dolce Vita* seems to me to be the most obvious key to the work. The cable from which the statue is suspended under the helicopter appears to remind us that in days gone by the faith of men was able to manage without him." *Fellini Satyricon* is the world before God, which amounts to more or less the same thing. Both films contain the same despair and exaltation faced with the end of certainty, simple and stirring choices, the same relief tempered by helplessness in the face of the freedom that must now be assumed by man, and that the Italian Fellini was willing to assume only with the somewhat reactionary caution of someone afraid of getting his fingers burned. At least they excel at showing the alleged dangers thereof; in both films one finds the very things that Lo Duca, once again, wrote in 1960, in referring to Petronius: "*La Dolce Vita* lights in us the fire of distant reverberations, from the *Annales* [of Tacitus] to the *Satyricon* [of Petronius]."

Fellini Satyricon can still logically evoke some lines by E. M. Cioran, whose jolly scepticism, fine affectation, and individualistic confidence as a man of the Right par excellence, in the best sense of the term, also indicate one of the directions and perhaps one of the limitations, if not faults, of Fellini's art: "Espousing the melancholy of ancient symbols, I would have freed myself; I would have shared the dignity of the abandoned gods, defending them against the insidious crosses, the invasion of servants and martyrs, and would have spent my nights seeking repose in the dementia and debauchery of the Caesars. As an expert in disenchantment, I would have riddled the new zeals with all the arrows of dissolute wisdom—with courtesans, in skeptical brothels, or in circuses with lavish forms of cruelty. I would have filled my thinking with vice and blood to stretch logic to unheard of dimensions, as large as worlds that are dying" (*Précis de Décomposition*, 1949).

In this great body of work that treats grand subjects related in the first person by a great artist very much in the forefront of things, *The Clowns* (*I Clowns*) is clearly a bit

Federico Fellini. *The Clowns*. 1971

of an accident.[1] It is a small film, with a (relatively) small budget, made for television! Here we have Fellini forced to treat a specific subject, to make a documentary! It was never a matter of freeing his imagination to play unrestrictedly with visions stemming from his fantasies. *The Clowns* had a number of clear constraints. But, as it happens, in meeting the stated obligations and at the same time breaking them down, *The Clowns* is one of his greatest films—one in which the filmmaker is able effortlessly and in a sometimes remarkably offhanded manner, with total freedom from the standpoint of the script, to focus on a single area and find an opportunity to confide in the screen and give himself over totally to it. This time, the sumptuousness of form is finally reconnected to the emotions that underlie and justify it. In other words, with *The Clowns*, a secondary work, Fellini finds coherent and solid support that he is able to use as a basis to express himself in a completely frank manner.

In his most recent films, the director, with a completely free hand, rejected the idea of a "realistic" point of departure, or at least one that could be considered consistent and outside of himself. He no longer had a subject to treat, and did not have to battle against any constraints in making the work meet his aspirations and creative demands. Total freedom of vision was therefore sometimes combined with a degree of gratuity—gratuity here meaning that audiences failed to recognize the images created (except, of course, aesthetically!), and hence there is a lack of emotion, meaning the director's failure to reach his public. With *The Clowns*, this is not the case. This "accidental" work looks at first glance like a television report. Never mind the special effects or the schematic format, or that the rules for putting such stories together are discarded along the way! Fellini's clowns are interesting and touching. Fellini, reacting to the circus, is even more interesting and touching. In short, this meeting in which nobody escapes unhurt, except perhaps Fellini, who is a sincere and prodigious magician of transposition, has much more to do with confession than information. But it is all the more sincere and shared because its informative role is not denied at the outset but rather accepted and used for other purposes. And lastly, the film *says* as much as his previous films. The apparently modest message paradoxically represents a deepening and enrichment of Fellini's personality. Not only does *The Clowns* gain in emotion, but the film also solidifies Fellini's body of work.

The opening of the film, which is serene, intimate, and fantastic at the same time, has already been widely described and praised. The big top raised in the night, whose twilight radiance will soon fascinate the child, appears to prefigure the grotesque and monstrous world of the circus as well as Fellini's inner world, which his other films have taught us to recognize. Anyone familiar with Fellini can easily anticipate how the rest of the film will proceed, with dreamlike sequences reminiscent of 8 1/2, a natural part of this world of the circus ring. However, Fellini very soon disabuses us of this expectation.

In the first show that the child sees, he rejects the magic and enchantment of the circus. More precisely, he submits to them, fears them, and then rejects them. The spectacle of the clowns—happy clowns, sad clowns, white-faced clowns mocking one another, beating one another up, grimacing, dishing out and submitting to all kinds of inventive abuse, and then starting over again—does not amuse him; it horrifies him. When the other children burst out laughing, he is frightened.

When the others are giggling like idiots, he bursts into tears. The adult Fellini has not changed. He will not modify his lighting, which is an indicator of his individuality. By rejecting the truly funny aspect of clowns, or at least refusing to share if not admit this aspect, Fellini delivers a lugubrious and cruel depiction of these white-faced figures who have to live through truly atrocious bits of business. It is as if a bullfight were treated as nothing more than a substitute for the slaughterhouse—a limited but perfectly defendable point of view but one that would no doubt displease all the Hemingways and Leirises. But, once again, Fellini is to be congratulated for not having shaped the circus world to his own desires—his own obsession with the grotesque within the confines of death. On the contrary, he stands back far enough from this other world to get to know it better and to understand himself better at the same time, by searching in these clowns for those very elements that cause his own personal anguish. In other words, from the very outset, Fellini does not falsify the world within which the clowns play their games in an attempt to make it correspond to his feelings, but instead finds among them those facets that are in tune with his own sensitivities. His impartial and admittedly incomplete investigation harks back to a very sensitive confession only in the sense that its main concern was attention to accuracy at the expense of exhaustiveness.

The lovely autobiographical sequences that follow the first encounter with the circus confirm the function the clowns perform for him. They evoke his childhood and adolescence in Rimini, along with all these somewhat monstrous characters who have haunted him ever since. The buxom matron, the half-crazy religious dwarf, the old fascist soldier, the irascible and powerless stationmaster, the near-tramp who falls into warlike and patriotic trances, all make up a captivating gallery of figures somewhere between dream and reality, and are all the more convincing for having stemmed from time lost and regained—the time it takes to shoot a film and to project it. So is it these real clowns that take Fellini back to his past and to the fantasies of his curious and already morbid childhood? Or is it rather his fascination with the monstrous or the unusual that leads him to recognize in these clowns—these grotesque and truly invented figures—the traits and excesses that he had experienced and felt around him very early in life? You can see here that the clowns' status is always ambiguous. As models they help Fellini find in himself the characteristics and impulses that they evoke. On the other hand, they fascinate him only in the sense that some of their features provide a homogeneous universe into which the director projects himself. The "real" sequences from the past do nothing more than illustrate the legitimacy of this projection.

The central portion of the film further extends Fellini's process in several respects, his quest for intimate truth in the circus world. After showing the monstrous and cruel side of the clowns' spectacle, Fellini searches, among the great comedians who have disappeared, for the presence of death, time lost, the tender derision surrounding the circus ring. Having shown death in the circus—through the clowns' play, but also through the presence of the big cats, along with the dazzling, dubious, and misleading vitality of Anita Ekberg—Fellini then talks about the death of the circus, which parallels the aging or death of the great clowns of its glory days: Footit and Chocolat, Rhum, the Fratellinis, and so many others. They are caught off guard in pathetic and forgotten retirement, with a lucid, cruel, and sometimes even embarrassing confidence from Fellini, even in his insistence and immodesty.

Here again Fellini uses a form of ambiguity that manages to communicate a degree of discomfort, as if the uncertainty about the film's "level of reality," as communicated to the audience, was also of concern to the director. Sometimes he shows his own film crew (at least they are supposed to be his film crew) and caricatures their behavior, no doubt in opposition to the deeply moving sincerity of his film. However, sometimes he rearranges certain sequences – some sketches of clowns are now gone, the visit to the Radio House, the meeting with Bouglione, perhaps?— and then immediately returns to treating the subject like a travelogue that is both accurate and subjective at the same time.

The last part of the film elicits a number of ambiguities while spectacularly synthesizing the previous episodes. To be sure, it is the clowns themselves who attract all the interest; only they can now represent the artist's emotions and obsessions. Furthermore, the crazy parade at the end reenacts, under the big top, all the usual morbid circus gags. But his over-the-top funeral is not for any particular character played by a clown, but rather for the idea of the clown itself. The death of the circus is, like death in the circus, a deafening, delirious, inventive, powerful, and breathtaking sequence, right up to the final slowing of the pace after the parties, which become so many days of mourning. Let us remind you once again, that this remarkable delirium is only as powerful as it is because of everything that went before, and that is why the epilogue is both unreal and necessary at the same time.

Fellini, the solitary and distraught prophet, now chooses, in the absence of any certainty, to turn inward and live with his ghosts, who tell him about death, the absurd, the monstrous, and the marvelous in life rather than speak reasonably and solemnly about the end of civilization. Since *La Dolce Vita*, he has apparently had total freedom that is certainly well-deserved to express the doubts and anxiety of a person who has found both disparate and shimmering images to show on the screen. With *The Clowns*, he has been able, on this same introspective quest, to triumph over the limitations of sponsored film production. Perhaps we should now hope that he encounters further obstacles, further constraints. In any event, Fellini has proved that he had nothing to lose. On the contrary, he had challenges to meet and obstacles to overcome in meeting all of the obligations of externally imposed imperatives.

1. For more on *The Clowns*, see M. Ciment, "Venise," *Positif,* no. 121 (Nov. 1970), p. 16.

No. 129, July–August 1971

The Clowns (I Clowns). 1971. Italy. Directed by Federico Fellini. Written by Fellini and Bernardino Zapponi. Produced by Elio Scardamaglia. Cinematography by Dario Di Palma. Music by Nino Rota. With Riccardo Billi, Fanfulla, Tino Scotti, Annie Fratellini, Anita Ekberg, and Pierre Etaix. In Italian. 90 min.

W e're not quite sure where Leonard Kastle is taking us when we see the first few scenes in his film. Or rather, we're afraid of becoming all too familiar with them. We dread once again finding ourselves in the kind of overly facile English comedy liberally sprinkled with incredibly stale black humor that people still dare to serve up from time to time. We are also afraid that we might be on the "highways" of so-phisticated and pernicious misogynistic horror intro-duced by Robert Aldrich with *Whatever Happened to Baby Jane?* While it soon be-comes clear that Kastle's approach is not in the slightest British, it takes somewhat longer to realize that the diabolical nurse whose adventures in crime

Verismo and Crime News: *The Honeymoon Killers*

Michel Pérez

The Honeymoon Killers, composer Leonard Kastle's only film, is a brilliant example of independent American cine-ma, which can take its place alongside the films of John Cassavetes, the Mekas brothers, Shirley Clarke, and Barbara Loden. The film is celebrated by *Positif* as an anti-dote to standard Hollywood fare.

he depicts so icily in no way resembles the gallery of decrepit monsters that still de-light lovers of camp on both sides of the Atlantic. It takes a long time to realize that the character was not based on an aesthetic of physical comic-strip monstrosity, and that it is innovative precisely because it refuses to follow the rules established by the architects of female beauty employed by the major studios and advertising agencies. Once you realize this, it comes as a revelation: *The Honeymoon Killers* is perhaps the first movie to destroy the conventional image of the "adventuress" imposed upon us for more than a half century.

Traditionally, the female criminal is a vamp. Her physical attractiveness is in keeping with the desires of romantic poets; she is Philippe-Auguste Villiers's future Eve; she is well-versed in cold and calculating egoistic subtlety; she needs all the hieratic seductiveness of Gustave Moreau's *Salome* paintings for us to accept and become interested in her misdeeds, and for the horror they elicit in us to become transformed into an exquisite form of fascination. Not only does Kastle's heroine not look at all like a sylph, nor have the relentless cruelty of triumphant youth (which for a time leads us to believe that she escaped from Aldrich's circus), but she also has none of the serene inhumanity of the sacred beasts on display in thrillers or dis-aster movies. Martha (Shirley Stoler) is neither a praying mantis, nor a narcissistic idol completely wrapped up in herself, nor a criminal genius that no sentimental weakness will deter from her doings. More than anything else, she is a woman who has been frustrated for a long time, and who has learned how to make her impossi-ble desires come true, and who, like the leading ladies in women's magazines, is pre-pared to go a long way to defend her newly acquired happiness. She is willing to do whatever it takes, even kill in cold blood if necessary.

Martha behaves like a jealous mother. Her passion for Ray (Tony LoBianco) is tinged with the incestuous, a passion that is never attenuated by the minor come-dies she forces on him in her attempts to try to shadow him in the unsurprising by-ways of his "profession." At the beginning, Martha the mother takes pleasure in playing with her child. Ray`s activities are innocent, and almost gamelike. He se-duces middle-aged women who are ready to marry or remarry, takes what little money they have been silly enough to make available to him (these women, in fact, "buy"

a man much more than they sell themselves), and gently slips away, hoping with all his heart, no doubt, that the bitterness of their deception will not tarnish their fond memories of him. Ray, a classy male sex object, is a high-class gigolo who is not satisfied to simply provide his clients with a level of physical satisfaction that they had given up hoping for, but also very skilled at meeting their emotional needs.

He is clearly passionate about his work, in which he takes considerable pleasure, and does not show any contempt for the women he is fleecing. It is only after he hooks up with Martha that he begins to smile about their ridiculous ways, and it is only to please Martha that he is cruel toward them.

In a society that has genuinely cast off all sexual prejudices, Ray would be an "erotic Samaritan," practicing an honorable activity with a high level of professionalism. Martha suddenly tears away this state of innocence. With her, the comedy of marriage becomes a horrible deception from the very outset. The game disappears just when she seems to want to play it with some amusement: she plays the role of a protective big sister, a strong-minded woman worried about seeing her little brother leave her for a "stranger." Fearing that her lover's attachment is similar to the services he provides his victims, she demands that he characterize the criminal nature of his ephemeral dalliances as violently as possible in order to affirm the legitimacy of their own relationship. It soon becomes apparent that this legitimacy, which has not been confirmed by the ceremony of marriage (a "real marriage" that would once and for all sanction the artificiality of Ray's deceptions), will never come about except through the killing of the pretenders who are supplied to him through the classified ads. It is after the murder, and only after the murder, that the game "ends," leaving Ray, whose soul is less "immersed" than Martha's, in total dependence. The tragedy stems from Ray's refusal to understand and accept this dependence, from his stubborn desire to prolong the game, and from his evasiveness about the choices he must make: accept a union sealed by murder; renounce the childish happiness of irresponsibility; or agree to grow up and stop being a little boy under someone's protection.

Kastle's tragedy is clearly among the works that examine the abdication of the American male, and a very important work it is, particularly as it does not give his heroes the erotic seduction scenes to which Hollywood has accustomed us for such a long time, particularly in adaptations of Tennessee Williams plays. This is no doubt because of the director's faithfulness to the real-life news story he has decided to tell. As we know, *The Honeymoon Killers* was made almost like a documentary, with a constant concern to eliminate any potential stylish affectations on the part of the filmmaker, and a total rejection of the baroque and fantastic overtones that have attached themselves to the world of crime, a striking approach in a director whose first artistic experiences were lyric in the true sense of the word.

We marvel at Kastle's mastery because it is almost impossible not to see it as a happy accident. There is a great temptation to consider *The Honeymoon Killers* as an outstanding and unique success, and to fear that if he makes a second film, it will be a disappointment.

We are not familiar with the two operas composed by Kastle, but we tend to think (based on what Kastle himself has said) that they are closer to Italian verismo than to any recent efforts of contemporary music. It is therefore not surprising to find a man who is passionate about traditional opera treating a criminal subject with such rigor. No lengthy analysis is needed to see that the subject of *The Honeymoon Killers* is an opera subject, and in particular a subject suited to Italian opera. As we have said

Shirley Stoler in Leonard Kastle's *The Honeymoon Killers*. 1970

already, his treatment breaks the conventions of romanticism, but in doing the very opposite, he does not forget any of these conventions. The inevitability of theater insinuates itself, the plotline developments follow the rules of an irreproachable mechanical drama, and the curve of the action appears to be one of total repentance, with the major themes, quartets, trios, and duets suitably placed. We unmistakably recognize those special moments when unbridled lyricism *could* suddenly erupt. *The Honeymoon Killers* certainly reminds us of the only true heir to the Italian verismo tradition, Gian Carlo Menotti, and we also know that Giacomo Puccini's masterpieces are often based on melodramatic events: *Tosca* or *Il Tabarro*, for example. *Tabarro* (*The Cloak* in English, a great dramatic opera and an admirably spare and quasi-documentary masterpiece of operatic literature) is the perfect illustration of what we are talking about. But it is too tempting to imagine this tragedy of family jealousy brought to the screen without Puccini's music. This would give us something like *The Honeymoon Killers*, the pure and simple negative of opera.

Trading musical composition for the camera, Kastle has certainly not cast aside the discipline he had first chosen, and it is very possible that the same creative process was at work. The lyric composer stalks his subject with the same implacable patience, tirelessly exploits all of its possibilities, and brings out the full dramatic potential of every moment. He both serves his subject and makes use of it without the slightest misgivings, and it is equally without qualms that the filmmaker allows himself to be carried away by his subject, so much so that he shot the film chronologically, which is not the usual way of proceeding. It is this total faithfulness to the subject that could cast a shadow over the cinematographic future of this man of the opera. The adventure of the heroes of *The Honeymoon Killers* is resonant, but it demands strict sobriety in terms of execution. Such dramatic diversity requires directorial classicism, because the manner in which the actors are directed and the overall style are all-important. A weaker subject would no doubt free the filmmaker of the obligation of artificially re-creating tension that was necessarily there from the outset, leading to the inevitable excesses of a temperament that we assume is well removed from Jansenism.

In any event, the documentary qualities of *The Honeymoon Killers* are invaluable. We have rarely seen a more lucid portrait of a middle-class American woman. The picture is stern, but stops short of easy caricature just as it avoids the misogynistic mythology so typical of New York wits. Kastle's strength stems from his undisguised tenderness toward these despotic and frustrated creatures. He does not see them as monsters who would frighten young and even older boys, but as dispossessed beings, pitiful victims of a society that places them on a pedestal, where they have to stay chained either willingly or by force. His X-ray of puritanism is horrifying, particularly as he shows it to us through the scenes that appear to be innocuous in the overall plotline. It is the submissiveness of the murderous couple's victims to the taboos of puritanical society that provokes, precipitates, and eventually allows the crime to happen. The presence of the "sister" at these successive honeymoons, which is considered an acceptable and natural practice, is what provokes the murders. Without her the marriage-swindle business would not have these extremities. The sister in question, whose presence is a guarantee of respectability, prevents these female suitors from thinking clearly about just what sort of adventure they are getting into. They are truly entering a family, which means that they are not just buying human flesh. The representative of this "family," who prevents them from consummating

their union immediately and from making use of the object they have just acquired, thereby relieves them of any feelings of guilt. This acceptance makes them incredibly vulnerable, and they are able to rebel only for a moment, before meeting their end, as the honeymoon killers become instruments of a stern God's vengeance.

Kastle is not afraid of injecting considerable humor into his film, showing that he has a very special temperament. *The Honeymoon Killers* does not fall into the trap of black humor, nor does it fall prey to the grotesque. It makes a clean sweep of the picturesque, without becoming overly solemn. It could well be the best modern tragedy that the cinema has given us in a long time.

No. 131, October 1971

The Honeymoon Killers. 1970. USA. Written and directed by Leonard Kastle. Produced by Warren Steibel. Cinematography by Oliver Wood. Music by Gustav Mahler. With Shirley Stoler (Martha Beck), Tony LoBianco (Ray Fernandez), Mary Jane Higby (Janet Fay), Doris Roberts (Bunny), Kip McArdle (Delphine Downing), and Marilyn Chris (Myrtle Young). 107 min.

The title of Stanley Kubrick's latest film, *A Clockwork Orange*, alludes in two different ways to something circular or spherical that is closed on itself and spins. We can immediately see, even though we think we are in the future, that we are at some considerable distance from *2001: A Space Odyssey*, and from Kubrick's vision of huge leaps forward in terms of progress, the latter film perhaps modeled on a spiral, but definitely not on a circle.[1]

Circular Misadventures: Stanley Kubrick's *A Clockwork Orange*

Jean-Loup Bourget

Stanley Kubrick, the most controversial of contemporary directors, who was often reviled by the press, has always found strong support in the magazine. For the fiftieth anniversary and five-hundredth issue of *Positif*, he was voted the favorite director and *2001: A Space Odyssey* the favorite film of the last half-century by eighty-seven past and present contributors.

The first article on his work, a review of *The Killing*, seen in Belgium one year before its French release, was written by the novelist Jacques Sternberg, who, a decade later, wrote *Je t'aime, je t'aime* for Alain Resnais. *Positif* also published two rare long interviews with Kubrick on *2001* and *A Clockwork Orange*. The latter was accompanied by two essays, one by Robert Benayoun, the other by Jean-Loup Bourget, which is translated here.

The circularity of *A Clockwork Orange* is particularly evident in its plot, which includes incidents such as: A (the beating up of the Irishman); B (the wrecking of the Alexanders' home); C (Alex in his parents' apartment); D (the fight between Alex and Dim). These are all repeated again in the following order: C (Alex returns to his parents); A (Alex is recognized by the Irishman); D (his former droogs, who have become policemen, find Alex); and B (Alex's second visit to Mr. Alexander). There is also the ironic "healing" of the hero/narrator at the end of the film, a healing that is made tangible through its similarity to (rather than a reversal of) the reprise. Whereas the incidents in the two previous series are opposed like the two halves of the clock face or the orange, at the end of the film, conversely, we have gone around the circumference and returned to the same type of erotic vision that Ludwig van Beethoven's Ninth Symphony evokes for Alex.

Stylistically, there are many circular misadventures: a round bowler hat on a round head, the single eye with a fringe of eyelash drawn on Alex's wrists (making the eye a clockwork wristwatch); later, Alex's eye, which he is forced to keep wide open with clips that ironically recall his false eyelashes, seems to be a replica of his round head with spiky hair; mothballs or billiard balls; the prisoners in a circle; women's breasts, particularly Mrs. Alexander's, which they "peel" like an orange, etc.

But the film is circular in other more subtle ways. Let us suppose; for example, that the moviegoer becomes disgusted by the violence in the first part. The next part of the film teaches the audience that reacting to violence through physical disgust (whether caused by drugs, a conditioned reflex, or simply education) is an amoral attitude that is extremely suspect and must be rejected. This presents the audience with an ironic contradiction. (I am not addressing here those in the audience who identify and sympathize with Alex, which is clearly the case for much of the young male public. This is a rather serious situation, because they don't get the

Malcolm McDowell (left) in Stanley Kubrick's *A Clockwork Orange*. 1971

basic irony of the film and can only maintain their fascination for Alex by forgetting that their hero is ridiculous for the rest of the story, including the ending.)

Let's take a more specific example. When Alex goes into treatment the first time, treatment to make him "good," he mentions that the film he was shown, a savage beating, was part of the tradition of Hollywood realism (the reference to Hollywood is not made in the Anthony Burgess novel), and he comments: "It's funny how the colors of the real world only seem really real when you viddy them on the screen."

By leaving Burgess's sentence in Alex's mouth, Kubrick himself tends to destroy the illusion of the film's reality (in this instance, an unreal reality because it has to do with the future, but never mind) after establishing it in the opening. Although we first believed in the existence of the Korova Milkbar because of its beauty and strangeness, and the disquiet it elicited in us and in the world of *A Clockwork Orange*, our belief is challenged within the film itself.

Any public that applauds violent or erotic passages therefore fails to understand that the subject of the film is the audience itself. The real subject of *A Clockwork Orange* is, in my view, neither the futuristic vision of the first part, nor the largely traditional satire of a world we know well because it is our world (in the second part). *A Clockwork Orange* is not a remake of either 2001 or *Dr. Strangelove*, but rather an ironic game of reflections between the public and the object of the public's fascination (sex, violence).

The film is a mirror held up to the audience in which they willingly recognize themselves without necessarily believing that they are being caricatured or even ridiculed by Kubrick. Something similar happened in Bertolt Brecht's *The Threepenny Opera*, about which Hannah Arendt says, in *Origins of Totalitarianism*, that the play presents gangsters as respectable businessmen and vice-versa, an irony somewhat hidden from any respectable businessmen in the audience who considered the play to be a penetrating view of the realities of life. Most people felt that the play was an artistic acceptance of gangsterism.

It is on the stage of a theater, to the music of Gioacchino Rossini's *Thieving Magpie* that the third sequence of *A Clockwork Orange* opens. Billy Boy and the members of his gang, undressing a girl to rape her, look like nothing more than robots (giant marionettes are indeed present on the stage): the organic hemisphere of the film (orange, violence, and sex) is reduced to the clockwork hemisphere (pendulum, brainwashing). The music and the theatrical setting, nicely framed by red curtains, have a distancing effect; likewise, in the next sequence, the fight between the two gangs is outrageously and deliberately choreographed like a ballet. It is clear that Kubrick is telling us that we are watching stuntmen and not hoods. In short, the satire touches lightly on its apparent object (the world of tomorrow or today) and then returns against itself and shatters its own mode of expression.

This clarifies the many references in *A Clockwork Orange* to other films. Is the inordinate ambition of *A Clockwork Orange* to be to the history of the cinema writ large what Arthur Penn's *Little Big Man* is to the Western? There is, for example, the physical resemblance—basically established through makeup, i.e., artifice—between Alex and the young "hero" of Luchino Visconti's *The Damned*. The modern cinema, with its undeniable predilection for topics dealing with fascism, would appear to indicate a genuine progression from *The Damned* to Bernardo Bertolucci's *The Conformist* and then to *A Clockwork Orange*. The general preoccupation with historical fascism is underscored by the use of the old German films that Alex is shown when he is in

treatment. If Visconti's Wagnerian style is riddled with futuristic flashes of brilliance, which become irreverent in Bertolucci, then the process becomes systematic with Kubrick's strokes, which are more like collage or Pop art, though he uses more intellectual materials than the latter (quite literally, the "Pop" Christs in Alex's room are filmed in pure meccano montage à la Sergei Eisenstein). It is clear that Kubrick is close to his European counterparts, if only through the musical complexion of his work. In addition, it struck me that there was an echo of Bertolucci (Jean-Louis Trintignant finding Pierre Clementi in the Roman lower depths) in the scene in which Kubrick has the tramps hitting Alex with sticks.

Alex's mental flashes, or erotic-sadistic visions, are straight out of the movies. One of the obvious examples is when he is reading the Bible in prison and first imagines himself as a Roman centurion whipping Christ, and then as an Old Testament king enjoying the repose of a warrior, voluptuously lying among grapes and Hebrew servant girls with pink breasts and gazelle eyes, redolent of *Scheherazade.* The sequence is reminiscent of a film by Cecil B. DeMille and recalls the old idea that the public only went to see Bible movies to sate otherwise illicit desires. Here *A Clockwork Orange* gives people whips to have themselves beaten: will the public be applauding a satire or simply getting an eyeful?

At other times, the doings of the four droogs lead us simply to the extreme conclusion of a clockwork logic, like that of the Beatles in *Help!* or of Gene Kelly and company in *Singin' in the Rain,* or the Marx Brothers: it's Harpo with the scissors just before Mrs. Alexander is raped.

It would similarly be appropriate to examine a number of the relationships between *A Clockwork Orange* and Kubrick's earlier work, which is not immune from the general atmosphere of parody. The clown masks worn by the hooligans are an old trick from gangster movies, and Sterling Hayden wore a clown mask in *The Killing.* The mechanisms of political oppression were analyzed in *Spartacus.* Here, no one can take seriously the absurd dilemma between the hoodlums and the police state (because the two are interchangeable) or between reactionaries and liberals (also interchangeable), the liberals tending to be rich, unprincipled, and full of contempt for "the masses": these are merely variations on the theme of the mirror or the circle, if you will. Everything is an echo of something else. Mr. Alexander as a double hypocrite of Alex, who has been made temporarily allergic to the suggestions of Ludwig van by the administration of the Ludovico (treatment) drugs. As for Mr. Alexander, the doorbell at his "home" plays (in the film) the first few notes of the Fifth Symphony, and as he is savoring his vengeance after having Alex locked up, he looks like a living bust of Beethoven.

At the end of the film, in a hospital setting, when the almost resuscitated Alex has a stereo delivered to him as a kind of settlement of his account with the Ministry of the Interior/Inferior, the scene, stylistically and thematically, looks like an absurd echo of 2001: it is Keir Dullea having crossed over after death and become a Superman in his rococo apartment, with his new companions keeping him well fed and soothed by music. Insofar as *A Clockwork Orange* is a satire, it resembles *Dr. Strangelove,* but its eroticism and evocation of the world of the nadsats, or teenagers, in opposition to adults, remind us more of *Lolita.* In the record store displaying 2001 posters, two Lolitas suck on phallic soothers, only one of which is in erection: a barely veiled allusion to the image of Sue Lyon sticking out her pink tongue. (In passing, we regret the failure of the next scene, in which Alex and the two nymphettes

make love over and over again in speeded-up action, to the sound of the *William Tell Overture*, a sequence that is too explicitly mechanistic and so distanced from the audience as to be like burlesque. It suffers considerably in comparison to the equivalent scene in Michelangelo Antonioni's *Blowup*.

Kubrick's intention is thus not for the audience to identify with Alex, but to see retrospectively that they are in the same situation as Alex, if they are to believe what they are watching. When he sees that Alex has been cured, the Minister introduces him to his public exclaiming, "But, gentlemen, enough of words. Action speaks louder than. Action now. Observe, all." Once again, the expression, from Burgess's novel, takes on a different tone in a filmic context. Some *William Tell* music once again introduces the commedia dell'arte that follows: Alex licks the boots of a brutish and well-dressed person (a bolshy big chelloveck), grovels at the feet of a naked devotchka (girl), a futuristic apparition with long platinum hair and tanned groodies (breasts), and then the two salute the audience professionally and formally, indicating that Alex has been the ridiculous victim of a staged scene. (He, of course, gets his revenge in the mental flash that closes the film. We see him making love in slow motion with a girl whose arms and legs are sheathed in black. Hollywood yet again: the snow is artificial, and the audience, dressed as if they were in the Ascot sequence of *My Fair Lady*, applauds Alex's performance. In his own eyes, Alex's eroticism is mostly a show.) But what about us? Our fascination for the opening of the film—or for the apparition of the platinum blonde—is also frustrated and even ridiculed.

Frustration is one of the key themes of *A Clockwork Orange*. We find ourselves here in the middle of a satire that is no doubt most interesting, a world in which art is no longer a sublimation of sexuality, but merely a stylized representation of it, not metaphorical, at the same time as morality continues to be theoretically attached to an obsolete Puritanism. Among these stylistic and satirical successes I would include the set of the Korova Milkbar, with its furniture shaped like naked women whose breasts spout the milk of artificial paradises (here, as in the scene in which Mrs. Alexander is raped, Kubrick was able to find the perfect visual equivalents for the teenagers' obsession for breasts in Burgess's novel); there is also the Alexanders' "home" (where Mrs. Alexander plays the same purely decorative role as the *objets d'art*, whereas her husband spends all of his time playing the pseudo-intellectual); Alex's room, in which a phallic snake makes love to an obscene drawing, and, in particular, sated with provocative but evasive sexuality (intellectualized, and thus maintaining its status as an *objet d'art*, and hence untouchable), the Cat Lady's house, the theater for the symbolic battle between the phallic sculpture (literal sexuality) and the bust of Beethoven (sublimated sexuality). The Cat Lady is ritually pierced, and Kubrick, rightly renouncing the false realism of spilled blood, cuts to the geometric garish mouth of a painting.

At other moments, the satire plays on the juxtaposition of stylization and realism. Sometimes this succeeds (for example, in the futuristic and highly British dress of the four droogs), but sometimes it is less satisfactory; for example, one does not know quite what to think of Alex's parents' apartment, not only the contrast between his mother's acid wigs and the English tea and cakes, but also the atrocious nudes hanging on the walls. The hideous colors are no doubt deliberate, but nonetheless hideous, coming up considerably short of style.

I would criticize the film for being merely realistic and failing to stylize the char-

acter of the drunk who sings "In Dublin's Fair City" and in particular the long prison sequence, which is admittedly effective, but whose atmosphere is more evocative of the 1930s than the 1980s. Kubrick's intent was no doubt for the prison to resemble a gigantic clock, but time does not go by very quickly there. The episode is saved in extremis by the visit from the Minister of the Interior, ironically accompanied on the soundtrack by Edward Elgar's "Land of Hope and Glory," closing on the procedures followed by the warder, which are performed like a clockwork mechanism.

Burgess's novel had only one level upon which he could distance what was happening and make it humorous, namely, the nadsat language. Kubrick's film does more than keep the language; it also increases its expressive power by giving it the voice of Malcolm McDowell speaking to his only and faithful friends, an imaginary plural for a reader, with the voice of the narrator now aiming directly at an audience in a movie theater. At the same time, Kubrick strengthens the effect of the distancing with the veiling device of the off-screen voice and a multitude of other veils: music especially, sometimes classical, sometimes electronic, sometimes both together (the Ninth interpreted by Walter Carlos), used ironically rather than its heroic use in *Space Odyssey*. But also visually, by distorting things with wide-angle lenses, which are used frequently, and with the style of play, grimacing and neurotic, of Deltoid drinking water through his dentures or Mr. Alexander, bright red, serving Alex drugged Bordeaux. The use of these many veils strengthens the impression of the falseness of the film as an object, and by the end what remains is the audience's basic frustration, sitting there as voyeurs and powerless, but laughing about their own fate.

1. A brief summary of *A Clockwork Orange* would be useful here. We are in England in the not-too-distant future. Alex, the hero/narrator, is the leader of a gang of teenagers known as droogs whose interests tend toward extreme violence and rape. We see the gang in action under a number of appropriate circumstances. Alex has a passion for Beethoven, which acts as a powerful stimulant on him. Unhappy with him, his acolytes turn him in to the police. In prison, he learns that the government is experimenting with releasing criminals after giving them medical treatment (the Ludovico treatment). He volunteers and becomes virtuous through conditioned reflexes. After being granted his freedom, he becomes the victim in a string of retaliations and falls into the hands of the opposition, which wants to use him for political purposes; he escapes death by the skin of his teeth, is "healed" by the government, and returns to being vicious again, and even more brutal than ever. A word about the language, nadsat: the slang used by Alex and all the adolescents of his era (nadsat = teenager). The language is largely based on London Cockney rhyming slang; he borrows many words from Russian, and sometimes combines them with English the way Lewis Carroll or James Joyce did with "portmanteau" words.

No. 136, May 1972

A Clockwork Orange. 1971. UK. Written, directed, and produced by Stanley Kubrick, based on the novel by Anthony Burgess. Cinematography by John Alcott. Music by Ludwig van Beethoven, Edward Elgar, Gioacchino Rossini, Terry Tucker, and Erika Eigen. With Malcolm McDowell (Alex), Patrick Magee (Mr. Alexander), Michael Bates (Chief Guard), Warren Clarke (Dim), and Carl Duering (Dr. Brodsky). 137 min.

THE REAL TRUTH

Death dominates Francesco Rosi's films just as it dominates American detective films, its original source of inspiration, as seen in *The Challenge* (*La Sfida*). Very soon, however, with *Salvatore Giuliano*, death takes on special meaning. The murder of a Sicilian bandit (*Salvatore Giuliano*), the collapse of a building on its inhabitants (*Hands over the City* [*Le Mani sulle Città*]), the goring of the toreador in the ring (*The Moment of Truth* [*Il Momento della Verità*]), exemplary executions (*Many Wars Ago* [*Uomini Contro*]), and the airplane "accident" (*The Mattei*

The Mattei Affair
Michel Ciment

In the constellation of political films about the 1960s and 1970s, Francesco Rosi's films very soon appeared as a model to be followed, not only in terms of his narrative method but also his lucid analysis and refusal to preach. *The Mattei Affair*, which won the Palme d'or at Cannes in 1972, was given a threefold analysis in *Positif* to highlight its aesthetic and ideological strengths; one of these analyses appears below.

Affair [*Il Caso Mattei*]) are all jolts, shocks with the same impact that natural disasters once had, mythological, usually negative, and sometimes ambiguous. Rosi successively presents these myths (the modern Robin Hood, the economic boom, wild social success, the fight for national unity, a nation's independence through the action of a single man), and then patiently dismantles them. Death also evokes destiny, but instead of accepting it, the filmmaker defies it by exposing its workings, destiny no longer a supernatural and immutable force. As Ernst Fischer commented, "In modern myth, destiny is indeed 'politics' in the broadest sense, in other words, man's struggle to maintain or change this world of national, economic, and social relationships that he created, and whose total alienation wears a mask borrowed from ancient destiny."[1]

In Italian history in this century, destiny is rooted in the deep southern part of the country: Rosi, in any case, constantly returns to this open wound at the foot of the peninsula. Significantly, the two deaths in *The Mattei Affair*—the death of the engineer (following a suspected sabotage at the Catane airfield) and the death of the reporter, De Mauro (kidnapped in Palermo and assassinated by the Mafia)—are set in Sicily. We all know violence is born of history, but never so plainly as in this land where the old must give way to the new, where underdevelopment and an agrarian society await entry into the industrial era and prosperity. Although Rosi may geographically leave the south (*mezzogiorno*), he returns to it again in the southern peasants fighting against their will on the rocks of Carso (*Many Wars Ago*), in the door-to-door salesmen from Naples earning their living in Germany (*The Swindlers* [*Il Magliari*]), in Miguelin, who leaves his familiar countryside for the city (*The Moment of Truth*), and even in Mattei, son of a poor state policeman who leaves Sicily to become a worker and then head of a company.[2] Here is where we gain insight into Rosi's bias in *The Mattei Affair*.

Among the host of topics he could have examined, he chose underdevelopment, expanding it for the first time in his work to a global level. He evokes, suggests, and sometimes comments on domestic politics, but in two hours, rather than get bogged down in party squabbles, Rosi decides to tackle head-on the major problem of our time: the exploitation of poor nations by the rich. No matter whether or not Mattei was trying to liberate a colonized people; Rosi has little time for psychology or

Gian Maria Volonté in Francesco Rosi's *The Mattei Affair*. 1972

personal motives. The boss of ENI [largest oil company in Italy], by brandishing the threat of a general Third World uprising, intended to frighten and make his Anglo-Saxon listeners give in, which is not to dismiss his sympathy for the exploited countries that he compares to Italy in terms of its economic submission and its own underdevelopment. Of particular interest to us is that *objectively* he was able at some point to become the instrument of history and give an impetus to a number of changes by breaking the oil monopoly, the fifty-fifty rule, or by helping the FLN [National Liberation Front]. We hear the filmmaker's voice in the end when, after all is said and done and the images of the aircraft debris reappear on screen, we listen as Rosi repeats for his own benefit and for viewers, the voice and words of Mattei: "If I don't succeed, the people with the oil under their feet will," thus drawing a general political lesson from the events.[3] The critical realism that characterizes Rosi's films never disappears, but is placed in greater jeopardy by the unquestionable complexity of the problem and the ambiguity of a character at the center of the screen in equally contradictory situations.

Putting his method to the test against the greatest odds, the filmmaker also questions it—hence the accusations against him of a fascination that we will discuss later. But for the first time and in his eighth film, Rosi himself appears in his work, like Federico Fellini through Marcello Mastroianni in his admirable 8 1/2 (though Rosi is oblivious to half-measures and knows no *mezzo* [middle], as we said before, but the *mezzogiorno*) and in doing so underscores a question about the ends and means of his art. *The Mattei Affair*, perhaps the most accomplished of his films, offers up many kinds of investigation—the filmmaker's favorite figure of style—a reporter's investigation into the Bescape accident, relayed through McHale's investigation into Mattei's life, the liberal reporter's investigation of his political ideas and, finally, the investigation by a group of reporters into De Mauro's disappearance, all combined with the director's own investigations into his film, the death of his character, and his collaborator.

The idea of a relay is also underscored by the arrangement of the story: De Mauro's elimination sets off the search again and enters the narrative at the point where Mattei has just mentioned that after he is dead and gone, the people with the oil will carry on the fight. The debate continues, the fight is not over: today, talk of Mattei persists because Rosi decided to make a film on the subject, but killing still goes on to keep the Mattei affair quiet. This cyclical construction, prized by the filmmaker, far from being an admission of powerlessness, reflects the tireless questioning of the scandals of our time. Using an investigative format, Rosi also avoids the pitfalls of imitation, of the hermetic story that viewers are expected to accept as an intangible whole. The film becomes an open and incomplete system. "This imperfection somehow involves the observer in the work process for it arises from the artistic process, conceived as gradually evolving rather than carved in stone. The artistic process does more than alter the object; it alters the artist as well who strives (consciously or unconsciously) to alter the recipient of the artwork."[4] Reality evolves, and the search itself causes it to evolve. As the film proves from the inside out, the filmmaking process changes the outlook on Mattei's problem.

Lorenzo Codelli has astutely explained Rosi's thoughts on newspapers and television, media that filter or distort historical events for the general public, ideas that make *The Mattei Affair* one of the most fascinating films ever made about the press.[5] Rosi, although aware that he in turn is offering viewers an image and hence a trans-

position of reality, tries to lift the veil and engage in the most lucid analysis possible, convinced, like Niccolò Machiavelli, that, "it is more useful to search out the actual truth of things than what we imagine it to be." The reference to Machiavelli is all the more appropriate considering that the Florentine secretary was admired by the leading Italian Marxist of this century, Antonio Gramsci. For Gramsci, Machiavelli exposed the mechanisms of power, showing politics as a self-contained activity, with different principles and laws from those governing morality or religion and, in doing so, proved that he was writing for the middle class, the class that "doesn't know," that has no political experience. "He taught this class the means it had to use to take power from those adept at Machiavellianism, from the princes. He let the cat out of the bag, disclosing what had to be done and what had to be kept quiet."[6] Rosi operates in the same way: he shows what is not supposed to be seen, exposes naked facts, stripped of pretense, in a genuinely materialistic approach to film. His films, like Machiavelli's *The Prince*, are about men of action, destined to be seen and talked about, and not a detached theory on the contingencies of the times. By filming men, the levers of history, and the workings of power and economics as they are, devoid of romanticism, and not as we would like them to be, he laid the groundwork for the political film. In Machiavelli's *The History of Florence*, Giono perceived the tone of an evening newspaper, and in his *Discourse*, the equivalent of a radio program. "It's the first examination of man, and perhaps the only purely objective one: a study of passion conducted free of passion, like the examination of a mathematical problem, with a fundamental concern for accuracy and truth and the absolute rejection of that which must be accepted without evidence."[7] Rosi looks at the politician with the eyes of an eagle, the way Fritz Lang looks at adultery and crimes of passion, or Joseph Losey relationships of submission and domination.

But Rosi is an *involved* spectator, as he himself says, and this is where the comparison with Machiavelli ends. The latter was limited by his empiricism, his disdain for the masses, and his refusal to judge.[8] We perceive Machiavelli no longer in the painter but in his model, the modern prince, driven by a single force, and for whom the ends justify the means, in other words, demagogy and corruption ("I use them like a taxi, I get out and I pay"), all action legitimized by the chosen political goal. And this goal, for Mattei, is economic independence, as for Machiavelli it was the creation of an Italian kingdom united against its enemies, France and Spain. In both cases, Machiavellianism is the political science of weak nations surrounded by powerful neighbors in the same period of transition (Renaissance, industrialization). But practice sometimes being imperfect, the author of *The Prince* (a coalition of small Italian states) or the president of the ENI (alliance with Arab countries and political guerillas in Italy itself) is undermined when confronted with the force of interventionist powers, foreign armies in times past, and oil cartels today. Mattei dies in a plane crash and even though he wasn't killed by anyone, his assassination was inescapable. He is similar in that respect to the hero of John Boorman's *Point Blank*, anachronistically representing American individualism in solitary confrontation with the Organization and emerging from the battle victorious; Mattei, a Renaissance hero, the new St. George fighting the seven-headed dragon (the seven sisters of the oil industry), cannot triumph through individual action. Too often we forget that Rosi is telling the story of a failure rich in meaning: the people who have the oil can liberate themselves, but no man can do it for them.

Mattei's death, not Mattei himself, is the real subject of the film. His death

discloses the flagrant injustice; De Mauro's death is the second disclosure, the disclosure of the disclosure. I therefore think that criticism of Rosi for trying to exalt Mattei is wrong. Granted, Mattei had positive value at some point in history: he expressed Italian patriotism (hence the support of the PCI [Italian Communist Party], for example), but we do not think that Rosi confused the character's historical value with his current political value, much less his everlasting theoretical value, precisely as Gramsci was scolded about Machiavelli.

In the contemporary Italian context, certain transalpine critics hotly argue about the ambiguity in Rosi's portrayal of Mattei. I think for the most part that he maintained a critical distance, not only through the disturbing portrait of an emerging megalomaniac, but especially in the construction of the story and the moral of the fable outlined above: individualistic temptations, regardless of the nobility of the undertaking, are doomed to failure. Far from reproaching Rosi for the absence of "the people" in *The Mattei Affair*, we see this absence more as evidence of his honesty and insight. The people, present in *Salvatore Giuliano* not only in the field of action (state police, Mafiosi, and peasants living side by side) but also as a third-rate force, are already pushed to the background and mediatized by the Naples city council. They are victimized by the maneuvers of the Christian Democrats and construction magnates in *Hands over the City*, and are excluded from the circles of power and the global economic problems in *The Mattei Affair*. Rosi is not Damiano Damiani or Elio Petri.[9] He is not part of a workers' movement for "social action" (the problem of salaries in *The Mattei Affair* is "solved" by the engineer's remark about international competition!), but prefers to show working viewers what happens out of their sight, what is hidden from them, and what determines their fate. Similarly, Rosi does not insist on the assertion that the end justifies the means. He merely shows that it governs our society, and perhaps every society past and present. People must create a system in which, as Lenin intended, the end dictates its own means. An artist cannot do it for them.

The Mattei Affair is not a film above controversy. The scope and complexity of the issues it explores make it Rosi's most challenging work and most likely target for criticism, yet it welcomes debate and discussion. By focusing on the contradictions of capitalism and international struggle especially, he chooses an approach that he considers the most productive and the most polemic, and undoubtedly the most progressive. We can always try to remake the film in his place and fault him for not addressing the relationship between private capitalism and state capitalism, or between politics and technocracy. There is also some doubt as to whether he gave in to a fascination with the character, a fascination that had to be shown, like the more extensive and convincing fascination with Nottola in *Hands over the City*, but which can detract from critical distance. Quite likely no work of art of any consequence is without some contradiction or mystery. *Salvatore Giuliano*, a good example of the destruction of a myth through the absence of the main character, by this very absence became a supreme mythification for Sicilian viewers.[10]

Hands over the City, rejected by the Italian far Left when it came out because it played along with traditional politics, is seen by some militants today as proof that the parliamentary path is a dead end. The broader the outlook on the world, the more a work's historical future opens the field to other possibilities. Some political films that also take a realist approach are self-contained statements offering clear, simple answers. Their immediate impact and strategic utility cannot be dismissed,

and neither can the reassurance they offer viewers or the inevitability that they will age badly. Rosi's films, however, are an ongoing questioning; they are the "historic possibility projected into the future from the past and present."[11] And this is where the imagination discarded by Machiavelli comes into play, not imagination that generates lies and error, but the incisive imagination of the artist seeking intensity and concentration, visual imagination that supports logical, fact-based arguments allied with reason. In such protracted debates like those raised by *Hands over the City* or *The Mattei Affair*, we too often overlook the deep beauty of the films, some going so far as to call them documentary. Rosi, while satisfying the modern need for truth and authenticity (hence the public fondness for briefs, reports, live broadcasts, etc.), spurns superfluous detail and anecdotal meandering, aiming instead for concision, the meaningful poetic image that expresses the author's subjectivity—a subjectivity already apparent in the choice of themes. Rosi meets Marx's requirements in his first thesis on Feuerbach: "As yet, the main flaw of materialism is that it perceives only the object, reality, the world of the senses, in the form of an *object* or intuition, not as *tangible human activity*, not as practice, in a subjective way."

Thus, in the mud and dark of the night, as searchers look for the body of the man who tried to triumph through oil but ended up perishing in an airplane fire because of it, we are reminded of the same mud and darkness that shrouded the combatants in *Many Wars Ago*. A white sheet and a few bones are all that remain of the new Caesar. The thundering music of Piero Piccioni, and a man still dressed and awake at six-thirty in the morning in a hotel room, looking bleary-eyed in the bright morning light, become the anguished expressions of death. All the fear and fascination surrounding modern technology are summed up in the shot of women peasants watching the oil flame burn in the night, and their desperate flight. The meeting between two men at dawn in the Dome square, shot at a slightly low angle, provides an account of the protagonist's frantic activity. The only visual reference to Mattei's private life is his wife collapsing into the arms of his "successor," thus recalling his public importance. Rosi eliminates the superfluous and goes straight to the essential. Among a hundred directorial ideas, we could mention the Eisensteinian metaphor inserted into the story, when the red-faced American financier, chewing a mouthful of food, becomes a symbol for the watchdog who breaks the kitten's back in the story Mattei enjoyed telling, or the lakeside sequence where Mattei listens to the tape recorder tell the story of his life.

At a time when abundance and accumulation are triumphing, Rosi searches for precision and concentration. For him, film is not only a commentary on modern objects, it adopts the form of the objects. Who has shown more powerfully (apart from Boorman in *Point Blank*) this world of polished, shiny surfaces, glass buildings and their lighted windows, airplanes, helicopters, and cars, telephones and hallways, the bustling of teletype machines and screens? The film echoes the pure form of the scenery it depicts: the juxtaposition of different structures, sensitivity to diverse proportions. A steel framework of relentless severity supports glazed surfaces that reflect every color of the rainbow—the green of the Italian countryside, the dark red of the Tunisian desert, the terra-cotta of Abadan, the cloudy sky of a trip in a twinjet aircraft. Among active filmmakers, I see only Losey, Boorman, and very few others who could achieve such intense shots, such nervousness in the pace of editing, such power in the direction of actors, such precision in the telling of a story. Another exploration of the past, in Federico Fellini's *Roma*, led to talk everywhere

of genius, and rightly so. But to see genius only in flights of imagination, however admirable, is to give in to a romantic view of the artist. In architecture, we have Antonio Gaudi, his extravagant constructions in the Sagrada Familia, and the phantasmagoria of the visionary. We also have Ludwig Mies van der Rohe, his search for purity, for an expression of increasing intensity and of the vitality of space. Genius can also be an affirmation that art is discipline, or that "less is more" to coin the words of the German architect. There is some Mies van der Rohe in Francesco Rosi, and *The Mattei Affair* could be the Seagram Building of modern film.

1. Ernst Fischer, "Eloge de l'imagination," in *À la Recherche de la réalité* (Paris: Denoël, 1970).

2. *More than a Miracle (C'ero una Volta)*, a story set in Naples, is no exception and cheerfully has more ties than we might expect to Rosi's other films, if only in its references to popular myths.

3. On Rosi's film, see Francesco Rosi and Eugenio Scalfari, *Il Caso Mattei* (film review and historical study) (Bologna: Cappelli, 1972).

4. Fischer, op. cit.

5. See Lorenzo Codelli, "Das Kapital," *Positif*, no. 138 (July–August 1972).

6. Georges Mounin, *Machiavel* (Paris: Club français du livre, 1958).

7. Niccolò Machiavelli, *Oeuvres complètes* (Paris: Gallimard, 1952).

8. For criticism of Gramsci's theories with an insightful exploration of Machiavelli as a revolutionary and precursor to Marxism, see the highly convincing theories of Mounin, op. cit.

9. Rosi's films should not be confused with those of certain imitators. He differs in the method and level of success. We prefer Damiani's *A Bullet for the General (Quien Sabe?)* or Petri's *We Still Kill the Old Way (A Ciascuno il suo)* and their indirect comments to Damiani's *Confessions of a Police Captain (Confessione di un Commissario di Polizia al Procuratore della Repubblica)* or Petri's *The Working Class Goes to Heaven (La Classe Operaia va in Paradiso)*, which exploit the popularity of political cinema.

10. See Paul Louis Thirard, "L'Africa a Casa," in *Positif*, no. 53 (June 1963).

11. Fischer's definition of "myth" (op. cit.): "a state of balance between 'this is how it is' and 'this is how it could be,'" a formula perfectly suited to Rosi's films.

No. 138, July–August 1972

The Mattei Affair (Il Caso Mattei). 1972. Directed by Francesco Rosi. Written by Rosi and Tonino Guerra in collaboration with Nerio Minuzzo and Tito Di Stefano. Cinematography by Pasqualino De Santis. Music by Piero Piccioni. Produced by Franco Cristaldi. With Gian Maria Volonté (Enrico Mattei), Luigi Squarzina (Newspaper Man), Peter Baldwin (McHale of Time magazine), Renato Romano (Newspaper Man), Gianfranco Ombuen (Engineer Ferrari), and Edda Ferronao (Mrs. Mattei). In Italian. 115 min.

INTRODUCTION

This study concerns the film *Sleuth* by Joseph L. Mankiewicz and does not make reference to the play by Anthony Shaffer for three reasons. A comparison to the text of the play offers little elucidation. In conversation with Michel Ciment, Mankiewicz mentioned the key role he played in developing the script and writing the dialogue.[1] Moreover, the subject of a film consists of what appears on screen: examining the original material falls more often to historical criticism.

This study was written before the author was aware of the conversation with Mankiewicz. The quotes herein were added later to illustrate certain points. Readers may well consider certain encounters as fortunate twists of fate that sometimes guide critics.

Little Red Clown: *Sleuth* by Joseph L. Mankiewicz

Alain Garsautl

In the latter part of their careers, Billy Wilder, Joseph L. Mankiewicz, Elia Kazan, and John Huston often saw their works neglected or treated as passé. Making classic films in an era of great artistic upheaval is the reason for this lack of interest. At *Positif*, on the contrary, we were struck by the fact that these great filmmakers were making superlative works. *Sleuth*, Mankiewicz's last film, is indeed a classic example of this.

THE GAME: ANDREW WYKE

Games are a vital component of the film and, for Mankiewicz, of life: "What fascinates me is the idea of games, the game inside the game, and the fact that after we play for a long time, the game ends up playing us." As he did with other components, Mankiewicz insisted on including obvious signs of this game. The interior of the Wyke home is filled with games, some even in the drawers of the furniture. These games have two things in common: they are all somehow intellectual and all somehow related to the detective novel—puzzles, chess, and so on. They set the tone for the kind of relationship that will later emerge between Wyke (Laurence Olivier) and Tindle (Michael Caine). This first sort of game introduces the childish, theatrical games that Tindle will be asked to play: dress-up, charades, "handkerchief." The second kind of game is a prelude to the third, the detective game, "entertainment for the elite," which makes way for the fourth, the game of staging, the ultimate disguise for the most important game: the game of life. The games are similar in their mechanisms: a close and constant pairing of detail and essence, small and large, is a fundamental aspect of the film's composition.

The detective game leads back to life precisely through the game of staging. Wyke takes to the stage through literary creation and the dual ideal he created for himself, "that great detective, Sir John Lord Merrydew." For him, there is no separation between creation and life. Not only does he perform the various roles of the imaginary characters he invents as he dictates his novel, but he constantly sees himself as a character too. The fact that he writes detective novels is merely a natural outcome of this duality. Mankiewicz reverses certain basic ideas about character and frees the subject of certain arbitrary constraints: Wyke is no longer a detective novelist who decides to live an episode of his life like an episode from a novel, but rather

someone whose general attitude, among other things, leads him to a career as a detective novelist.

Wyke stages every moment of his existence: after the success of his first intrigue, he prepares himself a snack with all the pleasure of a maître d'hôtel. He enjoys the perfection of his performance as much as his anticipation of the food. The hedged labyrinth, the elaborate decoration of the living room, and many other details are more than a mere reflection of his megalomania. Wyke lives in the midst of a permanent set, and all of its elements are vital to his successive performances, some reassuring him of his fame, like the framed dust jackets of his books. The house is a theater, complete with stage, box, and wings.

At first, he views Tindle's appearance in his life as the promise of a playmate and a partner, but this playmate has no idea of the role that Wyke intends to make him fill. His face-off with Tindle reveals the sadistic, staged nature of the game. To play and to stage is to impose one's will on others. The winner's enjoyment derives from leading, where and how he pleases, another person or entity (fate, for example) who thought he or it was acting or seemed to be acting in complete freedom. The game and the staging pose a continual challenge to the mind. We must anticipate our adversary's thoughts to outwit and play them. The games mentioned earlier are based on this principle, like the game of the detective novelist with the reader and the reader with the novelist. Wyke can only write detective novels that center on a puzzle, where the mechanism of the riddle must take priority following the precepts of his theoreticians (S. S. Van Dine, Dorothy L. Sayers). And finally, there is the game of the film director with the audience and the audience with the director. Starting from a conventional premise, Mankiewicz gains victory by unraveling the details.

Wyke is also an actor who enjoys acting no less than writing: this is the second, complementary side of the character. When Tindle makes Wyke hunt down the clues intended to convict him, Wyke is delighted; he is playing, he has a playmate. He feels a deep, erotic satisfaction to be possessed and to offer up a performance. Tindle watches him with disgust. The actor's masochism complements the director's sadism. The game of the director and the actor is a model for the interaction between Wyke and Tindle. For Wyke, the exercise logically ends in fraternization. Once the game is over, differences, bitterness, and vengefulness are forgotten. But Tindle gains a victory. Wyke suggests they go farther, this time taking the world for their unwitting playmate.

Wyke's entire life is organized around games and games within a game. He refuses all direct contact with reality. The game is a filter and a screen that allows him to control his contact with reality, where he plays the role of master, executioner, and spectator. Wyke lives in a world of illusion. The film begins with Tindle entering a labyrinth, which also represents Wyke's inner world, where he finds Wyke cloistered in its geometric center. Their departure from the garden suggests a conclusion: with the camera following his movements, Tindle loses all contact with reality other than the reconstructed reality of Wyke. The interior of the house reflects Wyke's solitary existence. No trace of a woman's touch here; the games can be played by one. Wyke lives here with the perfect contentedness of a bachelor, or an actor so accustomed to a play that he knows the exact location of every object.

At the start of the second part, the disorder created by the staged burglary is completely restored. With the servants away, Wyke is naturally the one who tidied up. The puzzle that was unfinished when Tindle arrived is now complete, as if the confrontation was over, and with Tindle gone, everything could return to normal and every

Laurence Olivier in Joseph L. Mankiewicz's *Sleuth.* 1972

imperfection disappear. A long, sweeping shot captures this restored order and gives audiences a glimpse of his minute attention to detail. The set conspires to maintain the illusion and offers opportunities for play. In the office, the safe is concealed behind a dartboard that opens by throwing the darts; the décor in the family room is an illustration of Wyke's mental universe; the four sides and optical illusions accentuated by the camera counter the impression of a theater stage; empty space and the somewhat overblown architecture counter the impression of realism. The mechanical puppets, as if aware of Wyke's incessant performance, serve as spectators. With the help of the sailor, Wyke gives himself approval. His basement contains small-scale models depicting crucial moments from each of his novels. The entire house is the very same theater: two still shots, outside and inside the house, mark the beginning and end of the film. The first act ends with a tableau similar to the models; the last act places Wyke back among his own characters. The film seems to exist between two of his fantasies. The only place that Wyke and Mankiewicz conceal is the master bedroom.

A child who reigns over a kingdom of his construction, in mind and in deed, Wyke would only allow a stranger to enter to prove his superiority in every way: "Life crashes [in] on [his] personal fantasies." The first part sets out to prove this point. Wyke intends to win the game, in other words, to fully involve another person in his fantasies. The scenes he devises offer various means of crushing Tindle. He relies on outward appearances; vaunting his sexual prowess is not only a defense against his actual impotence, it calls to mind college-day pretense. That he is boasting becomes all the more apparent in the context of a billiard match, a game, and an object which, sexually and socially, provides a clear symbol. During this first match, Wyke treats Tindle as a mechanical puppet and carefully strips him of any human feature; he has him dress up in a clown costume that conceals any facial or bodily features. Neither Wyke nor the audience can see Tindle's fright behind the grinning mask. Wyke wards off any intrusion of reality into the game. When the game is over, he indifferently abandons Tindle as he lies unconscious on the stairway, and busies himself first of all by picking up the scattered pages of his latest manuscript. The game is played for its own sake: winning is the only objective. However, Wyke loses because Tindle is a bad partner, a poor sport.

THE RULES OF THE GAME: WYKE-TINDLE

Tindle is not playing the game properly. He makes himself a party wrecker. This situation affects all interaction between, and every meaning to be construed from, the characters. Tindle's uncooperation emerges once in the action: disguised as Inspector Doppler, he interrupts Wyke's performance as maitre d'hôtel/diner. But Tindle's poor sportsmanship began earlier: when he seduced Marguerite, Wyke's wife (Eve Channing), he disturbed Wyke's universe, spoiled his game. He deserves punishment.

Tindle does not play by the rules. The rules of a game assign each player a function within precise limits. For Wyke, the world has rules, like a game: he never questions Doppler's identity because his physique, attitude, mentality, and language are all perfectly in keeping with the image of a police officer in his novels, hence the physique, attitude, mind, and language of a real police officer. In essence, Tindle's existence disturbs Wyke's life. By his crude behavior, seduction of Marguerite, reactions and refusal to keep playing the game, Tindle becomes an unacceptable obstacle: the obstacle of reality. Wyke's aim is to annihilate him. After a tied match, he tries to entice Tindle back into the game; Marguerite is out of the picture, too material a stake,

and the purity of the game is restored. But Tindle cheats by dropping out of the game. Wyke cannot allow such a breach of the rules. Thinking or pretending to think that the game can still go on, Wyke, out of infantilism, makes a mistake. Tindle triumphs by causing him to commit an irreparable action rooted in reality. Wyke has become a murderer; he did what he so often imagined in his novels, and tried to make a mockery of Tindle. The outside world intrudes for the first and only time in the entire film with the appearance of the police car light, so incongruous that it seems threatening. Wyke can only run away from the light, barricade himself in his home, and cry like a child surrounded by his broken toys. In the end, Tindle puts Wyke on stage, and he could not be more utterly defeated.

THE HUMILIATION: MILO TINDLE

Wyke imposed the most extreme humiliation on Tindle. He showed Tindle the meaning of the test: "The shortest way to a man's heart is through humiliation." Tindle recognized himself. The subsequent action depends on this first ordeal: the first command given in the strictest and most definite way in the whole story. Both are caught up in the mechanism set in motion by Wyke, and neither can stop it. Tindle is obliged to make Wyke suffer what he suffered by the same means. While Tindle discovers that, if faced with death, he would utterly renounce himself, Wyke realizes that he cannot live without playing. Their mutual reactions are equally violent. Each player wants the other, the only witness of his humiliation, to die.

Tindle goes along with the game; he lets himself be manipulated because he is vulnerable to the same tendencies that drive Wyke. He amuses himself with the clown costume and continues to amuse himself with the burglary. In seeking revenge, he dabbles in the pleasures of Wyke. After rediscovering his love of the circus and, by disguising himself, fulfilling a childhood dream, he then discovers his talents as an author, a director, an actor, and a spectator (all the talents of Michael Caine), and the function of these roles. Inspector Doppler (Alec Cawthorne) is a caricature of Tindle just as Sir John Lord Merrydew is an idealized version of Wyke. Tindle accentuates the traits that most set him apart from his adversary and takes revenge for his disdain: Doppler is unnaturally English.

But their reactions differ just as their lives differ. While Wyke thinks the game is over after the second match, Tindle forces another match. The first was not enough to wash away his humiliation. A fundamental difference exists between the attitude of the bad sport, Wyke, and the hate of the loser, Tindle. One is mere childish caprice while the other is rooted in a person's being. Tindle has suffered too much humiliation to view the first ordeal as a game. He must at least give Wyke a double dose of his own medicine without becoming personally involved as a player. This double dose fails to satisfy him. His dissatisfaction stems as much from himself, not fully enjoying his role, as from Wyke, who relishes his too much. The difference in reaction is a vehicle for Mankiewicz's virulent social critique.

For Wyke, the game is possible because it is harmless: the permanence of the rules keeps each player in his place, the permanence of the game keeps reality at bay. The device of the game and the rules maintain order in the universe; they allow Wyke to reassert constantly his superiority. Every participant strives to respect this principle. Tindle does not deny that the police sergeant very probably thought his escapade was fair, and his lesson deserved. Tindle cannot toy with innocence and indifference. The game is forced on him. Even when he leads it, he knows that he

is playing in the other's way, by the other's rules, in a system that tends to keep all Tindle-Tindolinis in their place. His role in the game reminds him of his place in society: the crux of the game is power and humiliation. The game that for Wyke hides reality, for Tindle makes it constantly and painfully present.

From whatever angle we view the characters, they are always in opposition, an opposition that is especially evident in language. All components of language come into play: vocabulary (each of the protagonists has a specific vocabulary that the other tries to imitate) and accent (Tindle quickly loses his affected accent and reverts to Cockney). Mankiewicz orchestrates the various accents, English and foreign, like a maestro. Language is only one aspect where criticism of Mankiewicz is very sensitive; it is also an area that best reveals the nature of such criticism. The opposition between Wyke and Tindle is so unshakeable and so radical because it is part of their very mental structures. Mankiewicz condemns not just one type of person who perfectly embodies a certain kind of society—aristocratic or bourgeois, English or American—he shows that this kind of man, trapped in his own behavior, has cut himself off from reality and would rather commit crime than face it.

The shape of the entire film puts this theory to the test.

THE NARRATIVE: ILLUSION

This "reality of unreality," which for Mankiewicz is film, is created in *Sleuth* by confusing illusion and reality through a game about theater and film. Working with material originally created for the stage, Mankiewicz maintains the theatrical appearance only to more thoroughly confound the audience. The credits open with models of theatrical sets, and the action begins with one of these models coming to life and ends with another shot of the same model and a closing curtain. Mankiewicz doesn't try to avoid confined spaces; the rare outdoor scenes do not expand space. They are constructed in relation to the interior of the house. Mankiewicz exacerbates the feeling of confinement by adding the labyrinth. The space is confined for characters who cannot find their way out of the labyrinth of their interaction. The film is based on a projection of this confinement into life.

The audience can only identify in a relative, sporadic way with either of the two protagonists: identification shifts from the victim to the assailant, each playing both roles in turn but never for long. This aspect not only establishes the mechanics of the film, it constantly challenges the film's relationship to the audience. The audience's association with the mechanical puppets that inhabit the living room further complicates identification. They gradually assume a life of their own: insert shots make them resemble a choir directed by the lady at the piano. Like the chorus of ancient times, the puppets seem detached from the action: the editing makes them appear to react in ways that offer commentary, usually ironic; furthermore, they come to life by themselves at the climax, and their racket accompanies the downfall of their master.

The puppets also play a role in relation to the characters. They are like caricatures, imitations, artificial reproductions of life; they are doomed to constantly repeat the same movements. But are Wyke and Tindle any different? Beings devoid of life by nature come to life while living beings become mechanical.

Uncertainty is one of the driving forces behind the film's construction, reinforced by another principal: duality. The film is not based on a single theme or a definite, isolated, dramatic thread. We could begin by studying it from a social point of view, with a focus on games or robots. Despite its linear appearance, the film is

organized along different lines that converge to reveal the whole. It does not consist of separate, unequivocal elements with a useful function. Each element forms part of a system, each component relates to another, each relationship is a metaphor for another relationship. The audience can no more interrupt the chain of meaning than Wyke and Tindle can stop the game. The momentum of the film affects the audience on a deep level. Illusion becomes reality.

THE DEMIURGE: MANKIEWICZ

Behind Wyke and Tindle, there is a supreme game master: Mankiewicz. The constant changes in point of view refer back to the director, like metaphors of the actor and the director. The only real "sleuth," he controls all of the keys. He directs the actors, the game, and the audience at will, and he stops the game when he pleases. The final fall of the curtain is like a guillotine and seems to be accompanied by derisive laughter. The audience confronts the crucial question: what exactly just happened?

Like any artist who achieves full and perfect maturity, Mankiewicz first addresses his artistic function: as a filmmaker, he can finally make it happen for real; he need no longer attach himself to one genre or one approach; he works in full freedom and asserts his concept of the filmmaker. Rarely has a film so precisely, by its very form, established its maker as the all-powerful, organizing intelligence that the audience cannot perceive directly. This concept is deeply rooted in Mankiewicz's attitude toward his subject and his art, which is the art of writing and revealing to make people think. He takes the moralist's point of view, devoted to the truth of reality, which is what he tries to present. Mankiewicz enjoys comparing points of view. Each film is an exercise that allows for an exploration of the individual in society. The choice of subject encourages searching and further development. Language closely associated with image allows for greater wealth of analysis and greater truth. Like the moralist, he refuses a final synthesis and prefers observation.

While it is true that the above-mentioned metaphors also include Mankiewicz, their meaning can apply to him personally. How can we fail to see the dominant role of intellectualized sadism, the desire for power behind the analytical mind and the absence of masochism, evident in signs like his refusal of conversation or his passiveness on the set?

How can we fail to grasp that beneath the appearance of a frivolous game and film, Mankiewicz is revealing himself and at the same time disclosing his concept of the individual with another metaphor: man or artist, in the end, is he anything more than a little red clown slowly dancing a pirouette?

1. Interview in *L'Express*, no. 140, May 14–20, 1973.

No. 154, September 1973

Sleuth. 1972. UK. Directed by Joseph L. Mankiewicz. Written by Anthony Shaffer, based on his play. Produced by Morton Gottlieb. Cinematography by Oswald Morris. Music by John Addison. With Laurence Olivier (Andrew Wyke), Michael Caine (Milo Tindle), Alec Cawthorne (Inspector Doppler), Eve Channing (Marguerite), John Matthews (Detective Sergeant Tarrant), and Teddy Martin (Police Constable Higgs). 138 min.

Tension-relaxation, then rebound; euphoria-melancholy, violence, confidence-panic, suburbs-relaxation, city, outskirts, and suburbs again, or qualms; constantly compromised stability, constantly rebalanced instability, endless discharge-recharge, as they say, "a rose is a rose is a ... ," in minor, in major; and, mostly, the endless passage, the permanent modulation of emotion, from one register to the next, frenzied, thwarted, like the stubborn flux of moods . . .

The Suburbs ... Did You Say the Suburbs
Vincent, François, Paul, and the Others (Claude Sautet)

Michel Sineux

Claude Sautet, a loner, who belonged to no group but had the admiration of his peers, never got the international recognition he deserved. Throughout his career, *Positif* consistently considered him to be one of the most important filmmakers of his generation.

Beyond (almost) any psychology or narrative convention,[1] Claude Sautet's latest film, *Vincent, François, Paul, and the Others* (we'll return to this title, which, like *Max* and *César and Rosalie*, perhaps suggests psychological types, just as we might say Adolphe or Corinne), is always alert, almost abstract in reality were it not so well fleshed out, full of nerve and sinew, through the rhythm of human behavior and its fluctuations. This preoccupation is what makes it ambitiously try to surpass previous efforts, which remain flawed because of a shortage of dramatic conventions: flashbacks to *The Things of Life (Les Choses de la vie)*; the "suspense" of *Max* and *César and Rosalie*, which is far more relaxed and still occasionally appears just below the surface, through glimpses of the tried-and-true system of a three-person comedy.

What Sautet's characters have in common with classical drama, and where, at the same time, they stand apart from it, is merely the fact that they are caught in a moment of crisis. But the crisis is not externally generated, and the least that could be said about it is that there is nothing Corneillian about it. It is the temporary conclusion of an internal evolution, both biological and moral, that is sanctioned by a certain conflicting relationship with the whole changing universe around it. By the same token, the crisis, pathetic as it may be, never comes from tragedy. It knows no end, only crescendos—if we may borrow from a musical term that is always on the tip of the tongue when talking about Sautet—and *resolutions*, which are every bit as misleading as they are fleeting. Death, which sometimes comes up, nonetheless always remains off camera: it only appears under the disguise of the shadow of time and only so that it can properly acknowledge the value of the apparent factual ordinariness of days and objects, respectively.

Pathos emerges brutally from the conflict of the blind, vital, and timeless euphoria that drives the characters. It also rises out of the panic-stricken clarity that suddenly impresses the coercive presence of the passage of time upon the consciousness. Thus it is hardly surprising that these characters, so full of life, whose main characteristic is to experience, if feverishly, the passing moments and pleasures along with the haunting fear of relapse, are all well in their forties. This is the age that stands for stability in appearances, especially in social relationships, but also

Serge Reggiani, Marie Dubois, and Michel Piccoli in Claude Sautet's *Vincent, François, Paul, and the Others.* 1974

a time when there is an undercurrent of change, both mental and physical, a bifurcation, the end of an illusion of balance between ups and downs, which is as deceptive as the serenity of summer or the fixedness of winter squeezed between the passing seasons. It is no mere happenstance that such comparisons with the seasonal cycles should come to mind. Sautet's films often call on them to help us feel the intimate modulation of moods. This is what the forties and fifties were in the lives of Pierre (*The Things of Life*), Max, César, Vincent, François, and Paul, albeit colored by their individual temperaments. The characters almost seem to reappear from one film to the next: the overall work truly appears to be the sum of the echoes reflected by each of its components. There is no doubt but that we are in the presence of a veritable universe whose consistency, by our standards, goes well beyond the "quartet," to include the earlier commissioned works: *The Big Risk* (*Classe tous risques*) and *Guns for the Dictator* (*L'Arme à gauche*), which Sautet managed to tame and make his own by tearing them away from their "genre." In the former, the friendship between two men, who are not from the same generation, gives us a peek at the nostalgia of a state of permanence corrupted by the ephemeral. The latter transforms the tale of an adventure into a dream of adventure.

There are other bridges between these works of circumstance, those in which the author makes his intentions clear through the choice of raw material: in the fact, for instance, that these men in their forties, some of whom are fathers, are removed from their offspring, both physically and psychologically (*The Big Risk* and *The Things of Life*), and their only experience of a father-son relationship is through transposition into the universe of pals. This universe, which, though parallel, is hardly marginal, draws its importance in direct proportion to the unconscious desire for isolation on the part of the characters. François essentially follows the same "isolationist" path as Pierre, which is metaphorically developed in *The Things of Life* through his physical death, and Max, which ends in social suicide. That these three characters, who are quite different at first glance, converge toward the same state of disintegration is underscored by the fact that all three are played by Michel Piccoli, whose successive characterizations, while original creations each, end up making the same fantasy of a dream of absolute order—safeguarded from the flaws of reality—quite tangible. Sautet contrasts this utopia of withdrawal, without actually contradicting it, with another form of escape, which is that of a vitality forever seeking a euphoric revival, as personified by César and Vincent, once again played by the same actor (Yves Montand).

The gallery of male characters takes on various shades in *Vincent, François, Paul, and the Others* through the character of Paul, subtly played by Serge Reggiani, whose far more perceptive awareness serves as a link between the essentially instinctive male universe and the no-less-resolutely-intuitive female one. Obviously, Sautet, who is equally brilliant at depicting the female psyche as that of the male, gives the former—even though he has the same attachment to all of his characters—the benefit of far more dignity or intelligence, provided that we are speaking of the heart. In the same way that Vincent is an extension of César, François is an extension of Pierre, whom Max was already reflecting, and Lucie (Marie Dubois) comes across as one of the possible outcomes, in this case hardened and stretched to the breaking point, of the female type personified by Hélène, Lily, or Rosalie (Romy Schneider). And far from being a convenience, the use of the same actor to portray these various types serves a humanistic imperative that is very typical of Sautet, who does

not claim to hold forth mawkishly on the nature of universal man but rather to provide a constant reminder of the fact that any man is not only this or that but that he is or could be, at the same time and in another context, that or this as well.

The point is not to respond to the objections, learned though futile as they may be, to Sautet's resolute desire to restrict himself to a limited universe, albeit one that he *fully* feels, and to a strictly private emotional issue, which may be aroused in detractors of intimist cinema. A combative guilty conscience requires that the artist conduct his orchestra with a revolver rather than a baton or he will end up facing the public disgrace of reaction combined with salvage, and he won't be given a second chance. Dare I repeat—even though I'm only stating the obvious—that the artist can only hope to restore a clear vision of the society to which he belongs if he depicts what he feels. Federico Fellini said as much himself, though with some weariness, in *Roma,* in reply to a question he addressed for the good of the cause. In less turbulent, if not more serene, times—some ten or fifteen years ago—a Joseph Losey or an Alain Cavalier (*Le Combat dans l'île*) were branded political filmmakers because they "contented themselves" with describing the specific customs of a society, leaving it up to the viewers to provide the critique after giving them nothing more than a sense of it by showing them what was, not what should have been. Yet, what we ask of filmmakers today, and of artists generally, is to depict what should be—a destruction, a utopia—at the cost of distorting or repressing their true personality, without seeing that this sanctimonious asceticism produces nothing more than an overload of confusion through its dissoluteness. The "middle-class intimists" are not the only victims of such ostracism; the direct analysts of *res publica,* like Francesco Rosi, end up joining them in the gutter. And a veil of modesty is cast over the consistency and courage of the citizen who follows his path without stumbling or straying, and which appears in the work, just beneath the surface, as long as we read it in good faith.

Thus, there is no use in wanting to castrate the artist of his style—which also makes the man—to gain a supposed apostle while forgetting, as Claude Roy so nicely put it, that the purpose of a work of art is not to do combat, but rather to make the heart beat; not to mention the fact that it is always easier to tell the artist what he should have said or shown than to analyze what he meant to do by translating into hypothetical language the concrete essence of his art, in this case Sautet's production. It would probably fit better with the idea of *impulses* than of movement, which would be too vague: impulses within the frame or the sequence, which precisely capture an invisible movement, the intermittency of the heart, the soul, or, simply, the moods, like so many *swerves* that we would sooner feel than analyze. The incredible restlessness of the characters is the palpable manifestation of this choice, this alternation between the diastolic and systolic, which is reflected in an aesthetic quality based, in part, on the coupling of displacement/withdrawal, with its various metamorphoses and, in part, on an essentially musical form of language.

When analyzing the construction of *The Things of Life,* Gérard Legrand referred to the "sonata form."[2] Personally, I prefer to refer to modulation, which relates to a tonality, a mobility, and does a better job of restoring the unstable alchemy of behavior, its Brownian movement—which is the fundamental common theme running through all of Sautet's works—than the "sonata form"—which emphasizes structure. There are examples of this aesthetic quality, though they are not moments locked into speeches, which could be different in another setting. On the

contrary, there is the continuing frame. One of the common threads running through *César and Rosalie* and *Vincent, François, Paul, and the Others* is a long, euphoric, and polyphonic introduction in which the characters and their psychological relationships are presented along with a tonality of the ambiance and forms of physical behavior that will soon be exposed as false. The art with which Sautet introduces his minor theme, that of the hint of the malaise that will dissolve the apparent unity and superficial gaiety, is based on the principle of movement that was previously mentioned: in *César and Rosalie*, after they recover from the euphoria of the party (Rosalie's mother's remarriage), César and Rosalie come face-to-face with a threat that surfaced during the party. The same method is used, even more masterfully and in a far more complex manner, in *Vincent, François...* Here an extraordinary scene, which plays on the reflections off a window pane, makes tangible the dissolution of a central pleasure theme (the country party) and the irrepressible rise of a minor pathetic theme (the first evidence of the crisis which, in various degrees, will affect each of the characters and which crystallizes around Vincent's suddenly anxious and darkened face).

The manner in which Sautet balances and inexorably intertwines the comic and pathetic elements through the contrapuntal game they generate flows naturally from this ambivalence of *modes*. At the same time, the factious unity that brings together the characters corresponds to their most intense individual isolation and serves as a reminder of the *dissonance* that brings them back to a form of solitude that amounts to fleeing forward until, once again, the group fleetingly reconstructs itself. This is a group that only survives as a regressive euphoric principle and explodes as soon as *communication* cuts a swath through its members. The opening sequence of *Vincent, François...* closes on the *precipitation* of this explosion. The impact on each of the characters in a twilight glow at the end of the party, where the main euphoric theme, the threat that only seemed to concern Vincent, breaks through one last time, carried by Vincent's voice. The minor tone is fully asserted and strikes home with the harshness of the exchange between François and Lucie. This musical aspect could be illustrated through the *staccato* in *César and Rosalie* when César, basking in the comfort of the complicity binding him to David, which is yet another expression of mental regression into a form of euphoric isolation, discovers Rosalie's abandoned room. This is the type of rhapsodic adventure, the leitmotiv in each of Sautet's films, that makes him the uncontested painter of the disoriented vitalism of the man at the wheel.

Naturally, this specific quality of Sautet's staging immediately colors his direction of the actors, which places him among the best in the world, as sensual as that of Elia Kazan and filled with all of the nuances of Michelangelo Antonioni. It contains the principle of modulation, which courses through most of the sets. Like a mood seismograph, it warns us of the imminent crisis before the quake. And though screen presence is so important, with Sautet it is nonetheless astounding to find such physical and mental presence in the roles played by actors and actresses who are "naturals" because the hiatus that normally prevails, as thin as it may be between reality and re-creation, seems altogether absent, even squeezing the performers in a Pirandellian way from which they have a great deal of difficulty extracting themselves and only after acquiring a few scars along the way. Seldom have Lino Ventura, Leo Gordon, Piccoli, Montand, and Schneider found such a state of grace. Today we can only dream of what Sautet could have built around Gérard Depardieu, Reggiani, or Dubois.

This staging, which we have attempted to single out by highlighting what it might have in common with music—the most sensitive form of expression—makes viewers particularly demanding, mainly because they must be exceptionally receptive, both on the intellectual and the tactile plane. If Sautet is an auteur—which we believe he is—it is more because of his style than his themes. Such a style is, by nature, fundamentally affective and designed, above all else, to elicit an emotional reaction from the viewer. Nothing could be more foreign to this mode of direct and physical apprehension of the world than the appearance of a symbol when it is not sufficiently incarnate in perceptible form that it causes us to forget, or maybe even *never to perceive the underlying idea.* So, I wonder—perhaps too subjectively—about the effectiveness of a scene such as the boxing match in *Vincent, François, Paul, and the Others,* where the symbol appears to dominate with a rather theoretical clarity and insistence, in spite of its spectacular quality, compared with its perfectly tangible integration into the previously mentioned opening scene, which used such a worn-out symbolic prop as fire without the slightest apparent reservation. A small flaw, to be sure, but one that nonetheless comes across like a blemish on a work of art that, in every other sense, exquisitely portrays the subtle and apparently infinite harmonies of the very heartbeat of life and whose pulse gives the suburban microcosm, as ordinary and boring as Sautet makes it appear, the seductiveness of all that is universal, captivating, and surprising, and which captures travelers who have come from afar, like David in *César and Rosalie,* and Jacques today, these spellbound voyeurs.

1. Sautet's hostility toward psychology is evident from his very first films (see Interviews, *Positif,* nos. 115, 126).

2. *Positif,* no. 115.

No. 163, November 1974

Vincent, François, Paul, and the Others (Vincent, François, Paul ... et les autres). 1974. France. Directed by Claude Sautet. Written by Sautet, Jean-Loup Dabadie, and Claude Néron, based on the book by Néron. Cinematography by Jean Boffety. Music by Philippe Sarde. With Yves Montand (Vincent), Michel Piccoli (François), Serge Reggiani (Paul), Gérard Depardieu (Jean), Stéphane Audran (Catherine), and Marie Dubois (Lucie). In French. 118 min.

here is nothing surprising about the fact that Robert Altman, who makes films for the fun of it, and who makes them about whatever pops into his head, whether on impulse or because he has suddenly become enamored of something, should use *California Split* as a long-overdue opportunity for him to engage, whether in person or by proxy, but always euphorically, in his passion for gambling, which was the inspiration in his first screenwriting attempts.[1]

or is it surprising that this *enfant terrible* of Hollywood should have wanted to play hooky for a few weeks in between two more ambitious and more "solemn" projects,

POSITIF

1970s

California Split
Michael Henry (Wilson)

During the Vietnam war, there was a tendency among French critics, under the influence of Maoist ideology, to reject wholesale all new American cinema, even though there were signs of a reawakening in Hollywood. *Positif*, unequivocally on the Left, instead paid tribute to the critical virtues of these innovative works, particularly Robert Altman's films.

namely, *Thieves Like Us* and *Nashville*, and used the time to gather his family, his friends, and their families together to make a relaxed home movie, although a home movie with the splendors of Panavision, or that he should have seen in the threadlike and invertebrate script by novice Joseph Walsh the ideal subject for an experiment that would allow him more than ever to let chance play a larger role than usual, and to improvise and allow the surroundings to provide him with the inspiration he needs. "I am much more afraid of losing my pleasure than my money," he said to the *Newsweek* reporter,[2] who expressed surprise that he had so often been impervious to apparently wonderful offers from the studios. And yet, by embarking on *California Split*, which is such a loose story that it does not fall into any previously known genre, and would make it impossible because of the lack of any structure to do anything except follow the moods of the narrator, Altman was taking even more of a risk than he had previously in subverting known genres like military vaudeville or the Western, film noir, or Depression melodrama. Now that he has settled his scores with Hollywood, and is through with all his long goodbyes (the only thing left for him to do was subvert the pirate film!), here we find him without a compass or map to guide him, left to his own devices, and enjoying himself lazily on virgin territory with unknown horizons open to him.

It is perhaps to action painting that we need to refer to explain this increasingly risky and puzzling effort of Altman's, for he is one of those artists to whom the time spent in making the work is more important than any eternity gained for what has been achieved. Ever since *M*A*S*H* we know that what he has demanded of his art is not so much the creative voluptuousness of building a work as it is the pleasure of tasting, in all of its phases, the unique and fleeting experience of the shooting itself, this daily infighting with a multifaceted and multivocal reality of which the film will only be able to use some tiny sparkles. Reality is something that needs to be decanted, filtered, disciplined, and informed, but above all lived intensely, both in front of and behind the lens, both on the stage and in the wings, and before, during, and after the shooting. The alchemy of creation is so much more stimulating than the final result, which more than anything else comes about as a result of the vagaries and contingencies of life itself. In his interview with *Newsweek*, Altman said that his role was not to create a work of art, but to deliver a reflection of the work in progress. At times, in *California Split*, particularly in the crowd scenes, which are the kinds of scenes he most enjoys directing,

Elliott Gould in Robert Altman's *California Split.* 1974

we can guess that the filmmaker was more concerned about what was going on around him than by what was going on within the necessarily limited frame of the lens. He was more fascinated by the show that he was putting on for himself than by what he was putting on celluloid, that would one day find its place in cinema history and museums. We are willing to bet that he would willingly agree with the famous statement by Vasily Kandinsky to the effect that it was important to liberate oneself in pictorial art from the constraints of figuration: "The palette, which results from the elements of which the work is comprised, is often itself more beautiful than the content of any work."

And indeed, what better palette can there be than the world of tripods, casinos, and gambling houses, particularly with Altman, a past master at making effective use of spur-of-the-moment and casual suggestions? These teeming microcosms, like cinema, secrete their own parallel reality, and Altman gets them not only to provide an atmosphere, but also to dictate much of what will happen. When he takes over an abandoned ballroom on La Brea Avenue and transforms it into a poker parlor, he is not behaving like a totalitarian director who strives to recompose reality in a sealed environment so that he can impose his creative will. On the contrary, Altman peoples the ballroom with unknown extras from actors' agencies, in other words, genuine maniacs recruited from the Synanon community, that is, from his own company—Lion's Gate. Where others work hard to create a vacuum and reduce the chaos of life, he enjoys creating a microsociety while he is shooting, one which has a virtually autonomous existence, in which each member has a role to play, even those who will not end up appearing on screen. He makes his actors and technicians live and behave and act the way his characters would. While for *McCabe and Mrs. Miller* he may have had to build the small town of Presbyterian Church from scratch in the snows of British Columbia, here, for most of the scenes, he had existing sets available to him and his team, and it was just like going off on a spelunking expedition. The environment did the rest. Indeed, the shooting at Mapes Hotel in Reno gave all the participants an opportunity to try their luck day and night at poker, baccarat, and the slot machines, whether in the lobby with the regulars or in the sky room, where Leon Ericksen meticulously reconstructed the ground-floor décor. One can only imagine the continual comings and goings between the two levels. In such an eclectic pandemonium, in which professionals (actors/gamblers) and amateurs (actors/gamblers) were completely intermingled, it quickly became impossible to tell the difference between the real casino and the copy, and the extra-filmic location from the stage, illuminated by the sunlights. This constant Pirandellism, miraculously controlled by the master, is assuredly what makes Altman's films such a rich and full sensory experience.

Within this environment, on the other hand, an exceedingly strict and immediate behavioristic viewpoint is taken, based on the "first impressions" of an anonymous observer. From the very outset, Altman refuses to detach his protagonists, Bill (George Segal) and Charlie (Elliott Gould), from their environment: far from placing emphasis on their meeting in the poker parlor, he introduces us to them in the middle of a crowd, as if by accident, with their initial repartee getting lost in the surrounding racket, where soliloquies and ad-lib conversations merge into one another, and the ground rules for the game appear on a closed-circuit screen.[3] Because Bill and Charlie are seen talking to one another in a bar, the next sequence could well have given rise to a traditional form of expository dialogue, but the dolly-back shot at the beginning of the scene reveals first one and then two bar hostesses, thus introducing

a totally peripheral anecdote that will soon confuse the initial discussion. Furthermore, the conversations between our heroes, both of whom have been drinking, sounds like nothing more than nonsensical babbling until it finally resolves itself in an onomatopoeic concert punctuated by something resembling burlesque choreography. The next two short scenes shed no further light on what is going on, whether at the station, where an ellipse deprives us of the expected comical developments (for more details, Altman appears to be telling us, check into the tribulations of Philip Marlowe at the police station in *The Long Goodbye*), or at the apartment of the two ladies of the night, where Bill and Charlie manage to do nothing except sleep. In short, you have to side with Altman: the "show," put off for so long, will not happen. It is up to the audience to glean whatever bits of information can be obtained about the specific circumstances of each of the two players. Here, essence does not precede existence, the characters are not taken back to a past that occurred prior to the narrative, and the story involves no earlier plot. The film develops as we see it, and gradually, visual, sound, and music information that it managed to record as it was being made will surface.

Any psychological story line is cast aside—particularly as the topic of the "double life," which is so common to the nearly always tragic stories found in similar settings—and is not touched upon at all in *California Split*. In the case of Charlie, who gambles the way most people breathe, and who gambles for the sake of gambling, it is clear that he cannot live any other way. He appears, does an about-face, and then disappears like a firefly, without ever eliciting any psychological comment. A poet and a virtuoso at talking continually, he expresses himself in soliloquies, neither caring nor hoping to be heard, unless pantomime is involved (the sketch with the one-armed flute player). Significantly, Gould is never isolated from his partners, unless in a close-up: he appears to emanate from the very surroundings. He remains completely "mysterious," but can the words still mean anything when the vision is prismatic, as it is here? Bill, on the other hand, who gambles by accident and plays to win, is more closely delineated, because he is shown on a number of occasions (in his office, which happens to be Altman's office in Westwood) in another context. The fact nevertheless remains that neither his wife, from whom he is separated, and whom we never see, nor his work as a journalist, which is only suggested, can counterbalance the world of gambling into which Charlie leads him, and from which he is inevitably rejected because of his debts to a bookmaker.

Although in *Thieves Like Us* the buzz of the outside world reaches us through news bulletins and soap operas on the radio, we do not leave aside the alternative society of gamblers, that unsettled community of strangers who move about, encounter one another, congregate, and separate under the fluorescent lights of huge aquariums. We learn no more about Bill and Charlie than their respective behavior on the green felt is prepared to reveal to us from time to time. Furthermore, the freedom Altman gives Gould and Segal leads us to think that their behavior reveals as much about the actors' personality as it does about the inner life of the characters the actors are playing. Indeed, one must await the final split of the title for the contrast between the two gamblers to become absolutely clear. As if exhausted from spending too long in a world that is not his own, Bill says to Charlie, "I have to go home. I'll see you," and disappears from the screen as abruptly as he dropped out of the game. While he goes off to find his other life, the camera lingers for a moment on the disconcerted Charlie, who nevertheless remains ready to resume his aimless journey through every game of chance he can find.

Having followed Altman from one film to the next, we are certainly familiar with these two loners lost in the solitary crowd of America, or rather we recognize them as brothers of McCabe, Brewster McCloud, or even Philip Marlowe. Less suicidal no doubt, but equally vulnerable in their obstinate individualism, they are dropouts—impenitent and puerile dreamers who float through casinos and dives in a perpetual state of weightlessness, so much so that when they show their feelings, they usually end up performing some kind of hilarious mumbled ballet. They are so volatile, and their environment so intense, that we are afraid they might dissolve at any moment. This is because in each shot, other faces, other silhouettes, and other plots arise, threatening to obliterate them or at least send their erratic trajectory off in a new direction. Altman's scenes ignore partitions of any kind, meaning that there is constant interference. The enraged punter at the Pomona racetrack, the armed black man at the ringside exit, the cross-dresser with the two prostitutes, and the poor loser who chases Charlie angrily are all bit players who lose their anonymity for the time it takes to complete a vignette, and are then engulfed once again by the overstuffed screen, filled with extremely dense sounds and images so saturated with signs and looks that they are almost stifling. If the women are all, or nearly all, called "Barbara," it is because, on screen, people are not so much motifs as chromatic vibrations, and the fresco in the foreground is no more significant than what we see in the background. Also the filmmaker appears to want to prove through the use of stereophonic sound that the plural is more expressive than the singular. Altman is tending more and more toward a polyphonic art form. *Nashville* and later *La Belle Époque* will, when they are released, no doubt confirm this by showing, in the case of the former, a complete city, and in the latter, several generations of Europeans on the eve of the Great War.

The film, which in this fashion is left open to the accidental or unexpected, needlessly deprives itself of the safety net of traditional screenwriting. Hence, as if to offset the enjoyment of the filmmaker, the audience becomes frustrated, no longer having any idea of what genre they are watching or which character they are supposed to identify with, or even what moral point of view is being espoused. Altman does not make the audience's task any easier, and places it more brutally than usual before a *fait accompli.* On the one hand, the heroes, like the plotline, are too unpredictable for us to anticipate what they are going to do or how they are going to behave; in addition, situations are never developed at a single level or in an expected direction. While the assault with a weapon acts as a reminder of reality, of the ever-present violence, the scene is filmed like a farce, from the moment Charlie persuades the dumbfounded crook to share the takings fifty-fifty. On the other hand, Bill's and Charlie's hoax, passing themselves off as morality-squad inspectors, stops being funny as soon as the cross-dresser at whose expense it is being perpetrated proves more to be pitied than ridiculed. This vague feeling of derision is similar to the gag with young Susan (Gwen Welles) being helped with her striptease by Bill, who slips away pitifully after his failed effort (the only "affair" that occurs in the film). While dramatization may appear possible, as in the final game in Reno, Altman is careful to defuse the suspense. The fearsome professional gamblers of the Mapes Hotel are, it is true, verbally introduced by Charlie, but Bill has only just sat down at their table for the final poker game when the camera abandons him to follow the meanderings of his partner.

In *Thieves Like Us*, Altman, with only one exception, spared us holdup sequences, either by leaving the camera with Bowie (Keith Carradine) in the trio's car, or having it linger only on the family "rehearsals." Here again, breaking all the usual dra-

matic conventions, he remains with the "useless" character, with Charlie, who is virtually excluded from the game, even though everything appeared to indicate that he would be playing the role of the casual but lucky player. When Bill, the loser on every one of his rolls, reappears and decides on roulette, we see him winning, but the idea that his luck might eventually change completely is never once suggested. The choppy editing also makes it impossible for us to follow the game with any continuity and therefore to share the anxiety or agony of the players. The surprise, the real surprise, that Altman has kept in reserve for us, comes from elsewhere; this is to cleanly break the euphoric tension created by a string of lucky rolls. Without any warning, Bill leaves the table and the casino, completely breaking off his association with Charlie, just when it looked as if it might begin to work.

"I am not in the morality business," Robert Altman willingly offers. In *Thieves Like Us*, the radio counterpoint nevertheless enabled him to introduce a point of view that was external to the narration, a kind of "State of the Union" address for the America of 1937. Keechie (Shelley Duvall) and Bowie's destinies were clarified, if only indirectly, by two antithetical speeches, Roosevelt's and Father Coughlin's, which made things meaningful. In *California Split*, such a function may well be played by the ironic songs of Phyllis Shotwell, but in a disintegrated society, as contemporary American society can be, and particularly when dreamers no longer even know what illusions they are chasing, any moral judgment appears to be superfluous. What Altman is pursuing in this fragmented story that is open to every possibility is the pure romanesque, but what it gives rise to is a picaresque universe in keeping with the new times. It therefore has none of the usual mythology or pathos that has for so long structured the rhetoric of films about gamblers. The hell that has been described, in melodramas from Dostoyevsky to Sternberg, has become this somewhat sad caravansary, in which some of the characters exchange the constraints of reality for the even more absurd constraints of chance. They don't even have the excuse or privilege of a genuine neurosis. No, these lost people are so ordinary and so familiar that they appear to be holding a mirror up to us. And if one had in the end to find some form of unity in *California Split*, it would be in the filmmaker's own register of tender derision. Derision, because this long and sinuous stroll ends on an anticlimax: "No special feeling," says Bill when he counts his $82,000 without any particular enthusiasm. Tenderness, because the maker cannot prevent himself from recognizing himself in his two lighthearted desperadoes: each in his own way is melancholy or comical; both behave like an elusive daydreamer; a migratory bird appears to stop on our shores only inadvertently; a daredevil maniacally programs his deadly acrobatics.

1. See interview with Robert Altman in this issue of *Positif*, no. 166 (February 1975), p. 10.
2. Story by Charles Michener in *Newsweek*, March 11, 1974.
3. Robert Eggenweiler, the associate producer of most of Altman's films, from *That Cold Day in the Park* to *Nashville*, carries out this task by reciting a string of truisms and pompous explanations. Thomas Hal Phillips, the associate producer on *Thieves Like Us*, plays himself at the professional gamblers' table at Mapes Hotel. In addition, as we move among the various people, we can spot most of the members of the technical crew.

No. 166, February 1975

California Split. 1974. USA. Directed by Robert Altman. Written by Joseph Walsh. Produced by Altman and Walsh. Cinematography by Paul Lohmann. Music and lyrics by Phyllis Shotwell. With George Segal (Bill Denny), Elliott Gould (Charlie Waters), Ann Prentiss (Barbara Miller), Gwen Welles (Susan Peters), Edward Walsh (Lew), Bert Remsen (Helen Brown), and Joseph Walsh (Sparkie). 108 min.

Fifty percent of people spend their time pretending they're someone else. And I would be the most humble of those, were I not the only one to admit that I am who I am, which is what I am not, this being what makes me unique.

—The fake "fake Archduke" in **The Unthinking Lobster** by Orson Welles

One of the last proponents of a disappearing style of cinematography is bound to be somewhat uneasy when talking about Orson Welles. Everything has already been said about the fact that he is the master of "total cinema," and there is no need to go any further to consign everything done before or during his period to oblivion. When the child prodigy showed absolutely no interest in proposals that sought to reduce him to one of Hollywood's many victims, caught up in his "liberal" contradictions and a puppet of every literary and moralizing variation to which he freely gave himself through his exhibitionist tendencies, which were matched only by his penchant for secrecy (see the epigraph of *Mr. Arkadin*), it was suggested to him in a thousand ways that he "seek forgiveness for his genius" because, in our day and age, genius is a dangerous commodity no matter what form it takes (Richard Wright was a good prophet). This is the same megalomaniac who, in connection

From Xanadu to Ibiza (and back): *F for Fake*
Gérard Legrand

Like other French cinephiles, the writers at *Positif* considered Orson Welles's body of work as seminal. In its early issues, *Othello* was discussed at length. But the later works, like *F For Fake*, were indicative of a prodigious creativity, which is explained in depth by Gérard Legrand—poet, philosopher, close friend of the Surrealist André Breton, and a regular contributor to the magazine.

with *Othello*, declared: "I am fighting for a universal cinema like a giant in a world of dwarfs." "What prevents film from attaining the dignity of a true art form is the lack of tradition . . . I believe in the death of cinema."[1] Why should we take this one-man orchestra, who has no instruments (and sometimes no audience), seriously?

Nowadays, Orson Welles, perhaps for the first time, is looking back at his own past with a sense of humor and calm, not only because he is remembering *Citizen Kane* (as well as his radio show "The War of the Worlds") and Howard Hughes, whom he confronts a bit like Norman Mailer fighting Arthur Miller for Marilyn Monroe in hindsight, but because *F for Fake*, hatched by Welles from a seed that he was not alone in planting, is an open invitation to raise questions about what the cinema means to Welles.

Some of the main expressions are:
1) the introduction of Oja Kodar, who makes every man turn to look at her in the street; 2) the introduction of Welles as a magician; 3) the reference to an unfinished film that Welles hates, which "was a hit" in Ibiza; 4) the introduction to the journalist Clifford Irving, the author of Hughes's fake memoirs and, before that, a book about the forger Elmyr de Hory: an introduction of the latter, who immediately starts explaining himself; 5) Welles's attempt to "reassure" the audience: for a whole hour, the audience will neither see nor hear "anything fake"; 6) a dialogue between Elmyr and Clifford Irving: the painter explains his method, ambition, and activities, much

Orson Welles in his film *F for Fake*. 1974

of which is "corrected" by Irving; 7) comments by Welles and François Reichenbach in a famous Paris restaurant: more stories about forgers; 8) Welles talking about his youth in Ireland, his relationship with Hughes, and interviews with Joseph Cotten and Richard Wilson about "The War of the Worlds" and *Citizen Kane*; 9) Welles's musings about the Cathedral at Chartres; 10) the story of Oja Kodar; her adventures with Picasso; Oja's grandfather's story; and, finally, Welles interjecting, telling the audience that the hour is almost up and that he's been kept on the spot for the past twenty minutes (the adventure with Picasso). Conclusion through a new sleight of hand.

It is obvious that Welles uses his work as a filmmaker as a medium for trying to inform the whole world about his culture and ideas, in short, "his message." At this point, we are less interested in the content than in the contradiction on which Welles's insight is based. For "message" (all the more because it comes from a genius!), we should read *craving for power*. For "film" read *creating an illusion*. From the very start, this illusion is not only encouraged by Welles, it is demanded. In 1959, during the reissue of *Citizen Kane*, Jacques Rivette correctly pointed out the rather considerable use of "stock shots." One could even say that with the insertion of *The March of Time* clip, Welles rose to the ranks of one of the creators of cinematographic "collage" (along the lines of Luis Buñuel's scorpions in *L'Age d'or*, Jean Renoir's squirrel in *The Rules of the Game*, and, especially, since we are in Hollywood, the Leo McCarey rescues in *Duck Soup*). But collage is one of the major concessions to illusion. For years Welles insisted on introducing his performers at the end of his films, as when he filmed the stage as the lights are dimmed (*The Magnificent Ambersons*). This tradition belongs to the theater, but nonetheless makes the same statement.

With each film, the duel between "craving for power" and "creating an illusion" keeps sustaining the otherwise disparate works: Welles plays on the craving for power of *all* his main characters, with an infinite array of nuances, as so many reflections of his own, and their own experiences with failure and illusion,[2] as though they were the product of reflections in the prism of cinematographic illusion. "Incarnating" Kane but without incarnating it in himself, Welles uses things like the special effect of timelessness, except for the time "canned" by the director so he can chat with Hitler on the terrace at Berchtesgaden.

It would thus be a waste of time to make a distinction between Welles's "commissioned films" and his original creations or his Shakespearean transpositions. No need to recall the machinations (or the sumptuous optical machinery) of *The Lady from Shanghai*. In connection with the majestic tracking shot that "globalizes" the little village at the start of *Touch of Evil*, Welles took the time to write London's *New Statesman*: "Given that Mr. Whitebait sees fit to expand on the richness of the urban scenery along the Mexican border, it might be useful to know that this entire sequence was filmed in Hollywood." The empty airplane flying through the skies over Barcelona before the credits of *Mr. Arkadin* drives the film in the same manner as the "false entrance" of the witches in *Macbeth*. This is a scene that all enlightened critics point out is anything but apocryphal because it is superfluous or awkward, but is rather a sign of authenticity because of its departure from convention and, more deeply, through its poetic borrowing from the Macbeth in all of us. This is why it appears in Welles's adaptation, a film whose extreme methodological simplicity underscores the artificiality of the source. To the extent that *Othello* draws on the double identity crisis of the Moor (who claims to be "civilized," Venetian, etc.) and Iago

("he is what he is, I am not what I am"), the full expanse of the ramparts and the deserted corridors do not overdo the illusion: Iago, master of the game, calls as witness the "monstrous universe" when he lies and the accommodating universe shifts 180° (reverse shot of the frothy sea). The same Iago, unmasked, will be reduced to the space of a cage.

Thus the central character in so many of Welles's films (and *F for Fake*, between his two sleights of hand, is no exception to the rule) does not come across as a rhetorical process but as the consequence of a fundamental forgery. The goal of Welles's films is not to study a psychological change: Kane grows old and changes but keeps his secret, which may be nothing and probably is nothing. (No need to call on European existentialism or American behaviorism. Shakespeare will do just fine, and his ontological "stuff that dreams are made of" matches the "ribbon of dreams" that Welles uses to define cinema.) But, contrary to what has been happening among filmmakers in the "closed loop," the cycle is never perfect: the craving for power wears out, the creation of illusion takes over. The journalistic process that "destroys" Kane's empire before our very eyes has neither more nor less significance than the bursting of the glass ball that held its life. The plot of *Mr. Arkadin* runs thin as soon as Arkadin phones his pitiful emissary, who happens to be quite close by without even realizing it, and the plot turns against Arkadin for the price of one more lie from that little scoundrel (who will get nothing out of it). But there is a reason why the original script for *Mr. Arkadin* was entitled *Masquerade* and why its central groups of characters are disguised penitents ("What are they doing?" "They are doing penance."), demonic dancers, inspired by Goya, and spy-secretaries, of whom it can be said that all they do is spy. Essentially, nothing but illusions. Even the plot of *The Immortal Story*, which involved putting a stop to the secret propagation of a "myth" by making it come true, fails, not only because of the "sincerity" of the sailor who preserves the illusion, but also because of the clerk's subconscious vow, which enables him to take revenge for his lowly position. Apart from Virginia, only he *knows* that the story has run its course.

In *F for Fake*, the creation of illusion completely overtakes the craving for power. Hence the exceptional euphoria generated by the film. When Welles starts with a pastiche of Alberto Lattuada (*Gli Italiani si voltano*), he is fully aware that this so-called cinéma-vérité sketch was set in a manner that cruelly confirms his attacks, at the time, against "semirealistic" or "semidocumentary" Italian cinema (as they called it). Thus, we have the parody of a swindle as a forerunner to "serious business."

Decked out in the cape and hat of *Ten Days' Wonder*, Welles clearly states his style.[3] Changing a key into money or making a white rabbit appear is child's play, as the (al?)chemists say (as well as Elmyr de Hory). Once the two forgers are in the presence of Welles, he suggests his own version of the paradox of Epimenides, by asking the confounding question: "And what if Clifford Irving himself was a forger before meeting Elmyr de Hory?" (which would cast doubt on his analysis of the latter, who from that point on . . .). Rest assured: the Howard Hughes business is only "linked" to Elmyr de Hory through an accomplice of Clifford Irving's, a past accomplice, after a few counterfeit checks passed in Switzerland. While it is true that Welles symbolized Switzerland through a cuckoo clock in his famous comment in *The Third Man*, when protests were expressed he claimed to be quite familiar with the fact that the clock came from the Black Forest and not Switzerland![4] But overstatement is a given in Welles, and all of his work is designed to "make us forget"[5] so a chapter of

lies can be added to Picasso's life. Picasso, who said (the word is authentic): "I can also make fake Picassos," deserves, from Welles's point of view, the title he earned (after demurring mildly when his own name was suggested) as "the greatest genius of the twentieth century."

We were once entitled to a real Welles: the story of his youth in Ireland should indeed be taken at least as an "intangible vulgate" based on the tales he told of it.[6] As well as the fake André Malraux: contemplating the human condition and the artistic survival of the "name of man" before the Cathedral at Chartres, filmed in hazy light and at times with the same angles used for the first shots of Xanadu. Welles talks about his old friend, the atomic (or thermonuclear) bomb, which exploded in the final shot of *The Trial* after having played a key role in the plot of the *The Lady from Shanghai* (Grisby's imposture rests on this obsessive fear).

The ambiguity of *F for Fake* and its mystifying conclusion should not mislead the audience. We were able to appreciate the special talent of Elmyr de Hory, who, with the evidence in hand, delivers an eloquent discourse against the "experts": a corrosive virtue of the film that should be neither exaggerated nor taken inappropriately.[7] But after Welles himself gave in to Oja Kodar's trickery, he put his cards on the table: he turns back to the anonymous child, who was quickly rated one of the great artists, not out of childishness, but because (hidden behind the gates of Xanadu, well beyond the reach of psychoanalysis) the secret of childhood remains the last in which he can "believe." He dwelt long enough on the fact that Elmyr was never caught for forging, whereas Welles signs his own works. He no longer says, with false modesty, "My name is Orson Welles" (the last sentence in *The Magnificent Ambersons*). He returns to his old music-hall tricks, his old magic lantern, his deepest conviction: "If wonder and enchantment don't draw the crowds to the theater, there must be something rotten in the United States and magic is not the only thing that's doomed."[8] The whole world is the Kingdom of Denmark and the ramparts of Elsinore, even nestled here on a Mediterranean island where more or less apocryphal snobs, actors on vacation, essentially Arkadin's potential procession, seek refuge.

It would not make much sense to talk about the "technical" brilliance of *F for Fake*. Virtuosity and subtle editing pushed to the limit prove nothing about an abstract theory. Welles has always used his stylishness to confirm that he "made" his films with a moviola, and Gregg Toland saw twenty different drafts of *Kane* before cosigning the last one. The excellence of the underlying material is undeniable: the two main characters are born hams, and Kodar deserves Picasso's glances (we know he was sought-after by countless photographers in search of a subject). The filmmaker even takes a mischievous delight in "incorporating" the crude special effects from an old movie, *The War of the Worlds*. After getting us interested in the many aspects of "art," authenticity, and all the rest, after insistently showing us his boxes of film and tapes, he settles for adding an elegant paragraph to several previous works. We need only think of the series of lies on which Kane's power and impotence are based (as well as those of his "double" Leland): *Falstaff* is both a tragedy about the "deception" of goodness (goodness seen as deception) and the courage of deception (war, the metamorphosis of the Crown Prince). I would gladly attribute to Welles who, we know, plays the main part in this film, the only surprising scene in Gregory Ratoff's *Cagliostro* (1947): a ball where hideous sick people and beggars all at once cast off their rags and "reveal" themselves to be a quadrille of gentlemen.

F for Fake is less a matter of irony than serenity, otherwise solidly grounded in the "real world": Welles savors his food and drink while listening to Reichenbach telling him tales about his financial adventures. But *F for Fake* follows the law calmly established by Chris Marker from end to end (*If I Had Four Dromedaries*): "We do not take part in the lives of the people we see on the screen; we take part in the lives of their images." The destructive violence that is often present in Welles's work (since *The Lady from Shanghai*) breaks into a smile. The power of entertainment matches the illusion of will. In the House of Mirrors, we no longer kill one another; we burn the pictures that we know we will be able to begin drawing again in the next hour. Here (as in the moderation and tidiness of the framing) Welles's so-called baroque approach reveals a playful vision of the world, which is also multiform and epidermal (some would say "superficial"), where nostalgia is a Renaissance that would have been possible in the 1950s (with a little help from Welles, of course) and that we have now lost.

1. Quoted by Claude Mauriac in *L'Amour du cinéma* (1954).

2. It's the same thing for them: this unique existentialist aspect of that which is correctly called Wellesian literature explains his interest in Kafka. But *The Trial* is the desire to rid oneself of the illusion that reflects off failure and ends with the Apocalypse.

3. Welles's concealed atheism, closely linked to his modernity, should be carefully studied. It inspires the Hollywood satire that influenced the choice of the epigraph for this article. It justifies its presence in Claude Chabrol's film (unfairly denied). It is not absent from *The Immortal Story* ("Paul and Virginia" watched by an impotent voyeur are not unlike Adam and Eve).

4. Maurice Bessy, *Orson Welles* (New York: Crown Publishers, 1971), p. 56.

5. Amnesia, the pretext that connects *Mr. Arkadin* to crime thrillers or whodunits (this theme will be explored later), is also the supposed weapon of a Monte Carlo croupier who wants to prevent World War III from breaking out in Welles's play *A bon entendeur* (1952).

6. *F for Fake* is almost a quote from Welles about this episode, from statements like those printed in the July 27, 1966, issue of *Le Nouvel Observateur*.

7. The one who really "knows" is not the pedant who meticulously gives a student of Raphael's such hands or feet in the Stanze frescoes in Rome that were previously attributed to the master and that another pedant may perhaps restore. It is Pope Julius II, who immediately recognizes Sanzio and chases away everyone in order to give him the order and the blueprint of the works. Orson Welles, in Bruce Elliott, *Magic as a Hobby* (New York: Harper, 1948).

8. Welles, op. cit.

No. 167, March 1975

F for Fake (Vérités et mensonges). 1974. Germany/France. Written and directed by Orson Welles. Cinematography by Christian Odasso and Gary Graver. Music by Michel Legrand. With Orson Welles (as himself), Clifford Irving, Oja Kodar, Edith Irving, Elmyr de Hory, François Reichenbach, Paul Stewart, and Joseph Cotten. In French. 90 min.

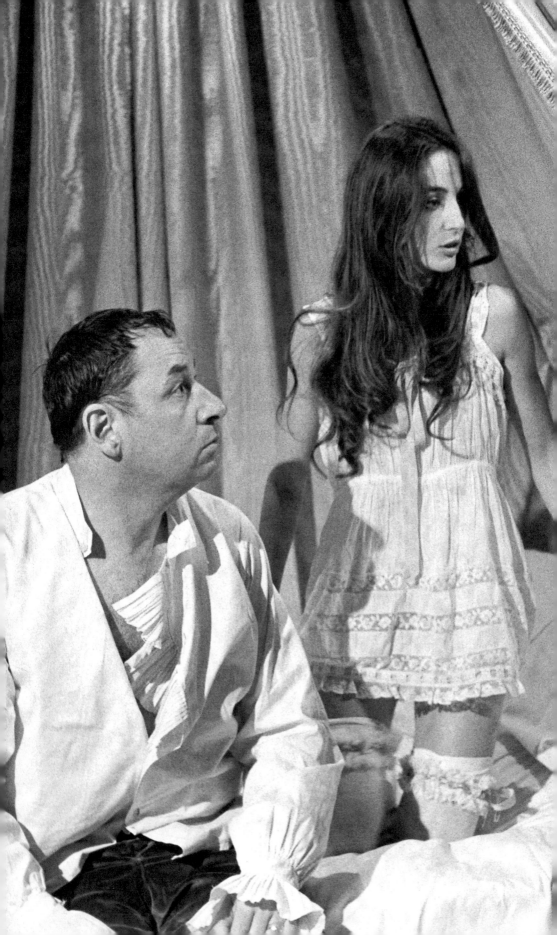

For his second feature-length film, Bertrand Tavernier has placed great faith in his team from *The Clockmaker* (*L'Horloger de Saint-Paul*): same writer, Jean Aurenche; same director of photography, Pierre-William Glenn; same lead actors, Philippe Noiret and Jean Rochefort, to mention only a few. Confident poker player that he is, convinced of his own authority and the strength of his four aces, he raises the stakes, avoiding anything that would make it easier for a new director's first film, such as using the scenic backdrop of a familiar town, depicting a modern subject, adapting a story by a tried-and-true author. Aban-

Let Joy Reign Supreme (Bertrand Tavernier)

Jacques Demeure

Bertrand Tavernier, who had been a contributor to *Positif*, very soon made his mark as one of the most talented filmmakers of his generation. With his second film, *Let Joy Reign Supreme*, he revamped the costume film, invigorating and modernizing the genre.

doning the idea of making a film of *A Daughter of the Regent* (*Une Fille du régent*) by Alexandre Dumas père, and working with Jean Aurenche, he opted for a historical rather than a romantic approach and offers us a chance to rediscover the Regency. The choice of this era, as obscure as it is maligned, immediately sets the tone of the film: a sort of irreverence. This is certainly not to say that the film lacks seriousness, since to bring the period alive Tavernier used sources ranging from columnists to current historians, from contemporaries of Philippe d'Orléans to people of today, from Saint-Simon to Arlette Farge by way of Michelet, a range of necessary intermediaries, since the purpose is not only to let us see, but also to make us discover, the hidden outcomes of adventures which began on Palm Sunday of 1719 on the coast of Brittany.

These are arranged in independent sequences, each of which begins *in medias res* but not in a disjointed manner that could distract the viewer. Far from suggesting simultaneity, they follow a strict chronological order, and this order is all the more powerful because most if not all scenes end forcefully, on a high point, and are often a rejoinder that hits the target. *Let Joy Reign Supreme* (*Que la fête commence*) is also the work of the screenwriters. We learn that while France is suffering a famine, "the poor are dying because they can't read." The Regent (Philippe Noiret) ends a conversation with Monsieur de Villeroi (Alfred Adam), who is in charge of educating the future Louis XV, saying, "M. le Maréchal, understand that I am as patient as you are foolish." And to his prime minister, Father Dubois (Jean Rochefort), who is happy to learn of the escape of the Marquis de Pontcallec (Jean-Pierre Marielle), who had rebelled against the crown to create a republic of Brittany and whom he had put on the path to deportation but whose severed head would better serve his interests, he says: "He is going to regret Louisiana!" Meanwhile the Marquis, writing to his wife to tell her of his latest arrest, wanted to make sure his identity was known to the officer who had taken him prisoner: "Captain La Griollais, to put it bluntly, tell me everything . . ." This use of truculence in words and situations requires strong performances, such as those present in prewar French films. Thus Jean-Pierre Marielle as Pontcallec works as a virtuoso soloist, with the rashness of a Don Quixote, indifferent to the enormity of the things he said when putting forward his plan for stirring up a rebellion that would involve most of Europe. Oblivious to the silliness of

Philippe Noiret and Christine Pascal in Bertrand Tavernier's *Let Joy Reign Supreme.* 1975

his inventions, such as the *"mistouflet,"* a firearm and hatchet combined into a single ridiculous weapon, or in the most astonishing situations, for example, in a convent when he hides fully clothed in a tub in which Séverine, the goddaughter of the Regent, is bathing nude. And this with sufficient nerve that a Breton nun could say after his execution: "He is our hero, especially now."

Philippe Noiret as the Regent and Jean Rochefort as Father Dubois are a dazzling team who, far from stealing scenes from one another, feed each other opportunities. This makes it possible for their characters, which are very different from the straight-forward Pontcallec, to demonstrate their complexity. The stiffness and bad luck of Dubois gets through to the Regent, who mocks him ("with your candelabra you look like a sexton"), or is nasty, as when, suffering from a bladder infection, he holds his stomach in pain ("there are times when I like to see you suffer"). These attacks bestow on the victim the humanity he lacked, putting him on an equal footing for the final exchange, when Philippe d'Orléans refuses to allow his prime minister into his coach and makes him sit like a servant beside the coachman: "You do not spare me, Monsignor." "Did you spare me, archbishop?" Otherwise this grasping court abbot, this pimp getting the benefit of "little suppers" with La Fillon, the bordello keeper, was nothing but a clown who, to make-believe he was abstaining from meat, hid a chicken in his writing desk and could happily run around the tables and chairs (a detail reported by Saint-Simon). He could not be thought of as a smart politician, completely without scruples, but he was ready to put his resignation on the line to have the Breton conspirators executed, and confident enough of his place in history to say to Philippe d'Orléans: "If people talk about you, they will talk about me." The dual personality shows up best when, on the eve of his much-desired consecration as archbishop, he goes shamelessly from a clownish practice celebration of a Mass in a church to the cynical organization of the rigged trial of the Breton conspirators.

The Regent is another kind of creature. This man, who finds the Breton political executions repugnant, stops the dragonnades and spares the Breton peasants. He wants free schools and hopes to get the Church to sell its lands. He also reveals himself as a fragile being who refuses royalty to the point of fleeing from the clair-voyant who predicted that he would become king, who cannot completely renounce his friendship for Dubois, the man who had saved his life at the battle of Nerwinden and who worries whether anything will remain of him other than the memory of the famous "little suppers." This fragility shows in his first appearance, when he wakes up fully clothed lying on a bed, while in the next room an autopsy is underway on his daughter, the Duchess of Berry, "Jouflotte," who had lived fewer than twenty-four years and was retarded at the level of a child of nine. She had been a regular companion at his orgies, and he says of her: "What I will miss most is the pain that she will no longer make me feel." This fragility shows again at the end, when he is shown the body of a little boy killed by his carriage. Between these two corpses, *Let Joy Reign Supreme* also takes place amid the fears of sickness, old age, and death, fears closely related to debauchery, vigorously nourished (some of the valets are used as substitutes to compensate for his sexual inadequacy), and youth (the plan dearest to Philippe d'Orléans's heart is to bring his goddaughter Séverine to Paris from her convent in Brittany to be his new mistress).

But these short sequences, powerful responses, strong dramatic shifts, and clearly drawn personalities do not make for easy storytelling, since Tavernier tells his story at high speed. He generally starts out fast, never afraid of very short shots. Dissolves

and fades are almost never used to go from one scene to another, and each scene moves to the next without the director allowing himself even a moment of satisfaction. It is with this ebullience that he recounts the orgies of the Regent and his entourage, a vivacity which ultimately reduces them to insignificance. A magic lantern session reverts back to something more like farce. One "little supper" is basically devoted to the debility of Philippe d'Orléans; another is mostly taken up with the frenzies and lethargy of the morning after. It is certainly not in scenes like this, where danger of sickness or death reappears, that the film approaches eroticism. Rather, the latter is verbalized, spoken. It is born from an evocation of the good offices that Joufflote could render to a couple, of a dream about Séverine's initiation to pleasure. This can only be created by a younger character, Émilie the whore, played by Christine Pascal, who revealed her silent presence in *The Clockmaker*, where she was the assassin's lover. She shows the generous ingenuity of someone who could not find another life and the rational energy with which she decides to escape from it. This female character appears as the conscience of the Regent, the only person capable of going beyond appearances. One of his former mistresses remarks, "He makes love like one goes to the commode." Émilie offers us the explanation when she says to the Regent: "You don't like debauchery, you like the noise it makes."

And it is this noise that Tavernier lets us hear, rather than showing us the orgy, though the accompanying gross language allows us to rediscover one of the major currents of thought of the era. That at a "Ball of the Unfortunates" there were actors in drag playing such characters as Misery, Disorder, and Crime, John Law after his financial scheme collapsed, and the Grand Dame of the Realm—a death mask hidden under the mask of old age—is as sane as it is cynical, and essentially a reasonably honest portrait of the legacy of Louis XIV. These are merely the most entertaining forms of defiance, with orgies on the side now and then, and occasional debauchery and licentiousness, as they were practiced in the seventeenth century. While his mistress, Madame de Parabère (Marina Vlady), says with materialist practicality that "sorrow always comes from the stomach," the Regent never stops attacking God, whether directly or through sarcasm, mockery being the finest expression of doubt, and, of course, negation. Following the death of Joufflotte, he says: "God is cruel, Madame." Talking to Émilie about his other abbess daughter, and thus the wife of Christ, he confides: "I should also tell you that I do not get on with my son-in-law." To the young Louis XV, upset by his teachers because he had his first ejaculation during the night, he says: "It is men who invented sin." To Madame de Parabère who says, "Let's have it off before Mass," he replies, "You will die a Christian." And when he sees to what point his political orientation can be altered by his entourage, starting with Dubois, he exclaims, "I've had enough of doing God's work." The best thing about Philippe d'Orléans is that he appears to us as an authentic man of the libertine party, moving toward freedom and progress, as opposed to the party of the Church, the church of military persecutions, ordered by the Regent and the Jesuit fathers, whom he blames for their activities as arms dealers among the Indians of North America.

Thus it is that the historical re-creation goes well beyond cultural references, as in Molière's farces or Corneille's musings on power. Even beyond the use of music from the era, a Breton lament ("*Gwerx marv Pont Kallec*"), and above all extracts from operas written by Philippe d'Orléans, which, thanks to Antoine Duhamel, become perfect film music and provide an opportunity to hear Colette Alliot-Lugaz, who could

soon become one of the great classical singers, along with the Opéra Studio de Paris chorus. These compositions not only demonstrate the music of the period, but also the intellect of their composer. In this historical reconstruction, I feel that Tavernier's greatest triumph was his use of costumes. They go beyond simply marking social class; the slovenly dress, sometimes appearing perfunctory or unfinished, completely removes any feeling of solemn disguise. Thus the costumes of the "Unfortunates' Ball" can by contrast become authentic disguises, bringing their derisory note at the end of the film. The same game is played with the wigs, which are repositioned, taken off, put back; they are a nuisance, but necessary to the proper attire of the nobility, in the aristocratic sense of the term. At the beginning and end of the film, their absence serves to show the fragility of the Regent, stretched out on his bed or beside a dead child. This in-depth reconstitution feeds on details which strike us as unusual only because of our lack of familiarity with the realities of the era: misuse of the masks by the conspirators, but also by the doctors; parks and châteaux where people pissed in buckets carried by servants, where one encountered starving rats, where children played darts on paintings by the masters. The impression of reality is reinforced by the use of natural scenery, roads and streets used for daily life, where coaches loaded with gold knock over the market stalls and where coach accidents kill.

But most of all, it flows from the extremely mobile camera, which is wonderful at following the fastest movements, always edited without fuss or smugness, like the opening, long tracking shot following the pursuit of a kidnapper in the Breton countryside. It is also adept at moving into the bustle of groups, with the roisterers organizing a "little supper" in the kitchen. This freedom serves an even more essential function in the sense that each locale opens into another, each place into another where, in addition to the remainder of the scene, there is another event so new and different that it might seem, at first glance, to be unrelated to the first. The Regent's bedroom adjoins the room where an autopsy is being performed on his daughter; his office looks into the antechamber where Dubois stuffs himself with chicken; Pontcallec's cell has a view of the scaffold; the house where the orgies take place looks out on the countryside where the peasants are hard at work. Thus it is that we have an analysis of the social classes of the past that to my mind is without precedent in French cinema.

Beyond Philippe d'Orléans, the Church, the church party, and the libertine party, there is Dubois, promoted to archbishop, who, to protect his financial holdings and avoid paying taxes, as a "pillar of the bank, that is of the state," causes the collapse of John Law's financial scheme by pushing to change banknotes for gold. For Jean Aurenche, this is an opportunity to take up again with his anticlericalism, which is only considered "primary" by those who are affected by it, as in the scene where the minister is being initiated into the art of saying Mass, and the string of forced marriages for people being deported to Louisiana. Like the Church, the court nobility is much occupied with speculation and with the making of a king who suits their own interests, commencing with Louis XV as a child. This nobility is full of the haughtiness of a Bourbon duke who looks down on the plebeian Corneille and the villainy of the Count of Horn whom the Regent orders beaten up on the day Poncallec and his accomplices are beheaded. These representatives of another nobility, relics that they are, can no longer influence a people whom they do not know. To the nobility the people are nothing but domestic staff, prone to thievery, which may occasionally lead to the hanging of a lackey, making a corpse from which someone even poorer takes the shoes. But mostly people are content to steal from the

revelers. The ultimate manifestation of these domestic staff arrangements are the whores, condemned to pox and deportation, at the final stage of alienation.

Thus, throughout *Let Joy Reign Supreme*, Tavernier shows us a picture of another people, a real people: his film opens and ends with them—Breton peasants at the beginning, peasants of Île-de-France at the end. They are always there, even though the gentry have the leading roles. And this is the reality that the Regent's humanity comes up against, and where he finds his limits. His common sense with respect to Brittany, where people are starving to death, led him to say, in connection with the revolt of Pontcallec, "Misery cannot turn a peasant into the brother of a nobleman." In the end it does nothing for him. Dubois cruelly underlines this when, referring to the denial of justice to the Breton conspirators, a denial that Philippe had denounced saying, "this trial is infamous," he tries to compensate by having Horn's assassin beaten up, causing him to lose Séverine to the convent in protest. "If they hadn't been nobles, you wouldn't have noticed them." To this degree, it matters little that he had to symbolically gag Pontcallec for the reading of the verdict.

Power and politics thus see their real importance reduced to the dimensions of an insider's game satisfying their personal ambitions. This game, where capital punishment and colonial maneuvers are only the equivalent of ransom money, is a warning, a call to order, where the nobility considers each state as a pawn on a chessboard. It is a game where the ravings of Pontcallec are only a caricature, though they sometimes seem very authentic. The ultimate reality of the era is certainly economic: the shares in Louisiana and Mississippi; Law's scheme, perfect for enriching the nobility; exploitation and oppression of the people scheduled for deportation to make the colonies prosper; abduction of their children; shootings by the rabble army; a system most unusual for the banknote found by a baffled country squire, or the young Iroquois offered by the Jesuits as a gift to the child Louis XV; a system of destitution which Arlette Farge minutely analyzed in the book *The Theft of Food in Paris in the Eighteenth Century*.

It is here that Tavernier and Aurenche end their story, without resorting to a classical ending, such as the death of a protagonist or the execution of condemned victims, since history cannot be given an anecdotal conclusion. On the morning after a night of debauchery, the Regent finds himself more vulnerable than ever and wants to cut off his left hand because he thinks it stinks. In the race toward Paris, his coach runs over a young boy. After he leaves, his frenzy over, having offered lavish commiseration (mainly monetary), the sister of the victim gets the peasants to burn the wrecked coach and, laying out the corpse because "he must see this," says to it, "See how well it burns. And we will burn others, little brother, many others." He is shown this inferno that foreshadows those of another celebration, the French Revolution of July 1789.

At this point of extremely rigorous social analysis and violent revolution, *Let Joy Reign Supreme* reaches its contemporary impact, all the more so because of the presence of a court doctor, whose name (by a mischievous accident of history) was Chirac, who stole a favorite statuette of Diafoirus, and goes back to *The Clockmaker*. This film popularized the left-wing of our era in the way that Jean Renoir's *The Crime of Monsieur Lange* did for the Popular Front. Here, the tribute is direct: confusing Africa with America on a map of the world, the Duke de Bourbon (Gérard Desarthe) yells: "It is always the Negroes," a good Prévert-style maxim for a world that was crumbling, but pictured by a filmmaker of our time. It would be unkind to quibble with the authors over the historical inaccuracies to which they admit (Dubois becomes younger,

the trip to Paris is invented, as is the forced marriage of Pontcallec), unless one is a stickler for meticulous storytelling or reconstructions. Moreover, one could always go back to Alexandre Dumas, who considered it all right to alter history, as long as it produced a good story, because the devil happens to be pretty good looking, after all.

No. 168, April 1975

Let Joy Reign Supreme (Que la fête commence). 1975. Directed by Bertrand Tavernier. Written by Tavernier and Jean Aurenche. Produced by Michelle de Broca. Cinematography by Pierre-William Glenn. Music by Philippe d'Orléans. With Philippe Noiret (Philippe d'Orléans), Jean Rochefort (Father Dubois), Jean-Pierre Marielle (Pontcallec), Christine Pascal (Émilie), Marina Vlady (Madame de Parabère), Gérard Desarthe (Duc de Bourbon), Michel Beaune (Captain La Griollais), and Alfred Adam (Villeroi). In French. 119 min.

I alone have the key to this savage parade.
— *Arthur Rimbaud*

When his friend George Lucas got the rather ludicrous idea of offering him a part in *American Graffiti*, Martin Scorsese burst out laughing. Of course, he turned down the offer. What could he possibly have in common with teenagers who grew up under the California sun, were fed milkshakes and good resolutions, and were carefully preserved in their sanitized high schools and wholesome drive-ins? The pharaohs? Nothing more than wanna-be black shirts, rascals at most. Choirboys and girls who had never even felt the steel of a firearm. For better or worse, these blond, somewhat soft youth, overflowing with kindness and awkwardness, represented the America of the Anglo-Saxon Protestant majority, the ones for whom there will always be a "Magic Carpet Airlines" waiting for them when they graduate from college. Scorsese, the grandson of Sicilian immigrants, could certainly not recognize it as his own. His was a world he had entered with an almost insurmountable handicap. He grew up in the ethnic melting pot of New

The Passion of St. Martin Scorsese
Michael Henry (Wilson)

The first major piece of writing about Martin Scorsese published in France was by Michael Henry, who later became *Positif*'s correspondent in the United States. He wrote a book about Raoul Walsh, and, as one of the best interviewers, published pieces on such great American filmmakers as Clint Eastwood, Robert Altman, and Martin Scorsese.

York's Lower East Side, where those fiercely individualistic enclaves called Chinatown, the Bowery, and Little Italy are found. At an age when teenagers are busy cruising and drag racing to while away their provincial boredom, Scorsese was busy trying to survive amid the ever-present violence pervading the city. It was an entirely different set of rituals, the kind that leads to madness or death, that the young Catholic boy had been practicing in the familiar obscurity of the chapels, as did the young hood in the cutthroat districts of the seedier parts of town. These were disturbing liturgies, in many ways, since his environment had predisposed him to both mystical pursuits and the occult rituals of a crime syndicate. Priest or gangster, missionary or Mafioso: those were his options until he discovered films.

Scorsese managed to escape the Church and the "Family," but how was he going to integrate into the "other America"? Everything about him betrays those years of apprenticeship in the ghetto: the dark look, the feverish speech, the gallant mannerisms, the aggressiveness of the inveterate macho. There is no doubt but that he would have exploded in Lucas's gentle little world! It is easier to picture him as a "Dead End Kid," taking hits and punches from a James Cagney, who would be stunned and delighted to be given the part of the protective big brother to this asthmatic kid, or taken under the wing of one of those priests of suspense that only Pat O'Brien and Spencer Tracy knew how to play in the days when basketball was considered the best antidote to juvenile delinquency. At any rate, Scorsese couldn't have responded to Lucas any better than by doing *Mean Streets* (1973): drawing his own graffiti, his "Italian American graffiti," he used exalted fury and blazing anger instead of nostalgia or soulful moods that lovingly reconstituted a lost paradise, to cast in film, once and for all, all the turbulence of a season in hell.

Scorsese owes everything to film. Through it he discovered a world other than that of gangs and the Mafia, and he gradually freed himself from their debilitating grip and hysterical taboos. He is beholden to film for the privilege of having found a means of expression while his companions remained prisoners of the codes of their communities. Once out of the ghetto, he could never forget what he had *witnessed.* And this was long before *Mean Streets.* This violent piece, as categorical and irrepressible as a cry of rage, which seems to emerge in a single stream as breathless as his breathing, was, in fact, preceded by several preludes, as though its author had tried to test his voice and instrument before orchestrating the definitive version. Barely had he laid his hands on a camera at New York University when he decided to take on film the way others write their diaries. First draft: *It's Not Just You, Murray* (1964). Under the pretext of retracing the farcical ascension of his uncles, he settles his first accounts, but more than that he has fun disguising his knowledge of bootleggers and chorus girls by making them mimic the epic of the Prohibition years in the cellars of Little Italy. Second draft: *Bring on the Dancing Girls* (1965). This time, having found his Jean-Pierre Léaud in Harvey Keitel, Scorsese, in spite of himself, ends up drawing a self-portrait. By the time all of the masks have been removed, he is completely exposed.

His double, J. R., is vested with his obsessions, giddiness, even his obsession with movies, before realizing that he has made a film that is strictly for his personal use. In 1966, still not satisfied, he drafts a first script of what was to become *Mean Streets,* though without being able to keep himself from loading it with monologues and religious symbols. In the meantime, he fills out and restructures his feature film, which, after a number of trials and tribulations, comes out under the title *Who's That Knocking at My Door?* (1968). Not only does J. R. come across more than ever like his alter ego, but the bit-part actors are readily identifiable since they have the same names as their respective models. The lead character's mother is simply played by the director's own. Former friends feel betrayed by this far too narcissistic variation. There is no doubt but that they feel, with some confusion, that Marty, the camera's new wonder boy, is no longer one of them and that in these choreographed scuffles, in these dark climaxes, it is less their common past that is portrayed than the mental landscape of a naturally visionary poet.

After moving to Hollywood, Scorsese becomes involved in *Boxcar Bertha* (1972), in which he finds a way to express some of his own craziness through what Roger Corman saw as a sequel to Corman's *Bloody Mama.* This chronicle, in which biblical quotes and veiled references make for a clever and surrealistic setting, introduces our Italian-American in the character of Rake Brown (Barry Primus), the Jew from the Bronx who is so out of place in the Arkansas of the Depression that he dares not open his mouth for fear of revealing his accent and origins. The constraints imposed on him by the tried-and-true formulas of American-International end up working to his advantage: he learns to tell a story. The abrupt change of subject in intrigues, the taste for almost autonomous playlets once again reflect Jean-Luc Godard's influence, but Scorsese passes his test with flying colors: he demonstrates his professionalism in his first attempt to drop the first person singular.

It is certainly not up to us to unravel what, in Scorsese's work, comes from his private life. It is enough to know that the two are not inseparable. What is important at this point, aside from the private jokes, is the *urgency* of expression, the irresistible

Barbara Hershey in Martin Scorsese's *Boxcar Bertha.* 1972

movement that allows him to vent or confess through one of his characters. What moves us is that, by practicing his art, he has learned to know himself, to shed light on the mysterious forces haunting him, even to deal with the most contradictory aspects of his temperament. After working so hard to put himself on the stage, what fascinates us is that he has managed to distance himself enough from his experiences to give us *Mean Streets*, in which every element of his earlier attempts finally finds its definitive form elevated to its highest degree of intensity. He certainly does not avoid incorporating some of the incidents he witnessed, and may sometimes even have been involved in. Nor does he hesitate to re-create the visual and sound effects of his adolescence, contrapuntally using his favorite films and records from those days. He indulges himself with a standard super 8 "home movie" partly directed by his brother and partly by himself. He even gets his own uncle, Cesare Danova, to play the part of his new hero's, Charlie's, uncle. After considering Barry Primus, Jon Voight, and Al Pacino, he ends up once again using Harvey Keitel, as if Charlie were just a slightly older J. R. However, particularly because it comes to us not from Little Italy but from Los Angeles where, for financial reasons, most of the movie was filmed, it is a wholly different voice we hear, one that is more distant and self-assured. And it is also another eye, this time retrospective, warm without being complacent, tender and ironic, that he turns on his unfortunate Charlie of Mulberry Street.

When Scorsese speaks the first line of *Mean Streets* off-camera on the still-dark screen—"You don't make up for your sins in church. You do it in the streets, you do it at home" —he is speaking to the viewer with all the seriousness of someone who wants to transmit an always painful, but now acquired and accepted, truth. He has now moved to the other side of the mirror, and it is precisely in front of a mirror that he immediately places Keitel, who awakens with a start in the cold light of dawn. As the first sounds of the city rise from the street with the wail of a police car siren, the young man, who has still not been identified, stands gazing at his reflection, as though devoid of any identity in the game of speculation. He remains in this uncertain place where there is no distinction between reality and fiction. He is no longer entirely Martin Scorsese, nor is he yet Charlie: he is, instead, that double from whom his creator has to detach and dissociate himself if he is to conjure up his demons. The spell is broken when Keitel breaks away from his fascinated contemplation and the first chords of "Be My Baby" by the Ronettes blare out of the stereo: the suspended time of the sequence-length shot is followed by a kaleidoscope of credit titles that restores all prerogatives to the performance. We are then introduced to a prologue in which we meet, by name, not one but four characters: Tony (David Proval), Michael (Richard Romanus), Johnny Boy (Robert De Niro), and, last but not least, Charlie. Scorsese substitutes himself for Charlie one last time, as we find the latter kneeling at an altar, reciting a favorite prayer of Scorsese's: "Lord, I'm not worthy to eat Your Flesh, I'm not worthy to drink Your Blood. If I do something wrong, I want to pay for it my way . . . You don't fuck around with the Infinite!"

The director is now free to sever the umbilical cord once and for all: the curtain rises on the theater of the imagination as the savagely pounding notes (the Rolling Stones' "Tell Me") accompany the slow zoom into Tony's bar, with an almost ceremonial slowness. By the time the camera once again finds Charlie, immobile, lost in dark contemplation, the red light bathing the set carves the enigmatic mask of the damned on his face. The word is not too strong: the apparently absurd round of characters

will be dictated by an infernal liturgy, which will also justify the peculiar, even concentric, progression of the story. We should not be fooled by the real-life shots of the crowd celebrating the feast of San Gennaro: they too are taking part in a fantastical reality. Barely have the four characters been set in their respective contexts before Scorsese plunges them into his very own universe, so impatient is he to shatter and dispel all of the naturalistic and psychological conventions. Every gesture and movement is stylized and arranged like a ritual, whether it be the sensuous dancing by the black stripper, whose body, glistening with sweat, is detailed in close-ups, or the appearance of Johnny Boy, which leads to two zooms on the same, but symmetrically opposed planes, or the scuffle in the pool hall where the hand-held camera plunges right into the fray. It is no longer a question of describing a lifestyle but of exorcising it. The idea is to capture the spasms and convulsions of a battle that is primarily spiritual.

Scorsese does not flinch at any extravagance, even if it means distending beyond any semblance of reality the scene in which the drunk rolls blissfully on the counter, until, riddled with bullets, he drags the young assassin from one end of the room to the other, or when he frames the wide-angle sequence of Charlie wandering increasingly dazed under a canopy of streamers, as tightly as possible. A very edgy physical setting, which can't be matched for bringing to the surface that which, in others, would remain latent. Because here all the characters reveal their real faces in the most acute stage of crisis: Teresa (Amy Robinson), when she collapses in an epileptic fit; the Vietnam hero who pounces like a beast on an unsuspecting young girl; Johnny Boy, when he knocks over and beats up a pedestrian on Broadway who is unfortunate enough to be in his way; or when he crouches on the rooftop, firing his .38 caliber pistol at the silhouette of the Empire State Building, imagining himself to be John Wayne in *Back to Bataan*. There is an endless stream of brutal swerves, breakaways to the unfathomable, which throw the tempo of the tale into a frenzy while at the same time giving it its true dimension.

What some might consider to be flawed construction, digressions, repetitions, or circularity in the anecdotal framework, and characters that go nowhere, we take as essential to the very premise of the movie. In *Mean Streets*, the individuals are not faced with a dramatic situation in the true Hollywood sense, but with something impalpable, starting from the far more worrisome neuroses that the Italian-American ghetto transmits to its children from one generation to the next. They are possessed, but their madness serves as a metaphorical reminder of their environment. None of the traditional approaches, especially not that of the documentary, could render it. One has to dispose of it quickly or transfigure it into a fabulously stylized opera. Scorsese sensed this and thought nothing of introducing a couple of wildcats in a cage in the back room of the bar, so as to establish a symbolic relationship that is stronger than any comment would have been, and which, in particular, injects each scene with *diabolical* imagery that has yet to be reproduced in contemporary American films: bedeviling neon lights and fluorescent nights in the metropolis; the obscurity of the bar lit up like a giant jukebox; the pale and overexposed light in a hotel room, where love can only lead to guilt; and far and away those candlelights, match lights, and even the stove on which Charlie practices his martyrdom. This is the mindscape of these young hoodlums, whose lives are *smoldering* away because of their inability to imagine any behavior other than that of their elders, which has been ritualized to the extreme. Every last one of them is a prisoner of his character—Michael mimicking the Hester Street bosses, Tony resting on the

laurels of his "success," Johnny Boy too much of a clown to see his suicidal terrorism through to the end, and Charlie, who fancies himself the St. Francis of Assisi of his neighborhood but keeps having to check in with his "uncle," the Don.

We guess that Scorsese injected each of them with a bit of himself to the point that, at the end, he has to appear in person, as the exterminating angel at the hour of judgment. He wanted to be the killer with the fixed stare, moved by a determination as unwavering as it is mysterious, who kisses the barrel of his revolver before propelling the expiatory victims that Charlie, Johnny Boy, and Teresa have become into an apocalypse of gushing blood and broken metal. Has he managed to exorcise the ghosts of the past? It's doubtful, since he couldn't resist throwing Keitel, more unbalanced than ever, right into the middle of *Alice Doesn't Live Here Anymore* (1974). In a terrifying sequence, he gives free rein to a furious madness that hits us like a ground swell, as though Scorsese suddenly wanted to resurrect the demons of Little Italy in that Phoenix motel. As though to emphasize the analogy, Keitel himself points to the scorpion pendant hanging from his neck and says: "You mess around with it and it's gonna kill you." And what is *Taxi Driver* (filmed in June 1975) if not a throwback to New York's mean streets, this hell to which the director just keeps returning?

With *Alice* at least the setting changes. As with *Boxcar Bertha*, this is a movie about transition, a genre film between two intimate and unclassifiable films. The fact that Scorsese did not become directly involved in the script for Alice, that he left the responsibility for the editing to Mrs. George Lucas, whereas he had previously always felt a need to control every beat of his scenes, shows how determined he was to take a step back for a while. The subject matter, from the very start, forced him to do this: he was hardly the one to paint a portrait of a thirty-five-year-old woman in the Southwest with which he felt no bond. Worse: he who hated horses, the wide-open spaces, and everything that served as a reminder of the countryside, was suddenly forced to make the rancher with a heart of gold played by Kris Kristofferson (David) credible! As well, the collection of material suggested and given him by Ellen Burstyn (Alice) fits somewhere between screwball comedy of the *Theodora Goes Wild* genre and the Sirkian elegies that plunged the most gracious and fragile widows into dereliction in the 1950s. The character of Alice belongs to Hollywood's heritage, carrying around half a century of soap operas and women's films. This is what Scorsese sets up, from the prologue-flashback, jumbling together half a dozen famous sets on a crimson plate as in the good old days of "Technicolor by Natalie Kalmus," and later multiplying the verbal references to current and past stars of the silver screen and music. (It's no surprise to find John Garfield popping up again.)

But how to inject life into what might be nothing more than an exercise in style, a variation on a theme that has been replayed a thousand times? Essentially, through the intensity of the tone: despite a budget three times that of *Mean Streets* and the presence of a well-known star, Scorsese uses the same approach as in the earlier film, which is to say, a hand-held camera. It never takes a break; most of the scenes involve complex movements, to the point where an indefinable anxiety weighs on these decentered characters who are incapable of settling into a role. The previously cited motel scene is exemplary for having been anticipated from both the visual and sound standpoints with a series of insidious internal rhymes: a single shot, from a vertical angle, of Alice and Ben (Harvey Keitel) sprawled on the bed after making love, just when Ben breaks a glass: the next scene with Alice cradling her son just as, in the

next room, off-screen, a domestic fight plays out, punctuated by the sound of breaking glass; a sequence in the kitchen where the camera spins over the breakfast table with disturbing agitation: and, a few minutes later, Keitel shatters the glass on the door and bursts into the room, knife in hand. Scorsese avoids repeating himself by not filming (or at least editing out) the accident that cost Alice's husband his life, but he instinctively returns to the choppy dark scenes from *Mean Streets* as soon as the main character, stepping out of the blistering heat in the street, penetrates the gloomy Phoenix cocktail lounges for her auditions. There, as in the bars of *Mean Streets*, the feel of disquiet is achieved through the camera's excessive movement which, in defiance of the traditional reaction shots, most often does 360° turns around a piano or a circular bar each time Alice, her heart in her throat, puts it all on the line.

Paradoxically, some of the most beautiful scenes in the movie, which crosses a good part of New Mexico and Arizona, take place within four walls. It would appear that Scorsese is neither a poet of the road nor a minstrel for the faraway horizons of the frontier. The dolly-out from Alice's and Flo's (Diane Ladd's) faces as they tan themselves in the sun, to reveal a very unflattering picture of a shantytown, betrays how little the director likes the Western US. He only seems to be really at ease when his characters can be boxed into a claustrophobic setting: motel rooms so narrow that he has to use a wide-angle lens, or the Tucson cafeteria where an ever-present camera follows the merry-go-round of plates and obscenities in a hyped-up atmosphere that imperceptibly takes us back to 42nd Street. "If I met a man like Robert Redford, that would be a different story," says Alice before she sets off on her odyssey. Not only will she not meet Prince Charming, but her itinerary will bring her back, a little more disillusioned, to her starting point: the long dialogue confined to the four deep blue walls of the washroom, during which Alice ends up admitting to Flo that she can't live without a man, is a perfect response to her declaration in Socorro, *before* the trip, where Alice proclaimed the opposite to her neighbor. But Alice could not achieve her liberation any more than the desperate characters in *Mean Streets* could theirs. Hypnotized by Hollywood, she undoubtedly took a wrong turn. But Martin Scorsese is not ready to give up. He has made it to Wonderland, but he can be trusted to resist its deceptive charms and to set off to find, in more familiar climes, those hurting souls whose tragic lights he is better than anyone else at capturing.

No. 170, June 1975

Boxcar Bertha. 1972. USA. Directed by Martin Scorsese. Written by Joyce H. Corrington and John William Corrington, based on characters contained in *Sister of the Road*, the autobiography of Boxcar Bertha Thompson as told to Dr. Ben L. Reitman. Produced by Roger Corman. Cinematography by John Stephens. Film editing by Buzz Feitshans. With Barbara Hershey (Boxcar Bertha), David Carradine (Big Bill Shelly), Barry Primus (Rake Brown), Bernie Casey (Von Morton), John Carradine (H. Buckram Sartoris). 92 min.

Mean Streets. 1973. USA. Directed by Martin Scorsese. Produced by Jonathan T. Taplin. Screenplay by Scorsese and Mardik Martin. Cinematography by Kent Wakeford. Film editing by Sid Levin. With Robert De Niro (Johnny Boy), Harvey Keitel (Charlie), David Proval (Tony), Amy Robinson (Teresa), Richard Romanus (Michael), and Cesare Danova (Giovanni). 110 min.

Alice Doesn't Live Here Anymore. 1974. USA. Directed by Martin Scorsese. Written by Robert Getchell. Produced by David Susskind and Audrey Maas. Cinematography by Kent L. Wakeford. Film editing by Marcia Lucas. With Kris Kristofferson (David), Billy Green Bush (Donald), Diane Ladd (Flo), Lelia Goldoni (Bea), Lane Bradbury (Rita), Vic Tayback (Mel), Jodie Foster (Audrey), and Harvey Keitel (Ben). 113 min.

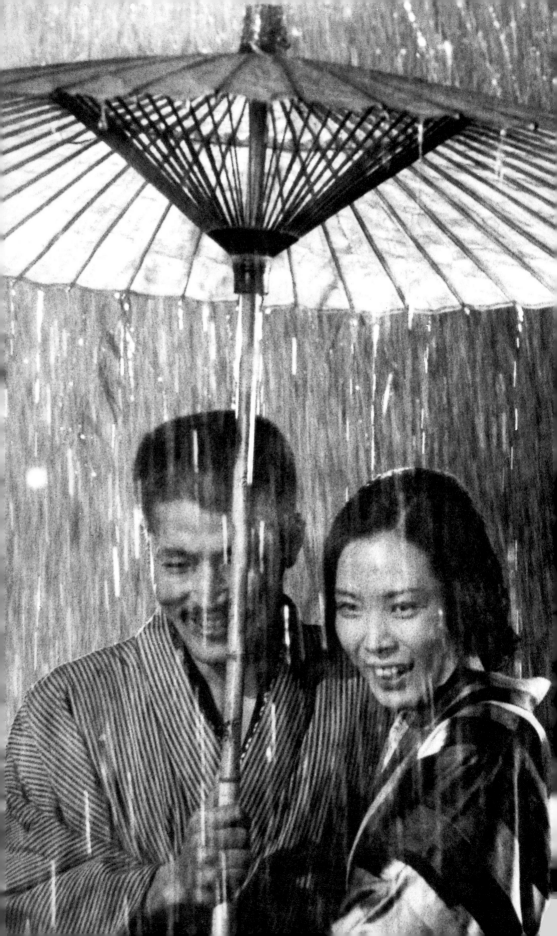

S erenity in intensity, bliss in turmoil, transcendence in total perdition; that, with very modest means, is precisely what Nagisa Oshima has achieved in his very latest film, *In the Realm of the Senses (Ai no corrida)*.

Never has open and natural eroticism been so pure. So high is his regard for the sex act (whereas the eye of the law, brought to bear on the same act, would, like the language of law, be intolerably sad) that we view this film with the same hieratic distance as Oshima's earlier, and on the surface more political, works, which are also more complex in terms of structure and more fleeting as well. There are many others I could name, jewels such as *Death by Hanging (Koshikei)*, *The Ceremony (Gishiki)*, and *Dear Summer Sister (Natsu no imoto)*.

The Spiral of the Absolute: *In the Realm of the Senses*
Robert Benayoun

Nagisa Oshima and Shohei Imamura soon appeared as the leading lights of new Japanese cinema. *In the Realm of the Senses*, co-produced by the Frenchman Anatole Dauman, caused a veritable scandal by stretching the bounds of erotic film. Robert Benayoun, who wrote the book *L'Érotique du surréalisme*, defended Oshima's film.

From the very beginning of the film, Oshima uncompromisingly sets up shop in the midst of paroxysm, as a landscape painter would set up his easel in a meadow. Kichizo (Tatsuya Fuji) , the amorous and hardened hero of this tale of fire and ice, is, whenever he is near the appropriately named Sada (Eiko Matsuda), always in a permanent, we might even say final, state of erection, because it can only be ended by death. The ultimate end of their unreasonable liaison is total exhaustion, which finally is the only way to measure boundless mutual possession. Everyone in the Yoshidaya Inn knows from the start that coupling at this level, as practiced by certain creatures in the grass, will find death in excess. Comments like, "I want to die! I am going to kill you, you'll see! She will end up killing you!" are heard among the chosen sweat and tears of Kichizo and Sada, who possess each other so much that they change kimonos and eat all their meals with only the dew of wild sex for spice. They take each other standing, smoking, singing, playing shamisen, walking in the street, out in bad weather and good, from inn to inn, in heavy rain, tormented by the idea of the strangler's rope that can provide unlimited ecstasy.

Such a love, blasphemous in its rigor, leads them to acts of transgression that are Oedipal in scope. Sada, who is virtually an orphan, and who at the beginning of the story gave herself for free to an ancient beggar, encourages Kichizo to make love to a sixty-eight-year-old geisha, which he does, almost killing her. "I had the impression I was kissing my mother's corpse," admits Kichizo, whose own mother died when he was very young. In short, the two lovers bring back their almost non-existent parents from nothingness to add a hint of incest to their partners in the transfer deliberately orchestrated by Sada. The same was the case in *The Ceremony*, with Sakurada's sons, unfamiliar with their ancestry, searching for Oedipus with their aunt Satsuko.

Kichizo's virility, which is so strong that it intrudes into his sleep, seeks annihilation and immediately recognizes it as incarnate in Sada. When he sees her for the first time, knife in hand, doing battle in the back kitchen, he says, "You'd be better off handling something else." But from this moment on, their relationship appears to involve both erection and castration. Kichizo will experience many edgy days,

Tatsuya Fuji and Eiko Matsuda in Nagisa Oshima's *In the Realm of the Senses*. 1976

perpetually shaving or being shaved, allusions to the key, threatened by the scissors Sada uses to cut off the symbolic hair of his beard, making love under his lover's suspended cleaver. The rite of strangulation they invent together as a way to achieve an almost absolute orgasm is a preliminary image of castration, as if the final purpose of erection was pure and simple detachment of the phallus-penis. Is this to be seen as a reflection of the organic oneness of love and death, leading the human being to a genuine extroversion of the death instinct as it is reflected in Norman Brown's *Eros and Thanatos*? When Heraclitus says: "Within us, the same thing is both living and dead, awake and asleep, young and old. Through a reversal, the one becomes the other and those in turn become these," he is putting forward Henri Bataille's basic idea when he says, "Of eroticism one can say that it is the approval of life until death," or as Georg Friedrich Hegel puts it, "The dialectic of reality is a Bacchanalia in which not one single participant is drunk."

And it seems that in the deadly game being played by the two lovers, the thread of life, as identified by the breathing, becomes increasingly valuable as it wears and approaches the breaking point. When Kichizo agrees, after many interrupted attempts, and not without attentive lucidity, to a final strangulation, it amounts to the satisfaction of a mutual conspiracy. Carrying out the deed in sadness and weariness achieves eternity, the time in which childhood lives. And Sada only really possesses Kichizo in this supreme moment when she appropriates the genitals of her now finally appeased lover, by cutting them off.

That the director at the end refers to a 1936 news story that is *unrelated* to the revolt of a number of young officers, apparently providing a little respite to people, sheds light on the relationship between realism and the ineffable. The key to Oshima's art clearly lies beyond this indefinable zone where facts and motives can be weighed.

No 181, May 1976

In the Realm of the Senses (Ai no corrida). 1976. France/Japan. Written and directed by Nagisa Oshima. Produced by Anatole Dauman. Cinematography by Kenichi Okamoto and Hideo Itoh. Music by Minoru Miki. With Eiko Matsuda (Sada), Tatsuya Fuji (Kichizo), and Taiji Tonoyama (Tramp). In Japanese. 115 min.

I am somewhat hesitant to discuss Rainer Werner Fassbinder because I have seen only seven of his films, less than one-third of his output. Those that I have seen are, in the order in which I saw them, *Why Does Herr R. Run Amok?* (*Warum läuft Herr R. Amok?* 1970), *Ali: Fear Eats the Soul* (*Angst essen Seele auf;* 1974), *Martha* (1974), *The Merchant of Four Seasons* (*Händler der vier Jahreszeiten;* 1972), *Fox and His Friends* (*Faustrecht der Freiheit;* 1975), *Mother Küsters Goes to Heaven* (*Mutter Küsters Fahrt zum Himmel;* 1975), and *Fear of Fear* (*Angst vor der Angst;* 1975). But I am very keen to see his other films and experience a form of jealous admiration for the prolific output of a director who was able to make so many films even though he is not yet thirty (and also has

The Vampire's Kiss (about Rainer Werner Fassbinder)

Jacques Segond

Along with Wim Wenders and Werner Herzog, Rainer Werner Fassbinder participated in the renaissance of German cinema, but it took longer for him to gain acceptance from French critics than his two fellow-countrymen. This article by Jacques Segond (alias Jean-Loup Bourget) is one of the first overviews that gives Fassbinder's work the credit it deserves.

written many film reviews as well as plays for the theater), acts in his own films and in the films of others, and, not so long ago, considered his directorial work in the theater more important than his film work. He was also able to display technical prowess, such as shooting *Martha* (which is superb from the technical standpoint) in 16mm in only a few days.

Subject to seeing more of his films then, it would seem to me that Fassbinder's main theme is exploitation. This vague exploitation is exerted by society on people like Herr R. (who works and is the father in a model family), Margot in *Fear of Fear* (a wife and mother in a model family), the immigrant worker Ali, the merchant of the four seasons, and the homosexual (played by Fassbinder himself) in *Fox and His Friends*, the father (whom we never see), in *Mother Küsters*, who, like Herr R., suddenly goes crazy and becomes a killer (he is also called by the press Hermann K.). Sexual exploitation: Fassbinder's couples are perpetually at war, alternately dominating and being dominated, and tending gradually to trade places with one another, as in Joseph Losey's *The Servant*. Likewise, in *Martha*, the frigid and inflexible wife gradually becomes the powerless victim of a sadist; in *Fox and His Friends* (the German title means the law of the strongest or the law of the jungle), Fox, an aggressive proletarian who is bad-mannered and stinks, dominates his overly refined lover and then the relationship between them is reversed. Fox is humiliated, loses the fortune he won in the lottery, is kicked out of his home and driven to the brink of suicide.

In *Ali*, once the common threat has been dispelled (society's hostility), the couple tends to fall apart. The woman takes the upper hand and behaves in a paternalistic manner. Ali takes revenge by being unfaithful to her. Within the family unit, members are jealous of one another; Brigitte Mira's children abandon her because they do not approve of her relationship and then her marriage to a Moroccan by the name of Ali. Margot's sister-in-law and mother-in-law, pretending to be helping her, spy on her and condemn her, and interfere with her and her husband (*Fear of Fear*). In *Mother Küsters*, relations between the mother-in-law and daughter-in-law are bittersweet, etc. It nevertheless needs to be pointed out that with only a few exceptions, there is some faithfulness in family relations, such as those between Fox

and his sister (*Fox and His Friends*), or Margot and her brother-in-law (*Fear of Fear*) or yet again between Mother Küsters and her children (after leaving her, her son still visits her and helps her carefully assemble electrical plugs; her daughter, who left her and in a certain sense betrayed her because she lives with the slanderous journalist, nevertheless comes to her when there is trouble).

In terms of structure, people have emphasized that Fassbinder owed a lot to the American cinema in general and to Douglas Sirk in particular. Indeed, while many of his films are naturalistic in terms of subject, environment, theme (society as a cold monster that exploits individuals), or the style of the interplay and the language (this foundation in naturalism is singularly lacking in Daniel Schmid's horrible *La Paloma*, although it superficially resembles Fassbinder's films: three of the main actors are in *Fox and His Friends*) at the same time these films are highly stylized in terms of photography, framing, and the use of unrealistic colors (whether overly bright or pastel). The oppressive sets and the camera movements are sometimes overly aesthetic, with insistent music and the presence of many mirrors, which is particularly reminiscent of Sirk's melodramas. (The mirrors are always there for a reason, and they always meet a need, whether to express the narcissism of the homosexuals in *Fox and His Friends* or the soul-searching of the heroine about her identity in *Fear of Fear*.) *Ali* is a barely disguised homage to the German-American director (Sirk), because it is in several respects a remake of *All That Heaven Allows* (1955), a romantic tale of a young man (Rock Hudson/El Hedi ben Salem) and an older widow (Jane Wyman/Brigitte Mira), who encounter problems because of class differences and the meddling of the women's children. In Sirk's brilliant and bitterly ironic treatment, as Jane Wyman looks at her own reflection on the television screen, a salesman is explaining how she can, with a single gesture, have access to all the theater of the world, a scene echoed in the Fassbinder film when the son (played by Fassbinder himself) angrily kicks the television set and breaks it.

It would nevertheless be wrong to overstate Fassbinder's debt to Sirk. There are, to be sure, a number of similarities and differences that go beyond the question of influence. Fassbinder, who wrote his own screenplays, had a level of freedom that Sirk never did. But, somewhat like Sirk at Universal Studios, Fassbinder surrounded himself with a team of regulars who helped to give his films a family feel and make the crew a kind of "collective." This was certainly true of Brigitte Mira, Ali's widow, who was also the heroine in *Mother Küsters*, and who plays a small but likeable and faithful role in *Fox and His Friends* (she sells Fox the lottery ticket that wins him the big prize). Margit Carstensen, the great pre-Raphaelite lily, is the heroine of *Fear of Fear* (in which she calls herself Margot) and of *Martha* (note the similarity of the first names); she is also Petra von Kant (*The Bitter Tears of Petra von Kant*; 1972) and in both *Mother Küsters* and *Martha* she plays Karlheinz Böhm's wife. Other regulars are Irm Hermann, Margot's sister-in-law (*Fear*), the granddaughter of Mother Küsters, the wife of the merchant of four seasons, etc.; then again, there is Ingrid Caven (playing a crazy woman in *Fear*; the singer Corinna, the daughter of Mother Küsters, the "great love" of the merchant of four seasons, etc.). The same is true of the male roles: Adrian Hoven plays the pharmacist in *Fear*, the newspaper publisher in *Mother Küsters*, the father in *Fox and His Friends*, etc.; Kurt Raab plays a crazy man in *Fear*, Herr R. in *Why Does Herr R. Run Amok?*, a homosexual in *Fox and His Friends*, etc. In addition, Kurt Raab, like Fassbinder, is a versatile person who was the art director on *Effi Briest* (1974). He was also the co-writer of the screenplay for

Gottfried John and Brigitte Mira in Rainer Werner Fassbinder's *Mother Küsters Goes to Heaven*. 1975

the latter film. For the music, we have Peer Raben, for the editing Thea Eymèsz, and for cinematography Michael Ballhaus or Jürgen Jürges.

It is only to be expected that Fassbinder and Sirk, both German and both from the theater, should each reflect a tradition which is not that of the American cinema, but rather German theater. There is, for example, Fassbinder's Kammerspiel (intimate theater). Space in his films is indeed closed, both thematically by reference to the family unit (parents plus children, whether married or not) and spatially (a family living in the same apartment or in the neighborhood). The sets for Fear are almost theatrical: Margot's apartment, the window in which we see her, as in a Vuillard painting, a chestnut tree in flower and her lover's pharmacy, and her in-laws live in the same building. Stylistically, in Mother Küsters and Fox, the image on-screen is often left in shadow and vague around the edges, with the action restricted to the central portion, an effect of depth and of enclosure, as in a box.[1] This is the intimism or confinement of Kammerspiel.

To return to Ali, is Fassbinder deliberately continuing to work in the tradition of melodrama? The story line of the screenplay reproduces that of All That Heaven Allows reasonably faithfully: the separation of the couple, the accident that happens to the man, the reconciliation in extremis at the bedside of the injured man. But Fassbinder, instead of falling back on Sirk's happy ending, opts for another kind of symbolism by making a significant reference to an illness that appears to readily affect immigrant workers. This turn of events thus reinforces the naturalistic side of the work. At the very moment that the film was being released in London, there was an article in Le Monde that began as follows: "By marrying a foreigner, some two hundred and fifty thousand German women have become second-class citizens, because their families can be broken up by the deportation of their husband," etc. (Daniel Vernet, September 19, 1974). This type of symbolism or stylization also evokes not only melodrama, but the medieval genre as well (morality plays, satirical farces known as sotie) in which there is a great deal of social content, or German theater of the 1920s (expressionism with its varying levels of social satire and aesthetics). Similarly, a distinction needs to be carefully made between the baroque (or the expressionism) of Mother Küsters (the scene in which the singer Corinna is introduced as "the killer's daughter," which is reminiscent of Josef von Sternberg's Blue Angel or Bertolt Brecht's Threepenny Opera) and of Martha, a stylistic exercise and a brilliant remake of those atmospheric films in which an apparently well-intentioned husband has horrible plans for his wife, and attempts to convince her that she is crazy (cf. Gaslight, both the Thorold Dickinson and George Cukor versions, Sirk's Sleep My Love, etc.). It is in the latter film, it seems to me, that Fassbinder went furthest in paying homage to Hollywood. But Fassbinder's true legacy comes mostly from Germany, where naturalism and stylization are freely mixed. The very title of Mother Küsters alludes to a film by Piel Jutzi called Mother Krausen's Journey to Happiness (Mutter Krausens Fahrt ins Glück; 1929); the name of the hero in Fox, Franz Biberkopf, is that of a character from Alfred Döblin's Berlin Alexanderplatz (adapted by Jutzi).

To be precise Mother Küsters is a kind of morality play, or sotie, whose sarcastic humor, tender for the heroine but equally ferocious toward all ideologies, caused the grinding of many teeth. I will summarize the story as follows: Küster, an aging German worker, suddenly goes crazy, kills the son of the plant director, and then commits suicide. Photographers and journalists from the major papers tirelessly hound and harass the widow, the son, the daughter-in-law, and the daughter of the "crazy"

man for interviews, recollections, and photographs, all falsely spontaneous. One reporter, likeable but cynical, assures Mother Küsters that he will strive to be as objective as possible and gains her confidence. The old woman is stupefied when she reads his article, which describes Küsters as a violent drunk. Distraught, she is taken in hand by Karlheinz Böhm and Margit Carstensen, who play a wonderful couple of Communist grand bourgeois. They then rehearse a plan, promising Mother Küsters that the Party will do everything possible to rehabilitate the memory of her husband. He was not crazy at all; he was right to rebel against a system that oppressed him, but he went about it the wrong way. His purely individual act was nihilistic and ineffective; he should have cooperated with the working class. Touched by so much gentleness, although not completely taken in by it, Mother Küsters joins the Party, and the Party uses her to kindle the faith of the converted. But the rehabilitation never happens; Böhm says that this is because an election campaign is under way, and that any publicity of this kind would have a negative impact on the Party.

The third phase in this voyage of political disillusion involves a left-wing anarchist taking Mother Küsters in hand, telling her that she could expect nothing more from the Communists, who are intellectuals cut off from the working class, and he suggests that direct action is needed. He therefore organizes a sit-in at the newspaper headquarters to demand an immediate retraction from the reporter. But the publisher pays no attention to the sit-in; the Left-winger quickly becomes discouraged and disappears, leaving Brigitte Mira alone. Then comes the security guard who closes up the building and invites her to his home to share his "Himmel und Erde"— "heaven and earth"— namely, sausages and potatoes. We can see the irony: rising to heaven, the Assumption, and we end up in the paradise of a plate of sausages (the film ends as it began, with references to food).

The popular press, like Springer, the Communist party, and the Left-wingers, are all sent off, with the Communists particularly harshly treated: the party of intellectuals, wealthy bourgeois holding a silver coffeepot, giving lessons to the proletariat, to the real workers; the party of Machiavellian calculating people ready to scandalously blackmail a poor and sincere woman (an alternative ending would have had the anarchist, rather than contenting himself with a sit-in, getting out a submachine gun, as a result of which Mother Küsters is killed by the police. I prefer the ending actually used: it confirms the impression that the Left-winger also talks but does not act; his bittersweet irony keeps the film from falling into noir melodrama in keeping with medieval morality or the theater of the 1920s). That this satire, with its various targets, hits the mark, at least in Germany, is clearly demonstrated by the fact that threats from the left were received when the film was to be shown at the 1975 Berlin Festival. After being withdrawn from official competition out of fear of "retaliation," it was screened on the fringe of the festival and was disrupted by threats made against Fassbinder stating what would happen when it was commercially released in Berlin. As was noted by Christian Braad Thomsen (program notes for the London Festival), such reactions proved that Fassbinder's satire had hit the mark and had exposed the latent Fascism of a number of fringe Left-wing groups.

That *Mother Küsters* is intended to be an all-out satire (which is what makes it so charming) is confirmed by minor details. For example, at the beginning of the film, when we know nothing yet about Küsters's "accident" or "craziness," there is a direct confrontation as dinner is being prepared between Brigitte Mira, who wants sausages for her husband, and her daughter-in-law, who wants natural food, and we

see a cucumber being peeled. We learn that Küsters is exasperated by his daughter-in-law's salads. Curiously, his antisocial anger also stemmed from the fact that people were trying to turn him into a vegetarian. There is irony here at many levels: contrary to Michelet's statements and the theories of mechanical materialism, it was the absence of meat that made him aggressive. Can we then extrapolate an allusion to Hitler's vegetarianism? The link between Nazism and the "ecological" left is tenuous, but it exists. Here again, Fassbinder is referring to all holders of totalitarian ideologies, insupportable moralists who, for the good of those close to them, prohibit them from smoking, eating meat, drinking alcohol, and a host of other things.

Less amusing and less jarring, but more revealing, is *Fear of Fear*. The title means anxiety of anxiety, and is also reminiscent of Ali ("Anxiety that attacks the soul"), which expresses the subject well. We have here a woman (Margit Carstensen) who becomes almost crazy *because she is afraid of becoming crazy*. Her expression becomes troubled, and her petit-bourgeois apartment, with its scary symmetry (e.g., shots in which pictures hanging on the wall are rigorously balanced by the lampshades), strike her as a reflection in the water. She has the feeling that she is losing her mind, and her sense of reality. All her husband can think about is passing an exam to improve their finances, and he has no time to spend with her. Her mother-in-law and sister-in-law think of nothing but making her jealous and spying on her. She has a brief affair with the pharmacist on the corner, begins to drink, slashes her wrists, not to kill herself, she says, but to feel pain, out of curiosity and out of a desire to feel emotion, whatever the emotion may be. Her doctor (Fassbinder's universe, like Sirk's, is full of doctors: needless to say, they are the conscience of a world in which God is dead, the laughable priests of capitalistic materialism) tells her that there is nothing wrong with her from the physiological standpoint and prescribes Valium, a scene that is repeated word for word from *Fox and His Friends* (Fox becomes ill), and also echoes Ali's psychosomatic illness, "the illness of immigrant workers." In short, Margot is a kind of 1975 version of Madame Bovary (it is worth noting that in both instances, there is a pharmacist, who in Flaubert specifically plays the role that would formerly have fallen to a priest; furthermore, *Effi Briest*, an adaptation by Fassbinder of Theodor Fontane's novel, has been systematically compared to *Madame Bovary* by the French press). Her illness is vague, a problem that results both from her social condition (the Germany of the economic miracle, the fact that she is a slave of her antlike work, exhibiting her bad taste as a parvenu of history, a Biedermeier of the twentieth century) and her status as a wife and homemaker. (We note once again that in Fassbinder, the exploitation is frequently mutual: whereas *Martha* or *Fear* are at least by implication feminist films, in *The Merchant of Four Seasons*, the hero suffers and dies at the hands of women.)

In addition, more than in Fassbinder's other films, *Fear* is reminiscent of the remarkable film by Dorothy Arzner, *Craig's Wife* (1936), with Rosalind Russell playing the role of the wife who goes crazy because of her mania for cleanliness and tidiness. Her obsession with the practical makes her lose sight of reality: the dread of the ordinary is a form of dementia. *Craig's Wife* and *Fear of Fear* are, in fact, horror films, and this, I believe, is an important key to Fassbinder's work. There are several signs of this: *Martha*, which is clearly an homage to gothic films, which are very close to horror films, with the heroine (Margit Carstensen) married to a husband who not only wants her money, but who is a sadist as well, a genuine vampire. The husband's role is played by Karlheinz Böhm, a regular in horror movies (Michael Powell's

Peeping Tom, 1959; wasn't he also in Giorgio Ferroni's *Il mulino delle donne di pietra?*). We find him again in *Fox*, playing the sardonic master of ceremonies at the ambiguous function; he is also the Communist in *Mother Küsters* once again showing irony, provocation, and additional involvement (given that he is, as usual, playing a Nazi), and once again a metaphorical "vampire" who exploits Brigitte Mira in spite of the timid protestations of his wife (Margit Carstensen, of course).

As for Margit Carstensen, how can we not notice how white and pale she is? In *Fear* the doctor diagnoses her as "anemic." Blood plays an important role in this film. When pregnant, she comes out of the bathroom with her hand covered in blood: this is the premature beginning of her delivery (the very fact of having a child, in petit-bourgeois society, thus appears as bloodied or involving vampires). Later she slashes her wrist, and the red blood flows freely. The atmosphere of *Fear* is worthy of Roman Polanski (*Repulsion* and *Rosemary's Baby*). References to horror films are completely in order: in contrast to her pale skin and to Margot's increasing thinness (e.g., the swimming pool scene, Margot's whiteness, and the bluish tone of the water, all equally indicative of illness), blood spurts crazily. All in all, the film is marked by very soft pastel tones, with great sensitivity, and it is stylistically reminiscent of *Neue Sachlichkeit*, new realism. It is meticulously shot, highly stylized, and reminiscent of the era of the 1920s (a phase of academic expressionism that it recalls, along with negation; this is another avant-garde German movement that was deemed decadent and degenerate by the Nazis, and hence George Grosz's exile to America, and Otto Dix's to Switzerland). The contrast with red could not be brighter: Margot's painted fingernails (her little girl imitates her, even though she has been told not to paint her nails; her indifferent mother lets her do so, but the parents are scandalized. This vital and deadly blood, this fluid of birth and death, needs to be diluted, erased, blotted out); her knitting; the injury to the young Bibi.

In *Martha*, Karlheinz Böhm rapes and bleeds the body of Margit Carstensen, who has been sunburned, as shown by her scarlet skin. In *The Merchant of Four Seasons*, one of the vampire women, Ingrid Caven, goes to the cemetery with her lips painted red and carrying red roses. This scene is found again in *Mother Küsters* (the red roses at the funeral), a film in which it is also worth noting the red-and-white-checked tablecloth that Brigitte Mira uses, which is also emblematic of melodrama (Sirk's *Written on the Wind*), here a foretaste of Küster's violent death? Thus, as seen by Fassbinder, Germany in the 1970s is a kind of death in life in which the only real signs of life (Werner Herzog) are rebellion, murder, suicide, and madness. While the theme of exploitation may be very ordinary, it moves us and fascinates us because Fassbinder is the incarnation of the metaphor of vampirism. It is literally that the exploiters drain vital fluids from those who are exploited and bleed them dry. They then abandon them like a horse bled by South American vampire bats. For example, Fox's body at the end of *Fox*, stripped and bare (in the film, the repeated kisses of homosexuals on the neck have connotations of vampires); *Ali*; the merchant of four seasons, who commits suicide (by drinking) after having been emptied by women; Martha, reduced to her wheelchair, becomes the familiar phantom of the haunted house where she is kept; Mother Küsters, in the first of Fassbinder's imagined endings.

These deeply rooted similarities between Fassbinder's films and horror movies are also confirmed both in terms of dramatic structure (for example, in *Herr R.*, as in many horror films, nothing happens for a long time until the audience becomes

almost bored; then the repressed drama suddenly explodes) and in terms of style (the surface academism of *Neue Sachlichkeit* belongs to horror film aesthetics). We need only refer back in this respect to *Horrors of the Black Museum* by Arthur Crabtree (1958). It would be interesting to know whether Fassbinder, a passionate moviegoer (when a teenager, his mother sent him to the movies to get rid of him), saw these films and remembered them. The sets for the country feast (the opening shots of *Fox*) are typical surroundings for horror films because they are inhabited by monsters (Fox, "the talking head"). In *Fear*, we can once again note the progression of the madness through visual and musical clues, typical of science-fiction films. The bad guys always listen and spy through keyholes, or watch invisibly from their windows. This is precisely what the silent and disfigured servants of horror films do (Henry Cass's *Blood of the Vampire*; 1958), "recording" all of the action without intervening. In *Fear*, this is what Kurt Raab does; his ability to materialize suddenly and noiselessly, with the green flame that shines in his eyes, is a cliché from horror movies. From doorways, Bibi, the little girl, also observes her mother with the innocence of the little girl in *The Golem* and *Frankenstein*, or the knowledge of the mutant children in *Village of the Damned*. I am not certain, but I would opt for the second of these hypotheses.

1. Bathélemy Amengual had noted this process with respect to *Ali* in *Positif*, no. 161 (September 1974), p. 74.

No. 183–184, July–August 1976

Ali: Fear Eats the Soul (Angst essen Seele auf). 1973. Germany. Written and directed by Rainer Werner Fassbinder. Cinematography by Jürgen Jürges. Film editing by Thea Eymèsz. With Brigitte Mira (Emmi), El Hedi ben Salem (Ali), Barbara Valentin (owner of bar), Irm Hermann (Krista), Rainer Werner Fassbinder (Eugen), Karl Scheydt (Albert), and Liselotte Eder (Mrs. Münchmeyer). In German. 93 min.

Martha. 1973. Germany. Directed by Rainer Werner Fassbinder. Written by Fassbinder, based on a novel by Cornell Woolrich. Cinematography by Michael Ballhaus. Film editing by Liesgret Schmitt-Klink. With Margit Carstensen (Martha), Karlheinz Böhm (Helmut), Gisela Fackeldey (Mother), Adrian Hoven (Father), Barbara Valentin (Marianne), and Ingrid Caven (Ilse). In German. 112 min.

Fox and His Friends (Faustrecht der Freiheit). 1974. Germany. Directed by Rainer Werner Fassbinder. Written by Fassbinder and Christian Hohoff. Cinematography by Michael Ballhaus. Film editing by Thea Eymèsz. Music by Peer Raben. With Rainer Werner Fassbinder (Franz Biberkopf), Peter Chatel (Eugen), Karlheinz Böhm (Max), Rudolf Lenz (Rechtsanwalt), Karl Scheydt (Klaus), Hans Zander (Springer), Kurt Raab (Vodka Peter), and Irm Hermann (Madame Cherie). In German. 123 min.

Mother Küsters Goes to Heaven (Mutter Küsters Fahrt zum Himmel). 1975. Germany. Directed by Rainer Werner Fassbinder. Written by Fassbinder and Kurt Raab. Cinematography by Michael Ballhaus. Film editing by Thea Eymèsz. Music by Peer Raben. With Brigitte Mira (Emma Küsters), Ingrid Caven (Corinna), Karlheinz Böhm (Tillmann), Margit Carstensen (Frau Tillmann), Irm Hermann (Helene), Armin Meier (Ernst), and Gottfried John (Journalist). In German. 120 min.

Fear of Fear (Angst von der Angst). 1975. Germany. Directed by Rainer Werner Fassbinder. Written by Fassbinder, from an idea by Asta Scheib. Cinematography by Jürgen Jürges and Ulrich Prinz. Film editing by Liesgret Schmitt-Klink and Beate Fischer-Weiskirch. Music by Peer Raben. With Margit Carstensen (Margot), Ulrich Faulhaber (Kurt), Brigitte Mira (Kurt's mother), Irm Hermann (Lore), Armin Meier (Karl), Adrian Hoven (Dr. Merck), and Ingrid Caven (Edda). In German. 88 min.

W im Wenders is one of those rare filmmakers who suddenly becomes the conscience of a whole generation: someone who reveals hidden *thought* as he transforms into language that which is most fleeting in the sensibility of an era. When I say generation, I hasten to specify that I mean a rather imaginary entity. It would, how shall I say, include all those who today are bright enough to realize that they are taking part in the end of a world, and have sufficient memory to recall what was or what should have been: a generation of survivors. This is not the first time, of course, that such a generation has appeared on the

American Detour: On the Trail of Wim Wenders

Petr Král

Poet and essayist Petr Král, who was also a member of the Czech Surrealist group before his exile to France in 1968, is particularly sensitive to the poetry and sense of space in Wim Wenders's films, as he is to these facets of Michelangelo Antonioni's films.

screen. Recently, the American cinema also allowed survivors to speak, those representatives of youth who inherited from their forebears a collapsing world. There is a difference, however. Whereas the memory of young Americans is more directly social, those for whom Wenders speaks, it would appear, are referring more to a cultural heritage. The slow death reflected in their eyes is, in short, that of the old European humanism, more specifically in its "modernist" phase, which began—particularly for art—just over a century ago. Why this specific humanism? No doubt because modernism—that of the "avant-gardes," from Romanticism to Surrealism—was a promise that was not kept; nursing hope for radical change in the world, modernism opened new horizons but only in the way it stacked up projects like so many corpses.

The more or less apparent paradox is that Wenders approaches his European agenda through America. His references to America in his works are so frequent as to be almost obsessive. Conversations between the heroes of *Kings of the Road (Im Lauf der Zeit)* culminate in an abandoned US Army shelter; *Alice in the Cities (Alice in den Stadten)* tells the story of a photographer's tour of the US; the protagonist of *The Goalie's Anxiety at the Penalty Kick (Die Angst des Tormanns beim Elfmeter)*, accosts a stranger and talks to him about a soccer player who has taken refuge in California; and *The American Friend (Der Amerikanische Freund)* is a story of two competing gangland organizations controlled remotely from New York. Everywhere, America appears as a kind of criterion which characters must fall back on, whether they want to or not, to determine what their dreams are worth and what the likelihood is of succeeding or failing. But there is more to it. In Wenders's films, America is also present in his way of looking at it, and in the concrete manner in which he takes stock. His films, while they are about the heritage of European culture, rarely refer to that culture directly; most of the time his views are directly spelled out in their language, and the sensibility it espouses. In addition to being present explicitly, America intervenes precisely at that level: the level, both actual and figurative, of Wenders's own perspective. And even then it acts as a qualification: whether in terms of the way the actors act, the way the screenplay is written, or how the camera behaves, Wenders's vision is that of an Americanized European, or better, a European who, in order to define himself, deliberately expresses himself, almost without an accent, in "American."

Wenders is already very much American in his refusal of rhetoric, his deter-
mination to look at the past and his heritage always through an empirical approach,
which focuses more than anything else on the present (*Wrong Move [Falsche Bewe-
gung]*, in which Goethe's Wilhelm Meister becomes a young man of today, is only
one borderline example of such an option). Most of the best American filmmak-
ers, for example, have never done anything else. Except for one thing: Wenders's
freedom from the rules of classical drama, in spite of Robert Altman and John
Cassavetes, are still the norm in America, and it is true that that is where real
drama lies.

ACTORS WITHOUT A ROLE

In Wenders's films the only direct ways in which cultural institutions draw our atten-
tion are more American than European: the mass media and show business, partic-
ularly recordings and movies. While there is indeed a painter in *The American Friend*,
and one of the protagonists in *Kings of the Road* is haunted by writing, what matters is
that in the former there is the obsessive presence of all kinds of image-capturing
devices (only a camera witnesses a crime) and in the latter, the hero uses a newspaper
to write to his father. (This relationship between the media and writing—including
cinema—is found in a number of writers, such as Peter Handke and Patricia High-
smith, both of whose works were adapted by Wenders.) Cinema, of course, lies at
the center of this trivialized culture. Whereas Josef Bloch, the sports-minded killer
in *The Goalie's Anxiety*, wanders from movie theater to movie theater the way other
people drift from bar to bar, the projectionist in *Kings of the Road* goes so far as to at-
tempt an investigation of the past through cinema, questioning the owner of an old
movie house at great length, visiting small village movie theaters like so many
museums, in a study of the history of Europe in American, like someone for whom
the cinema has already become a tradition.

Generally speaking, it is true that mass culture is primarily created to be con-
sumed, and whether we are speaking of movies, television, or jukeboxes, Wenders's
heroes work hard, explore every room, and push all the buttons available to them.
The protagonist of *The Goalie's Anxiety* is the most systematic of all. Even before ask-
ing a receptionist whether she can give him a room, he turns the television set on
her desk toward him. He is a cinephile and is also never far removed from his tran-
sitor radio; he only puts it down when he wants to browse through a newspaper or
a magazine. The projectionist of *Kings of the Road*, in addition to earning his living
from movies, makes solitary trips to listen to old rock music, and he knows all the
words by heart (in English, of course). The story of *The American Friend* is punctuated
as much by the appearance of all kinds of optical gadgets, from an old praxinoscope
to a tiny spy television set, as by the narcissistic masturbatory games of one of the
protagonists, the character played by Dennis Hopper, with his tape recorder, his
camera, or his own private music. All of this consumption, despite its being obses-
sive, is more neurotic than truly passionate. Newspapers are thrown out after only
a few pages have been turned, jukeboxes, once the coins have been put into them,
play to themselves in an empty corner of the room, and the projectionist, alone in
a movie theater with the cashier, endlessly watches a montage of his own making,
when it is in fact nothing more than vomit, garbage that encapsulates the emptiness
of all the shows. Nevertheless, he remains tireless. What pushes these people to
persist, to consult all these newspapers, listen to or watch all these television or

Arthur Brauss in Wim Wenders's *The Goalie's Anxiety at the Penalty Kick.* 1971

radio stations, only to immediately turn away from them? Could they be searching for something other than entertainment?

Indeed, on the screen as in a magazine, Wenders's characters search first of all for a story—a play—in which they themselves could have a part. One cannot say that there is no relationship between such people and "real" dramatic heroes (when in fact there is very little that makes them different from the stars they see in the movies or on television), and they are not quite willing to stop believing that they will join these heroes one day. They have charm (*Alice in the Cities, Kings of the Road*) and physical attributes (*The Goalie's Anxiety*). They know the same "hits" (see above), and they are also capable of wearing their own costumes (Hopper's hat in *The American Friend*). There is, of course, their external behavior; here again, the behavior of the young protagonists on American television and in American movies stems from their ability to be "natural," a casual "behaviorism" in which the most important things are how one lights a cigarette or raises the collar of one's trenchcoat. At worst, the young men in Wenders's films are a little more heavy-handed and slower. but whether they are stubbing out a cigarette or taking the telephone off the hook, the worldly-wise attitude is certainly familiar, that ability to be both casual and self-assured which, from Humphrey Bogart to Warren Beatty, we are so fond of in our real heroes.

The problem, however, is that in their real lives, they are only actors in, and only heroes of, a fictional story. They can search all they want (most of them spend their lives traveling), with the world spreading out before them like a set which, no matter how fascinating it may be, has stories that can only be found in the movies. Because they have no roles and are reduced to mere gesticulation, they automatically become doubles, characters who have an exterior but no destiny. The urbane exterior is empty, like a supreme authority that does a poor job of hiding the fateful question, "Why bother?" It is, paradoxically, in Handke's *The Left-Handed Woman* (*Die Linkshändinge Frau*)—the two directors clearly have a lot in common—that the best portrait of a Wenders hero can be found. I am thinking here of the brief appearance of Rüdiger Vogler, the protagonist of *Wrong Move, Alice in the Cities,* and *Kings of the Road,* who, when recognized by the heroine's father, is criticized for wanting to act like an American actor while managing only to pose like one.

Through Vogler's acting, Wenders defines the very characters he directs. Occasionally, of course, some of his heroes complicate his life somewhat, by committing murder, for example. But this does not necessarily make this person's destiny any clearer. On the contrary, because it is so excessive, the act of murder merely underscores the absence of any such destiny, against the gray background of the everyday, like an act or "number" without a future. By killing someone, the protagonist of *The Goalie's Anxiety* gives a structure to the emptiness in which he lives; in *The American Friend,* the Hopper character, nervously moving billiard balls around on a table— covered in plastic— shows clearly that in spite of his experience with crime, he still doesn't know what his real role is. Even the picture framer (Bruno Ganz) in *The American Friend,* though his case is somewhat more complicated, is not really an exception to the rule. It is true that the murders he commits get him involved in quite a story. But is it really his? In fact, he limits himself to following orders from someone, knowing nothing about that person's motives or those of his victims. All that really belongs to him is basically the death within him—his illness—which the gangsters use to corner him. Is this enough to constitute a destiny?

EXPECTATION AND RETURN

This absence or even impossibility of the story clearly hides another: the absence of the only thing that can create a drama or a destiny, namely, meaning. The quest of all Wenders's protagonists, whether murderers or mere wanderers, basically does not consist only of thumbing through illustrated magazines or exploring darkrooms. His characters meet people, speak to them, confide in one another, and observe the world around them—towns, countryside—touch things and play with them; they hear an anonymous telephone ringing in a deserted street at night (*The Goalie's Anxiety*), they find a syringe while searching through a dusty drawer, or catch the projectionist masturbating in his booth (*Kings of the Road*). Even their exploration of movie theaters is not limited to watching a movie; they begin by asking the cashier questions, trying to seduce her if possible (a situation which is repeated a number of times and becomes a ritual for getting past the threshold). They also pensively contemplate the theater lobbies and occasionally get involved in changing the poster (*The Goalie's Anxiety*). This attention to detail is so systematic that it has to be there for more than curiosity's sake; it is part of a search for meaning, a striving to discover the secret of the world and the things that Franz Kafka knew already, namely, that such things were on the very surface: "In detective novels, the emphasis is always on discovering secrets hidden behind extraordinary events. In life, it is exactly the opposite. The secret is not lurking in the wings. On the contrary, it is right under our nose. This would appear to be self-evident. That is why we do not see it. Everyday triviality is the biggest piece of daylight robbery there is."[1] Kafka is certainly wrong to oppose the enigma of the real to that of detective novels. Even in detective novels, whether by Raymond Chandler or Souvestre and Alain, the real mystery lies not so much in the intrigue as in the trivial gestures and objects that flesh out the story.

Alas, it is precisely at this "primary" level that the world, faced with Wenders's characters, remains silent. Their casual attitude toward reality leads to actions that appear to be taking place in a vacuum, because in spite of their knowledge they miss the boat on how to really use things and what things really mean: they have everything except the key. That precisely appears to be the failure of European humanism, which, after claiming to have the answers to all questions, dropped Wenders's characters—and all of us—right in the middle of the desert. "Modernism" itself, in that sense, was .nothing more than a final burst of hope, all the more deceptive as it promised at a stroke to correct all the mistakes of the past. With Surrealism leading the parade, are not all the avant-garde movements equally dead after claiming to have held the universal key and the ability to re-inject meaning into every vein?

Wenders's characters—and the director himself—always remember, as do most of us, and they question objects or beings. There is something in their behavior that relates to this quest for "signs" of a search for the marvelous, through which there is a decisive revelation or an adventure, in which some form of Surrealism has replaced the old concepts of *salvation*. Not so long ago, apparently, for them as for us, there was still this "starting point" in which, as there was at the beginning of the century and of "modernism" itself, things were still possible: walks, meetings—whether happenstance or not. Trips were also ways of approaching the unknown, and each neon sign might be the doorway to an Eden (or a hell), and even the rain wrote messages on the windowpanes.

The emptiness of these promises is all the more cruel. Although the things of the world may sometimes continue to suggest affinities similar to those that organize

them into significant patterns—such as the fortuitous meetings of Lautréamont [Isidore Ducasse]—they are in reality no more than pile-ups, crashes which, instead of yielding any hoped-for revelations, simply cast their own shadows on the surface of the world. When the character played by Rüdiger Vogler in *Kings of the Road* discovers, while drinking in a bar, that he can lift his glass with a pair of pliers, or when he tears a sheet from a pad and accidentally knocks a syringe over in the drawer from which he took it, or when cutting something from a page of a magazine an unexpected picture shows up through the hole underneath, these finds really don't go anywhere; they are simply things that follow one another in time, fillers that will disappoint expectations in which, however inventive and worldly-wise someone may be, all they reveal is his own uselessness.

Thus the storyline, in which universal meaning takes shape through personal destinies, is no more than a useless, vague impulse that is continually frustrated. While the trappings of the world may still be there, and while there is no shortage of props, the theater has been reduced to a place of episodic occurrences with a half-baked plot in which the participants appear to be marginal, or extras, with nobody occupying the center. Worse still, there is no center. As they bounce from movie theaters to bars, and from train stations to hotels, Wenders's characters seem to inhabit only the wings, without ever getting on the stage. The trip itself and the almost obsessive proliferation of alternative routes—and forms of transportation—in the filmmaker's work amount to nothing more than shifting their disarray to another location. Outside, there is nothing but endless waiting, the perpetual confinement in one's own body, such as the framer's race against time in *The American Friend*, which is settled ahead of time by the hieratic and immobile vision of the old painter who, already half-blind, awaits the final sunset near a desolate highway. While there may be a few small gadgets for distraction, they, far from filling the emptiness, only exacerbate our expectations by referring us back to the image. When the Hopper character in that film literally machine-guns himself with his Polaroid camera, it is like someone beating his head against a mirror.

There is a dual confinement here: prisoners of the body we may be, but we are also even more prisoners of the fact that things in themselves happen in the present with no real possibility for transcendence. Every now and then, there are fleeting moments of possible transcendence: the unexpected conjunction of two facts, or two beings, a hand touching an object, a glance and some setting or other can take the world beyond itself, literally, and give it new meaning. But it is still the same world around us and still only a prop. When asked about their lives, the people to whom Wenders's heroes speak only reveal that which is already known. For example, the protagonists of *Kings of the Road*, leaning on a large sign covered in numbers, are involved in an unusual scene only in the eyes of the audience; for themselves, they are, in all likelihood, simply in another ordinary situation. Here, Wenders is reminiscent of Edward Hopper, the fascinating American painter to whom he appears to be referring in some specific shots (such as the elevator going up in *The Goalie's Anxiety*, or the phantom New York in *The American Friend*) and whose recent rediscovery[2] is itself significant. This is also the case for Hopper's characters behind their windows (in bars, offices, hotel rooms): the face of the goalie just before he commits his crime can be seen immobile under the stream of the shower, a shallow enigma, that of his mere presence. The unknown tragedy that is apparently taking shape deep behind his face—or in the silhouettes—will never happen; opacity is

the same thing as transparency, and the mystery is simply an unusual side of triviality, always the same. Hopper's paintings are as magical as the most troubling of Giorgio de Chirico's. They are at the same time the very opposite of the marvelous utopia depicted by the Surrealists, and meaningful because of all the reverie that was both the glory and shame of the avant-garde. By referring to Hopper, Wenders is drawing inspiration from an American viewpoint, in an area where, on the surface at least, Europe would appear to have the least to learn: namely, traditional art. This also demonstrates the distance that separates Wenders from Werner Herzog, for whom America is not only the very opposite of any true values (*Stroszek*) but whose very language refers to Romantic art.

In desperation, Wenders's heroes decide to return to their roots, to childhood, and to their birthplace. While riding an old motorcycle, the protagonists of *Kings of the Road* find the cabin where one of them used to spend his holidays; the second part of *Alice in the Cities* describes a young man and a small girl's search for the village where she often stayed with her grandmother; the main character in *The Goalie's Anxiety*, after committing his crime, returns to see an old girlfriend who runs an inn in the mountains. Even in *The American Friend*, the Hopper character, going to Europe on business, returns to his roots. It is not for nothing that he befriends a framer, an archaic representative of professional honesty, qualities that are disappearing (even into art) precisely because of people like Hopper, and his friend even collects various devices that are the ancestors of his own preferred gadgets (Polaroid camera, television). Old inventions also constitute a discreet echo of modern inventions in all of Wenders's work. The motorcycle in *Kings of the Road*, the antiquated coin-operated elevator of *The Goalie's Anxiety* and also in the same film, the hideous and outdated jukebox . . . Likewise, the many mannerisms used by Wenders's characters to put a gloss on their errant ways are old habits from their childhood, the first rituals of initiation to that long-ago world, when it was still a game. Examples are the long flame of a gas cigarette lighter, putting a coin on railway tracks and recovering it, flattened after the train has gone by (*Kings of the Road*).

Beyond childhood, people are searching for another corpse: that of an order of things which, if memories are to be trusted, would give it meaning—some kind of value—and, in a related manner, a satisfactory lifestyle in which it would still be possible to be worldly-wise and at the same time participate and enjoy. Could it be that such a time was also nothing but an illusion? Was the mistake to become detached from it, to refuse its constraints in the name of some kind of utopia? Or was the mistake built in and therefore unavoidable? Wenders does not answer these questions. Focused solely on the present, he brings all investigations into the past back to the present. Once in the cabin, which from the outside looks like a den of mystery, the heroes of *Kings of the Road* simply need to break the windows in order to open them and take the ambient night. On both sides of the window they hear echoes of the same emptiness; the corpse, already scattered to the four corners of the world, will not be identified.

TIME REGAINED

Although their travels may appear to have followed a circular route, our heroes do not return to the point of departure, and not only because it is hard to go backwards. Something is hinted at during their travels; not exactly meaning—nor properly speaking a story—but rather some light—complicity. While love, for Wenders's

characters, is basically simply one additional vain "gesticulation"—for example, according to the projectionist in *Kings of the Road*, a man is never so alone as when he is in a woman's vagina—in friendship it is possible for two people to get close. At the end of *The American Friend*, when he kills himself in a car with his wife, the framer wipes out through a single action his whole earlier quest. It is for his wife and child that he decided to kill almost everything, except for one thing: his complicity, specifically with the Hopper character, to whom his suicide is addressed like a final angry wink. Even though it may be as ephemeral and fragile as the rest, and even though this too does not allow for escape from one's body, friendship is an opening or perhaps a truce. At the most dramatic point in the action, in the middle of the craziest and most absurd of undertakings, the solidarity offered by the American to the framer suddenly becomes more important than the crime they have undertaken, and made doubly suspenseful through a paradoxical form of détente. In reaction to a world where victims and hangmen know nothing about one another, even their names, this pause provides an unexpected lull in mutual laughter, where mutual disenchantment transforms into song. Here we have the formula put forward by Jean-Marie Gibbal in *Exit*, suggesting with respect to *Kings of the Road* that what we have are "two marginal men who nevertheless find themselves on shifting ground with lots of time on their hands."[3]

Just as this image of friendship reminds us once again of a constant in American cinema, that of having lots of time but no destiny, it has links with another discovery from overseas, by which I mean Western thought about certain nihilistic beliefs about ecstasy, inspired by Zen Buddhism and other sources through which America not so long ago revealed a vein that has been completely neglected by modern sensibility. Even though snobbery took over the idea, there was undeniably a real opportunity, which we can now see today, thanks to someone like Wenders or Handke who go beyond militant exploration (by people like John Cage or the Fluxus movement), to make such encounters the springboard for a new form of thought. However, this form of thought, despite the lesson it has been able to draw from different cultures—whether in the United States or India—remains in touch with its primary sources. Indeed, the very productiveness of such thought stems from the fact that it assumes both its Europeanism and European criticism in wedding the real to the contradictions inherent in reality.

Wenders's treatment, which is as disenchanted and solemn as his characters, is not an empty take on things. Awareness of their limitations did not kill their desire; the pragmatism they learn from the Americans did not stifle their imagination. These things simply changed their nature. In all Wenders's films, there is a subtle role reversal at work, which ends by somehow filling the very emptiness of existence. Lacking any revelations, his heroes' waiting and hopes become transformed into becoming attentive to the most futile facts of life, enabling them to find a way of bonding again with things as they are. Once they have given up on the idea of salvation, everything, paradoxically, becomes an option, even if it means losing. At the end of *The American Friend*, the very fact that there is no story turns it into a story. Through the hysterical and dazzling operatic slaughter, which puts an end to the career of the framer (Ganz) playing the role of an imitation gangster, he is able at least to assume the role of a ghost, an absurd and caricatured hero. It may even be that Wenders uses this ending to broach a new issue: the problem of the false becoming true owing to circumstances. Curiously, in this he resembles Herzog who, in his *Nosferatu*, was able to demonstrate an almost Wenders-

like sobriety. On one occasion in particular, when the vampire was disembarking, he suddenly stops paying attention to whether or not he is casting a shadow on the walls and simply allows the mystery of the night and the deserted piers to speak. Even in *The American Friend*, the magic stems more than anything else from the rediscovery of apparently innocuous accidents: the reflection of a neon sign in the shining chrome on a car; an invisible electrical discharge in a hotel room which suddenly repels the hand of the framer from the television set; the thousand and one windows of a remote "residence" where the audience, alone, with no establishing shot to help them get their bearings, needs to be able to figure out from which of these windows a man seems to be waving a scarf. . . .

In the final analysis, what converts the wandering of Wenders's characters into affirmation is undoubtedly the filmmaker's way of looking at them: the coherence he gives to the disparate elements by combining them into an "aesthetic" object, in a game of independent signs in which even the most bitter thoughts are a pretext for pleasure. However, as the building blocks of his films are kept as natural as the everyday events in our own lives, the coherence is the very opposite of a simple view of the mind. Rather than cutting off reality, it provides an example of how life itself can be conceived as an autonomous "work of art" and how one can enjoy it in spite of its frustrations.

At the end of *Kings of the Road*, only the few remaining letters on the sign outside a movie theater provide an answer to the silent question in Rüdiger Vogler's gaze. But although they do not convey any particular message, they remain physically there, like a concrete enigma, infinitely more attractive than any of the thrashy dramas ever projected in that theater.

1. Gustave Janouche, *Conversations avec Kafka*, Les Lettres nouvelles (Paris: Maurice Nadeau, 1978), p. 176.
2. See the article by Jean-Philippe Domecq (from the eponymous book) "Edward Hopper ou l'énigme à plat" in *XXe siècle*, no. 50, 1978. In *Positif*, Isabelle Jordan recently spoke about Hopper, coincidentally, while dicussing Wenders's co-screenwriter Peter Handke; I think, however, that she made the link unconsciously because she was remembering Wenders's films.
3. *Exit*, no. 10/11 (winter 1976–77).

No. 217, April 1979

The Goalie's Anxiety at the Penalty Kick (Die Angst des Tormanns beim Elfmeter). 1971. Germany. Directed by Wim Wenders. Written by Wenders and Peter Handke, based on the novel by Handke. Cinematography by Robbie Müller. Film editing by Peter Przygodda. With Arthur Brauss (Josef Bloch), Kai Fischer (Hertha Gabler), Erika Pluhar (Gloria T.), Lipgart Schwarz (Anna), Marie Bardischewski (Maria), and Michael Toost (Salesman). In German. 101 min.

Kings of the Road (Im Lauf der Zeit). 1976. Germany. Written, produced, and directed by Wim Wenders. Cinematography by Robbie Müller and Martin Schäfer. Film editing by Peter Przygodda. Music by Axel Lindstadt. With Rüdiger Vogler (Bruno), Hanns Zischler (Robert), Lisa Kreuzer (Cashier), Rudolf Schündler (Robert's father), and Marquard Bohm (Crash victim's husband). In German. 176 min.

The American Friend. (Der Amerikanische Freund) 1977. Germany. Directed by Wim Wenders. Based on the novel *Ripley's Game* by Patricia Highsmith. With Bruno Ganz, Dennis Hopper, Nicholas Ray, Sam Fuller, Lisa Kreuzer, Gérard Blain, Peter Lilienthal, and Jean Eustache. In German. 123 min.

I t would be inaccurate to say that *Days of Heaven* is an undervalued film. It won the best director prize at the last Cannes Film Festival, it was favorably received (although reluctantly) by most of the critics, and it did well at the box office. It establishes the credentials of Terrence Malick, whose work we have previously praised here [in *Positif*] for his film *Badlands*.

But *Days of Heaven* was received neither with the song reserved for Volker Schlöndorff nor the dance for Francis Ford Coppola's *Apocalypse Now*. He should have had a piece of the Palme d'or shared by Coppola and Schlöndorff. And the esteem he received could barely be distinguished from the kind of attention so generously given these days to unimportant films. It is precisely the importance of *Days of Heaven* that we wish to highlight here, for Malick's masterpiece is one of the most original and complex films in the contemporary cinema.

Terrence Malick's Garden: *Days of Heaven*

Michel Ciment

Along with Francis Ford Coppola, Martin Scorsese, Brian De Palma, Bob Rafelson, Sydney Pollack, and Jerry Schatzberg, Terrence Malick is acknowledged in this article as one of the most brilliant representatives of the new American cinema of the 1970s.

PAST PERFECT

The twenty-four vintage photographs that appear as the credits roll by for *Days of Heaven* provide an introduction to the body of the film (people in the snow near a castle; President Woodrow Wilson standing, with hat in hand; children playing on the banks of a river), but focus mainly on urban America at the turn of the century, with its poverty and dereliction (clothes hanging on a line between two houses; an elderly couple; boys playing baseball in a rundown area) as evoked briefly in the prologue. There is nothing new about the technique, but unlike *Bonnie and Clyde*, *Butch Cassidy and the Sundance Kid*, or *The Godfather*, there is no attempt at nostalgia, so typical of photographs from the distant past. The stiffness of the people in the photographs, as we now know, resulted as much from the exposure time needed to pose for a photograph as from any attempt to rival painting. It was not long before photographs could be captured on the fly, without the subject even being aware that his picture was being taken. But the Lewis Hine, Frances Benjamin Johnston, and Edie Baskin photographs chosen by Malick, the care he has taken in the composition, and the importance assigned to space and depth of field, show that while a great deal of research was done, it was not at the expense of realism.

Hine had been appointed the official photographer of the national commission to investigate child labor, and his photographs helped to pass an act prohibiting work by minors. And yet, in an interview he gave in 1920 entitled "The Esthetic Presentation of the Worker Environment," there was an indication that exposing social inequities did not necessarily exclude the search for beauty.[1] These pictures of workers, perhaps because of their cold gaze, kept emotion at a distance, and they enable us to see right away how they made it possible for Malick to go forward with his project. Neither the film nor the photographs bear any traces of sentimentality, even though imbued—like Ennio Morricone's music—with a persistent melancholy, a sadness appropriate to snapshots, which, according to Walter Benjamin, record not only a moment in human life, but the fact that it is now irremediably in the past.[2]

Brooke Adams and Sam Shepard in Terence Malick's *Days of Heaven*. 1978

Because *Days of Heaven* is so heavily marked by death, the mourning process begins with the credits, and all theorists of photography have noted that there is a close link between the photographed portrait and death, between the vulnerability of the subject and the device that is going to "freeze" an instant of his life forever.

We would not have spent so much time discussing this sequence of still photographs had they not shed light on the filmmaker's research. But, unlike those detractors who too hastily concluded that his cinema is overly static, we beg to differ. It is true that the photographs anticipate the film in terms of subject matter, point of view, and a distancing effect. But they are also radically opposed to what is in the film, as if Malick, aware of potential criticism, wanted to point out the essential differences between the two mediums. The cinema is not a mere extension of photography, as far too many theorists believe. It is the child of the magic lantern, which plays with time, the persistence of vision (and hence illusion), and the photograph, with its sense of space and the surface of things (thus realism). Contrary to much that has been written, nothing could be less fixed or constrained than Malick's cinema, as shown in the initial sequences at the plant and the trip westward, in which an extraordinarily mobile camera (thanks to the Panaglide, Panavision's version of the Steadicam), and extremely inventive editing, which keeps things fluid at all times. This movement is justified by the story itself (altercation in the plant, a train trip) until it slows down and occasionally lingers over the natural beauties available for contemplation. Malick indulges this tension at the heart of his cinema, between the fixed and the dynamic. It is the same tension that he finds in himself, a romantic filmmaker, and his characters—between the desire to preserve the instant in order to enjoy it ("O time, suspend your flight") and the desire to roam, move forward, and run away. Romantic art is an art of becoming, of transformation (observation of clouds, storms, paintings of heroes and their all-conquering paths): there is thus nothing surprising about the fact that he should enjoy observing nature.

Malick has been criticized for his attention to the cosmos, and the emphasis he places on the visual. But it is precisely by limiting the role of dialogue and the story line that he chose to return to the cinema all of its visual and auditory powers. Like Stanley Kubrick or John Boorman, he is a director who, without rejecting the spoken word, wanted to return to the origins of the art form. F. W. Murnau's *City Girl* has been compared to *Days of Heaven* because, like the great silent films, Malick's film requires a specifically cinematographic analysis.[3] The filmmaker's refusal to comment on his work, and his reluctance to grant interviews, which is of Kubrick proportion,[4] his wish to consider film as a nonverbal experience whose full meaning is up on the screen and ought not to be weakened by any symbolic or other form of interpretation by him, are consistent with his nonliterary approach to cinema. Based on current trends, some theoretical schools appear prepared to accept a cinema of pure image (Carmelo Bene, Werner Schroeter, the American underground movement) or alternatively, a cinema based on dialogue and actors, but the same school of critical thought appears to reject the idea of dealing with a work in which all these elements (dialogue, music, image, sound, commentary, actors . . .) are found together in internal balance under the control of impeccable direction.

A TWO-WAY MIRROR

Beauty is suspect. Like the misogynist who automatically assumes a beautiful woman has an empty head, film enthusiasts appear to think the formal qualities of a work

can cast doubt on the depth of what is being said. In the reviews of *Days of Heaven*, we sense reticence, a kind of reluctance in light of such splendor, and we are not far away from Jean-Paul Sartre's criticism of Orson Welles's *Citizen Kane* in *L'Ecran français*, to the effect that it was like watching an artist writing. It is true that beautiful images are often the refuge of filmmakers who are short on ideas and that we have all had our fill of the bogus lyricism with which we are permanently bombarded by images from advertisements or tourism. It is also true that those in favor of modernism mistrust formal perfection, all the more so when it is applied to nature. More authenticity is assigned to the unfinished and the vague than to photographic accuracy. Dissonance and discordance appear to do a better job of expressing our world and the doubts it inspires than aesthetic plenitude.

And yet for a number of years now many filmmakers, and not the lesser ones either, from Miklós Jancsó to Wim Wenders, from Francesco Rosi to Theodoros Angelopoulos, from Stanley Kubrick to Federico Fellini, appear to be concerned once again with form. But it is not enough to say that *Days of Heaven* strikes us, like *The Golden Coach, Senso, Red Desert,* or *Muriel*, as one of the most remarkable examples of color on the screen. The premeditated beauty found in each shot (which could have been shot with a handheld camera just as well as from a rigorous and quasi-geometric formal organization) should also be able to translate in depth the maker's meaning. Malick, as we have already noted, is from many standpoints a romantic filmmaker. His relationship with nature and the function he assigns to his painting express themselves in many different and complex ways. There is the admirable shot in which a train carrying workers from the city to the countryside over a high bridge opposes the serenity of an azure sky to the weary and anxious faces of the passengers. Their arrival at the fields and the long-desired meeting with prolific nature are given to us by the filmmaker in a lyrical offering, an almost Whitmanesque exaltation of the beauty of the land. The harmony is short-lived because the characters are immediately plunged into the mazes of calculation and passion.

The splendor of the world merely further trivializes the destiny of humans, as if relations between beings and the universe were governed from now on by mere indifference. To the terrible beauty of suddenly cruel and hostile nature (locusts, fire), an ephemeral reconciliation (escaping to the woods) succeeds, as if men could not really enjoy the things of the earth other than by cutting themselves off from society. In *Days of Heaven*, it is living nature that is filmed, a nature that expresses the feelings of the characters and their ties to the world in the purest romantic tradition. And it is only through an apparent paradox that we can qualify this approach as "realistic." Malick films what he sees, the essence of the American landscape. His celebration of the cosmos is like the shock all visitors feel toward this boundless space. The director, mistrustful of an epidermal or impressionistic realism, sticks purely to the surface, striving once again to find a reconstituted reality in which the tangible remains, but filtered through an idea. This is the higher realism that is similar to Kubrick's *Barry Lyndon*, and his Hegelian conception of art.[5] For Malick, a plant that grows in slow motion, or a locust devouring an ear of corn, are the expression of natural order/disorder, which is to be found equally well in fields stretching as far as the eye can see or in clouds of insects. The natural-light photography and the use of Dolby sound to accurately render that which is recorded beyond the screen provide what might be considered an overdose of realism. Like his friend Stanley Cavell, he holds to an ontology of cinema that is reminiscent of André Bazin. Malick could

no doubt speak to him about his art as a response to the desire of men to magically reproduce the world, and in so doing, to see it, in its totality, but "to see it without being seen, which is our natural mode of perception."[6] Film as a two-way mirror.

WHAT LINDA KNEW

In a work in which the role of the image is so central, it should come as no surprise that expression should be so important. The twenty-fifth and final photograph that opens the film is also the only photograph of a fictional character: Linda (also the name of the actress [Linda Manz]: the confusion is significant). It is through her that the transition is made between the still pictures and the moving images, and the expression on her face as her eyes look at us is the same look she will bring to a story for which she will provide the temporary conclusion. Malick's use of narration or voice-over is not new in the cinema, but the way he employs it in *Badlands* is singularly original. For its literary ancestor, you have to go back to *The Adventures of Huckleberry Finn* (1884), in which Mark Twain revolutionized the art of the American novel by having the story related by its young hero in a written but apparently spoken language whose intent was to re-create the newness of sensations and the lyricism of nature. This popular, familiar, and flexible style attempted to break through the academicism of high-flown language.

If we look at chapter nineteen of Twain's masterpiece, in which Huck describes dawn on the Mississippi River, and we compare the diction, pacing, and tone to the passage in *Days of Heaven* in which Linda describes how the threesome escape into the woods and down the river, we will find the same search for real-life experience, an ever-changing reality, an exchange between awareness and reality. Twain wanted to rediscover the feelings of a past that he had lived some forty years earlier by using a process echoed in Malick, who as a child lived in the immense landscapes of Texas and as a young man worked in the fields in the Midwest. But in Twain the commentary is, of course, the book, as if the adventure had been written by the child using his own language. In *Days of Heaven*, on the other hand, any hesitations, approximations, or spontaneity in Linda's narration operate as a form of counterpoint to the highly developed aesthetic of the photography. The verbal chaos establishes an ambiguous relationship with the strict visual structure. And, in a strange way, it accentuates the distancing that has already been placed there by the academic glaze that the image has put over reality. And although Linda intervenes about fifteen times in the course of the story, and her commentary opens and closes the story, we can hardly say that it provides much in the way of explanation because the narration in *Days of Heaven* is extremely disconcerting. Neither the reasons for what people do nor their feelings is explored. Sequences are left hanging and are never resolved dramatically.

The story itself is guided more by discontinuity, ellipsis, emptiness, and silence than by psychology or the classical devices of plot, as the melodramatic theme could well have opted to do. And Linda's monologue adds to this spareness. There are references and comments about feelings, philosophical thoughts, or purely descriptive comments, but one waits in vain for a line of thought that would shed light on the opacity of the action or the characters. We no longer identify with Bill (Richard Gere), Abby (Brooke Adams), or the farmer (Sam Shepard), and are kept at some distance from them insofar as we know more than she does and are able to observe with detachment, irony, or compassion the discrepancy between the events she has experienced and the knowledge she can have of them. For example, in Linda's conversation with the fore-

man, she expresses pity for the farmer because he doesn't have a woman by his side but we the audience know that he is well aware of the real relationship between Bill and Abby, and we see him, after the death of his master, lead the posse to capture and kill Bill. But like her creator, Linda is deeply sensual and capable of understanding the texture of the world ("I thought about what I might be able to do in the future. I could be a mud doctor, listening to what happens beneath the earth"), a superior and prophetic knowledge ("I met this guy called Ding Dong. He told me that the earth would be consumed by flames"), metaphysical ("There has never been one single perfect being; each of us is half devil, half angel"), social ("If you don't work, you'll get fired. They don't need you. They can always find someone else . . . Some need more than they have. Others have more than they need"). As with some of William Faulkner's narrators, dazzling and poetic intuition sheds more light than rational analysis.

TRIANGLE OF DESIRE

Although Linda observes, she does not comment upon or at least does not confide in us the extent to which relationships between the other characters are based on a form of looking that does not wish to be seen. Malick thus shifts from the apparently objective point of view of Linda's voice-over in the story to the subjective point of view of Bill and the farmer. Using a telescope, the farmer watches Abby alone and with Bill, or sees them kissing behind the movie screen. We could note the same voyeurism in Bill, who spies on the newlyweds several times. While the first impulse that becomes established among the three heroes is clearly Bill's attraction to easy money, and he literally plunges into "the icy waters of egotistic calculation," can we not in a deeper sense see the illustration of this triangle of desire, which René Girard has analyzed in the great novelists?[7] In his attempt to imitate, man cannot desire an object unless it is desired by someone else toward whom he bears at least some envy. This mediator becomes a rival who needs to be defeated. The farmer and Bill are locked in a triangle, each acting as the mediator for the other. Bill is fascinated by the farmer's comfortable life and wealth and appears to be following the law described by Denis de Rougemont in his book *Love in the Western World*: "We come to hope that the loved one is unfaithful so that we can pursue him or her again and experience the feeling of love once more." The farmer, with an incurable disease, is cloistered in his enormous house. On the one hand, he admires the energetic side of the young proletarian, and the suspicions that it elicits in him increase his attachment to Abby. But according to Girard, "all striking successes in the universe of dual mediation stem from indifference, whether real or simulated." This apparent coldness or insensitivity, this control over emotions, how can one not see that they are the very basis for the behavior of the characters in *Days of Heaven*? Like Stendhal, Girard sees in the love triangle the source of envy, jealousy, and powerless hate, which are, according to Stendhal's *Mémoires d'un touriste*, the three *modern* feelings. Taken to the limit, resentment leads to death, as shown by the fate in store for Bill and the farmer. Malick's characters are indeed the incarnation of an unhappy conscience, strangers here, deprived of a dream they have nurtured. These whole days in paradise as mentioned in the original title can be understood both as irony and concrete reality. Because the sky and the crops truly exist, they can be seen, but like the torment of Tantalus, they always escape and become an illusion and a chimera. What *Days of Heaven* is talking to us about is the death of the pastoral.

THE DEATH OF THE PASTORAL

For a long time, the West was considered the immigrant's reward. Working in a plant in the eastern United States was only a stage before heading for the fertile lands beyond the Mississippi. In that sense, the trip that led Bill, Abby, and Linda from the mills of Chicago to the Texas panhandle is part of the movement of history. They are not simply fugitives with existential anxiety and a mysterious laconic aura about them (in American cinema today Monte Hellman stands almost alone in giving us heroes like these); they bear the national traits of mobility and the willingness to break with constraints (when plunged into an emotional tragedy, Bill decides to leave with the traveling acrobats). Just as Bill escapes from the plant at the beginning of the film, his sister Linda runs away from boarding school at the end. But this is 1916, and the way West has been closed for several decades. Malick lingers for a long time in the film over the contradictions involved in the growth of the West. Except for a few dissonant voices, the development of mechanization in the nineteenth century was not considered to be necessarily incompatible with the ideal of the pastoral. The railway in particular—and *Days of Heaven* illustrates this clearly—may have appeared as a method that finally made it possible to reach virgin territory. Just as technology could help them clear the land and settle in paradise regained. Leo Marx once and for all sheds light on the evolution of these ideas, and on their transformation into a hollow form of rhetoric as industrial advances caused the natural environment to be degraded.[8] *Days of Heaven* retraces this evolution in various ways: by associating fire with hell and industry, and the sun with heaven and nature. When the farmer is dying, the smoke from the fire that is ravaging his fields shields his eyes from the sun. As the film progresses, the contradictions exacerbate one another. The train, which was a source of hope in the movement that left the polluted industrial East behind for the agrarian West, becomes a sign of death when it makes the return trip, bringing soldiers to war in Europe and the servitude that Americans, an immigrant people, had wanted to flee. (Charlie Chaplin's contemporary film, *The Immigrant*, which shows our hero brought over by the Italian circus and passengers tied up with rope in front of the Statue of Liberty, condemns, almost as an aside, the myth of a land of sanctuary without constraints or conflicts.)

Malick does not simply illustrate the physical deterioration of a landscape through symbolism. Everything that happens is as if the desire for money and the hypocrisy in the social relations that derive from them (as demonstrated in the relations between those in the triangle) destroy this rustic simplicity in human relations that are in harmony with nature. This fable of the original fall, as we can see, is all the richer because of its Biblical references. In seeking profit, man destroyed Eden before the locusts and the fire chased him out. And in terms of influences, people have been right to make comparisons to George Stevens's *Giant* and the gothic house set in the landscape, but it is surprising that Elia Kazan's *East of Eden* has never been compared to it. Even the assonance of its title makes us think of it, as do its agrarian parable, its echo of Genesis, the triangular relationship, its search for a formal structure, its "fallen angel," James Dean. Malick's characters irresistibly remind us of *East of Eden*, and of the same war years from 1916 to 1917 so much so that we take to thinking that Abby in the train will console Aaron, the new conscript, for the loss of Abra.

The incurable sadness distilled by *Days of Heaven* is also just that: not only the tragic death of its two remarkably similar heroes, almost brothers; the drifting away of a woman who has become a soldier's girl; and the future closed horizon of a lit-

tle girl. In addition, there is loss, without any hope of returning to a garden of Eden that was only glimpsed in all its magnificence and has already been lost. "Et in Arcadia ego." If the proper role of great works is to express the contradictions within the culture that nurtured them, then *Days of Heaven* is such a work, because Malick, the poet and philosopher, has done a masterful job of playing with the dialectic of opposites. Within his art we find romanticism/realism, static/moving, feelings/rational. But his myths also contain innocence/experience, nature/industry, reality/illusion. The garden that was lost by his characters thus becomes the central metaphor of his cinema. It is a place of tension, where savage nature, without bounds (raw reality), can have rules imposed upon it against the deliberate artifices and gratuitous forms invented by man in a solipsistic process (art cut off from the real). And it is a garden that is difficult to maintain because in it, the directing that is going on is full of secrets that are being shared less and less. And the word "culture" in every sense seems particularly appropriate to define a work that aims at nothing less than the original purpose of the cinema, which is to become a synthesis of all the arts that preceded it.

1. We obtained this information from Susan Sontag's book *On Photography* (New York: Farrar, Straus, and Giroux, 1977) and from the remarkable catalogue of the Venetian exhibition entitled *Photographie* (Milan: Electa Éditrice, 1979), which devoted a section to Lewis Hine's work.

2. See his essay "The Work of Art in the Age of Mechanical Reproduction," in *Illuminations* (New York: Schocken Books, 1973).

3. See Terry Curtis Fox, "The Last Ray of Light," *Film Comment* 14, no. 3 (September-October 1978), pp. 27–28. Jean-Loup Bourget's analysis of the film, "American Gothic," *Positif*, no. 218 (May 1979), p. 65, with its emphasis on the importance of pictorial references, combined with the space given in the same issue to director of photography Nestor Almendros, focus on the formal and technical aspects of the film, which is key to its importance. It would, however, be absurd to reduce it to only that, as we shall attempt to demonstrate. This aspect is no more important than the role of Billy Bitzer in D. W. Griffith's films or the influence of expressionism on F. W. Murnau's work, both of which were discussed in their day. As for those who refer to Malick's as a "director of photography film," they need only read Almendros's comments about Malick's first film, *Badlands*, which is comparable in every way, and yet which was photographed by three different directors of photography, just as the final sequences of *Days of Heaven* were under the supervision of Haskell Wexler, without our ever noticing it.

4. To our knowledge, Malick has given only two interviews (to *Positif* and *Sight and Sound*). That was five years ago when his first film, *Badlands*, was released. Since then, he has not granted any, even in the United States, except for some comments gathered together by *Le Monde*, May 17, 1979.

5. See comments on Kubrick in the article entitled "Entre passion et raison," *Positif*, no. 186 (October 1976).

6. See Stanley Cavell's *The World Viewed* (New York: Viking Press, 1971). The author, a professor of philosophy and aesthetics at Harvard University, gives an acknowledgment in his foreword to Malick, who read his manuscript and who was also teaching philosophy at MIT in Boston at that time.

7. See his brilliant study *Mensonge romantique et vérité romanesque* (Paris: Grasset, 1961).

8. See the indispensable work entitled *The Machine in the Garden* (London: Oxford University Press, 1964). Bourget, in his study of the film (see n. 3), has already discussed this machine/garden concept to clarify Malick's work.

No. 225, December 1979

Days of Heaven. 1978. USA. Written and directed by Terrence Malick. Produced by Bert and Harold Schneider. Cinematography by Nestor Almendros with additional photography by Haskell Wexler. Music by Ennio Morricone and Leo Kottke. With Richard Gere (Bill), Brooke Adams (Abby), Sam Shepard (farm owner), Linda Manz (Linda), Robert Wilke (farm foreman), and Doug Kershaw (fiddler). 95 min.

1980s

n a September 1973 interview, John Boorman, explaining why he had set the fable of *Zardoz* in the future, said: "I did not feel ready yet to put the Arthurian legend on the screen."[1] His attraction to the legend of the Holy Grail stems not only from his explicit cultural interest in it, for it is also unconscious, as revealed by a number of the preoccupations that underpin his films. These concerns were similar enough that Michel Ciment, as soon as Boorman's second feature, *Point Blank* (1967), was released, was able to perceive Walker, the central character in the film, as "a chaser of shadows searching for an inaccessible

The Sword and the Barren Land: *Excalibur*

Jean-Philippe Domecq

Since his second feature, *Point Blank*, John Boorman seems to have had a subscription to the cover of *Positif*, with eight of his films on display there thus far: *Zardoz, Exorcist II: The Heretic, Excalibur, Hope and Glory, Where the Heart Is, Beyond Rangoon, The General,* and *The Tailor of Panama*.

Grail, surrounded by a cortège of obscure and malevolent forces, images of death and fear."[2] Likewise, in 1970, speaking of *Leo the Last*, this thematic analogy was suggested in terms that evoked the mythical climate of those dark days of the quest for the Grail as follows: "If Leo is the fisher king, destroyed and weakened by illness, if his land has become barren, and his task is to restore it, then the company of the Grail are these puppets who live in basements, and the Grail itself is nothing but a sugar bowl with a silver strawberry that serves only to bring death."[3]

The opening sequence of *Excalibur*, with the silver sword emerging from the water brandished by a female hand, clearly evokes the ending of Boorman's *Deliverance*. The weapon of power and feudal unity, born in the aqueous reign, appears in an aura of twilight and supernatural serenity proper to the quintessential reality of myths. The image invites us into this reality: the magical blade in its fluidity and subdued crystalline clarity, with only a few mellifluous shimmers filtered in tones of lake blue, with water streaming down in slow motion. It is a poetry of dormant waters to which the Arthurian legends have given regenerative powers. The silence is quickly troubled by rumors of war, and the second sequence develops another motif that is essential to the Grail, that of internecine battles using fire. Forests burn and rival suits of armor rather than men kill one another in an amalgam of blood and mud—the two opposite poles of sacred light and profane misfortune within which the cycle of the Arthurian legends is told. The structure of Boorman's film is analogous to the circular periodicity of these legends.

Excalibur thus offers us the opportunity to plunge once again into a number of the founding myths of European culture. It is worth mentioning this in order to be able to measure not only what an audience expects and what its motives are in going to see such a work, but also Boorman's ambition and the risk he takes in making such a film, given the state of contemporary cinema. Having selected a topic that is clearly not topical, Boorman has openly opted for image. The opening sequences described above give the impression that we are watching a cinematographic opera[4] in which the closed vision will work on behalf of a baroque supernature and typography.

As Boorman himself wished, the spectacular nature of the film, which is full of special effects and even excesses, contributes to the overall theatricality. King Arthur's castle appears after the restoration of political unity is achieved along with community ethics; this is the time of light, and the crenellations sparkle with the reflections

Nicol Williamson in John Boorman's *Excalibur*. 1981

of fire. When the time comes to leave on the quest for lost values, and when the sacred circle of the Round Table is broken, the chromatic range becomes denser for a third of the film, covering everything in shadow—the Irish landscapes, the leafy bowers under which Lancelot and Guinevere entwine in the fervor of their unquiet desire; faces darken, as does armor. And when the possession of the Grail sounds the hour of the renaissance, the restoration of values, we are shown a time-lapse shot of flowers blooming against a background of flowering almond trees as Arthur and his armed knights ride out. While it is the cinema that has given us the means to observe this magical germination at the speed of human actions, our amazement loses nothing for its having been shown to us by a modern filmmaker; there are some déjà-vus that strike us as fables with which we are already familiar.

Although Boorman was not afraid of weighty images, none of his excesses is really excessive. His images reveal an aesthetic of the supernatural that is necessary to the story of *Excalibur*. The same is true for the composition of his shots and the scenic games, in which the characters are not there for psychological musings but are presented as archetypes. Expressiveness takes precedence over ambiguity. We do not feel the desire mounting between Queen Guinevere and Lancelot; Boorman has followed the mythological dramaturgy, and worked to show just how this ethical failing would be fatal to the sacred ties that bind the Knights of the Round Table. Just as with the plague in Thebes, which was the fault of one person alone, Oedipus, the profane invades and perverts the sacred and human ties and laws, and natural cycles are disrupted. Boorman gave this part of the film a depth of inflection, weighing down gestures, slowing the rhythm of sequences, muffling the tones, altering faces, and adding contrast to chiaroscuro effects. The final murderous sequences and the dénouement of the tragedy are notably constructed in accordance with hieratic expressiveness. On a night of spells, there is confrontation between Arthur and his rebellious son born of Morgana. The armor and helmets of dead warriors frame the scene, with the father and son killing one another, swords and lances crossed against a reddening solar disk.

While such a register of exaggerated images seems always under control, it is because they translate a gaze that is both fervent and distant, the wrathful and enchanted gaze of Merlin, representing Boorman, casting his spells with awareness of his mission, but enjoying playing at it all the same; his sense of derision is built in to his use of the magician's powers.[5] Merlin, sometimes afraid and sometimes amused, is the only true protagonist in the fable and the film, an orchestra conductor through whose powers all these visions become reality, with all their inherent malice—in short, Merlin the film director.

1. Michel Ciment, "Deux Entretiens avec John Boorman," *Positif*, no. 157, p. 16.
2. Michel Ciment, "Un Rêve américain," *Positif*, no. 96, p. 72.
3. Michel Ciment, "Le Guetteur mélancolique," *Positif*, no. 118, p. 38.
4. The soundtrack consists of extracts from Wagner's *Ring Cycle* and Carl Orff's *Carmina Burana*.
5. He can never be controlled by his spells, but only by the charm of a woman, Morgana, to whom he reveals his secrets; magical knowledge enchanted by love.

No. 242, May 1981.

Excalibur. 1981. USA. Produced and directed by John Boorman. Written by Boorman and Rospo Pallenberg, adapted by Pallenberg from Sir Thomas Malory's *Le Morte d'Arthur*. Cinematography by Alex Thomson. Music by Trevor Jones. With Nicol Williamson (Merlin), Nigel Terry (King Arthur), Helen Mirren (Morgana), Nicholas Clay (Lancelot), Cherie Lunghi (Guinevere), Paul Geoffrey (Perceval), Gabriel Byrne (Uther), Liam Neeson (Gawain), and Corin Redgrave (Cronwall). 140 min.

Some works, not just because they are successful, but because of their promi-
nence, enormity, and exhaustiveness, lead us to question and cause us concern.
What can a filmmaker possibly do next after such a major accomplishment?
What task, under the circumstances, can avoid appearing trivial?

This was the position in which Francis Ford Coppola found himself after *Apoca-
lypse Now*. Or Stanley Kubrick after every one of his films since *2001*; Alain Resnais af-
ter *Providence*; Andrei
Tarkovsky after *So-
laris* and *The Mirror*.

Third Dive Into the Ocean: Andrei Tarkovsky's *The Stalker*

Emmanuel Carrère

These four ex-
amples are all I need.
In addition to avoid-
ing any major omis-
sions, they include
everything that has
been great and de-
finitive in the cin-
ema in recent years,
and they also have

The thaw in the Soviet Union made it possible for new film-
makers, although not without difficulty, to assert their personal
vision. The most striking of these was indisputably Andrei
Tarkovsky. Emmanuel Carrère, an early devotee of fantasy films
and the future famous writer of *La Moustache* and two novels
adapted for the cinema—Claude Miller's *Classe de neige* and
Nicole Garcia's *L'Adversaire*—discusses the grandeur of *Stalker*.

something else in common. They are, in the true sense of the word, avant-garde
works whose craft, however (more than their budget), keeps us from labeling them
experimental cinema.

What to do now? These four filmmakers must certainly have asked themselves
that question. And their solution, unless they were prepared to stop shooting, was
to work on what they felt was as remote and different as possible from the film just
completed. How could the new work, when compared with those that came before,
fail to make the differences obvious and restore inevitable unity to the work of a
great creator? But events happened as if a frenzied search for the antithesis were an
indispensable springboard for the artist to continue. After *Barry Lyndon*, Kubrick
made a contemporary and limited horror film. Coppola, it would appear, will follow
up the atrocities of war as shown in *Apocalypse Now*, and its sumptuous over-production
values typical of Hollywood, with the refinement of *One from the Heart* and the apparent
modesty of a project conceived along the lines of young German cinema. After the
overwhelming confidence of *Providence*, Resnais follows an Anglo-Saxon elegy with
the hilarious and dry scherzo of *Mon Oncle d'Amérique*, a film whose spirit is entirely
French (as we say of Rameau's or Ravel's music) even to the point, according to the
director, of being "frenchouillard."[1]

I have saved Tarkovsky for the end. First of all because it is about his film that
I am writing today. Secondly, because he proves that everything I have just said is
false. These introductory remarks, whose purpose was primarily to place him on the
same pedestal as these other better-known artists, and to state at the very outset
that he is one of the four or five greatest filmmakers now working, do not apply to
him. With only his second film, he appears to me to have reached a level of majesty
in terms of flow that only Kubrick has been able to achieve in the past fifteen years.
Andrei Rublev, Solaris, The Mirror, and *Stalker* are four units, each of which appears to
be a world unto itself, a universe which can barely be imagined as being part of a
whole, and can only be compared to Kubrick's *2001–A Clockwork Orange–Barry Lyndon*
trilogy. Each of these total, self-sufficient, and proudly unique works is nevertheless

part of a trajectory of staggering scale and determination. Far from being one of those masterpieces, in the sense of craftsmanship, that are recapitulations, visits to an itinerary that goes in a circle (like Akira Kurosawa's *Kagemusha*), each is a new experience, each conquers territory that is completely new to the director (although there were clear signs in the previous films showing the future direction he might take) and often to cinema itself.

But whereas Kubrick's method of working proceeds with the dialectical negations that I have mentioned, and which Michel Ciment has analyzed in detail,[2] Tarkovsky's approach keeps raising the stakes. Both artists leave us with the same impression. The immensity of what they are doing suggests a lack of living space. But Kubrick deliberately makes us think of a conqueror who, as soon as he has incorporated a region into his territory, sails to the antipodes to discover new worlds. He strikes us as capable of indefinite expansion in space. Tarkovsky is more sedentary but is still in constant renewal. Where possible he annexes bordering countries. But, more often than not, he continues to plow the same furrow, digging and revealing strata that served as the foundations for his previous work.

What could he possibly do after *Solaris*? This strikes me as a legitimate question, given the casual reception given to this incredible film. What Tarkovsky did was shoot *The Mirror*, a very loosely constructed fabric of childhood memories that is only very superficially different from metaphysical and linear science-fiction films, and that I think it would be possible to prove stemmed wholly from *Solaris*, or at least was irrigated by the same underground lake (and I would not deny that I am thinking of the ocean of memories in which the mysterious planet is bathed; this is not a metaphor, and I will return to the topic later). Likewise, *Solaris* and *The Mirror* later generated *Stalker*.

Stalker takes place in a different kind of space, and it is one of the great merits of the film that the Zone, as it is called, has been presented convincingly. An opening title card explains the premise. A meteorite hitting the earth, a visit by extraterrestrials, a mutation attributable to some form of human carelessness? We're not quite sure. What we know is that one day a corner of the country became different and dangerous. People disappeared, inexplicable things began to happen, noises were heard, and there was even talk of a secret room where the most intimate vows were being made and where happiness could be found in the middle of this unsettled region. This, as we said, is the Zone. It was immediately surrounded by barbed wire and watchtowers, and access was prohibited. Curious people, adventurers, and even some desperate people were sometimes brave enough to enter with a guide. The film recounts one of these illegal expeditions.

The opening is one of the most gripping and visionary moments I have ever seen in the cinema. Tarkovsky, who also is credited with set design, begins by imagining the universe that surrounds the Zone. Neither the country nor the date is specified. A railway landscape, with vague and muddy surroundings, barracks, darkened brick buildings with tunnels worthy of Daedalus, dead waters stagnating, and perhaps spotlights shining their pallid beams on oozing trenches: all are reminiscent of Bergman's *The Silence*, of the enormous and claustrophobic building, striped in shadow and light, that Orson Welles in *The Trial* was inspired to use after a visit to the Gare d'Orsay. But it is mainly Giambattista Piranesi's dark imagery that is evoked by this gigantic prison, filmed in sepia with terrifying acuity. To begin with, the outside is

Natalya Bondarchuk in Andrei Tarkovsky's *Solaris*. 1972

very different from what one might expect to find inside, and the implacable architecture, with its many traps, removes any form of stability. The play of perspectives hidden in shadow, with scaffolding over cesspits and the haunting authority of windowless walls, creates a clearly interior theater whose terror appears to stem more from the nightmare of the travelers than from any reality, however threatening the latter might be.

Traveling through abandoned warehouses, dried-up canals, on foot, and in a jeep, and then in one of those cars used to travel in mine shafts, the heroes manage to outwit the police surveillance around the Zone, and to penetrate inside. Once the border has been crossed, a sooty trip ensues. The film shifts to color and the real trip begins.

We do not know the real names of the three travelers, only their nicknames. There are two customers: the writer, apparently pushed to this extreme by desperation and lack of inspiration; and the professor, who appears to be there out of scientific curiosity. Then, of course, there is their guide, the Stalker, who approaches furtively and is familiar with the Zone, and who has derisively been nicknamed Chingachook by the writer, a name borrowed from James Fenimore Cooper. The Stalker is the person who, from the moment he appears, reveals the laws of "no man's land." They can be readily summarized: there are none. Anything can happen, and every kind of trap is possible, unless they are impossible to imagine, and all one can do is remain on guard, knowing full well that this will not be of any use. They make progress by feeling their way along.

The Zone reacts unpredictably to everything the men do and sometimes leads them to do things. This animism is not, however, systematic. The entity must not be offended, to be sure, but it is difficult to know whether one is behaving well or badly toward it, because one never can tell when the entity will send a nasty denial to someone who appears to be respecting and venerating it, and on the other hand fail to reprimand those who are not observing the empirical and deferential code muttered by the Stalker. Thus the professor, ignoring the advice of his guide, turns back (which according to the guide is a mortal sin) to recover his knapsack, in which he is hiding a bomb big enough to blow things up over an area of several kilometers. The Stalker predicts that he will never be seen again, and that the Zone will have devoured him. And yet, when he and the writer have made only slight progress and gone through trials, they find the latecomer has been able to reach the same point with only a few steps, leapfrogging along in this game in which the unknown rules include an abyss in each square, with the last square representing happiness. Even the Stalker, who is accustomed to the whims and incoherence of the monster, is surprised. But he accepts it; after all, it's the Zone. He has nothing further to say.

The travelers' goal is to reach the House, and then the Room. Rather than linger over an image that is both simple and brilliant at the same time, as he did in *Solaris*, for example—the ocean imagined by Stanislas Lem—Tarkovsky develops a series of interlocked or embedded clues around the secret. There is a sacred region (the Zone), at the heart of which is hidden a sanctuary (the House), which in turn shelters a tabernacle (the Room). This level of burying is more conducive to an initiatory trip than immediate revelation, because what is involved here is truly burying. The quest is directed toward the depths. While it may have to tolerate nature while crossing the Zone, *Stalker* is no less an inner film (insofar, however, as Piranesi's *Prisons*

are interiors: without any limits ever allowing us to state that they are. The very idea of a vault under which these vertiginous vaults rise, or a wall capable of enclosing the exponential proliferation of such walls, or of an ultimate higher or lower level, the very idea of a fence, is imperiously combated). Once in the House (How did they get there? They never went through a door and there was no continuity to signal the idea of entering inside), the travelers will only episodically see the light of day, and they find themselves caught up in a capricious topography that is incomprehensible and not Euclidean. The Stalker warned them: the shortest distance between two points is not a straight line here, and even if it were, there is no such thing as a straight line. We would otherwise have trouble understanding how a house could possibly contain the route they travel, and the audience needs to treat it instead as an imagined trip to the center of the earth. This too allows Tarkovsky to place himself in his element. A Bachelardian analysis of his work would be appropriate. Since *Andrei Rublev*, he has been turning away from the sky and the air. Fire, here, appears to have been introduced only for the purpose of initiation. On the other hand, we ardently plunge into the bowels of the earth, where the flow of water varies from cascades to swamp. This arduous progress through the chthonic darkness is not, however, as we might believe, a trip through the unconscious. Or rather it is, but it is not the unconscious of men, but the unconscious of the world.

The middle part of *Stalker* is subterranean, then, and lacks anything that would allow us to get our bearings. Stairways, passageways, inner channels, grottoes, immense sand-covered rooms, vestibules whose windows suddenly shine with the light of day. Just when we believed we were at the far end of some cave, these heterogeneous places, which succeed one another with no apparent logic, follow the changeable laws of a universe in which one is neither going up nor down, neither right nor left. Just going. And the film's success owes everything to Tarkovsky's extraordinary visual power, which he applies to this topographical aberration.

Moreover, the expedition comes to a sudden end because the travelers in extremis refuse to enter the Room, and the Stalker, discouraged by their stupidity, takes them back, we are never sure how, to their point of departure. The end of the film returns us to this border point, which we left two hours earlier, at the café where the three were prior to the adventure, shown in sepia. Against all expectations, this demented trip does not appear to have deeply affected the two tourists. They will in all likelihood return, one to his calculations and ridiculous measuring instruments, the other to his desperately white sheet of paper—unless their visit to the forbidden land provides them with a hot story. They found neither happiness nor themselves. As for the Stalker, he is right to feel exasperated when he thinks about the two nasty men who desecrated the Zone he jealously guards. It is an initiatory voyage that initiated no one, except the one who was already there. The mystery of the Zone remains complete.

Stalker, while a brilliant film, is not without its defects, but its obvious weaknesses put us on the trail of more secret riches. This is the case for some aspects of the script and the treatment of the characters. The initiatory nature of the plot strikes me as too obviously revealed—and *Solaris*, in this respect, used it more satisfactorily. The protagonists undergo trials by water and fire. The Stalker never stops reminding them that it is impossible to go back, and that nothing will ever be gained

from the quest they have undertaken. In particular, their respective attitudes toward the Zone, and toward happiness and the ultimate answer, promised by the Room from which they turned away after getting there, illustrate a known issue, one which we would like Tarkovsky to become obsessed with—he is not the only one—but this issue remains a prisoner of highly rhetorical oppositions.

During the first half hour, indeed until they enter the Zone, the personalities of the three travelers remain vague and indistinct, and the ease with which they can be confused appears to be deliberate. Barely visible against the haggard and torturous universe in which the sepia photography attempts to bog them down, they are mere silhouettes, with tense faces, and appear to be more the extensions of the human antennas of ambient anxiety than real individuals. We think once again of the tiny crushed figures who haunt Piranesi's invented prisons, who climb staircases overhanging the void, wend their way around oozing columns, and thrust themselves down frail and aimless passageways without a handrail, between Herculean blocks, all created by the black frenzy of the engravers. Their crossing through the mirror is engraved with the crazy and busy precision that hallucinogens can create, in which the "ego" abdicates its despotism to become no more than a receiver, a clean plate of copper on which visions are inscribed, corroded by an acid whose nature is unknown.

But once the border has been crossed and we return to color, the self reasserts its rights, and the egos of the two tourists are pervasive and talkative. They never stop attacking the "you." Up until the final quarter of the film, they are the stars. The Stalker remains an enigma. He guides, laments, implores, and his fearful and whining attitude is disconcerting to us, the audience, and his two fellow travelers in the same way as the Zone disconcerts us, the Zone of which he is the keeper and perhaps also the ambassador. He remains withdrawn. While following his orders, although they never hesitate to rebuff him, the writer and the professor turn against each other. Suddenly, they become responsible for incarnating two different ways of being in the world, of conceiving life, which are expressed not in terms of alternate pleadings of a case, with each defending the values he believes he represents, but through reciprocal invective. The writer attacks the professor's scientific curiosity—his thermometers, barometers, "crapometers"—and his mania for analysis, although neither ever gives us any proof. As his reward, the professor cannot find enough contemptuous words for the nonsense or the lack of imagination he attributes to the writer, though he never displays any more wit than his opponent.

Neither of these artificially opposed *Weltanschauung* [world view] finds any concrete application, as if the Zone made their use obsolete. They only exist as memories of the outside world, anchored in the obsessions of the two protagonists. They are pretexts for hatred, pure intellectual constructs, deprived of any observable support in behavior, or even in each character's comments, when he says something about himself rather than simply against his counterpart. They also resemble one another, even physically. Their latent conflict gives rise to pauses in which they taunt one other with their perception of the adversary, which each uses to define himself negatively, all under the worried eye of the Stalker, who knows full well what vanity is involved in these jousts in the Zone. These discussions, which are in the foreground throughout the central portion of the film, and which seem to summarize its purpose or intent (and then we say to ourselves: Is that all it is, simply a haven for arguments between old students, that Tarkovsky built these unbelievable sets

and imagined this trip?) but they are at certain moments insidiously undermined by the images, which impose an otherwise fascinating mystery. The most curious thing is that these areas of "distraction" arise precisely when the never-ending discussions are at their most heated, as if the filmmaker, suddenly contemplative, coincided with the characters' desire for a break to continue their discussion.

In the last part, which begins at the threshold of the room that the travelers will not enter, they squabble for a pathetically long time in a manner annoyingly evocative of an out-of-context scene from the theater of the absurd, when the figure of the Stalker suddenly moves into the foreground. The professor wants to blow up the Room and the Zone with the bomb he brought with him. We even understand him: spending time in the "Diamat" can only encourage people to behave radically against a center of obscurantism that we suspect is more or less Christian in nature. The Stalker explodes. He pleads on behalf of the Zone and the Room, which are all that he has in the world, the only hope for unfortunates like him, whom he can help by taking them here. He does not plead in any formal manner, and is not particularly good at arguing logically, like the two others, but a long and sublime monologue interspersed with tears is the focal point of the film. The Stalker moans, threatens, hits, and begs. The pathetic opposition between the writer and the professor disappears and makes way for another much more crucial form of opposition, which we immediately recognize. The innocent against the doctors, openness against intrigue and quibbles, faith against analysis.

The immense debate of Fyodor Dostoyevsky's *The Possessed* (also called *The Devils*) erupts into the film, and we can clearly see the position of Tarkovsky now, the mystic, the Slavophile, the man of roots, the earth, and loam. The Zone is the last enclave of Faith, the last chance for Love, the refuge of Transcendence. As for the mercenary Stalker who takes tourists around, his bearing, his worried and awkward fervor, are now explained. This innocent blond man with a Christlike beard and blue eyes arises like an avatar of a certain Prince Myshkin [from Dostoyevsky's *The Idiot*] or Alyosha Karamazov [in *The Brothers Karamazov*]. And it is only accidental, of course, but on the other hand the writer, full of sarcasm, hatred, and despair, babbling insistently and ferociously about their derision, stooped over, twisting up his haggard and contemptuous face, with his narrow shoulders and his tramp's overcoat, often makes me think of the fiercely malevolent Louis-Ferdinand Céline, the French incarnation of the logorrheic man in *Notes from the Underground*, for whose bitterness the inexhaustible Dostoyevsky took responsibility.

The visitors allow themselves to be swayed by the disarray of the Innocent. Tarkovsky skips the return trip. All he does is go back to the sepia tones used at the beginning of the film to remove us from the spell of the Zone. The protagonists separate and the admirable penultimate scene, which echoes the first, leads the Stalker home, to the edge of the Zone. He is literally suffocating from a sacred indignity and stigmatizes these men of learning as being incapable of love and faith. He has a fever—for a while, he appears to be epileptic, but that is perhaps only because we want the literary parallels to be too neat [Myshkin in *The Idiot* is epileptic]. His wife removes his clothing, has him lie down, and calms him. When he is asleep, she turns toward the camera and, like Bergman, speaks to us, telling us that the Stalker is, in fact, a simple soul, but gentle and good, that she loves him, that she likes being near him, and that in spite of their problems she has never regretted her choice. To keep the references straight, this statement is reminiscent, with the sexes

reversed, of Shatov's love for the lame half-wit in Dostoyevsky's *The Possessed*, even though she is scorned by Stavrogin and his valets. *Stalker* gives us a resounding echo of this love, this battle, this faith.

Tarkovsky is not merely showing off a series of tours de force around a miracle. His visual treatment is already enough to make this film a masterpiece. Nor does he limit himself to showing and judging the range of human emotions when faced with this miracle. The confrontation of these reactions nevertheless provides fuel for an essential debate, the repercussions of which are unequal in importance (to some dissident Russian writers toward our "new philosophy") and at least have the merit of promoting modernity. He also speaks to us directly about the miracle, not only about how it reveals itself, or what men do with it, but about its essence. He never takes the easy way in doing this in *Stalker*. To understand more clearly what he is up to, we need to refer back to *Solaris*.

Briefly, the plot line of *Solaris* is not unlike that of the Zone. This faraway planet provides a theater for inexplicable events. It is completely covered by a foaming and mutable ocean that exerts a dangerous fascination on the scientists posted at the station. The hero of the film, who is responsible for investigating the planet, discovers—gradually and to his cost—that the ocean is a kind of immense collective subconscious (I write this reservedly, subject to further research), in which the thoughts, memories, and dreams of men come to life to haunt them. Among other things, Solaris resuscitates the dead. The protagonist is thus able to find intimacy once again with the woman he loved, who had disappeared years ago, and he has great difficulty avoiding being engulfed by this insistent and tender ghost, indestructible moreover, because she lives in his memory. (Once again, this detail is reductive. It would work if *Solaris* were no more than a projection from the brain of men. Thus if the hero had forgotten his wife, he would not find her again. But *Solaris* is much more than that. Indeed, it projects itself into human brains and dictates their fantasies.)

With this love story, one of the most heartrending I know, *Solaris* easily moves us more than *Stalker*, a more impressionistic and austere film, but the story is clearly the same.

When speaking of Tarkovsky, one cannot avoid seeing everything converge toward *Solaris*. That is because the very subject of this film is the source of all images, all feelings, and all dreams. *Solaris* claims to approach and even reveal the secret power from whence emanate all the troubles of the soul, and everything with which art attempts to deal. The filmmaker's work is no more than a series of snapshots of the shreds of life that float to the surface of his inner ocean. He was daring enough to give us this ocean as an overview in one of his films. It is as if he were telling us: there is the sanctuary, the prison, where my dreams and yours are hatched, composed, and decomposed.

It was inevitable that he should then go back there to trawl for memories from his childhood, and that he should deliver them to us in the apparent disorganized state they are in when they drift from one body of water to another or rise to the crest of a wave. *Solaris*, which was about love, already signaled this line of attack by ending on the image of the father, as if the ecstatic and confident return to the real, the roots, the early years of life made it possible to tear oneself away from the magic of

the planet (a very shaky illusion, as I will soon mention, because everything emanates from *Solaris*, including the father, the earth, and the dead). It is before his own father, the poet Arseny Tarkovsky, that the filmmaker prostrates himself in *The Mirror* (also called *The Looking Glass*). His verses give emphasis to the story of the film and erupt once again in the most beautiful and enigmatic scene in *Stalker*.

Stalker is a film in which Tarkovsky, tirelessly and once again, plunges into the ocean. To be sure, the metaphor has changed. No doubt he is primarily interested in human reactions rather than in phenomenon. The Zone is here on earth, but at the heart of his labyrinth, the same secret lies. And although his definition may be imprecise (is it happiness, knowledge, faith?), it is because it is the answer to all questions, the key to the enigmas of our lives and also, as we shall see, much more than that.

Some of the great dream films end by returning to the evening before, to the everyday reality. There are in these landings, however fascinating may be the spells that precede them, a form of plenitude, reassurance, and pure magic that I believe returns the powers of dreams to their proper place. For example, the ending of Kenji Mitzoguchi's *Ugetsu Monogatari* is all the more moving coming after a false ending in which one's intuition of the splendor of the world is accompanied by an illusory return to individual felicity. Alas, the potter is disenchanted, but his sadness becomes even deeper when it is mixed with resignation, the extent of the act of faith and belief in the mystery of diurnal existence that is the final word of the movie. The end of Resnais's *Providence* also frames the most radiant quintet imaginable; the final moments include a night of delicious nightmares, cross-dressing and pitfalls, glorious Nature, in the brightness of a summer's afternoon. And, of course, the endings of *Solaris*, *The Mirror*, and *Stalker*. Tarkovsky is the filmmaker of these returns: to the father, to the land, to the inanimate. His love of still lifes, which was noted by Jean-Pierre Jeancolas,[3] leads him to caress objects and to reveal their slow, secret palpitations. Approximately one-third of the way through *Solaris*, the hero spends an evening, like the eve of a battle, in his father's house. He wanders around empty rooms, burns old papers, and walks in the early morning on the meadow, wet with dew, where a horse is trotting. I know of no other scene in all of cinema more intimate or as rich. The whole of *The Mirror* stems from this sequence, and if I may say so, it is of the same water.

But the final scenes of *Solaris* and *Stalker*, which are very similar, are rich in added meaning. The astronaut has left *Solaris* and returned to earth, and believes that he has left behind, somewhere deep in space, drifting on the surface of a faraway ocean, the woman he loved. She will be no more than a memory from now on, and perhaps even a constant pain to torment him. He returns to his father's house, where his father is waiting for him at the threshold. The astronaut, without saying a word, kneels before him. At this point, the camera takes flight, over the house, in front of which the two figures get smaller and smaller. The neighboring countryside comes into view, and this final scene has already achieved a serene beauty. But the frame becomes even wider and reveals the house and the countryside surrounded by water. A tiny island in a sea we recognize, which we believe we left just a short while ago. Back on earth, all that has happened is that we have fallen even more deeply into the mystery of *Solaris*. In addition to giving us what is to my knowledge the most beautiful final shot in the history of cinema, the height from which it is taken shows the full scope of the *Solaris* metaphor: the plunge into the ocean, into this breeding

ground of memories, dreams, and regrets, followed by the peace achieved by returning home. But the return home is another plunge into the ocean. Out of this conclusion *The Mirror* was logically born.

The ending of *Stalker* closely matches that of *Solaris*. The metaphor is not as grand, but it is more secret and worrisome. I just described the Stalker's return—exhausted, angry, and worried about his injuries—and how he ended up abandoning himself to sleep under the watchful eye of his wife. The final sequence is constructed around his daughter. At the beginning, the tourists had alluded to this child, who was described as a sort of mutant. Just as the lineage of the inhabitants of a region that has been affected by radiation may well give rise to malformations, the daughter of a Stalker, a native of the Zone, could not help but bear its imprint. She was described as a legless cripple or something very much like that. As her closed and opaque face moves to the center of the screen, Tarkovsky returns to color, whereas previously all of the sequences in the Zone told us unambiguously that we had not finished with it, and that it was an illusion to think that one could ever leave. The scene is reasonably evocative, moreover, of the final pirouette so often found in fantasy films when, just as we think we are safe, some minor detail proves that the monster is, in fact, indestructible and that the horror will continue. The child, leaning over a table, looks only at the objects placed there and, using telekinesis, makes them move. As someone who has emanated from the Zone, she has the powers, the perfidy perhaps, and who knows, the secret. The Dostoyevskyan debate incarnated to some extent in the character of the humiliated Stalker has moved to the background. The film ends on a discovery that goes considerably beyond him, on the evidence of the unknowable.

I spoke just now about the ocean as a fitting metaphor. This is not true, because undoubtedly the ocean stirs up our memories and dreams. These are what Tarkovsky puts into each of his dives, those that he puts on display arbitrarily under our eyes. The ocean resuscitates the woman we loved, or our childhood. The mirror allows us to fix fleeting images. But above all else, it is ocean.

Much more than a symbol, or a Platonic cavern strictly for human use, more than an inexhaustible reservoir of anthropomorphic reveries that float to the surface like oil slicks or garbage on the seas that we know, the ocean is an autonomous entity that cannot be reduced to our understanding. It is its mystery and its unknowable nature on which Tarkovsky finally ends his film. Man finds what is good there, and it is an inestimable and heartrending treasure. But the ocean is much more than a metaphor of our unconscious, and that, no doubt, is what Tarkovsky is whispering. The unconscious is not only our unconscious: what I mean is not only what is unknown to us or hidden from us—any planet that shelters such a pathetic enigma would be unnecessary—but also everything that is unknown to us and in which we have no part.

At this stage, Tarkovsky's metaphysical reverie abandons anthropomorphism. He speaks to us of man on a quest for himself. Very well. That is a beautiful and vast subject. But also about man on a quest for what is not himself, and also for that which is not man, and of which man cannot even dream, toward which he would have a great deal of difficulty even beginning a quest.

And although his initial questions are sometimes set out in rhetorical or allegorical terms, the answers, because of a paucity of terms and the inability to even

grasp the scope, can only be solved in pure poetry. An end then to thinking and to discussions about faith and the superiority of the innocent over the intellectual—no more metaphors. Establishing the superiority of the innocent because he is in contact with the Cosmos simply serves to abandon the innocent and to have him sucked into and absorbed by the Cosmos. It is usually from the spectacle of the heavens that poets borrow pretexts for their meditations on the relativity of man, the immensity and mystery of the universe. As we noted, Tarkovsky turns away from it, like the astronaut who, abandoning *Solaris*, returns to his planet. He looks at his feet, scrutinizing the earth and the water. Especially the water.

In the filmmaker's last three films, the empty beaches are, in only a few moments, suddenly flooded and covered with water. In all of cinema, I have never seen shots more dense and mysterious than these aquatic images. The same calm waters that lap over pebbles slowly float away algae. Bubbles occasionally break at the surface. They irrigate that which is no longer the planet of the ghosts, but the very soil of *terra firma*, in *Solaris*, in *The Mirror*, and in this unbelievable scene in *Stalker*, where they fill the screen, inviting nothing but contemplation, while on the accompanying sound-track, the writer and the professor work hard to illustrate in words an opposition that we, the audience, can plainly see. Their comments are stupefying, and the Stalker, lying in the silt, allows himself to be fascinated by the flow, and appears to be at one with it. Out of this surprising counterpoint, with the image winning out so clearly over speech, are we to infer that Tarkovsky basically does not attach too much importance to the intellectual structure of his film or its human content? In any event, he allows them to fade, without any remorse, and to be left to their vacuity by the evidence and physical apprehension of the mystery. They are no more than a buzzing sound, like insects on the surface of the water. What is clear is that we are these insects, and the problems and conflicts that they are debating are ours. All artists speak to us of these insects. Tarkovsky, too, but he alone films the water.

1. I must admit that I was somewhat disappointed by this rather brilliant exercise, which Robert Benayoun (*Positif*, no. 231) did his best to tell us, as intimately and confidentially as possible, was perhaps because this completely legitimate shift in the scales was so obviously deliberate that it is not only the pretext for *Mon Oncle* but the driving force and the story itself.

2. *Positif*, no. 186.

3. *Positif*, no. 206.

No. 247, October 1981

Solaris. 1972. USSR. Directed by Andrei Tarkovsky. Screenplay by Tarkovsky and Friedrich Gorenstein, based on the novel by Stanislaw Lem. Cinematography by Vadim Yusov. Film editing by Ludmila Feiginova. Music by Eduard Artemyev. With Donatas Banionis (Kris Kelvin), Natalya Bondarchuk (Hari), Yuri Jarvet (Snouth), Vladislav Dvorzhetsky (Burton), Anatoly Solonitsin (Sartorius), Sos Sarkissian (Gibarian), Nikolai Grinko (Kelvin's Father), and O. Yislova (Kelvin's Mother). In Russian. 167 min.

Stalker. 1981. USSR. Directed by Andrei Tarkovsky. Written by Arkadi and Boris Strugatsky, based on *Picnic by the Roadside*. Produced by Aleksandra Demidova. Cinematography by Aleksandr Knyazhinsky. Music by Eduard Artemyev, Maurice Ravel, and Ludwig van Beethoven. With Aleksandr Kajdanovsky (Stalker), Nikolai Grinko (Scientist), Anatoli Solinitsyn (Writer), and Alisa Krejndlikh (Stalker's wife). In Russian. 160 min.

It has been said of *Fanny and Alexander (Fanny och Alexander)* that it is a "testament." Certainly not. Bergman is not bequeathing anything, and he is not passing on a legacy or last wishes. It has also been called a "summation." This is not true either. The Bergman of *Fanny and Alexander* is a different Bergman, a Bergman from another age, or shall we say two other ages: childhood and old age, which he says melt

A Calmer Ingmar: *Fanny and Alexander*

Jean-Pierre Jeancolas

Following the major Scandinavian retrospective organized by Henri Langlois at the Cinémathèque française, Ado Kyrou, in the 1956 June-July issue of *Positif*, called Ingmar Bergman "one of the greatest filmmakers of all time." *Positif*'s interest in the Swedish filmmaker was consistent over the years, as demonstrated in this essay about one of his last films. The author, Jean-Pierre Jeancolas, is also an acknowledged expert on French and Hungarian cinema.

into one another. "We are old and at the same time a child, and cannot understand where all this time, which we considered so important, has gone." This elderly Bergman is a more satisfied and almost serene Bergman, detached and sovereign— detached from the anxieties and rendings that were the subject matter of his work, from the two trilogies to *Cries and Whispers*. His mastery of his art was supreme.

Fanny and Alexander, while indisputably a film in the Bergman mold, is striking. It is not part of the long line of "summer films" that the director made in the 1950s. Nor does it contain the unbearable violence of *The Silence (Tystnaden)*, *Hour of the Wolf (Vargtimmen)*, *Cries and Whispers (Viskningar och Rop)*, or *From the Life of the Marionettes (Aus dem Leben der Marionetten)*. No blood, no mutilation, and Emilie Ekdahl's wails of grief are no louder than those to which people who read classical novels are accustomed. Let's say that they are in the tradition of Balzac. The bishop's tireless efforts to break down the resistance of the young Alexander, through dominance, castor oil, and darkened rooms, is no more than the villainy of the bad guy in a story by Charles Dickens or Hector Malot. No mutilated sexual organs, slit throats, or bodies floating on a metaphysical sea.

The Bergman of *Fanny and Alexander* is a quiet Bergman who gives us enjoyment by telling us a story, his story, on condition that one does not read into it too much that is personal as if it were nothing more than autobiographical.

Ingmar is not Alexander.[1] At least no more, or barely more, than he is Oscar, Gustav-Adolf, or, of course, all his women. It is the uncertainty, the joy, the creative fullness and wisdom, punctuated nevertheless by the nostalgic sighs of old Helena Ekdahl. Nor is he Bishop Edvard Vergerus or the Jew Isak Jacobi. We will return to this later.

The story begins on Christmas Day 1907 and continues for approximately eighteen months. There is a first summer, the summer that Emilie Ekdahl gets remarried to Bishop Vergerus. A second winter, which for the children is a time of detention behind the thick walls of the Episcopal palace. Then a spring and another summer, which show the liberation of the children, the death of the bishop, the reconstruction of the family circle around two cradles, and the signs of a dual departure: to the city— another world, off screen where history is made—for Petra, Maj, and Maj's

Bertil Guve and Pernilla Allwin in Ingmar Bergman's *Fanny and Alexander*. 1982

child, and toward the theater—life—for Emilie and the old Helena, the matriarch around whom the story is spun.

The world of the Ekdahls is a world in which men do not matter much. We know nothing about the first Oscar, the one who built the theater and, when he died, left it to his widow Helena and his sons.[2] The three sons (Oscar the second, a not very good actor, and the father of Alexander and Fanny, who dies while rehearsing the role of the ghost in *Hamlet*, and who lives again, a sad contemporary specter in the imagination of his son and his mother; Carl, the failure, and Gustav-Adolf, the fully developed and superficial hedonist, smoothly irresponsible, to whom Bergman gives a lengthy epicurean tirade at the end of his film) are all characters without depth. On the Ekdahl side, we are given not three brothers but rather three women. These are Helena, the actress, Emilie, also an actress, and two other women, who are less in the forefront, along with the dizzying business of a dozen servants, ranging from the old Ester to the young Maj, wearing white aprons over heavy black skirts, who regard each other with conniving glances, with an exclusively feminine warmth enveloping the protected childhood of Alexander and his sister. We do not see a single male in this small domestic retinue.

In Bergman's work, children have often been neglected or treated lightly (there are noteworthy exceptions: Gunnel Lindblom's son in *The Silence*, the child-understudy killed by Max von Sydow in *Hour of the Wolf*). Here, they are so much at the center of things as their names are in the title of the film. Fanny and Alexander, especially Alexander, are pushed into the foreground by the maker's determination. They are also on the poster for the film and on the cover of the Gallimard book. Fanny and Alexander exist because Bergman gives them a boost, because the production inflates their importance. Despite these efforts, they exist less than the bigger adults, less than Emilie, less than Helena, less than the two large hovering outlines who define opposed views of the outside world: the Jew, Isak Jacobi, and the bishop, Edvard Vergerus.

Bergman's eye, now serene, nevertheless remains full of spellbound Manicheism. Jacobi's and Vergerus's roots run very deep in the filmmaker's work. We know that Bergman deliberately chooses the names he gives his characters. In his work there is a Jacobi line and a Vergerus line. The Jacobis (Gunnar Björnstrand in *Shame [Skammen]*, Erland Josephson in *Face to Face [Ansikte mot Ansikte]*) are rather mysterious but, if I may say so, full of positive electricity. The Vergeruses hark back to Mabuse.[3] In *The Magician* (*Ansiktet;* Björnstrand), *The Passion of Anna* (*En Passion;* Josephson), and *The Touch* (*Beröringen;* von Sydow), the misadventures of Vergerus represented both "the spirit of evil" and "at the same time, the feeling of guilt that Bergman, as a good puritan, harbors toward knowledge, which is never innocent."[4]

In *Fanny and Alexander*, guilt has disappeared. Rather than the cold, mortification, punitive authority, and metaphysical anguish, Bergman has chosen life, movement, profusion, and, at the same time, the assumed existence of a mystery, communication with the beyond, which no longer troubles him.

For thirty years, Bergman has created a gallery of characters that includes tormented priests, pathetic people, characters inhabited by disorders and his own uncertainty. Much has been written, often quite rightly, about Bergman as the son of a cleric who fought in hand-to-hand combat against his world: God and his father entangled in a complex form of suffering. In *Fanny and Alexander*, the priest has been promoted and is now a bishop. But he has become simplified and purified into an

objectively revolting character, a sadistic stepfather who enjoys the humiliation he inflicts on others. Were it not for his wild-eyed and distressed gaze when he realizes just how badly he has failed, his death in the flames would be nothing more than appropriate. He is already out of the picture because of his condemnation by Emilie, who leaves him—a Vergerus who is a caricature worthy of the cloth.

The bishop is reduced to a disgusting shell because God is dead. The child Alexander has already killed him, in himself, through the obscene litany he murmurs at his father's funeral: "Shit – cunt – ass – prick – arse – hell – Satan – fuck – wanking – shitting – piss – poo – tits – pussy – bums."[5] He kills him again in a conversation with his father's ghost, and then after the puppet Aaron falls at his feet, in an even more precise conversation with the young Jew, who then tells him that he is an atheist but that there are "many bizarre things that cannot be explained."

Life needs to be learned from the Jews. Bergman sees Jacobi in his cave looking the way Rembrandt posed the Jews in Amsterdam. To the dull uniform of Batavian Calvinists and their strict black costumes, Rembrandt countered with brilliant coppers, real or imitation stones, silks that he would buy in the ghetto and get his models to wear, as he himself did for the most provocative of his self-portraits. Bergman, consciously no doubt, uses the palette of the artist who painted *The Jewish Bride*: the shots of Vergerus's monstrous aunt, or Emilie very pregnant, with her naked legs, seated on the edge of the marriage bed in a symphony of icy grays, hark back to Rembrandt's matrons and Bathshebas. Jacobi's immense housecoat, heavily brocaded, with thousands of bright reflections glimpsed deep in the rear of his shop, old books, exotic masks, or foreign mummies all refer back, like Rembrandt's paintings, to a humanism that is both disorganized and elicits all kinds of curiosity.

Jacobi's bazaar, the first stage in the liberation of Alexander, is a secular bazaar, not necessarily rationalistic, but secular.

For Bergman, like Rembrandt three hundred years ago, the Jewish world is a moment of freedom. They are not asking the Jews for an alternative form of mysticism, but they are asking for the profusion that the church of the Christians, Calvin's version for the Amsterdam painter or Luther's version for the Uppsala filmmaker, coldly stamped out. Neither Bergman nor Rembrandt sees another religion in Jewish culture. They do not see Jewish culture. What they see in the Jews, with whom they cohabit in a positive otherness, makes possible everything that the power of the priests had extinguished. Bergman is no longer "guilty, like a good Puritan, toward knowledge."[6] He is asking the Jacobis of this confused and uncertain culture, from these images from a fantasized East full of gold and crystal, for an approach to these questions to which time, one day, will perhaps provide an answer. The mummy stopped breathing a long time ago.

In the city of *Fanny and Alexander*, people's movements are infrequent and show signs of torpor. The people are slow, restricted. They do not know how to hurry, and they awkwardly push the pathetic small cart to the house of the dying specter. The bishop, taking his new wife and two children home, even though morally and financially he wanted them naked in his palace, strolls down the sidewalk with affected solemnity. There is only one light moment in the three hours of film, when a heavy four-wheeled wagon pulled by powerful horses, not elegant creatures but beasts of burden, primitive, born before civilization organized things, bursts from the rear of the screen, crosses the market with great noise, and stops in front of the Episcopal

residence. On this wagon is a chair, resembling the throne of an Eastern king: Jacobi the liberator makes his entrance.

The immense Jew, tender with Helena as an accessory of the old lover, thunderous and cunning like the good spirit in a children's tale when he is within range of Fanny and Alexander (Bergman deliberately denies any credibility to the kidnapping scene: Isak goes up and down the stairway twice while the abominable prelate and his sister conveniently turn their backs, as in a farce), and he is the only father figure in the film who is positive. He is a chosen father, acceptable because he is different: he comes from this overabundant elsewhere that I mentioned earlier.

He is not like ordinary adults, those who live in a time that Bergman tells us today is not "so important." He talks to his ancestors (Helena, whom he loved) and to children.

He shares this faculty with the dead. With the father, who at least made a successful exit: "Now, I will be able to play a ghost perfectly well, and nothing, absolutely nothing, separates me from you, now or after." No more ghostly than he was when alive, in fact more loquacious, he arrives in his not very clean flannel costume to exchange disappointed glances and then disabused comments with the living. But he chooses those to whom he speaks or, more precisely, Bergman chooses those who have a rich enough inner life to be worthy to receive them. Of the five apparitions the filmmaker gives him, the first after the funeral (he plays mournfully on the harpsichord), the second in a ray of golden light when the bishop and Emilie come to tell the children about their plan to get married, the third, during the wedding ceremony, the fourth at the Ekdahls' country house and finally, in Jacobi's messy bazaar, half-hidden by the profusion of cut-glass chandeliers and cabochons, four for his son (the last time, Alexander speaks to him and provokes him: "It would be better for you to get out of here! Is God fed up with you? Is God fed up with all of us?"), but the fifth (the fourth chronologically) is for his mother. They are seated melancholically in the white light of the veranda, talking about the vanity of existence, and get worried about the children the bishop holds as prisoners.

The fourth intrusion of the ghost into the story upsets a hypothesis that might have been attractive, and to which we were invited by the film's prologue (Alexander, alone in the Ekdahls' large house, allows himself to be deliciously frightened by the spirit there and proves to us that he knows how to make objects move: a marble statue, a Venus clearly, but for him a naked woman, and he turns and bends over, making himself an accomplice): in *Fanny and Alexander*, there is a projection of the young boy's world. Alexander generates the ghosts—even that of the late bishop, threatening or vindictive— just as he manufactured images with his magic lantern. But it is his grandmother who generates the fourth entrance of Oscar as a sad phantom.

Let us not make prophesies. Not Alexander, not Helena, but Ingmar. The director cares not in the slightest about providing a rationale for his entrances. He is in charge. He places his characters, dead or alive, in the field, with the smiling detachment of someone who knows where he is going. In 1971, while in Farö, during preparations for *Cries and Whispers*, he wrote a text entitled: "We are going to make a film together."[7] He developed his project, then devised what he called a "short interruption." It reads as follows: "How I get tired of seeing the imagination always having to be reasonable!"

1. Alexander is undeniably like the child that Ingmar Bergman was, although a generation apart, and the world in which Ingmar was brought up no doubt more closely resembles the house of the bishop than the house of the Ekdahls. By giving his hero a childhood in a household of rich, cultivated actors who lead a life of luxury, the director, who is in his sixties, is perhaps living an old dream. But he gives Alexander a toy from his own childhood: "It was a metal box, very simple, rather large, black, equipped with a system of rudimentary lenses, with an alcohol lamp and a kind of chimney going straight up, and from this chimney, there was always a little smoke rising." In the first interview with Bergman in the indispensable *Le Cinéma selon Bergman* (Seghers, 1973), he gives a description of the projector he had when he was ten. In the film, he makes it a magic lantern (Alexander was ten years old in 1907, and Ingmar was ten in 1928), but the smoking chimney is still there. It was something that had already been seen in a flashback sequence (it was called Aunt Olga's magic lantern) in *Cries and Whispers*. In the same book, the future director of *Fanny and Alexander* refers to his humiliation (see pp. 100 and 101). I will quote from two passages that would appear to have ties to his most recent film: "This is a feeling that affected my childhood, and one that I remember best: humiliation, being humiliated, physically, verbally or in various situations." And a page and a half later: "I fiercely criticize Christianity largely because humiliation is very strongly present in that religion, and almost inherent to it."

2. Gallimard published a work by Ingmar Bergman, also entitled *Fanny and Alexander*. It is not exactly the screenplay, and even less a shooting script. It is a story, which he completed in Farö in July 1979, more than two years before he made the film. It can be considered a first literary draft of this film. It gives us valuable information about the historical background of the characters, their past, and how Bergman views them. Between 1979, when the draft was written, and 1981, when the film was shot, it was simplified: some characters disappeared (an elder sister of Fanny and Alexander, called Amanda, a little girl called Eva who would come to speak with Helena in the Ekdahls' country home), and other lengthy scenes that were never filmed. The Gallimard story begins with a prologue that summarizes the history of the Ekdahl family before the action begins.

3. Michel Sineux made this connection in speaking about the character played by Heinz Bennent in *The Serpent's Egg (Das Schlangenei)* (see *Positif*, no. 204).

4. Ibid.

5. Based not on the subtitles, which are rather inadequate (they do not match the staccato and rapid rhythm of Alexander's speech), but on the book published by Gallimard, p. 98.

6. Ibid.

7. Published in *L'Avant-scène du cinéma*, no. 142 (December 1973).

No. 267, July 1983

Fanny and Alexander (Fanny och Alexander). 1982. Sweden. Written and directed by Ingmar Bergman. Cinematography by Sven Nykvist. Music by Daniel Bell. With Pernilla Allwin (Fanny Ekdahl), Bertil Guve (Alexander Ekdahl), Anna Bergman (Hanna Schwartz), Ewa Fröling (Emilie Ekdahl), Jan Malmsjö (Bishop Edvard Vergerus), Erland Josephson (Isak Jacobi), and Gun Wållgren (Helena Ekdahl). In Swedish. 189 min.

A little girl jumping rope counts up to one hundred. It is night and her counting is also for the stars coming out, to which she assigns invented names. The girl's shadow sometimes falls on the wall behind her, out of all proportion to reality, like the shadow of the young woman picking up the lost drachma in Domenico Fetti's famous painting (Pitti Palace, Florence). A red glow also fills the scene occasionally.

That is how Peter Greenaway's new film begins.

Counting up to one hundred postulates perfectly regular division. The girl herself shows just how arbitrary such

Hermes and Delilah: Peter Greenaway's *Drowning by Numbers*

Alain Masson

Peter Greenaway's violently controversial films very soon found some of his staunchest defenders in the columns of *Positif*. His formal research, playfulness, cultural references, and philosophizing would inevitably prove seductive for a magazine with close ties to Surrealism.

an operation is: after one hundred, the stars are considered to belong to other groups of one hundred, which are treated as equivalent. The rhythm can only organize finite sets, but we can also see that the definition of these sets involves a progression to infinity. This then is an initial celestial and ideal form of architecture. But does the recital of the numbers keep in time? Surely not: the fact that the numbers are of unequal length, as are the names of people with whom they alternate and among which we can hear Kracklite (Greenaway's *The Belly of an Architect*), makes any rhythmic consistency impossible. The regularity of the phrasing is therefore based on a conventional equivalence that resembles those used in metric theory: arithmetic, astronomy, versification, and so on. Choreography: rhythmic movement, with the skipping more or less precisely matching the beat of the counting rhyme. The hoops of the girl's crinoline oscillate as a result of the jumping, but not without introducing further complexity. Indeed, each of the luminous phenomena introduces a new tempo, giving us a polyrhythmic image. How heterogeneous is the visible! An overall rhythm in which all the separate rhythms get along can be conceived, but cannot be grasped. Who could perceive a one-hundred-foot-long verse? The fact that there are so many rules and that they can be degraded make a supreme form of regularity impossible at the same time as it becomes more essential, more urgent. Such formal matters permeate the whole film: the essential but impossible transcending of any barriers, the interminable fitting together of the pieces.

And what of the metamorphoses of lighting? It is not difficult, after a few minutes, to determine that they come from a beacon, but in an impossible way. How could such a high lamp produce such a long shadow? For the little girl's silhouette to extend upward as it does would require a source of light close to her feet. Sacha Vierny has explained clearly Greenaway's passion for composite and difficult lighting, and how he cares little for reality in such matters.[1] Of course, not only is it impossible to reduce the lighting in a scene to the identifiable sources thereof, but it is clearly different, and must come from another source that is more intense than any identifiable lamps. That is how two characters in the film can be lit by the headlamps of a car in the dark without the half-light that makes them visible changing significantly in character. But as soon as the source of this dominant light becomes evident, another form of treason occurs: the beacon may explain the shadow and the red tint but does nothing to help us understand the former and in particular how the shadow comes about without the overall lighting

Juliet Stevenson and Joan Plowright in Peter Greenaway's *Drowning by Numbers*. 1988

changing in any noticeable manner. Between the lighting and the suffused luminosity, there is therefore an interplay of reciprocal excesses analogous to what happens between the angle of the lens and the painter's veil in Greenaway's *The Draughtsman's Contract.*

This leads to two conclusions. First of all, Greenaway's style sets in motion a sensitivity to the formal structures that govern perception of the world. Anyone who has never meditated on the mysterious relationships, correct proportions, chromatic affinities, and sympathetic congruence of lines that make it possible for certain objects to lend themselves harmoniously to disinterested contemplation will never be able to understand Greenaway. Secondly, this way of seeing things, with an effort to discover and identify relatively clear laws for organizing these things, in sufficient numbers to treat them appropriately, is the very definition of direction from the most general possible standpoint. The play of lights and angles, combined with other methods, materializes this form of direction and yet underlines the fact that there is no ultimate justification for it.

There is no artist in this particular work. But the coroner and his son perform the role instead. The former, as a forensic doctor, interprets death, which he claims he can take away from nature; for him, there is no such thing as natural death. The latter records, numbers, and marks in red and yellow, depending on the day of the week, the corpses of various animals. Both thus subject mortality to an intellectual rule, signifying that they belong to the living world. The director's consistency and constancy to his argument are thus undeniable. See *A Zed and Two Noughts* and *The Belly of an Architect.*

The story, like the counting, is an organized series. Notwithstanding what Paulo Antonio Paranagua said about it, there is nothing Surrealistic or Symbolist in this film.[2] Is everything calculated? Surely not, because what arithmetic could possibly cover so many different happenings? But everything appears to be calculable. A member of the audience can work hard to follow the counting from one to one hundred. Or if the one is on a tree (later, apples will enter the picture; original sin? Let's pass on that one!) and if the one hundred is found on a wooden boat, it can't simply be there by chance. There is therefore symmetry. The first murder coincides with the three and the last with the one hundred; as it happens, the little girl added three stars to her hundred, implying some form of equivalence between the two numbers; is not one hundred the first three-digit number? So many subtleties and questions! As for symmetry, how to justify the enormous 50 that appears in the middle of the beach and looks like 05 backwards, which does not follow correct geometry. And what of the numbers that appear out of turn, and those that repeat themselves? Those that are mentioned rather than seen? Those larger than one hundred? Can the four tines of a fork be read as IIII, like the Roman numeral four? What to do when we don't see a number? Does numbering govern the increase in the number of characters? The required series proliferates indefinitely, and filmgoers are caught up in a brutal oulipian progression. Games are extremely important here: most men live by recounting their own lives like a novel, and Greenaway's heroes live and die treating their lives like a game: the hanging of Smut is carried out with an exemplary simplicity that is upsetting in its lack of emotion.

But the game, which is beyond us, and the sequence of numbers are not enough to organize the story. There is some narrative order involved, but unlike the usual procedure, it does not express the motives of the characters. The three drownings, for example, are understood only because they reproduce a unique conjunction of circumstances without anything able to be considered as effectively having caused the crime. Cissie Colpitts kills her husband in the water during a sexual adventure, or at least that is the theory. It doesn't matter whether or not Cissie feels jealousy,

frustration, or satisfaction; nor are the details concerning the dimensions of the place, the pool, the sea or a swimming pool, or the mood of the murderess relevant to this way of rendering intelligible events. One has to resign oneself to it. The identity of the criminal herself is of little value.

Cissie is three different characters, but also, in keeping with the general law of excess, she is all of them together; the coroner is the husband of this set of women insofar as his own sexual successes with each of her parts (not at all, almost nothing, very little) are proportional to the intimacy they had with their respective husbands; the fourth killing thus follows the same law as the first three.

Furthermore, there is a network of allusions to shed light on the fable. Cissie, after all, although sometimes spelled sissy, means "an effeminate boy"; on the other hand, the men become pregnant: men are asked whether they are pregnant. As in *The Belly of an Architect*, there appears to be an inversion of the sexes. The name Colpitts makes us think of culprit: an accused who pleads not guilty (or who is guilty); a Colpitts is a culprit who is missing an "r." Furthermore, the three Cissies, whose first name derives from sisters, evoke both the Fates and the Eumenides; they are rowing their boat on a river in hell; the coroner thus appears as a buffoon version of a psychopompous Hermes; the census of the dead, death understood as a form of counting, that is what the operation amounts to. People think they make love; they kill or die; one believes he is an accomplice of the murderesses and becomes their victim, hence the inversion of the sexes and of power. We are counting in a time that is being told to us. *The Draughtsman's Contract*, as noted by Louis Seguin at the time in *La Quinzaine littéraire*, was an exploration of Thomas Hobbes's philosophy of the opposition between violence and the contract; this time, Greenaway illustrates and exaggerates David Hume's argument to the effect that we can never perceive the necessity of a causal connection between two events. Hence what is our understanding of the world based upon?

In 1984 Greenaway mentioned to Michel Ciment a film project entitled *Drowning by Numbers*, which was "inspired, from the visual standpoint, by Bonnard and Vuillard."[3] It is hard to identify the influence of these painters, expect perhaps at the beginning. But another project, which in 1987 was an alternative with the above[4] appears to have infected him: here we find "three acts, each associated with death by drowning." This may hark back to the "Lady of the Lake." The third drowned person, with an admirable and amorous struggle in a swimming pool and twin refracted images, nevertheless appears to be inspired by the legend of Hermaphrodite (Ovid, *Metamorphoses 4: In liquidis transluce aquis . . .*) which leads us to Hermes and the snails so dear to Greenaway. As for pictorial referencing, the two French painters have been replaced by Peter Paul Rubens, whose *Samson and Delilah* is quoted, as well as Anthony van Dyck and a number of other Flemish friends whose speciality is luxurious still lifes. The tormented rending of a tree or the gripping descent from the cross concludes the second drowning. It is both an adaptable inspiration and an ironic effect because no school of painting has better mastered the presence and exaltation of movement than this Baroque northern art. As for Delilah, her scissors hint at circumcision (castration?), but could they not also be the scissors of Atropos?

1–4. *Positif*, no. 302.; *Positif*, no. 329.; *Positif*, no. 376.; *Positif*, no. 320, p. 25.

Drowning by Numbers. 1988. UK. Written and directed by Peter Greenaway. Produced by Kees Kasander and Denis Wigman. Cinematography by Sacha Vierny. Music by Michael Nyman. With Joan Plowright (Cissie Colpitts 1), Juliet Stevenson (Cissie Colpitts 2), Joely Richardson (Cissie Colpitts 3), Bernard Hill (Madgett), Jason Edwards (Smut), and Bryan Pringle (Jake). 114 min.

1990s

The French release of the admirable film *City of Sadness (Beiqing Chengshi)* was delayed for a year for obscure commercial reasons. Among them, it seems, was the timidity of the distributors about showing a Taiwanese film that was two hours and forty minutes long; its reputation for being "difficult"; and the greed of Chinese marketers placing too much confidence in the prestige of international recognition (the film won the Lion d'or in Venice in 1989).

Window on China: *City of Sadness*

Yann Tobin

By putting an image from King Hu's *A Touch of Zen* on its cover as early as 1975, *Positif* signaled the arrival of a new generation of filmmakers from the Far East, which had previously been the preserve of Japan alone. In addition to films from mainland China and Hong Kong, Taiwan's cinema began to shine particularly brightly. The films of Hou Hsiao-hsien, including *City of Sadness*, may be compared in scope to Theodoros Angelopoulos's *The Traveling Players*.

Even though delayed and launched in only two modest theaters with a minimum of promotion, Hou Hsaio-hsien's film is one of the best to appear in France this year [1990]. The overworked term "masterpiece" to designate an artistic triumph as well as the successful completion of an ambitious undertaking can be applied here without reservation.

LIVING LANGUAGES

First let us deal with the presumed "difficulty" of the film. The historical context of Taiwan, formerly Formosa, unknown to most Westerners, is clearly summarized by the lead-in preceding the French subtitles, added so as to accommodate export to the West.

The problem of language is more subtle: all the characters in the film speak the language they would have spoken historically. That means Taiwanese, Japanese, Mandarin, or Cantonese, not to mention regional dialects! Obviously, for the French viewer, all this is . . . let's face it, Greek. In one charming scene, only the Chinese members of the audience laugh; it's a group language course in a hospital and the height of abstruseness is reached when the older brother (there are four of them, and the film tells their stories) communicates with gangsters through an interpreter: the French subtitles can only repeat the same lines twice, to make us understand how difficult it is for the character to express himself. This, in fact, supports one of the major themes of the film: the absurdity and despair of a country searching for its cultural identity. But this kind of problem occurs only rarely in a work that consistently opts to show the supremacy of the visual over the pitfalls of language. It's not for nothing that the protagonist (Wen-ching, the youngest of the four brothers) is a photographer who is a deaf mute.

The thesis, therefore, is clear, even classical: a family saga in which each character represents a significant historical attitude. From *Gone with the Wind* to the films of Theodoros Angelopoulos, the cinema has been able to prove just how well a description of a community microcosm can describe a whole country's development. Here the destiny of old father Lin and his four sons begins to resemble a didactic fable that reveals the contradictions of a country shaken by History. The succession of tragedies that affects the four brothers becomes the keys to their collective despair: disappearances, silence, madness, and death strike each of them in turn, while

Hou Hsiao-hsien. *City of Sadness*. 1989

the socioeconomic and political upheavals are unleashed around them. The father outlives the children, an indestructible symbol (albeit fragile) of the roots of Taiwan.

The presence of women gives a discreetly melodramatic texture to a system that is austere on the surface. Sisters or betrothed, wives or widows, mothers or mistresses, create the various facets of the feminine side that tempers the narrative. Very often it is a woman's glance that alters the viewpoint of a sequence. The key character in the film is thus the young and beautiful Hinomi, who brings together the disparate elements of the fable. In love with a Japanese man, sister of an intellectual, wife of the fourth son, mother of the last-born in the family, she provides the link between the Lin family and the outside world, and plays an essential role in articulating the story. This is the only character for whom communication is not a problem: she is fluent in several languages; she learns to communicate with the deaf mute Wen-ching (her future husband) in deeply moving sequences in which the messages they write to one another are inserted like intertitles in a silent film. She is even allowed to explain her feelings to the viewer, through a private journal read in voice-over.

(DIS)CONTINUITY

But it is not the hidden subtlety of this apparently simple story that makes the film so original. What hits home, what is most disorienting and requires the most effort from the viewer, is not the historical revelation of a period until now taboo in Taiwanese cinema. More than anything else, the strength, beauty, and audacity of the film lie in the details of the writing and direction.

Hou Hsaio-hsien is faced with a difficult challenge: explaining the entire history of a country through a "window" of four decisive years (1945 to 1949, when Taiwan shifted from Japanese control to the Chinese nationalists while fighting in vain for independence). The cinema gives him the ideal opportunity to apply the "window" system strictly. A shot is a window in space and time. He selects a limited space called a frame, and cuts a self-contained time span which is then fitted into the edited version. The historical window selected by the writers allows us to understand or imagine the surrounding context (which is neither shown nor explained). Likewise, each shot in the edited film constitutes a fragment which, through careful observation, allows us to deduce the circumstances. Hence a film style which requires the greatest attention from the viewer so that one can understand what is happening, and a style of film writing that requires attention to understand the story: shot sequences, most often static, long shots in which the space is painstakingly organized, colors and light sources carefully placed, character movements handled like choreography, voices and conversations caught "on the fly" before cutting abruptly to the next scene.

There are no scenes of what might be called introduction or explanation. We are not introduced to the characters; they are simply there. They present themselves "live" through their gestures, actions, and words, while the camera seems to catch the fragments of life that we are shown arbitrarily. This elliptical process requires us to deduce what happens *between* two sequences, to figure out what happens *before* and *after* what we see. The juxtaposition of the episodes leads to striking changes of tone (a funeral immediately followed by a wedding). This juxtaposition reinforces the realism of the production (life "as it happens") while at the same time distancing itself from it (one can identify the characters, but not identify with them).

EXQUISITE FRAMING

From this "fragmented" historical and storytelling approach (comparable to the work of the filmmaker Axel Corti in his Viennese trilogy), the director develops the visual structure of the film, and thus completes its extraordinarily formal cohesion.

The repeated but masterly use of frames within the frame is reminiscent of Ernst Lubitsch, Yasujiro Ozu, or some of George Cukor's films. Every element of scenery contributes to the pictorial obsession, likening the flatness of the motion-picture screen to that of traditional Asian painting: the depth of field comes only from the superimposition of frontal shots, and the composition of most shots is based on this concept. Thus a "window" outlining a character can be located in front of him (Wen-ching as a prisoner, seen through a peephole), or behind him (Hinomi, loosening her garment, is set against a bright frame in the background). Similarly, the street where the older brother's restaurant is located is invariably framed by the building facades, and the violence of an antigovernment revolt is seen in the interior of a hospital through an open door.

The visual leitmotiv of the "framing" not only gives body to the overall conception of the film, but strikingly suggests the isolation of the characters and the pressure placed on them by a chaotic environment.

In one of the most beautiful scenes in the film and also one of the shortest, the frame within the frame begins to move. More precisely, it becomes movement. Wen-ching, Hinomi, and their little boy, immobile on a station platform, are fleetingly seen between the cars of a train passing in the foreground—a poignant premonition of the breakup of their family and, at the same time, an homage to cinema itself, to the stroboscopic effects of a camera shutter that can immortalize fragments of history.

No. 358, December 1990

City of Sadness (Beiqing Chengshi). 1989. Taiwan. Directed by Hou Hsiao-hsien. Written by Wu Nianzhen and Zhu Tianwen. Produced by Qiu Fusheng. With Li Tianlu (Lin Ah-lu), Chen Songyong (Lin Wen-hsung), Gao Gie (Lin Wen-liang), Tony Leung (Lin Wen-ching), Wu Yifang (Wuttinoe), and Xin Shufen (Wu Hinomi). In Taiwanese. 155 min.

V an Gogh is a far cry from a standard film biography that attempts to follow the evolution of an artist, where shot after shot focuses on a look or gesture as a signpost marking the pain of creativity. Maurice Pialat does not always adopt van Gogh's point of view. He avoids putting him on a pedestal of incomprehension and turning the supporting roles into mere caricatures. He makes van Gogh an or-

dinary person, not center stage at all times but nonetheless the very core of the film. When Theo van Gogh and Dr. Gachet seem to be discussing homeopathy, they are evoking Vincent's painting; when Madame Chevalier is talking about her son who died during the Commune, she is talking to

Two or Three Things about
Van Gogh (Maurice Pialat)
Olivier Kohn

Like Claude Sautet, Maurice Pialat gained international acclaim too late to have been part of the Nouvelle Vague. After *Naked Childhood* (*L'Enfance nue*; 1968), he nevertheless had to be considered one of the most remarkable of all French filmmakers, and *Positif* rated him very highly indeed. *Van Gogh* was recognized as one of his best films when it was presented at the Cannes Festival.

Marguerite Gachet about her lover, etc. The same is true of Theo and Jo, Marguerite and her father: all the characters define themselves primarily by their attitude toward, and image of, Vincent. They instinctively measure themselves against him, as if they know intuitively that only through him can their dull lives find meaning. Like Christ revealing their own reality to those who approach him (the idiot refers to "bread and wine" when he sees Vincent for the first time), after a hiatus the artist—in appearance a lightweight, in reality a colossus (Pialat does a magnificent job of depicting him)—is set apart from the others, thus revealing their depths and his own mystery. The sheer impossibility of the relationship creates the revelation.

Van Gogh is not a soulless biography of a hieratic character lost in a timeless world. To say that van Gogh was ahead of his time does not mean that he foresaw the coming century and its painting: he probably couldn't have cared less. An artist is not great because he presages the future, but because he expresses his own era (including its fantasies, which have nothing to do with prophesying the future). Pialat must be applauded for showing us, as no one else has, the painter in his own time. There is little discussion of the artist's work (essentially only the dispute between Vincent and the young painter Gilbert). The film concentrates on the basically trite: the group of diners humming "Le Temps des cerises," Madame Chevalier evoking her dead son, the piano teacher singing "Lakmé" in the beer garden—these things are the lifeblood that flows through the film and quietly unifies it.

Pialat uses Sunday parties on the banks of the Oise to represent our forgotten relationship to nature and our own bodies. The countryside, dance, and prostitutes are non-threatening and impulsive, and Vincent is as able to put aside his inspiration for a formal dinner with the Gachets as he is to disturb the harmony of a Sunday meal because his painting is misunderstood. Contradictions are remarkably stated through the acting of Jacques Dutronc, stunning in the role of the artist. He is van Gogh while remaining Dutronc: with a mixture of blind rage and cynicism, he seems to be improvising the brilliant retorts he intersperses with more laconic and desperate thoughts. Pialat, a friend of Dutronc's for many years, has long wanted to work with him (initially, he had thought of him for the title role in *Loulou*). He made the most of the actor's dramatic potential and proves what he said: "In my

Jacques Dutronc in Maurice Pialat's *Van Gogh*. 1991

opinion, Dutronc is not someone who should be struck, but someone who should strike . . . He is not the closed-off, introverted actor everyone thinks he is. He is capable of bursting forth and doing extraordinary things."[1]

The absence of a score points up the silences and noises of a meticulously crafted soundtrack, and Arthur Honegger's cantata played over the final credits has all the more impact because it extends the final line spoken by Dr. Gachet's daughter, "He was my friend." Simple confidence makes a deeply moving conclusion.

1. *Positif*, no. 235 (October 1980).

No. 369, November 1991

Van Gogh. 1991. France. Written and directed by Maurice Pialat. Produced by Daniel Toscan du Plantier. Cinematography by Emmanuel Machuel, Gilles Henri, and Jacques Loiseleux. With Jacques Dutronc (Vincent van Gogh), Alexandra London (Marguerite Gachet), Gérard Séty (Dr. Gachet), Bernard Le Coq (Theo van Gogh), Corinne Bourdon (Jo), and Elsa Zylberstein (Cathy). In French. 155 min.

Unlike other navel-gazing "Nouvelles Vagues," the young Taiwanese film-makers of the early 1980s—Hou Hsiao-hsien, Chen Kun-hu, and Edward Yang—depict current society from the perspective of common historical experience. In *A Brighter Summer Day (Gulingje shaonian sharen shijian)*, Yang's point of reference is a 1960 news item from his own youth, the first crime committed by a minor.

The film is primarily a story about gangs, a micro-cosm of civil war and war be-tween nations, and is marked by extreme violence in spite of the age of the protago-nists (fourteen to twenty-five years old). There is civil war

A Brighter Summer Day
Thomas Bourguignon

Edward Yang, after Hou Hsiao-hsien and before Tsai Ming-liang, was the second major discovery among the young Taiwanese filmmakers.

because the various sides belong to well-defined social classes (e.g., civil servants, soldiers), and war between nations, in which the continental Chinese who arrived in 1949 with Chiang Kai-shek's troops consider the native Taiwanese enemies. Starting from these sociological and historical data (teenage crime, a night of massacre wor-thy of Mafia gangland killings), the filmmaker uses symbolism to mythologize the protagonists: Shandong, traitor and leader of gang 217, who shoves Honey under a car; Ming, femme fatale who seduces all the men and triggers a battle of gang lead-ers (Honey killed the former leader of the 217 for her); Honey, the legendary twenty-year-old ex-leader, tired from too many battles, who returns to attempt to make peace and die.

Yang also focuses on a typical family, a micro-society that allows him to reflect on the contradictions and aspirations of individuals, less a function of nationality and class (as in the gangs) than of age and sex. The family Yang depicts is splintered: the father, an educated Mandarin unable to find a place in the strongly American-ized society, a man who constantly harbors the impossible dream of returning to the mainland; the mother, who is emancipated and has adjusted completely to a mar-ket-based society, a woman who has lost all capacity for affection for either husband or children; the other sister, a Protestant in a family where the other members prac-tice no religion; the two brothers who follow diametrically opposite paths, the elder, Lao Er, a delinquent who mends his ways (to protect his younger brother, he allows himself to be punished in his stead), and Xiao Si'r, the main character of the film, who wallows in crime.

Si'r reflects the various people around him who distort his thirst for justice and truth. In the opening scene, while spying on a movie crew working in a studio, he is shown as a voyeur. This impression is strengthened by his taste for cinema, his dreamlike passage through a group of bloody corpses (following the massacre), and his complete passivity, perched on a wall, watching his brother brutally punished for something he himself did.

He is an observer who hides in the shadows. After the injustice at school and the night of the typhoon—a metaphor for the unleashing of mysterious forces that man is unable to resist—where he suffers the horrifying experience of evil, crime, and death, his destiny appears sealed. He aspired only to the true (he criticizes the filmmaker for confusing "natural" and "true") and the just (he rebels against his punishment), but because violence and duplicity triumph, he embraces them, steals his mother's watch, allows his brother to be punished in his place, and kills the woman he cannot have.

The filmmaker has created a polyphonic tale in which the central themes of truth and evil are brought to life in the hero and reflected in the two father figures: his father and Honey. Zhang Ju, the father, is at the outset a model of virtue. Because he comes from China, where he was a Mandarin, he is as naive and innocent as his son about the real workings of Taiwanese society. Like his son, he experiences injustice during a highly mysterious interrogation; like Si'r, he is betrayed by his best friend; again like Si'r, he becomes unjust (in a drunken stupor, he hits his older son for no reason) and no longer believes what he sees with his own eyes. Si'r considers Ming a whore; his paranoid father thinks a thief has entered the house. His utopian dream of returning to China, an echo of the impossibility of his son ever changing Ming's heart, leads him to despair.

Whereas the father is an accurate reflection of Si'r's tragedy, Honey, the park gang leader, is Si'r's dark out-of-sync twin who has already tasted desolation and for whom "a calm despair . . . is the essence of wisdom" (Alfred de Vigny). He tries twice to protect Si'r, as if he recognizes in him his still-innocent twin. Nonetheless, Si'r follows in the footsteps of Honey, who dreams of changing the world, although the cynical Ming rejects his dream. Si'r became a criminal by killing the leader of another gang, again because of Ming. At the same time, he wants to change people—Jade and Ming—but cannot. He also becomes a murderer because of Ming and, while killing her, whispers, "You drive me to despair, you drive me to despair." While Honey is based on a character in Leo Tolstoy's *War and Peace* who wanted to kill Napoleon to change the course of history, the crime scene is reminiscent of Tolstoy's short story "Kreytserova Sonata": "Having plunged the dagger in I pulled it out immediately, trying to remedy what had been done and to stop it." The impossibility of changing history or the heart of man illustrates, at both the social and individual levels, the director's deep pessimism.

As in Fyodor Dostoyevsky's *The Brothers Karamazov*, it is a female figure who polarizes the desires of men. Grouchenka and Ming are both angel and devil. They move from one man to another, incite to crime, set brothers and friends against one another. Paradoxically, they are gentle and beautiful, simple and intelligent, loving and devoted. Their power of fascination is in fact a by-product of their purity, and the fights between the brothers the product of the desire for possession that drives men. For Dostoyevsky as for Yang, a woman is capable of giving herself fully, the incarnation of love, while man loses his way in intellectual reconstructions of the world and gets lost in the maze of his own thoughts. In Russian novels, the woman saves the man from himself, his ideas, pride, and spiritual suicide (in the *Brothers Karamozov*, Grouchenka saves Mitia; in Dostoyevsky's *Crime and Punishment*, Sonia revives Raskolnikov's hope). The Taiwanese filmmaker is more pessimistic: Si'r cannot see the purity of Ming's heart or live in the real world. He stabs love and the whole world in a single gesture of despairing pride.

The story line of *A Brighter Summer Day's* is extremely complex, with the director deploying a subtle network of parallel plots as background to Si'r's tragedy. Ellipsis, a key feature of Taiwanese cinema, is seen here at its most perfect. With skillful editing, the filmmaker weaves together dramatically heterogeneous events linked on a deeper level by an underlying theme. Thus Si'r is there when Shandong dies; the police come to get his father. The viewer thinks the events are dramatically linked, that the police are going to question Zhang Ju about his son, but they are merely there to ask him about his relationship with the Communists. The link between

Lisa Yang and Zhang Zhen in Edward Yang's *A Brighter Summer Day*. 1992

the two scenes, the night of the typhoon during which both father and son experience evil and injustice, marks them forever. The story's message concerns movement of the soul rather than action.

Yang built his film on a dialectic of obliteration and revelation, in both the elliptical story and the production design. The images, framed by doorways, windows, and shadows, represent the fragmentary nature of knowledge. Through symbolism, light becomes the quest for truth in the shadows. In China there is a saying that light is knowledge. The opening credits include a close-up of a lightbulb going out, suggesting the inevitability of failure. The flashlight stolen by Si'r is a kind of eye that tracks truth through the pitch-black night and represents the hero's unquenchable desire to understand the world. However, it gives him only a fleeting and partial glimpse of people and things, slivers of reality plucked from the darkness and incapable of reconstituting truth. In fact the truth remains hidden until Jade's final revelation. Even if Si'r had seen Ming in a compromising position, he would not have recognized her. Even if he had illuminated Shandong's death, he would have had no answer to his question concerning Honey's "accident." The recurrence of lights turned on and off, and the passage from night to day, suggest the uncertainty of victory in the ongoing combat between truth and lies. By refusing to live in the world as it is, Si'r denies knowledge. His first act of rebellion is to hit his supervisor, and the baseball bat causes a lightbulb to explode. He trades his flashlight for a dagger and murders Ming (which means "light" in Chinese). Si'r's descent into the very heart of darkness begins on the night of the typhoon. At the same time his father, beneath a swinging lightbulb during his interrogation, is devoured by fantastic shadows that reveal an inner conflict between doubt and hope.

The film closes with purposely trivial images: light has lost the battle, the soundtrack takes over the meaning. "Are You Lonesome Tonight?"—the Elvis Presley song that is the source of the film's Taiwanese title—and the list of students who have passed their exams serve as an optimistic counterpoint to the images of prison and the mother drying her murderer son's shirt. Like human life at all levels, in the cosmic plan a dark era is followed by a luminous, pure, regenerated era. After Si'r is expelled from school, the shopkeeper tells him and his father that they shouldn't be so downhearted because the sun will come up tomorrow. The symbolism of these words is clear: since man has no power over light, admission of defeat is the only possible philosophy. Si'r, his father, and Honey despair because they thought they could change the heart of man. But, in the words of Charles Baudelaire, "The shape of a city changes more quickly, alas! than the heart of a mortal."

No. 375 376, November 1992

A Brighter Summer Day (Gulingje shaonian sharen shijian). 1992. Taiwan. Directed by Edward Yang. Written by Yang, Yan Hongya, Yang Shunqing, and Lai Mingtang. Produced by Yu Weiyan. Cinematography by Zhang Huigong and Li Longyu. Music by Zhang Hongdu. With Zhang Guozhu (Zhang Ju), Elaine Jin (Tan Zhigang), Zhang Zhen (Xiao S'ir), Zhang Han (Lao Er), Wang Juan (Juan), and Lisa Yang (Ming). In Taiwanese. 185 min.

How is it possible to espouse simultaneously the primacy of reason and to depict the desire to live and love and the mystery of creation? Jane Campion holds that man believes himself to be a creature of reason, although he is not; he is governed by something else altogether.[1] In film after film, with ever-increasing depth and intensity, this filmmaker invites us to contemplate human beings lost in the sleep of reason. In *The Piano*, the heroine says she is afraid of her will that she describes as "so strange and so strong" but, far from being a free and conscious judge, her will suggests the unconscious and the desire to live. Drawing on the poetic

The Piano
Thomas Bourguignon

Alongside Peter Weir, George Miller, Rolf de Heer, and Alison Maclean, Jane Campion makes a very strong case for Down Under Cinema. With three covers in a row for her first three films—*Sweetie*, *An Angel at My Table*, and *The Piano*—the first director to be so honored since Andrzej Wajda in the 1950s—*Positif* could do no more to pay tribute to the magazine's belief that her films were very important.

anthropology of female artists, Campion weaves a web of secret correspondence between art and life, with the portrait of this third woman the most sublime. Midway between the romanticism of *Wuthering Heights* and fairy tales in the manner of *Bluebeard*, *The Piano* is a marvel of calm and violence, refinement and crudeness, passion and reserve.

THE FAT LADY, THE REDHEAD, AND THE MUTE

The New Zealand director projects three different facets of the artist's persona: the child star of show business (*Sweetie*), the writer Janet Frame (*An Angel at My Table*), and the pianist, Ada. Each of these women is physically different: Sweetie is fat, Janet is a redhead, and Ada is mute. They also stand out because of the sensitivity that lets their imaginations run free and create mental images. In an English class, Janet sees Excalibur rising from the lake; Ada's daughter, Flora, imagines a cartoon of her father bursting into flames. Each dramatic event shakes them to their very core, endangering a fragile psychological balance. This overactive receptiveness takes them to the limits of reason. Their behavior is often perceived as insane: Sweetie starts to bark; Janet is considered (wrongly) for years to be schizophrenic; and Ada's husband, Stewart, wonders whether she is "brain affected."

Because of their condemnation by others, Campion's artists suffer all the temptations of despair, from ostracism to voluntary seclusion. The opening shots of *The Piano* are framed by Ada's fingers and saturated in red. They express the filmmaker's desire to place the viewer at the very heart of the individual, within the purple membrane that is a metaphor for the soul, at the same time showing the heroine's fear and confinement. She hides her face and refuses to reveal herself through speech. The same image occurs in *An Angel at My Table*, with Janet in a train passing the asylum and looking at it through her fingers. Sweetie, betrayed by her father, takes refuge in a tree; she is naked and painted black, in imitation of Aboriginal funeral rites; Janet, rejected by the living, often takes refuge in a cemetery; Ada locks herself in the silence of a tomb. This interior prison has its counterpart in an exterior wall raised by the men who put Janet in an asylum; similarly, Stewart keeps his wife a prisoner in her room.

THEATER OF SHADOWS

Campion makes films that deal with the pain of being in the world but not of the world. She reveals the interior life of these tormented and fragile beings in which the line dividing external and internal is both infinitely large and infinitely small, and real life and spiritual life are abolished. *Bluebeard* encapsulates this journey to life through art and anticipates the future drama. Stewart is a kind of Henry VIII figure who plans to expand his kingdom (he attempts to take Maori land and exchanges his wife—via the piano—for land) like the monarch who won Wales, Scotland, and Ireland for England. He finally locks Ada up and comes close to decapitating her. As Anne Boleyn had an extra finger, Ada becomes a "freak," like her predecessor, with her silver index finger.

This fantastic current, in which life is reflected in art, which in turn overwhelms existence, turns the protagonists into shadows, spirits, specters. The silhouette of a phantom governess appears behind a glass partition just prior to Ada's departure for Stewart's home; Ada herself appears as a shadow figure behind an immaculate sheet when she asks her daughter to bring her lover a piano key. In each cut of the film, fate appears as a shadow, in the tragic theater of life.

WOMAN AS PIANO

This perception of life transcended by art is expressed in communication that eschews words and goes beyond rationality, honing in on the recipient's innermost being. As Ada says, "I could lay thoughts out in his mind like they were a sheet." A listener describes her music as "like a mood that passes into you." Conversely, normal people are all afflicted with a deficient sense, a metaphor for an inability to fully grasp another person, or indeed the world: Stewart does not understand the Maori and is insensitive to music; Baines, a Maori, is illitcrate; the piano tuner is blind. Ada's non-discursive communication is emotional and physical (looks, gestures, caresses, telepathy, odors). When she sleepwalks, her passion and revolt are directly expressed on her instrument.

This purely sensitive, sensual, and sentimental communication is carried out primarily through the piano, which becomes Ada's metonym. With the exception of the prologue and the epilogue, "voices off" are those of the instrument. It becomes a substitute for her body, even bearing her odor, as noted by the tuner. These Baudelarian connections make the piano the pretext and the instrument of seduction. It is the stake in the romantic bargaining. Ada unconsciously plays romantic pieces that bewitch Baines and express her love for him more surely than she would wish. On one occasion only she bangs out a few furious chords that drive him back when he becomes too eager. His love is facilitated by the gift from Broadwood, who cancels a contract that made her a "whore" and him "wretched." His gesture saves them and frees Ada's passion. The piano becomes inextricably involved in this love story, and loses a key as Ada loses a finger. Later the absent piano is replaced by a table with a keyboard carved into it just as the body of Stewart, over which Ada runs her fingers, is a substitute for Baines.

LIKE WEATHER THAT GOES RIGHT THROUGH YOU

Although Campion is a filmmaker who delves into the very depths of the individual, her style is not at all abstract. On the contrary, it shows reality at its most concrete, through bodies, landscapes, and elements that reflect the protagonist's inner

Holly Hunter and Anna Paquin in Jane Campion's *The Piano*. 1993

feelings. Ada's body is the primary object of the purely romantic passion of Baines, who discovers and adores every inch of it, from the toe of her boot to a glimpse of skin seen through a run in her stocking.

The branching tattoos of the Maoris evoke the veins of leaves, stylized ferns, and set man in the vegetable kingdom. Campion paints human beings whose sexual urges remain buried in an occult-ridden and terrifying subconscious (with the forest the symbol), and the lines on Baines's face mark him as a tropical animal. Although Flora is still a child, she imitates the young Maoris who rub themselves against the trunks of trees in imitation of the sex act. Stewart punishes her, saying that she has "shamed the trunks" of the trees. His attitude is extremely illuminating, as all his sexual forays end in failure: he fails to rape Ada in the prickly underbrush; a dream follow shot, through the same underbrush, leads the viewer to his second unsuccessful attempt, while his wife is asleep. The places where the two men live are poles apart. Baines lives at the heart of a virgin forest, while Stewart burned down all the trees surrounding his house, and the scorched clearing is every bit as dead as his sterile and perverse sexuality (the Maoris call him "dry balls"; he becomes a Peeping Tom when his wife is unfaithful). His house seems to float on a very real lake of mud, a metaphor for human beings mired in the impossible sublimation of their instincts.

CUPID'S ZEAL

The relationship between Ada and her daughter is extremely complex and —through Flora— reveals a glimpse of an artist fulfilled and open to the world. Their relationship finds a grotesque echo in Morag and Nessie, vulgar, scandal-mongering old biddies, with the daughter parroting the mother. Flora is a Cupid who loses her way because her zeal, making her prefer the husband to the lover, leads to complications and then by a circuitous route, allows Love to triumph. The girl is depicted primarily as a messenger, who travels by various methods (pony, roller skates, etc.). She is also a member of the choir of angels in a play. She is wearing her angel's wings, which she refuses to take off when she finds her mother and saves her from rape in the forest. As Cupid, sent by Ada to carry a message to Baines, she hesitates. After a few steps along the path of Love, she turns back and opts for the conventional. The messenger's voyage is a marvel of staging, alternating low-angle shots in which she seems to fly with shots in which, as a minute silhouette glimpsed at the top of a hillock, she slides and climbs to the next summit. The second message substitutes an index finger for the piano key, and the accompanying threat (one finger per visit) is a devilish reminder of the love bargain struck by Baines, who obtained one black key per visit. Cupid becomes an avenging angel in the cause of Love, and her wings floating in the water represent consummation.

Two idealistic shots give the point of view of the angels who watch over Ada's voyage: the small boat that cleaves a limpid, turquoise sea, and the camera that flies over the deep green forest. These disembodied views are the exact opposite of the observations of men in their peregrinations. A foreground shot shows the raging ocean, with gray and foaming waves; in the middle distance, we see the footprints of travelers in the mud. Only the heroine's viewpoint matches that of the angel when she looks at the forest, after Baines gives her the piano and she realizes her love for him. A zoom shot of her hair fades into a dolly shot zigzagging through the woods. In fact Ada has three personalities, depending on the perspective of the character considering her. As soon as she disembarks, all possible outcomes are on the table:

the Maoris find her "pale like angels," Stewart sees her as a piece of livestock and finds her "very small, stunted," while Baines looks at her with compassion and states that she appears "tired." Just after amputating her finger, her husband realizes she is an angel and says, "I clipped your wing, that's all." Following this assault, Ada falls into the mud and seems to sink to the hips, like a fallen angel.

The structure of the perfectly balanced story in *The Piano* is made up of mirror images. The hands of the Western sailors who attract Ada to the depths of the sea and the mud on her arrival are echoed by the arms of the Maoris who drag her from oblivion toward a blue sky in jerky slow motion, weightlessly like a rebirth at the core of an angelic people. As Janet Frame, on completing her autobiography and inviting us to hush and listen to the wind, like the enterrement where Sweetie's life flows into the sap of a huge tree, the final images of *The Piano* are a dream of returning to cosmic harmony, where the heroine sees herself floating in the azure waters of the ocean, where "there is a silence where no sound may be—in the cold grave, under the deep, deep sea."

1. *Positif* , no. 347 (January 1990).

No. 387, May 1993

The Piano. 1993. Australia. Written and directed by Jane Campion. Produced by Jan Chapman. Cinematography by Stuart Dryburgh. Music by Michael Nyman. With Holly Hunter (Ada), Harvey Keitel (Baines), Sam Neill (Stewart), Anna Paquin (Flora), and Kerry Walker (Aunt Morag). 120 min.

Seemingly very different from one another in tone, theme, and structure, Krzysztof Kieslowski's trilogy *Three Colors: Blue, White, Red* (*Trois Couleurs: Bleu, Blanc, Rouge*) looks at contemporary Europe and its lack of guideposts and emotional security, where each individual, alone with his passions, strives to seal the ever-widening gaps as best he can. The three films have no character continuity or common architecture. There are fleeting similarities but no order, either linear or dramatic. There is, however, a common return to

Immersed in Passion: *Three Colors: Blue, White, Red*

Vincent Amiel

While this article by Vincent Amiel—the author of a monograph on Krzysztof Kieslowski—is devoted to his final film, the Polish filmmaker was to be found in the pages of *Positif* as early as the 1980s. He was interviewed and articles appeared about him ten years before he gained international recognition with *Thou Shalt Not Kill*, which was presented at the Cannes Festival.

the earth, to the place of birth, the matrix, and a gradual shift from blue to red, from the most open of worlds to the most powerful feelings.

PROTECTIVE UNITY

The same is true of each individual film and the set they form. All the characters are casualties striving to reach more solid ground, one step at a time. In the first part of *Blue*, the breach is at its maximum, disorder unlimited; the electronics, the video, the cold reflection of the images are reminiscent of Kieslowski's *The Ten Commandments* (*Dekalog*). The glass beads on the blue chandelier symbolize this world of projecting facets that shed light on an infinity of unpredictable and changing traits. Embracing solitude solves nothing: neither breakup nor death erases memory. The modern world's impersonality and freedom of behavior do not destroy passion. Julie has to find herself in a familiar space, and envision a relationship with another person that recenters her, in which she can finally *see herself* with the other—following the example of the other characters, building their intimate relationships on screens (ultrasound, peep show, television).

In *White*, Karol returns to his homeland and to his landmarks to gain control over a passion that exile essentially forbade him. The final shot shows a radical way of taming this misery: seal it off. It is not seen on ultrasound or through a window, but is framed by a prison window. This is another way of using sight to acquire an object of love. Moving directly to the final sequence of *Red* for another example of random manipulation, the female character appears on a television screen and is seen by her partner. A glass, a window, a screen—all frames that mark mastery and possession, albeit through an intermediary. A "reframing" is essential if one is to forget that all the ruptures expose the individual to the danger of the world to which passion leads.

This movement can be seen in each individual film and also moving from *Blue* to *Red*, like a sort of broad retreat. *Blue* describes a world of international communications, screens opening to the universal through music, an adventurous and risk-taking world where losing oneself seems almost normal. Even the memory of a mother is no longer an anchor. Only the blue of the multiple screens covers each individual's life. *White* has no universal stranger: two defined countries, familiar rituals (marriage, trial), death close up, shock and physical displacement. Public spaces exist to

Irene Jacob and Jean-Louis Trintignant in Krzysztof Kieslowski's *Red*. 1994.

make one forget private passions: economic and social progress take the place of a moment of accomplishment. But the ultimate aim, from the very beginning, is intimate possession. Although *White*, like *A Short Film About Love* (*Brève Histoire d'amour*), deals with conquering society, it is not the goal of the film. In *Red*, the ultimate running to ground, everything plays out on a single street corner, a single neighborhood, a well-defined area of sensitivity. From the opening shots, the labyrinth of telephone signals proves non-operational: the line is busy, the outside world no more than a hypothesis. The judge's house, linked to the entire neighborhood as the result of his pirating operations, becomes the crucible in which the stories of yesterday and today come together. With its warm light, the house evokes serenity and flatly refuses to allow emotions to be dispersed and lost. It is a site of crimson withdrawal, the importance of which can only be clearly understood in relation to the other two films, exposed by snow, ice, and water to the silence of infinite space. The path toward the other, the object of passion, in each instance becomes an abhorred exile whose only consolation is introspection.

It is as if the expanding reflections of *Blue* become, in *Red*, converging rays, to achieve a unity that is a sequel to the duality of *White* and the multiplicity of *Blue*.

A SERIES OF POSSIBILITIES

Unity of space, unity of time: chronology and linear progression are shot down in flames; even time turns in on itself. Kieslowski explains that he wanted to tell stories simultaneously that could (or should?) be simply two episodes with a single story line. Instead of a single character depicted at thirty years of age and then at sixty, a thirty-year-old and a sixty-year-old meet on the same day, several times over, protagonists of what could be a common story. By the end of *Blue*, through the similarity of different faces, one can feel a common thread linking the muddled memory of the mother, the maternal feelings of the young woman, and Julie's heartbreaking tragedy, a comforting convergence of time and eras. There are all these characters glimpsed from one film to another, repeated situations, similar gestures. Throughout the trilogy, indeed in many other films such as *The Double Life of Véronique* (*La Double Vie de Veronique*), which withdraws into itself, there is magnificent coherence in the range of possibilities, reflected in each face: a profound refusal of necessity, of logical, and of linear articulation. It is not random abandonment, as has often been said, but a true culture of the potential. Probable states are not simply becoming, not merely predictable hypotheses; they are occurring here and now. That is the puzzling mystery of the two Véroniques: these lives that speak to each other but do not coincide. It is also undoubtedly the sense of Julie's gesture of moving her husband's mistress into her country house so that the mistress's child can experience what Julie's own daughter has. It is also the two crossings of the English Channel. History does not stutter in Kieslowski films: words and signs simply fall, unordered by any sentence.

This is the source of the primary impression of a free structural design uniting the three films. The very issue of progress is questioned by the organization of the various elements. Correspondences and reflections pull at the multiplicity of threads and deny the very principle of cinema. Linearity, chronological editing, dramatic necessity, all fade away, and in their wake come constant surprise and shifting significance. *The Ten Commandments* skewed the imposed frame, but no one confronted the paradox. Here, although the frame provides a reference point, it is only an illusion. As in a painting by Jan Vermeer, the most minor character is every bit as complex

as the lead and, because the scope of each element is always shrinking, analysis is extremely difficult. Gradual shrinking of the field of view makes *Red* the final destination. Focusing the fire adds to the density, but simplifies nothing because of the ever-expanding potential outcomes.

No. 402, September 1994

Blue (Bleu). 1993. France/Poland/Switzerland. Directed by Krzysztof Kieslowski. Screenplay by Kieslowski and Krzysztof Piesicwicz. Produced by Marin Karmitz. Cinematography by Slawomir Idziak. Film editing by Jacques Witta. Music by Zbigniew Preisner. With Juliette Binoche (Julie), Benoit Régent (Olivier), Florence Pernel (Sandrine), Charlotte Véry (Lucille), and Hélène Vincent (Journalist). In French. 98 min.

*White (*Blanc). 1994. France/Poland/Switzerland. Directed by Krzysztof Kieslowski. Screenplay by Kieslowski and Krzysztof Piesicwicz. Produced by Marin Karmitz. Cinematography by Edward Klosinski. Film editing by Urszula Lesiak. Music by Zbigniew Preisner. With Zbigniew Zamachowski (Karol Karol), Julie Delpy (Dominique), Janusz Gajos (Mikolaj), Jerzy Stuhr (Jurek), Grzegorz Warchol (Elegant Man), and Jerzy Nowak (Peasant). In French. 92 min.

*Red (*Rouge). 1994. France/Poland/Switzerland. Directed by Krzysztof Kieslowski. Screenplay by Kieslowski and Krzysztof Piesicwicz. Produced by Marin Karmitz and Gerard Ruey. Cinematography by Piotr Sobocinski. Film editing by Jacques Witta. Music by Zbigniew Preisner. With Irene Jacob (Valentine), Jean-Louis Trintignant (Judge), Frederique Feder (Karin), Jean-Pierre Lorit (Auguste), and Samuel Lebihan (Photographer). In French. 95 min.

A s the twentieth century comes to a close, the more "popular culture" likes to look back at the most ludicrous aspects of its past. A subtle mixture of nostalgia, affection, and ironic disdain feeds this cult of what is passé; the worship of junk films of the 1950s (among many other sources of perverse delight) provides a rich source of deliciously silly icons. The spirit of "camp," long the privilege of the marginal elite, has sufficiently penetrated the mainstream to make a project like *Ed Wood* vi-

Ed Wood: Unshielded Innocence

Jean-Pierre Coursodon

able. Certainly such a project was unthinkable a few years ago. (Tim Burton had problems getting it accepted, not because there was a lack of en-

From the beginning, *Positif* took a liking to Tim Burton's universe, in which imagination plays an essential role. The magazine's Surrealist leanings tended to make him one of its favorite filmmakers.

thusiasm for the subject but because the Disney executives wanted to retain the services of Burton as a proven director of mega-hits; the executives finally gave the project the green light).

The curious posthumous notoriety of Edward D. Wood, Jr. (who died in poverty in 1978 at the age of fifty-six) is due in large part to a book by Harry and Michael Medved titled *The Golden Turkey Awards: Nominees and Winners, the Worst Achievements in Hollywood History*, published in 1980, which was a list of the worst films ever made (in the opinion of the authors). The mere existence of such a work is symptomatic of a particular state of mind. Wood's films were well represented, and the unfortunate director was even awarded the title of "worst director ever"—a derogatory label which, by a strange twist of fate (but then everything in Wood's life seems to be ironic in just this way), eventually gained him a sort of fame, the Burton film being the obvious apotheosis.

Acknowledging an artist for lack of talent seems a paradox, if not a contradiction in terms. Being designated as "the worst" could only rescue Wood from the anonymity of the mediocrity which had originally earned him the distinction. Burton, who refuses to apply this demeaning label to his hero (for him, the concepts of "good" and "bad" do not apply to Wood's films; rather, they achieve a sort of involuntary poetry: Arthur Rimbaud's approach—see the third paragraph of *L'Alchimie du verbe*—is the most generous and probably the only defensible approach for a film like his), really meant it when he said that Wood must be *very* special to justify such an absolute superlative. To begin with the most obvious, one can at least say that no other male director is known to have directed his films while dressed as a woman.

Even though the idea for the film did not originate with Burton (it was brought to him by director Michael Lehmann, having been submitted by screenwriters Scott Alexander and Larry Karaszewski), it is clear that he was attracted to the character of Wood, whose films he already knew. Also evident are the affinities with Burton's other protagonists, notably Edward Scissorhands. The two Edwards (both played by Johnny Depp, excellent in both roles) are two quite different people, full of a creative energy that manifests itself through the dichotomies of the character: scissorhands for one, transvestite tendencies for the other (in one indicative scene, Wood, after a confrontation with his producers, who disagree with his decisions, repairs in high dudgeon to a dressing room and, to calm himself, puts on a dress and his famous angora sweater, applies makeup, and places a blonde wig on his head;

thus transformed he returns to the set and imposes his will on the flabbergasted producers. Like Antæus in contact with the earth, he seems to regain his strength by contact with the angora).[1]

Burton's Ed Wood[2] is an innocent blessed with eternal optimism, who obstinately refuses to allow himself to be affected by adversity, hard knocks, or lack of understanding in a hostile world. His main quality (which also causes his downfall) is absolute self-confidence (he never lets go of it, except briefly in a single scene at the beginning, when he ruminates that, by his age, Orson Welles had already directed *Citizen Kane*).

When a producer phones to say that his *Glen or Glenda?* is the worst film he has ever seen, Wood's perpetual smile barely changes, and he replies without batting an eye, "The next one will be better!" If, while shooting, the first take is always good (to him at least), it is not just that he can't afford more, but also and above all that he truly believes in the perfection of what he has filmed ("perfect" is one of his favorite expressions). One must see how he loves his characters, silently reciting with them the dialogue he has written; he has no sense of self-criticism, since for him the magic of the cinema works without fail from the moment he yells "Action!" by the simple presence of a camera with actors (it doesn't matter what actors!). When one of his characters, a gigantic wrestler, bangs into the scenery while trying to exit through a door and the chief cameraman suggests another take, Ed asserts that the first take was more realistic and therefore more convincing: "In the real world, Tor [the name of the wrestler] could have this problem anytime." The criticisms do not seem to affect him. When a writer demolishes one of his films (he had already sent a reviewer, the only representative of the press, into a dreadful theater, almost empty and with water dripping down), Ed reassures his friends: "Look at the bright side; he says that the soldiers' uniforms are very realistic."[3]

Perversely and infinitely naive, Wood retained the essence of childhood, a sense of play, taking pleasure in inventing and telling stories that could only attract Burton. It seems that Wood also exercised real powers of seduction over those around him, which explains the faithfulness of this peculiar and eclectic team: a star fallen on evil days, alcoholic and drug-addicted; an operetta magus whose every "prediction" turns out wrong (it is he who recites the memorable introductory text to *Plan 9 from Outer Space*, faithfully repeated in the opening of Burton's film), a "pre-operation" transsexual (Wood's first film is probably the origin of the story of Christine Jorgensen) whose fantasy was never realized; a neophyte actress (Wood hired her hoping that she would finance his film only to learn that she has only three hundred dollars and *no* cash), not to mention the formidable Swedish wrestler, Tor Johnson (his name is at the top of the credits for *Plan 9*; In *Bride of the Monster* he is Lobo, the mute assistant of the *idiot savant* embodied by Bela Lugosi), a color-blind director of photography and, last but not least, Dolores Fuller, star of her husband's first two films, before being replaced by Loretta King, the penniless patron, in *Bride*. Martin Landau recently said of Dolores: "She is probably the worst actress I have ever seen." This statement shows that anything about Wood always elicits superlatives.

A little later, a local mini-celebrity, Vampira, joins the group, which marches to the beat of a different drummer. She is a bit of a special case, since she already had her own entourage (Burton shows us a fascinated Wood trying to recruit her; she dismisses him with supreme disdain). Vampira, who became the face of the famous character in Charles Addams's drawings, hosted old horror films on a local televi-

sion channel, where she provided sardonic commentary with a lot of double-entendres. At the time, she epitomized one of the first media manifestations of "camp," which much later resulted in the belated glory of Ed Wood, who also seems, in his innocence, to have been completely unaware of the movement. In one scene of *Ed Wood*, he watches a classic of the genre with Bela Lugosi (Victor Halperin's *White Zombie*, 1932, whose junk-film style is "Woodian" even before the term was invented) and is annoyed by mocking comments from Vampira. Only after losing her job on television does she agree to join Wood's troupe (she appears in *Plan 9*).

Burton discusses the "strange naiveté" of this group who "seemed to live in a parallel universe" (he also compares them to the "Magnificent Seven"). He asserts that they influenced him profoundly when he was a child and, when seeing the film, one cannot doubt his affection or respect for their serious intent, their implementation, the apparently complete lack of awareness of their mediocrity and outlandishness (only Dolores suffers when describing what she considers to be a freak show: she finishes, in the Burtonian way of things, by leaving Ed shouting: "I need to get a normal life").

Since Wood's cinematographic work is completely unknown in France (except for hearsay, which can only add to the exotic charm of Burton's film), it will doubtless be helpful for French audiences to understand that the films re-created by Burton have been very faithful to the originals. This extends, to some extent, to the overall visual style of the film, which tends to mimic the ultra-cheap look of the Z movies of the era—mimicry, sometimes perverse, but necessary, and sometimes incomplete (a shot in a bar would have been improved by cinematographers Nicholas Musuraca or John Alton; the scene of the calamitous "world premiere" of *Bride of the Monster*, in a horrible little suburban movie house full of noisy teenagers throwing tons of popcorn at one another, is treated in almost slapstick fashion, with unreal irony completely turning its back on the solemn platitudes of the reference works).

Ed Wood is nevertheless one of the most convincing evocations of the old Hollywood, perhaps (paradoxically) because the re-created universe is so marginal, lacking so much of the traditional Hollywood glamour. The scenes from Wood's films "cited" by Burton are almost always shown during the shooting process, which reminds us that these strange and pitiful artifacts like *Plan 9* or *Bride of the Monster* are not completely "found art" but were really written and produced, filmed on a stage with a crew, at a real point in time now gone forever, though caught permanently on film.

But, at the same time, the fact that these pictures, which have become derisively "classic," were reproduced causes the audience some difficulty and discomfort (which also, for me at least, contributes to the charm of the film rather than compromising it). Is there not something a bit sacrilegious in wanting to revive in fiction a unique creative act (however modest it might have been) which, by definition, speaks for itself?[4] Is this not, in a sense, disturbing the graves of the old films? And what about the unsettled status of these living dead? (The fact that the extraterrestrials of *Plan 9* are grave robbers—the original title for the film was *Grave Robbers from Outer Space*—has emboldened me to slip in this metaphor.) Also, the meticulous fidelity to sources mentioned above does not prevent some variations, inevitable in any "historical reconstruction," between the evoked past and the present context (a historical film always bears more resemblance to the era when it was actually made than to that which it pretends to re-create). In *Ed Wood*, every reverse-angle shot of the film crew at work doubly underlines this discrepancy.

Coming back to less theoretical considerations, it must be said that the film owes much of its appeal to the quality of the relationship that Burton established with his actors, an echo—with talent added—of what Wood himself had established with his. The mimicry referred to above is not limited to the style of camera work, but includes the acting, more often trying for fidelity than simple parody (parody would, in fact, be redundant since Wood's films are their own parody). Thus it is that the combined talents of the actress (Sarah Jessica Parker), the makeup artist, and the cameraman reconstitute before our eyes the immortal Dolores Fuller—including the horsey face. Jeffrey Jones, as the tragic magus Criswell, seems to be the twin brother of his model, and one can say the same for George "The Animal" Steele, who incarnates Tor the wrestler, or Lisa Marie who, as they say, *is* Vampira.

Martin Landau's Bela Lugosi reaches the pinnacle of a career which, between Alfred Hitchcock (*North by Northwest*) and Woody Allen (*Crimes and Misdemeanors*), has known more downs than ups. As well as being a film biography of Ed Wood (the scope is limited to his brief "golden age"—if one can call it that—from 1953 to 1959), the film is a chronicle of the last years of the fallen star and his surprising relationship with the young director. If *Plan 9* deserves to be seen for any reason other than a dubious taste for old-fashioned kitsch, it is really for its moving scenes of a zombielike Lugosi leaving his modest house and smelling a rose before disappearing. Burton remakes these respectfully and weaves variations around the Wood-Lugosi collaboration, which is also a curious friendship, variations which are likely imaginary, but are plausible when taken together as well as touching (the notion of plausibility also has little relevance in the extraordinary universe where all of this takes place). All the more so because they take place in the shadow of death (the first meeting between the two men occurs in a funeral parlor where Lugosi, probably sensing that his own end is near, "tries out" a coffin; next, Wood saves him *in extremis* from suicide by overdose; and Lugosi dies on the second day of filming *Plan 9*).

Burton and the scriptwriters have conceived—why not?—an encounter between Wood and Welles, one filming *Plan 9*, the other *Touch of Evil*. This collision between the best and worst of American cinema of the 1950s excites the imagination (but at that time in Hollywood, wasn't Welles as marginal as Wood? Do not forget that, in spite of its stars, *Touch of Evil* was released and handled in the US as a crude B movie). The two filmmakers have problems with their producers. Welles (acted in most acceptable fashion by Vincent D'Onofrio) galvanizes Wood by confiding: "Dreams are worth fighting for." Wood had his dream, grotesque and ridiculous perhaps, but his own, and was fighting for it with all the strength of despair. He did not protect himself either as man or director. Burton rewards himself with a fairytale ending, the triumphant premiere (obviously pure invention) of *Plan 9*, in which Wood proclaims, not without foresight: "This is the film I will be remembered for."

1. It should be acknowledged that *Ed Wood* was the first film (to my knowledge) in which cross-dressing was not intended as comedy (*Some Like it Hot, Tootsie,* and innumerable farces), or a dramatization (*The Crying Game*), or the central "problem" of the protagonist (*Glen or Glenda? The Christine Jorgensen Story*), but simply something that is done, important (even though we don't understand its "significance"), but in no way obsessive or invasive, and whose status is nothing more serious than a slightly odd hobby. The practice being generally considered (much more so in the 1950s than now) as shocking, shameful, or laughable, the spontaneous serenity with which Wood seems to have done it in public indicates a somewhat unusual personality. Burton's film underlines the fact that it is not only harmless but natural: when asked (the classical confusion) if he is homosexual,

Ed replies that quite the opposite, it is because he adores women that he likes to dress as they do, an explanation that only narrow or twisted minds would misinterpret. Indeed, it is no more peculiar for a man to dress up as a woman to direct a film than it is for Bruce Wayne to dress himself up as Batman to do his job as an upholder of the law.

2. According to Ed Wood, as well as other witnesses and commentators, this version of Wood really exists, as proved in a 1992 biography (*Nightmare of Ecstasy*—a flamboyant title worthy of the moviemaker—by Rudolph Grey) consisting mainly of interviews with survivors of Wood's entourage, who contradict one another no end. Burton notes that various witnesses have changed their stories over time. Very wisely, he concludes: "Memory is revisionist." It is all the more so, one might add, when dealing with a near-legendary being.

3. This piece, dating from before Wood's film career, illustrated quite well, if one can judge by the scene re-created here, the few instances where the author went in for sad realism, and his taste for allegory. Two soldiers exchange philosophical ideas on a battlefield. Suddenly, an angel coming out of [the machine] gives them a dove of peace along with a little moral lecture (the role of the angel is played by Mrs. Edward Wood, of whom the drama critic mentioned above wrote, not politely, but with complete accuracy, that she was horsefaced).

4. The photography for *Ed Wood* had to be in black and white. That said, and black and white today being extremely rare, a formal (almost moral) choice, strictly tied to aesthetically and intellectually ambitious projects, one finds oneself with a curious paradox: an evocation of the most humble commercial cinema presented in a visual form that risks being taken for aestheticism. The beautiful photo of Stefan Czapsky is an obvious testament to this ambivalence.

No. 406, December 1994

Ed Wood. 1994. USA. Directed by Tim Burton. Produced by Tim Burton and Denise Di Novi. Screenplay by Scott Alexander and Larry Karaszewski, based on the book *Nightmare of Ecstasy* by Rudolph Grey. Cinematography by Stefan Czapsky. Film editing by Chris Lebenzon. Music by Howard Shore. With Johnny Depp (Ed Wood), Martin Landau (Bela Lugosi), Sarah Jessica Parker (Dolores Fuller), Patricia Arquette (Kathy O'Hara), Jeffrey Jones (Criswell), G. D. Spradlin (Reverend Lemon), Vincent D'Onofrio (Orson Welles), Bill Murray (Georgie Weiss), and Max Casella (Paul Marco). 127 min.

A bbas Kiarostami readily admits that he is like each of his characters in turn.[1] According to him, his cinema resembles Tahereh's reaction in *Through the Olive Trees* (*Zir-e derakhtan-e zeytun*), when people are explaining to the wealthy actress that she will have to give up the dress she had dreamed of wearing on the screen because it is inconsistent with the social status of the character she is supposed to be playing. Tahereh protests and maintains that the dress will do perfectly. All it would take would be a few minor alterations! This incongruity between the clothes and the character, prefiguring the incompatibility between the two protagonists, delineates a schism be-

Retake: The Films of Abbas Kiarostami

Stéphane Goudet

Rereading articles in *Positif* on Iranian cinema recalls opportunely that the appearance on the international scene of Abbas Kiarostami was not without precedence: the films of Dariush Mehrjui and Bahrâm Beizaï had been shown in festivals when they were not screened in movie theaters. The soil of Iran was already cinematographically fertile, and the French welcomed the films of Kiarostami, but also of Mohsen and Samira Makhmalbaf, Bahman Ghobadi, and Jafar Panahi.

tween the subject and the "object of her desire." This schism underpins Kiarostami's fiction and the quest that virtually all of his heroes have undertaken since *The Traveler (Mosafer)*. Stubborn heroes, none the wiser, unhesitatingly break laws and traditions when they stand in the way of achieving their dreams. When that happens, Kiarostami must feel as close to Hossein, the illiterate opportunist, who lusts after Tahereh, whose only activity is reading, and asks her to turn the page of her book to indicate that his love is not unrequited. Condemned to the literality of gesture—like the hero of *The Traveler* shooting with no film in the camera—Hossein makes use of what separates him from the young actress and attempts, like all the filmmaker's characters, to make his own that which is radically other (whether a book or a woman). He thus behaves the way the filmmaker does when he strives to make sense of the great book of human nature, traveling to unknown lands (Northern Iran, its actors, their social environment, etc.). Of course Kiarostami's discourse also changes the course of events,[2] even when he pretends to be keeping his distance and *a fortiori* when he tries to narrow gaps, right injustices, and heal the wounds of the real. Like Tahereh suggesting that she make some minor alterations, his cinema strives to make its mark, sometimes against any semblance of good sense, as a method of intervening in the real, a method which is no doubt also inappropriate, but the only way of making his dreams come to life. So much so that one could speak here of a cinema of alterations, or better yet a cinema of mending, attempting with ridiculously few resources to hold together a reality that is being torn apart: the social fabric and, more specifically, the exercise book in *Where Is My Friend's House?* (*Khaneh-je doost Kojast?*), the landscape in *And Life Goes On* (*Va zendeg edameh dared*), the "couple" in *Through the Olive Trees*—to mention the three titles of Koker and Pochté's trilogy, while awaiting *The Dreams of Tahereh*—his next film?

Kiarostami's cinema is, consequently, a "cinema of intervention," not only because of the political metaphors suggested by *Close-Up* (*Nema-ye nazdik*), *The Chorus* (*Hamsarayan*), or *And Life Goes On* . . . , but also because he likes to represent "the act through which a third party, who was not originally involved in a legal action (and we add in any form of trial), appears to take part" (*Petit Robert*). While the seventh art may be able to play this role of a third party (cf. *Homework* (*Ashg-e shab*), *Close-Up*, *Through*

Hossein Sabzian in Abbas Kiarostami's *Close-Up*. 1990

the Olive Trees, etc.), it is because the Iranian filmmaker is well and truly "someone who 'believes' in the cinema."[3] One might even suggest as an epigraph for his latest film— which in many regards is "anti-*Contempt*"— the apocryphal quote from André Bazin: "The cinema offers up a world that is in keeping with our desires." In *Close-Up*, for example, the filmmaker tries to make all of his protagonists' dreams come through. He gives Mehrdad Ahankhah the opportunity to act in a film, occasionally promotes Hossein Sabzian to director or editor, and incorporates into his work the filming of his first screenplay (two friends on a motorcycle, one of whom lends money to the other). In addition, he gives him the opportunity to display real talent as an actor and to make himself "useful to society" by arranging for him to meet the filmmaker Mohsen Makhmalbaf, whose identity he has usurped, and the Ahankhahs, who are victims of this imposture. Kiarostami indeed keeps the promise of his protégé because he transforms the house of these petit bourgeois from Turkey into a real sound stage (unlike Hossein in *Through the Olive Trees*, who appropriates a public place in which to shoot and plans to restore it to live in it as a private home). "The dream of cinema led Sabzian into prison, and the reality of cinema saved him," the director maliciously concludes, "but only for the time being!"

One of the filmmaker's favorite techniques is to cause a diversion, to mask the real questions with false problems, to place the film's real stitching in the background by drawing the audience's attention to false stitching in the foreground. Kiarostami also allows himself in *And Life Goes On . . .*, in speaking to Mr. Rubi, to condemn the cinematographic lie which, in *Where Is My Friend's House?* made him appear older than he really was, while not saying anything about the fact that this complaint was made to a mere actor, who was supposed to play the role of the director! In an apparent attempt to dispel illusions, Kiarostami fools the audience once again by leading them to believe in the plotline through a pseudo-effort to pretend to be telling the truth, which opposes—along the lines of "this is not a film"—immediate reality (apparently to expose it) and the earlier fiction. His art thus consists of condemning the false in order to be able to better maintain it. But he bases this on the conviction that deception and subterfuge facilitate and even condition the appearance and expression of the true. For example, in *Close-Up*, in a courtroom, he shows the scaffolding, lighting, and shooting equipment to highlight "the key role they play in the very conduct of the trial" and in its "favorable denouement" (the judge's clemency). But this enables him to better hide his intervention in the reconstituted scenes: the beginning of the film without any explicit commentary—which reinforces the next scene in which Kiarostami notes the address by the Ahankhahs, whom we already know because we spent a long time looking for their house in the first sequence; there is Mehrdad's naïveté, ready to make the same mistake again by paying for the journalist's taxi; Sabzian's direction, in which he appears to be virtually the first victim of imposture—a little like Satyajit Ray's *Goddess*. Thus Kiarostami shows himself only to withdraw more effectively. He also masks his work as a demiurge by placing in the foreground, in the penultimate sequence, a problem that is technical, contingent, a completely factitious "false contact," but how eloquently it speaks of the human relationships that have developed throughout the film. In fact, the false device shown to the audience makes it possible to hide the lie, manipulation in the sense of continuing to shoot with the accused and the complainants when, in fact, "the real trial had ended nine hours earlier," naturally without the judge, though Kiarostami's editing nev-

ertheless includes him in the discussions! It is as if the last word in the power strug-
gle is inherent to the situation in which art and the law come face to face, and which
give rise to two different judgments, which may possibly converge.

In *Homework*, the director pretends to eliminate the sound from a prayer scene at
the request of his country's religious authorities. Once he had done so, they approved
the scene in question, but by taking the sound away the scene became even stronger
and more subversive (so much so that the sequence was completely removed from Iran-
ian copies of the film). Feigning humility and respect for the sacred, Kiarostami gives
back to the children who are pure products of Iranian education a taste of life, auton-
omy (which etymologically means "giving oneself one's own law"), and freedom, by
allowing them the right to kick up a fuss, break ranks, and pretend not only to repent
their own sins ostentatiously, but those of their immediate neighbors as well. And when
the sound returns—in this film based on reiterated language—the children one by one
go before the camera and recite the "lessons" learned "by heart" under threat of the
strap or the ruler. These are lessons about the uselessness of cartoons; religious and pa-
triotic lessons with an indictment of Saddam Hussein; lessons about the legitimacy of
corporal punishment. In these scenes, the filmmaker appears to be casting his film, in
the metallurgical sense of the word, a kind of molding that makes it possible to repro-
duce a model infinitely. The sound brings to light the indoctrination and the physical
and intellectual bludgeoning of the children, who are the victims in such educational
systems, through which each new generation must unfortunately pass. What comes out
of the mouths of children is not so much the truth, but what their parents want them
to say! But the cinema in these two films nevertheless manages to teach vigilance ("let
us supervise the supervisors or watch the watchers"), to render justice and help to al-
lay suffering somewhat, while acting directly or indirectly on those institutions that lack
the humanity needed to complete their mission: "It is the business and responsibility
of art to look at things more closely and to make people think, to pay attention to men,
to seek to understand them, and to learn not to judge them too quickly." This business
does not, however, exclude some forms of violence, sometimes verbal, sometimes
through questioning (in which maieutics often goes much further than images) and
through framing.

It is also perhaps no accident that the separated "couples" in Kiarostami's works
are so numerous. Beyond any form of autobiography, it is a feature of the screenplays
in all of the filmmaker's works, and in particular in the way he structures his shots.
The Report, which is still banned even though it was made as early as 1977, and hence
was not released in France, showed a male character condemned to do battle to keep
everything the same in his life and to maintain—through force—his job, his office,
and his wife. Kiarostami's shooting still reflects the strength (physical and otherwise)
of this film, but also all the ambivalence of this lovely hand gesture in which the hero,
in a single movement, deciding to slap his wife, eventually holds back when she tries
to get out of his car. The direction thus consists in a potentially violent piece of be-
havior that in *Homework* actually prevented a child from going out to play with his friend
in the field (a principle that reappears throughout a film in *Where Is My Friend's House?*),[4]
and in *First Graders* (*Avaliha*; 1984) immediately gets two children together after they
have just had a fight and reconciles them and gets them to promise never to do it again.

And yet there is never any trace of naïveté in Kiarostami (just as there is no com-
placency in the direction of oneself). Believing in the powers and the "magic of
cinematography" in no way means being aware of one's limitations. While he gives

Sabzian the opportunity to acquire a form of "recognition," this does not mean that he forgets that the way cinema affects life is ephemeral and even an illusion: the shooting of the dreams in *Close-Up* is also tainted, because it does not really allow the characters to change their lives[5] and assume another identity, as each of them wants to do. In other words, having characters played by the very people on whom they were modeled turns out also to be a manifestation of the limitations the filmmaker admits affect his art. "It would have been impossible to imagine—and I would not want to make them believe either—that their lives would change with a single film," said Kiarostami in speaking of Sabzian, who had become unemployed again. Similarly, the remarkable short film *Regularly or Irregularly* (*Be Tartib ya Bedoun-e Tartib;* 1981) shows a sense of humor in attacking the illusion of being in control. It begins as an educational film that praises order (in the name of effectiveness—whether of an action/a plan) and ends in total confusion, to the great consternation of the filmmaker, who admits (in a voice heard off-camera) that he is gradually losing complete control both over his film and the reality that he is attempting to record—rules for city traffic, whereas keeping a lid on young schoolchildren was so easy for him in the first (well-ordered) part of the film!

In *Through the Olive Trees*, the fictitious director also strives, with muted results, to affect the course of events and encourage a virtual love story between his actors. He strongly encourages Hossein to pursue Tahereh, whom he has probably kept on (because she will never be called to the bottom of the staircase to appear in any of his scenes!) to "serve the interests" of his actor. But the cinema as such has an effect on this improbable couple that can be described, to say the least, as ambivalent and perverse. On the one hand, it is the off-camera voice saying, "Action!" that interrupts Tahereh's gesture just as she is about to reveal her feelings by "perhaps" turning the page of her book. It is also the ritual of cinema which, breaking the most elementary rules, forces Hossein to say hello to Tahereh three times without waiting for an answer! But conversely, when Hossein, showing every possible minor attention to her to seduce "his promised one,"[6] exclaims, "That's life!" naturally forgetting that the only thing keeping him from living together with her at that moment is the shooting. Furthermore, he neglects the fact that the scene— the household and the film—which he rehearses incessantly with her, is far from merely fictitious, and could also constitute a prolepsis, or anticipation, which is confirmed by its final renewal on the stage among the technicians, those "professional organizers."

Kiarostami's cinema likes to play with these contradictions, inconsistencies, and temporal paradoxes. There are many examples of them in the trilogy. We need only think of the young girl doing the dishes in *And Life Goes On . . .* , which is filmed *a posteriori* (*Through the Olive Trees*) who purely and simply refuses to turn! Or the sudden appearance of the script girl at Mr. Ruhi's in *And Life Goes On . . .,* , which Kiarostami comments upon as follows· "I wanted to include a scene to say that I had no intention of reproducing exactly, 'faithfully,' what had happened on the day of the earthquake. I reminded my crew that if I had the power to go back in time to the day of the disaster—and if this were possible, then I would, and I would place the action of the film on the eve of the earthquake in order to be able to warn people: 'There is going to be a terrible earthquake tomorrow, leave now, run away!' It thus appeared to me to be impossible to return to the day of the tragedy without rewriting the story. 'We are busy reconstructing the real, I kept telling them. And that is what cinema is.'" This time Kiarostami asks the audience to show perceptiveness by designating this other inescapable schism. He nevertheless manages to keep their rapt

attention and gradually gets them to believe by using various techniques, including some extremely simple mimetic devices.

The whole scene with the household is based on rehearsing mutual criticisms. In this sense, one can speak of *Through the Olive Trees* as a "necessary correspondence" between the content of the scene and its structure (the many retakes). These forms of mimesis, which are very common in Kiarostami's work, allow him, for example, to draw parallels between the road, speech, and the tale itself. Hence in our traveling trilogy, there is systematic lateness, wrong turnings (false beginnings and false endings), erring ways and labyrinths, the repetitions and the inability to get anywhere. Hence also in *And Life Goes On . . .*, the "blind alleys" forcing people to do U-turns, the blocked roads that lead to the suspension of dialogue, or the superb shot in which two children, their voices heard off-camera, are looking for a way to bet on who would win the World Cup soccer match. At first glance, there is nothing to link this apparently misplaced dialogue and the dirt road that we see in the middle of the shot. And yet, the very fact that this conversation goes nowhere and that the two children are unable to find common ground (their concerns being totally disproportionate) announce the disappointing and open ending of the film.[7] Hence his evolution toward a form of stripped-down abstraction, fixing the final movement of the object of the quest onto ethical ground and substituting for the individual (the specific search for two actors in *Where Is My Friend's House?*) the collective, the generic (the children encountered along the way are just as important as those who motivated the trip).

If *And Life Goes On . . .* can truly be considered an adventure film, it is because it more or less reconstitutes "the ethical adventure of the relationship to the other man."[8] After *Where Is My Friend's House?*, which subjectively explored the feeling of injustice and showed a child attempting to make his voice heard, Kiarostami puts on the screen the very personal experience, which is difficult to transmit, of suffering and mourning. Thus he retraces the boundaries between self and other, depicts man as solitary, and defines his identity as inalienable. However, this does not prevent him from structuring his film around a "concern for others," or to use Emmanuel Lévinas's terms, "responsibility for others," which is specifically rooted in the fear of his disappearance. Aesthetically, this relationship to the other person rests mainly on how Kiarostami deals with sound. Venturing into the underbrush, Puya's father is drawn by the crying of a newborn baby, whom he discovers sleeping in a hammock, apparently abandoned, when suddenly his son, who was sleeping alone in the car, calls for help. At this moment, he is "midway," divided, torn between what is close and familiar to him and that which is foreign to him. But then a third voice appears and releases him: the mother's voice, singing a few steps away from the hammock while gathering wood.[9] The sound in this scene literally conjures up the image. It calls it up and guides it. From this point on, we can consider the trip that the film represents as the outcome of the desire to see for oneself the extent of the disaster in order to be able to attach images to the horrifying words heard on a radio, while getting close to the suffering of another, incarnated in a people literally cut off from the world.[10] Not only is the sound the source of movement, but it virtually seems capable of breathing life, giving birth, or constituting a renaissance. Hence the off-camera crowing of the rooster reassembles the pieces of a clay rooster, another victim of the earthquake, and transfigures it into a flesh-and-blood rooster capable of crowing. It is as if sound alone could bring things back to life and conjure up from the rubble a new dawn and a hope for a brighter tomorrow. But that is when a grandmother, dressed completely in white, leaves her home, has her image superimposed over that

of the rooster, and, without the help of the filmmaker, manages to extract her carpet from the ruins. As it happens, it is this same grandmother who in the next film (after a reversal of the dominant points of view about her character, as was the case for the earthquake) refuses to allow her granddaughter to marry Hossein.

There is no longer any doubt that with Kiarostami, both truth and reality are female. Like the two Taherehs in *Through the Olive Trees*, or the veiled women in a circle in the fade-out just before the credits, woman is, in the eyes of the Iranian filmmaker, a force of resistance and opposition (both fierce and impenetrable) that allows no room for "pretenders," who hide from their gaze and address only those with whom they are forced to converse in a conventional, eminently everyday, and repetitive conversation. Who then can be surprised to see that the spring water (or reality) needs to go through pipes and taps (or fiction) to reach the isolated villages of *And Life Goes On . . .* ?

1. Interview with Kiarostami: "Problématique de l'intervention chez Abbas Kiarostami," DEA thesis, Paris III. All quotes in this article from Kiarostami are taken from this series of interviews, published in no. 442 of *Positif.*

2. This code, which is "proposed" to Tahereh, may be either an avowal or a warning: interpreting, wanting at any cost to seize the real and make it meaningful, is to risk preventing things from happening!

3. Serge Daney, "Images fondues au noir dans Téhéran sans visage," *Libération*, March 3-4, 1990.

4. If we consider *Where Is My Friend's House?* to be a story about apprenticeship, then it needs to be added that it is an apprenticeship in lying as well as in friendship. The lies are now curiously "cinematographic" because characterized by "analogous reproduction" and the devising of a false story "to replace another," an imposture that, according to Hossein Sabzian, defines the director's methods.

5. Hence Kiarostami's harshness toward his actors (whom he refuses to consider as such so that they won't entertain any illusions about their future) in Jean-Pierre Limosin's admirable *Vérités et Songes*, which is both a very relevant exegesis of the work and its virtual continuation (hence Kiarostami's imposture, in which the program *Cinéma de notre temps* engages as well, and Jean-Pierre Limosin himself this time seems to be having a film directed by someone other than himself!). It is a harshness that is also present in *Through the Olive Trees* because Hossein never manages to make people forget that he is also, and especially (off camera), a bricklayer and waiter.

6. Interview with Kiarostami in *Vérités et Songes*, with the real wife of "Mr. Hossein" (sic), magnificently contradicts the promises made here by the male character about how the household tasks would be shared.

7. How today can we not admire the retroactive justification of the director in not showing, at the end of *And Life Goes On . . .* , the children that people have been looking for since the beginning of the film, merely through their positioning "on the fourth side," which could logically only be revealed in *Through the Olive Trees?* Before helping with the shooting of the latter film, the children had worked at virtually every possible function within Kiarostami's film world: they began as characters for whom educational films were intended (*Dental Hygiene, Colors*), and gradually became actors, the raw material, and then (*And Life Goes On . . .*) doubles and substitutes for the director, changing from characters who raise their hand to characters who point things out.

8. Emmanuel Lévinas, *Le Temps et l'autre* (Montpellier: Fata Morgana, 1979), p. 11.

9. "For there to be somebody who exists in this anonymous form of existence, it is essential that there be a way of leaving oneself and returning to oneself, which is the very task of identity" (Lévinas, p. 31).

10. Comparing cinema to television, Kiarostami confides: "If I myself had had a camera (when I took my first trip), the shouts of people would no doubt have attracted me toward them, and I might not have been able to resist the temptation to film them as they moaned! Fortunately, cinema has a specific task: it forces one to think before shooting . . . and constrains the filmmaker to take his time."

No. 408, February 1995

Close-Up (Nema-ye nazdik). 1990. Iran. Written, directed, and edited by Abbas Kiarostami. Cinematography by Alireza Zarindast. With Hossein Sabzian (Himself), Hossain Farazmand (Reporter), Abolfazl Ahankhah (Father), Mehrdad Ahankhah (Son), Hooshang Shamaei (Taxi Driver), and Mohsen Makhmalbaf (Himself). In Farsi. 94 min.

With *Secrets and Lies*, Mike Leigh at first appears to be following in the footsteps of a twenty-year tradition in British films, giving us nothing more than a series of disconnected fragments, "slices of life," that, by themselves, would more than serve their purpose: at one end, the young black female optometrist seeking out an unlikely mother; at the other, the single woman, bogged down in a conflicted relationship with her daughter; likewise, the frustrated photographer and his wife. It all adds up to a sense of fragmentation, pieces of a puzzle: the brevity of the scenes, which suc-

The Paradox of Melodrama:
Secrets and Lies
Noël Herpe

When *Positif* underscored the importance of Mike Leigh's *Bleak Moments* in the early 1970s, the filmmaker's reputation in France was strictly underground. After winning the Palme d'or, *Secrets and Lies* definitely made Leigh's reputation as a director who, along with John Boorman, Peter Greenaway, Stephen Frears, and Ken Loach, symbolized the distinctiveness of British cinema.

ceed one another without any obvious coherence, the significance of the objects, which rivet the characters in purely functional and fetishistic activities—the cardboard that Cynthia cuts up, the trashcans that Roxanne fills up, the letters and photos from which Hortense vainly seeks to extract her origins, the photos (again) that Maurice takes in his studio, as he parades a succession of compositions before his camera, as lifeless as his wife's middle-class decoration of their home, with an impersonal automatism. It's the same veiled, hazy light, the same disembodied comfort within which any suffering (that of the woman who wants to have her disfigured face photographed or the wife longing for a child) is suffocated, stripped of its drama in a misleading sense of decorum.

All of Leigh's work deals with snapshots, which he endlessly accumulates and juxtaposes in order to defuse them better. In this case, snapshots are used radically, in their most concrete dimension. They are, literally, that which separates or artificially isolates people from their surroundings, including their inner life, by reducing it to a social mask (just like those anonymous people who come and go before Maurice's camera against an interchangeable backdrop, and who only define themselves in terms of some prized accessory like boxing gloves, a silver cross, a poodle, etc.) and, at the same time, take away their movement and fix them in a frozen moment. We get the impression that the portrait of Roxanne as a child, for instance, which her uncle and aunt gaze at nostalgically, has more presence than the real twenty-one-year-old Roxanne and her succession of mistakes, misunderstandings, and things left unsaid. But the French word "cliché," which means "snapshot" or "photograph," also sometimes means what it means in English, with its only function to dispel feelings and provide a shorthand for stereotypical roles. When the studio's former owner unexpectedly drops in on Maurice, he closes the door behind the now down-and-out drunk and sighs, "There but for the grace of God," and we see how language can be limited to the indifference of good conscience (while some of the characters, such as the social worker and the secretary, are nothing more than machines pumping out readymade phrases and soothing stereotypes). Cynthia's character escapes this pervasive logic of talking to say nothing (or rather to avoid saying anything) and social representation precisely because she incarnates them to the end, taking on, as she does, their contradictions with a sort of hysterical

extremism; her confused logorrhea—not to mention the silence of her long-lost daughter—suggests the renewed possibility of a real dialogue with another person.

Through this character, Leigh transgresses the law of fragmentation and modest submission to everyday life, which make the latest chronicles of Ken Loach (*Ladybird, Ladybird*) and Stephen Frears (*The Van*) pale somewhat in comparison. He has no complexes about rehabilitating that which, for some time, has appeared as nothing more than a cliché, also hidden by the clichés of intimacy and that really should be called melodrama. The theme of the lost relation, renewed through destiny, is one of the oldest melodramatic themes since the days of D. W. Griffith's *Orphans of the Storm* and includes the works of Charles Dickens and Marcel Pagnol. If Leigh brings it back, he readapts it to the standards of a dispersed society deprived of its traditional landmarks, so as to hark back to the theatrical eloquence of the director Alexander Korda in his *Marius* and *The Well-Diggers Daughter*. As with Pagnol, it is through the spoken word that the art of film is recaptured and overwhelms us with its excesses, its outbursts, and its timing (as is so clearly illustrated in the "recognition" scene between Cynthia and her daughter and in the family reconciliation scene).

A spoken word enables the actors to imprint their own pace and, as in theater, to live on in the same time as the public, with all that this implies in terms of length and repetition, not to mention risks and surprises. As with Pagnol, there is some rather obscene language that oversteps the boundaries of good taste and manners, and that focuses on self and forces the protagonists to reveal themselves, even if only through ridicule and tears. The characters of *Secrets and Lies* paradoxically rise above clichés and find a plain human density only through repeated efforts to re-create old-fashioned or caricatured situations and to pour out their feelings and drown themselves in mawkish embraces. Only after this moment of crisis, in which they each get a chance to express their truths (as extreme and subjective as they may be), can the director once again film them from the serene distance of the reporter—now that he has restored to them their personal integrity and returned them to the community of a family, which the viewers also share. In these days of snickering postmodernity and mockery, this reliance on feelings and the virtues of catharsis comes across as somewhat anachronistic and disturbs our recent habit of merely viewing movies as outsiders, as though they were objects from another world. But this is exactly the challenge taken up by Leigh (as probably only a man of the theater could have done, by embracing a subject that the writer Paul Auster himself, in *Smoke*, handled too aloofly by half): bring film back to its community calling and remember that, beyond the confusion of images and identities, there are, after all, people with pasts, sufferings, things to say, families—and we are all part of it.

No. 427, September 1996

Secrets and Lies. 1996. UK. Written and directed by Mike Leigh. Produced by Simon Channing-Williams. Cinematography by Dick Pope. Music by Andrew Dickson. With Timothy Spall (Maurice Purley), Brenda Blethyn (Cynthia Rose Purley), Phyllis Logan (Monica Purley), Marianne Jean-Baptiste (Hortense Cumberbatch), and Claire Rushbrook (Roxanne Purley). 141 min.

Brenda Blethyn and Phyllis Logan in Mike Leigh's *Secrets and Lies*. 1996

he tone of a movie: one could say that *Fargo*'s chief merit is that it maintains its tone. But this is another one of those concepts borrowed from literary culture. What does it mean? A certain moral attitude reflected in a form that is both constant and discreet.

The Coen brothers' screenplay contains some surprising signs of unity. The cold, for instance, is always perceptible: parking lots with no more than a couple of vehicles; hockey featured on television and in conversations (if you can call them that);

Blood on the Snow: *Fargo*

Alain Masson

Like Tim Burton and Quentin Tarantino, the Coen brothers were able to renew American film genres by their storytelling, points of view, and iconographic themes. The combination of rigor and fantasy, which is so characteristic of their work, is particularly in evidence in *Fargo*.

comments about the weather; difficulty opening a window; an oven door left ajar to provide heat; deserted streets and roads; a frozen lake and snow.

These things add up to more than sidelong glances at the region. The very names of the characters, almost all Scandinavian, add to this feeling of the north. The harsh climate also becomes the main characteristic of the people. It rules their moods, in the Hippocratic sense. A wound does not heal, it freezes; the bloodstain on a tissue stuck to a cheek matches the red marks all over the snow, and the tiny scarlet tip of the scraper supposedly indicates the location of buried treasure. Narrow-minded, stubborn, frozen by an obsession: that's what human beings are, almost all of them. One refuses to pay a parking ticket while another, somewhat later, stubbornly will not allow a driver who is threatening him with a gun out of the garage for free. So what if their safety and lives are at risk? The millionaire is recklessly determined to make sure personally that the ransom is paid: "It's my money!" The official at the credit office unexpectedly demands that every number on a form be legible: that's the rule!

People get hung up on trifles: an accomplice shows up late, with no harm done as it turns out, for a meeting where a shady deed is being planned; a gun has to be fired in the middle of a kidnapping; a kid has a passion for hockey; a mother resists. The obstinacy of people is matched by that of objects—a snow-covered landscape, uncertain and dismal, whizzing by as a car speeds through it, indifferent as the chatty killer rambles on about the silence, trying in vain to loosen up the quiet killer. Later, the killer stares at a television screen that stubbornly refuses to respond to the commands, pleas, and blows to which his partner subjects it. Conversations all end with the phatic "Oh yeah? —Yeah!" that only serves to indicate that whatever was said really was said. Any flow of ideas or conversation is impossible in this icy setting. A grinder muffles the police warnings— a killer is grinding up a body, spraying a huge red stain over the white expanse.

As mentioned, the world is frozen solid. All of it. One could get somewhat philosophical about this. These are people lost in a space that fills them with trepidation but fits in with their ideas. But this is clearly not the tone.

Coldness and stubbornness determine everything. In close-up, the actors display a strange determination. They soberly convey simple feelings in confusing situations. "I'll take care of that!" says one of the kidnappers who is driving a car that gets stopped by a cop because its registration has expired, as he transports his victim, whom we know is driven by despair and prepared to do anything. The man is completely sure of himself, calm, composed, and opinionated. Suffice it to say that he hasn't got what it takes to pull it off.

Frances McDormand in Joel Coen's *Fargo*. 1996

The nervousness of William H. Macy, the impassivity of Peter Stormare, the vehemence of Steve Buscemi always project an assurance, preciseness, and composure that contrast with the hopeless messes into which they get themselves. The clear handling of the actors mercilessly exposes them to mockery.

A man discovers his father-in-law's body. He could not have anticipated it, but, in the foreground, his car trunk pops open. Without hesitation, the machinery of things overtakes decisions. We guess that he is going to hide the body and dispose of it, and that he is about to get himself into the worst possible mess. It's all there: the automatic reaction expresses the manner in which obstinacy reacts—and how punctually!—to the world's icy demands. Set notions and reactions always seem ready-made. It has nothing to do with premeditation or calculation. It is the very expression of thoughtlessness, a demonstration of stupid, though somewhat fertile, spontaneity that sets off the act, precipitating and exaggerating it.

The kidnappers' incompetence and their victim's clumsy efforts contribute to the burlesque of the kidnapping, so predictable that it hardly needs to be filmed. One victim's idiotic idea to hide in the washroom is echoed by the other's stupid look as he stares at himself in confusion in the bathroom mirror. The shower curtain becomes the instrument of the abduction. Once discovered, this collaboration appears to have been unavoidable. The violence is captured on film indirectly, with shots of actions and results rather than of the body being subjected to them. The Indian's whipping is relentless, but we no longer see his victim. The shot from the car and the blood splashing on the driver's face, fine, but not the murdered cop! The camera only watches death from a distance. Regard for propriety is all well and good, but there's something else: the persistence of the signs contrasts with the elusiveness of the action. That's the source of the film's particular brand of comedy. Human restlessness continually comes up against imperatives that taunt it. It's not that ridiculousness disfigures the characters, but the way their behavior and their actions fit in with reality and with the world reduces them to nothing. This feeling of vanity is not new to the work of the Coen brothers.

There is no more pleasant display of this morality than the scene in which one of the murderers buries a part of his bounty in the snow, in feverish and laborious haste, glancing left and right to mark the spot. Two reverse shots answer back: two dismal, white, and identical expanses with two endless fences. There is no sign of rage on the clever man's face. Hasn't he figured it out?

The unforgettable foreground is the emblem of this metaphysical mockery: on a very straight road, in the snow, a car tries to materialize. It has barely emerged when it disappears in a dip that can't be seen because of the perspective. It then reappears, powered by an insistent tune. That same pigheadedness to be, act, express oneself, is what makes the characters both absurd and pathetic.

There are a few exceptions. A clutter of humble and familiar but very typical objects, the camera dollying through the home of the cop, who happens to be a woman, and pregnant to boot. She lives cozily with her husband, who pampers her, in the land of the legendary Paul Bunyan. Massive, impassive, the giant lumberjack's statue, a recurrent image, watches wide-eyed, stiff, and rough: this pioneer is the symbol of a somewhat boorish common sense. The town is called Brainerd, a name that seems to be a blend of brain and nerd.[1] The film contrasts them with the agitated clever folks, murderous passion, and laughable tactics. The only exception to

dramatic concision is the camera's languid sweep over the homes in these caves and its deliberate depiction of their hearty food.

Serious thought, low-key action. The female hero owes her success to her anti-epic kindness. After a brilliant investigation, she remains every bit a woman, telling her husband how much she admires him. After all, wasn't it his drawing that was selected by the post office to adorn their three-cent stamps? To hear her tell it, there is absolutely no doubt about how important this stamp is.

Some might say that the filmmakers are praising mediocrity or that they couldn't care less about it. It's not that easy. If you observe the investigator, you see that her genius lies not in brilliant deductions but in a methodical, constantly alert attentiveness, like Paul Bunyan's. This clear look at nature, which also characterizes her husband, a wildlife painter who is no rocket scientist, suggests an acceptance of reality as it presents itself, but with total faith that it can be understood. This is our break from the criminals' pigheadedness and excesses. Humility, not a very popular American virtue, underpins knowledge, whereas blind ambition . . . It was time to spell it out: financial greed and bloodthirsty brutality are stupid and servile.

Only once does the investigator let herself be fooled. In a scene that has no relevance to the police intrigue, she allows herself to believe the sentimental tales of a former classmate. This passage highlights the film's morality. First of all, the young man, who is bent on seducing her, displays a great deal of flexibility toward her; his attitude changes when she tells him that his advances are in vain. At that point, his fabrications are not mere trickery. To some extent, at least, he believes them and weaves a romantic thread through his tale. How puny the car salesman's lies appear in comparison to this story, which is so full of humanity! How stupid the kidnappers' way of escaping the cops appears! Because lies are always linked to reality, which works tirelessly to expose them, all it takes is a clear outlook. Thus, the conversation with the mythomaniac comes across as a disturbing lesson in fanciful sympathy. It expresses a form of respect against the abuse of trust.

Extreme tidiness and total brutality are the tried-and-true staging techniques that make up a world in which the characters only manage to fool one another because of their respective pigheadedness. The sex scenes, as Americans so crudely put it, are of the more revealing types: brief and technical, they leave no room for play. Although a woman of few words, the investigator has contacts with others that nonetheless remain rather friendly and cheerful. The hostess' seduction by one of the killers, in a stereotyped sequence of shots, is as stiff as a cliché, and in strong contrast to the polite meeting between the two classmates, which is handled with far more finesse.

Thus the spirit of comedy counterbalances the violence of the gangster film and trumps it hands down. Kind ordinariness and the wordy story clash victoriously with the irony of fate that lies in wait for enterprising hearts.

1. On this point and on the film's realist reference, see J.-P. Coursodon's article in *Positif*, no. 423.

No. 427, September 1996

Fargo. 1996. USA. Directed by Joel Coen. Written by Joel and Ethan Coen. Produced by Ethan Coen. Cinematography by Roger Deakins. Music by Carter Burwell. With William H. Macy (Jerry Lundegaard), Steve Buscemi (Carl Showalter), Frances McDormand (Marge Gunderson), Peter Stormare (Gaear Grimsrud), and Kristin Rudrüd (Jean Lundegaard). 98 min.

One of the reasons why David Lynch's films are so fascinating is their ability to create imaginary worlds that bear a superficial resemblance to reality—all the better to mislead viewers through labyrinthine and disconnected tales. *Blue Velvet* and *Twin Peaks: Fire Walk with Me*, unlikely little towns painted with shiny colors straight out of a children's picture book, reveal malignant worlds where the forces of Evil are unfurled. On the flip side, films like *Eraserhead* are imbued with a nightmarish strangeness right from the outset. The latter is certainly the case with *Lost Highway*,

Lost Highway: Dick Laurent is dead!

Philippe Rouyer

Like Stanley Kubrick, Tim Burton, or Terry Gilliam, the otherworldly tone of David Lynch's films is seductive to those who feel that the offsprings of Georges Méliès are at least as important as those of Louis Lumière. From this standpoint, *Lost Highway* and *Mulholland Drive* confirm Lynch as one of the great explorers of the irrational.

which starts in the claustrophobic confines of a house with a stripped-down interior. While the big screen instills a sense of subtle malaise by isolating the characters in the emptiness of the surroundings, the viewer, deprived of any reassuring spatial-temporal points of reference, ends up sharing the suspicions of Fred, the saxophone-playing main character, about his wife Renee's fidelity.

But there is more to this story than this supposed tale of adultery. Who is Dick Laurent, whose death is announced in the first scene over the front-door intercom? Who is sending anonymous videos—every day—taken from outside, and then inside, the house? Just an inkling of an answer begins to surface when Fred meets a mysterious man in black one evening at a wild party. The man, with a portable phone in hand, proves to Fred that he is, at that very moment, inside Fred's house. The tale is once again cast into darkness. Viewers are left with nothing more than speculation based on whatever knowledge they may have about Lynch. The snowy blur on the video cassettes, the red curtain, and the lengthy corridors pierced by halos of light are evocative of *Twin Peaks*. The main character's insistence on observing his reflection in the mirror brings to mind the preludes to Bob's metamorphosis in *Twin Peaks*. The man in black (Robert Blake, the unforgettable criminal in Richard Brooks's *In Cold Blood*) has the Mephistophelian features of the bartender in the Overlook Hotel in Stanley Kubrick's *The Shining*.[1]

At this point, we are not altogether surprised by the evidence of Fred's murderous schizophrenia, as he appears smeared in his wife's blood on the third cassette. His transformation (off-screen) in his cell is more unexpected: in the morning, a guard finds in his place Pete Dayton, a young mechanic living with his parents. By the end of the first third of the film, not only has the main female character disappeared (as in Alfred Hitchcock's *Psycho*), but so has her main partner (and, incidentally the two stars playing them). The director cleverly capitalizes on this frustration to render that much more tangible the lack of any sign of surprise on the part of Pete's family when he returns to them. This rejection of the most elementary psychological reactions is followed by a reversal of the sides taken at the beginning of the film. After the psychodrama of the couple behind closed doors, the carefree group outings and the wide-angle exteriors feel like an oxygen bubble: even the incongruous looks of the characters (the dark glasses of the parents, faux adolescents moronically glued to their mind-numbing television programs) are a pleasant contrast to Pete and Renee's

Bill Pullman in David Lynch's *Lost Highway*. 1997

austere garb. And that's where a second tale begins, in a typically Lynchian suburb that picks up where *Blue Velvet* left off: the adventures of a nice boy attracted by the sensuality of a gangster's moll, except that Alice, this femme fatale, is Renee's blond double, also played by Patricia Arquette.

The actress, who first appeared in John Boorman's *Beyond Rangoon*, is remarkable in this dual role. She is every bit as convincing as the blond extrovert enamored of her own body (she brings to mind Lula, another David Lynch and Barry Gifford creation) as she is in the part of the mysterious brunette wife. Evidently, the two women, who take turns wearing the same white dress and outrageously painted fingernails, are flip sides of a single character (Alice, as Renee's double, reflected from the other side of the mirror)—like Fred and Pete. The director indulges in the accumulation of parallels throughout the eventful plot twists (the two police tails, appearances by the man in black), while at the same time playing on the dissimilarities. Fred and Renee's distant lovemaking between intimidating black satin sheets is followed by Pete and Alice's frenzied couplings in sordid motels and in the middle of the desert. After a brilliant role inversion, it's no longer the duped husband but the lover who is pushed by the traitoress to commit the act.

The codes of film noir, not to mention neo-film noir (in this movie, Robert Loggia, who has already played Mafiosi in a string of films since Brian De Palma's *Scarface*, plays a Tarantino-style gangster who is totally irresistible in the hilarious sequence of the "driving lesson" he gives to someone who was tailgating him), have progressed to the "shaker" of Lynchian fantasy to redefine the outlines of an America that exorcises its puritanical tendencies through sex and violence. The director himself falls back on these tendencies when he gets bogged down in a display of successive pornographic scenes, and his slightly masochistic films owe more to the teasing softcore of a Just Jaeckin film than to the turpitude of hardcore cinema. But that's not the point. The real secrets are guarded by the mysterious man in black, who manipulates pictures and sounds with his camcorder and telephone. As for the main character, who becomes Fred again just in time to close the endless spiral of the story, no police car can stop him. He escapes into another space-time, a fourth dimension that materializes through those hypnotic sequences of a "lost highway," which has just been illuminated by the headlights of a car racing into the endless night—the first and last images of a film that cannot be fully enjoyed at first viewing.

1. There are several reminders of the film by Kubrick (admired by Lynch). Note the flashes on a hotel room door and the night photography, etc.....

No. 431, January 1997

Lost Highway. 1997. USA. Directed by David Lynch. Written by Lynch and Barry Gifford. Produced by Deepak Nayar, Tom Sternberg, and Mary Sweeney. Cinematography by Peter Deming. Music by Angelo Badalamenti. With Bill Pullman (Fred Madison), Patricia Arquette (Renee Madison/Alice Wakefield), Balthazar Getty (Pete Dayton), Robert Blake (Mystery Man), Natasha Gregson Wagner (Sheila), Robert Loggia (Mr. Eddy/Dick Laurent), Gary Busey (Bill Dayton), and Richard Pryor (Arnie). 135 min.

That she is living, were it but told you, should be hooted at, like an old tale; but it appears she lives, Though yet she speak not.
 —Shakespeare, The Winter's Tale, Act V, Scene III

N ow that *Tales of Four Seasons (Contes des quatre saisons)* has come full circle (as much as possible), one may question the generic title and wonder how well each film illustrates it. The most obvious thing that emerges is the conjunction between the ages of the main characters and the dominant colors of the season filmed. *A Tale of Springtime (Conte de*

Time as Image: *Tales of Four Seasons*
Noël Herpe

printemps) is the story of a girl shaded by trees in bloom, and the entire film follows her passage to adulthood, with the disillusions that ruin

Positif was not very impressed with Eric Rohmer's first film, *The Sign of Leo (Le Signe du lion)*. But the director, who was a favorite of the rival film magazine *Cahiers du Cinéma*, gained the admiration of *Positif's* editors, and many interviews were conducted and articles written about him.

her adolescent dreams of invincibility, her oedipal fantasies, her tales of a lost necklace. *A Summer's Tale (Conte d'été)* is clearly in the tradition of a summer apprenticeship, with shades of *The Last Vacation (Les Dernières Vacances)* and *The Flowering Wheat (Le Blé en herbe)* (which Eric Rohmer likes to tell over and over, from *Claire's Knee [Le Genou de Claire]* to *Pauline at the Beach [Pauline à la plage]*); the protagonists are young people who have dabbled in many things and are arriving at the age when they must make choices. *Autumn Tale (Conte d'automne)* is a story of September and the harvest; it is also the first film in which Rohmer deals with the pangs of love as suffered by mature adults. The only exception to the falsely naive rules of the tetralogy (it even upsets the chronological order) is *A Winter's Tale (Conte d'hiver)*: winter is certainly present as a backdrop, but only as a symbol in the central itinerary of the young woman, and her faith in the return of a summer that is gone.

As usual in Rohmer films, we are presented with a literary framework that is simply an illusion which, if taken at face value, risks total confusion. Not one of these latest *Tales* can be reduced to a linear proposal, no more than the *Moral Tales (Contes moraux)* or the *Comedies and Proverbs (Comédies et proverbs)*; there is no clear moral expressed in varied circumstances. If these stories do, in fact, fit into each of the four seasons, it is in an organic, buried, diffuse way, obvious in the simple dialogue but, at the same time, a hurdle that must be jumped to reach another reality. One could say that all the characters in the cycle engage in discussion, become lost in the labyrinth of language, misunderstandings, and red herrings, and, in the long run, the denouement is beyond words.

Thus Félicie, in *A Winter's Tale*, exiled from the *absent reality* of a prior life, finds herself almost damned by words (a slip of the tongue separated her from her lover), and forced up against other words she barely understands, literary or philosophical references with which she is unfamiliar, references that merely give her contradictory fragments of her truth. Only Shakespeare's *The Winter's Tale* has something to reveal, like the play within a play in *Hamlet*, but it is through the artificiality of the play and rhetorical exasperation that Rohmer finally, in a sort of counterpoint, illuminates the young woman's face with inexpressible certainty. Similarly, Gaspard's verbal excesses in *A Summer's Tale* simply highlight the fluctuations of inexpressible

introspection: all these words lead, cruelly, to a subtext, a subfilm, that plays out in parallel with the dialogue, continually contradicting the conclusions of his self-analysis. The abyss separating language and being is even more patent in *A Tale of Springtime* and *Autumn Tale*, in which the protagonists also use words to dominate. The teenager in *A Tale of Springtime* lies to herself constantly, rewrites the family history, at the same time using the frankness of her philosophical girlfriend to demystify her father's lover—even if it means seeing her strategy work against her— and the freedom of others reasserts itself. The teenager in *Autumn Tale* has great faith in the power of words, attempting to pair her philosopher friend with the mother of another friend, with no concern for their own wishes, while the classified-ads section gives credence to the paradoxical status of prewriting. By trying to program Magali's love life through impersonal words or a text not her own, Isabelle creates an idyll that escapes her, that requires the assistance of this play-acting, like a ritual awaiting its sacrifice.

Language is used to circumvent language, based on the hypothesis that absenting the speaker leaves room for a supernatural goal. This is the basis for the strange *revelation* that clothes Rohmer's strict realism with its omnipresent rational interpretation. When the words suddenly stop, something happens that is on the order of grace, a pure phenomenon. In *A Tale of Springtime*, after a long and convoluted discussion, the philosopher listens to the girl playing the piano; then, in a striking dolly-back, the camera pans back from a face that has become silent, as if to leave it to its mystery. The increasing importance of music in these tales deserves further comment. In *A Summer's Tale* it is only through music that Gaspard spontaneously expresses his personality. It is also music that offers him his ideal chance, an unexpected solution to all his problems. Up to and including *Autumn Tale*, there is a sung epilogue, more and more common in Rohmer films, used to suspend all meaning and suggest a naive morality, with a close-up of Marie Rivière showing an unexplained nostalgia for another meaning.

If language is the territory of wandering, hazard, and hypothesis, and can only return to the individual a multitude of fragmented reflections, music is compatible with cinema because it can be adapted to the time frame, because both music and cinema flourish in the present tense. And if Rohmer's revelation leads to a miracle, it is a completely cinematographic miracle, based on the fullness of the moment, when the individual, freed from speculation and unifying concepts (as expressed with irony by Gérald in *Autumn Tale*), coincides exactly with what he is at a specific moment of life. The individual can only understand himself within a time frame, in a fleeting situation that cannot be broken down into words, but leaves him open to all possibilities. Gaspard's final flight may be disappointing, but it is the only action in his image, his response to the intermediate state in which he finds himself (waiting to turn thirty, when Margo tells him he will find himself). The comings and goings of Magali and Gérald at the end of *Autumn Tale* may be incoherent, but they are the most immediate expression of desire frustrated by too many good intentions: nothing remains to be said.

In *A Winter's Tale*, the Romanesque profusion and the parade of successive lives are absolutes inasmuch as it is all instantaneous (the only photographs are holiday photographs, fleeting images that seem to hide eternity). The cult of the moment and timelessness are not incompatible: the moment leads to a renewed continuity

Béatrice Romand and Marie Rivière in Eric Rohmer's *Autumn Tale*. 1998

that, rather than made up of mental projections, consists of the moment leading naturally to the future. The long scenes at the beginning of *A Tale of Springtime* and the opening scenes of *A Summer's Tale* in which we see Jeanne and Gaspard strolling along in solitary silence seem like emanations of their persona that are far more eloquent than any words. In the absence of exchanged looks, or the "look" that is speech, they are doomed to an existence only perceptible by an invisible eye, perhaps like the magical ring of Gyges [a shepherd who discovered a ring that made him invisible], thanks to a camera that reads them more accurately than their own thoughts.

Over the spareness of these tales is superimposed a respect for the rhythm of the characters and the rhythm of the actors (at every step, out of the fabric of time, emerges the exceptional that each individual has but is incapable of revealing except spontaneously). In *A Winter's Tale* each of Félicie's partners, in *A Summer's Tale*, each of Gaspard's girlfriends, give the interior of the film an independent dynamic, embraced by Rohmer even if it means moving very slowly, jerkily, and perhaps not always on track. It appears that Rohmer himself is always changing his approach, moving from a Bressonian solicitude (enabling him to capture a once-in-a-lifetime glimpse of the young actors of *A Summer's Tale*), to an almost Pagnolesque display. This is particularly true in *Autumn Tale*, where the actors seem to be using unrelated scripts and the very cacophony proves creative. Between the overly theatrical acting of the men and the more naturally Rohmerian style of the women, interaction is out of sync, suggesting a subtext, a story that unfolds in spite of the characters, a story available to the viewer through the musical variations.

This is the ultimate paradox of these tales: they never seem to be basically more than *reincarnations* of an old familiar film, a film that takes ultimate freedom and captures it within ultimate rigidity. Reincarnation uses all the icons: in the Balzacian return of fetish actresses (Amanda Langlet, Marie Rivière, Béatrice Romand) who pop up at different ages like vaguely familiar figures. There is also the literal repetition of an anachronistic text: in a more lighthearted mode than *The Marquise of O* (*La Marquise d'O*) or *Perceval* (*Perceval le Gallois*), the classified ad in *Autumn Tale* revitalizes a childish and outdated body of work, right up to the final scene harking back to the light comedies of the 1920s and 1930s. This is the basic issue of *A Winter's Tale*, with reincarnation going way beyond pure philosophical speculation. In any case, there is pleasure in the remembering, bringing to the surface a lost secret (whether in the form of a necklace, a loved one, or simply an inner feeling); all the details of the story, random as they seem, come together to form a forgotten prediction. Rohmer explores cinema as if it were life after life, a theater of happy shades amusing themselves replaying their earthly mistakes, world without end, amen. By so doing, he fully accomplishes the tales' intention—to tell a child a fairy tale she knows by heart but never tires of hearing. The ideal spectator of *Tale of Four Seasons* is undoubtedly the little girl holding Félicie's hand throughout *A Winter's Tale*: she knows all the secrets of the stories and waits patiently.

No. 452, October 1998

A Tale of Springtime (Conte de printemps). 1989. France. Written and directed by Eric Rohmer. Produced by Margaret Ménégoz. Cinematography by Luc Pagès and Philippe Renaut. Film editing by Maria-Luisa Garcia and Françoise Combés. With Anne Teyssèdre (Jeanne), Hugues Quester (Igor), Florence Darel (Natacha), Eloïse Bennet (Ève), and Sophie Robin (Gaëlle). In French. 112 min.

A Winter's Tale (Conte d'hiver). 1992. France. Written and directed by Eric Rohmer. Produced by Margaret Ménégoz. Cinematography by Luc Pagès. Film editing by Mary Stephen. Music by Sébastien Erms. With Charlotte Véry (Félicie), Frédéric Van Den Driessche (Charles), Michel Voletti (Maxence), Hervé Furic (Loïc), Ava Loraschi (Élise), and Christiane Desbois (The Mother). In French. 113 min.

A Summer's Tale (Conte d'été). 1996. France. Written and directed by Eric Rohmer. Produced by Margaret Ménégoz. Cinematography by Diane Baratier. Film editing by Mary Stephen. Music by Philippe Eidel and Sébastien Erms. With Melvil Poupaud (Gaspard), Amanda Langlet (Margot), Aurélia Nolin (Léna), and Gwenaëlle Simon (Solène). In French. 113 min.

Autumn Tale (Conte d'automne). 1998. France. Written and directed by Eric Rohmer. Produced by Margaret Ménégoz. Cinematography by Diane Baratier. Film editing by Mary Stephen. Music by Claude Marti, Gerard Pansanel, Pierre Peyras, and Antonello Salis. With Marie Rivière (Isabelle), Béatrice Romand (Magali), Alain Libolt (Gérald), Didier Sandre (Étienne), and Alexia Portal (Rosine). In French. 112 min.

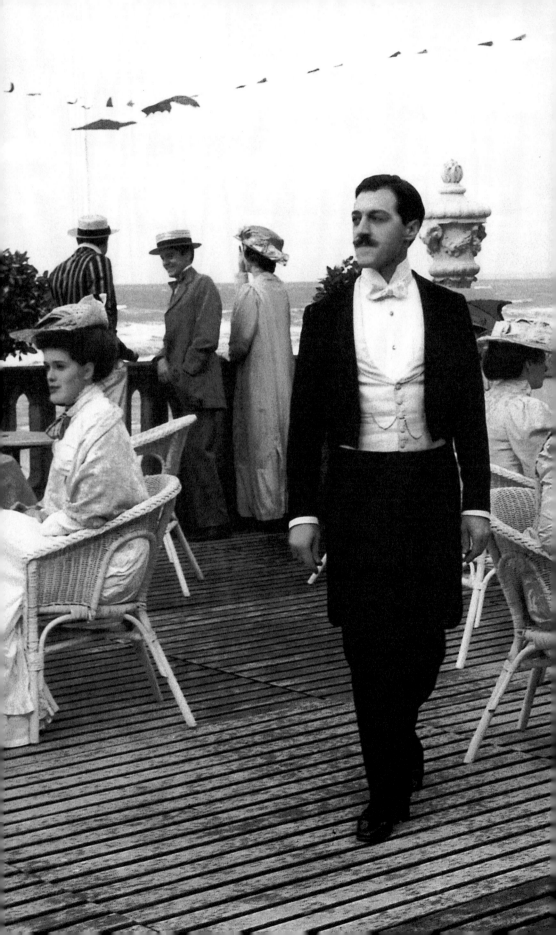

> *I call this course transposition: structure, another.*
> **—Stéphane Mallarmé**

ON "ADAPTATION"

"For a long time I used to go to bed early." This introductory sentence to *In Search of Lost Time* [also translated as *Remembrance of Things Past; A la recherche du temps perdu*] is exactly the type of statement that cannot be committed to film and is impossible to translate into images. Conversely, it goes without saying that the physical sensation created by the first scene in Alfred Hitchcock's *Vertigo* (the rooftop chase, the fall) could not be rendered through the written word. I think we run a serious risk of losing the delicate thread of the relationship between literature

Reflections on *Time Regained*

Guy Scarpetta

In the early 1970s, *Positif* discovered *Three Sad Tigers* (*Très tristes tigres*), an early film by Chilean director Raúl Ruiz, and decided to include it in a week-long program of unreleased films. In the following thirty years, he became well-known because of his prolific output and the wide variety of his works, in addition to his rich imagination and his sense of humor and of the absurd. His work on Marcel Proust's *Time Regained* is one of the most daring cinematic adaptations ever made, as demonstrated by Guy Scarpetta, a literary critic and a specialist in the baroque, as well as a member of the group Tel Quel.

and film (and, therefore, that of "adaptation") unless we start by recognizing their inexorability. We are talking about two radically different languages, both in terms of form and function. This is why most adaptations do little more than bring literature and film down to the smallest common denominators (all of the action and dialogue), which ends up mutilating both art forms. In most cases, the end result is two-fold frustration: for fiction readers, the impression that "the important things have been missed"; for filmgoers, the feeling that the films are too "literal," meaning that the language of the images is reduced to nothing more than its illustrative function. As for the rest, it's no accident that most "adaptations" (in the conformist films of the 1950s and in today's equivalents, the popular made-for-television movies) are based on realistic novels or nineteenth-century adventure classics (Guy de Maupassant, Emile Zola, Alexandre Dumas) or those that perpetuated their codes in the twentieth century (Georges Simenon), which amounts to a concept of literature in which reality coincides with appearance, that which is visible and that which can be heard. This form of literature, in and of itself, is easy to "adapt." We could even ask ourselves whether such "adaptability" might not be an essential feature of the actual naturalization of the nineteenth-century code, that form of advocacy as a natural standard of the romantic style that is no more than a historical phase, limited in space and time. Herein lies the paradox: a good many contemporary novels are written as they were in the nineteenth century, precisely because their only ambition is to be made into film.

TECHNIQUES, CONSTRAINTS, AND CHALLENGES

In order to clarify this insurmountability, it is important to point out a few key technical differences. A novelist essentially disposes of a number of procedures that, by definition, are not available in film. In terms of dealing with time, like a director, a

Marcello Mazzarella in Raúl Ruiz's *Time Regained*. 1999

novelist can play with the order of events recounted (the chronology is just as mixed up in *The Sound and the Fury* as in *Citizen Kane*), the frequency (Proust's sentence, which is quoted at the start, reflects the iterative mode, which belongs to the written and spoken words), the duration—mostly by using pauses (interrupting the fiction to make way for a reflexive or descriptive commentary), the summary (ten years in a life summarized in a dozen lines) or expansion (a fleeting sensation detailed over twenty pages, à la Claude Simon). None of these possibilities has any parallel in film (neither the freeze-frame, slow motion, nor speeded-up action can provide the same freedom). Not to mention the fact that even though the film medium can shift the point of view (subjective camera techniques, reverse-angle shots), it is still quite limited compared to the truth that a multiplicity of voices can inject into a novel (no film adaptation of *Dangerous Liaisons* has succeeded in restoring the build-up in plot from the contradictory and lively epistolary game). In any case, we know that a novelist can penetrate (through the "all-knowing narrator" or the "inner focus") inside the characters. This cannot be done in film where, aside from the difficult trick of voice-over, we have no access to the domain of secret thoughts, hidden feelings, concealed intentions, unless they are *betrayed* (or at least made obvious) through actions, facial expressions, or words.

Two more key points should be added. A novelist has the ability to insert the most wide-ranging spreads of space and time into a single sentence; for instance, Proust has but to mention the "enchanted universe of the Thousand and One Nights" for us to be transported on the wings of these few allusive words. In film, in order to create such an effect, it would be necessary to gather into one single frame, for the space of a few seconds, a whole setting and a host of characters and costumes, which hardly ever happens (admittedly, the constraint is an economic one: in a sense, literature is endowed with a narrative luxury that is beyond the reach of film). The other element concerns the manner in which a character is made up. Here again, a novelist has a bag of procedural tricks, ranging from painting a full portrait at the point when a character first appears in the novel (like Honoré de Balzac), progressively revealing bits and pieces of the character (Gustave Flaubert, Fyodor Dostoyevsky, William Faulkner, and Ernest Hemingway) or giving no portrait at all (Franz Kafka)—whereas in film, the character, who is played by an actor, is immediately characterized in his or her totality in one single shot.

Naturally, the difference is most striking in terms of the style. Many novels hold together because of their style as much as because of the story told, and are therefore impervious to any other form of adaptation (it would be difficult to imagine the "pictures" equivalent of the great novels of Céline or Thomas Bernhard). For instance, the use of metaphors (which are the key to Proust's appeal) does not work at all for film. At the end of the day, there are very few metaphors in film. This medium owes more to metonymy than metaphors, committed as it is to bringing together the two ends of an analogy (as with Sergei Eisenstein) rather than substituting one for another…

A writer, essentially, has more freedom than a director. Or, at least, there are more technical constraints limiting the various parameters of the art of storytelling in film than in a novel (even though film has methods and effects at its disposal that a novel simply does not). Under these circumstances, "adaptation" involves a certain number of

biases. The easiest and most popular approach is to attempt to reduce the distance between the two languages, which is to say to bring a novel to its intrigue, its action, to eliminate anything that is not directly filmable. The outcome is generally, by definition, mediocre (Claude Berri's *Germinal*). But any time an inventive director has come across a major piece of literature, he or she has traditionally accentuated the difference, rather than reduced it, and made it explicit, rather than erased it. This is done by essentially literalizing the film, by subverting its rhetoric through the deliberate primacy of the text over the image (this was the approach used by Marguerite Duras, Jean-Marie Straub, and Eric Rohmer) or, on the contrary, by superimposing the film over the written text code, using the latter as a challenge to be overcome by mobilizing all of the resources available to the film medium. The result is a film that is entirely driven by the novel rather than an illustration of the novel. This could take the form of an operating homology (for instance, Luchino Visconti's long scenes, devoid of any action but focusing on the set and the costumes, create the film equivalent of a novel's description), a translation or amplification (Orson Welles propelling Kafka's universe into an expressionist dimension, or Pier Paolo Pasolini jumbling the Sadean tale with historic realism). Each time the differential elements of the literary code challenge the film, they force it to reinvent itself, come up with unique visual solutions. This is why film (that of Welles, Visconti, Kubrick, and Pasolini) is not based on adaptation as much as on transposition, strictly speaking.

ON MODERNITY

Where this transposition trips up is with the novelistic art of modernity, starting with the turn of the century because everything happens as though it (there is no doubt that film had something to do with it) had chosen to cultivate the "unfilmable" in itself, in a way giving up on some of film's former realistic functions. From tales without description (Kafka), to the annexation and development of abstract intellectual reflection (Proust, Musil, Broch), the conjunction of inner contemplation and the proliferation of word games (James Joyce), the polyphony of narrative voices (Faulkner) and the rhythmic musicality of enunciation absorbing the presentation (Céline). It is difficult to imagine how film could take such fictional universes unto itself other than by flushing out the essential. And it is no coincidence that, so far, the only successful transposition of a masterpiece of modernity (Welles's *The Trial*) owes its success, which is undeniable from the point of view of film, to nothing more than a manifest betrayal of Kafka's fictional world.[1]

But of them all, the one who seemed to best resist the language of film was Proust. There are at least three reasons: a style that, from the outset, is based on metaphors and, thereby, not very amenable to being elegantly transfigured into the language of images; an ability to short-circuit or condense temporalities, which goes far beyond what can be achieved through simple flashbacks; and an explicit rejection of realism, which limits the novel to an examination of external reality, to which Proust contrasts a tireless passion for interpretation,[2] an endless and varied revelation of the opposite of appearances, a permanent exploration of the meanderings of the inner being, independently of the linearity of "objective" time; whence its disdain for the "literature of notations," which contents itself with "giving things a puny linear and surface description."[3] Such disdain, it so happens, does not hesitate to extend itself to film— this art form spread during the very period in which Proust wrote *In Search of Lost Time*, and he remarks on its appearance in the customs referred to in the last volume of the

set of *Time Regained (Le Temps retrouvé)*. For Proust, film seemed ontologically linked to this "realism" that he could never stop contesting. Hence his formulations such as: "There are those who would see novels be a sort of cinematographic sequence of things. This is absurd. Nothing could be farther from our observation of reality than such a cinematographic perspective."[4] "That which we call reality is a certain relationship between the sensations and memories that simultaneously surround us—a relationship that disappears in a mere cinematographic vision, which is thereby that much more removed from truth because it claims to restrict itself to it."[5]

In other words, Proust writes against film, or at least against the idea he has formed of it in his mind (a simple mechanical reproduction of appearances). This shows to what extent Raúl Ruiz's project, the purpose of which happens to be to develop a film based on *Time Regained*, takes up the challenge. We should tip our hats to the success of such a project.

RUIZ'S WAY

"Instead of the flat psychology we normally use, we should apply a form of spatial psychology." (Marcel Proust, *Time Regained*)

THE CLOSE-UPS

Ruiz's first bold innovation is to have specifically chosen *Time Regained* as his prop. Of all the books that comprise *In Search of Lost Time*, this is the least "narrative," the one in which action is at a minimum (only the scene in Jupien's brothel involving Charlus's whipping uses the primacy of fiction over narration), in which the performances shown (Paris during World War I, the party at the Princesse de Guermantes') are thought as much as they are description, wrapped in interpretations, meditations. There is one particular scene with a very long reflexive discourse, rather tentatively linked to the tale itself, which addresses both the multiple and ramified perception of Time that emerged in the previous chapters and the notion of Art (particularly the art of the novel), which will justify and restore the experience. Ruiz's choice of the most discursive, least figurative, book was probably deliberate: he makes it impossible, right off the bat, to choose the path of "realistic adaptation," that of film in the sense in which Proust understood (and challenged) it, because Ruiz's own art, as he developed it in his prolific previous output, is far less related to that type of film than to the strange effect (mentioned in the very first pages of *Swann's Way*) produced by the magic lantern projecting its fabulous images onto the day-to-day scenery up to the point of transfiguring it. This passage from one universe to another is precisely what Ruiz's films have always practiced (from *Three Crowns of the Sailor [Les Trois Couronnes du matelot]* to *Genealogies of a Crime [Généalogies d'un crime]*), to the point of radically destabilizing the tale's traditional parameters (of space and time); if the episode of the magic lantern (and its palimpsest effect) is applied by Ruiz in his film, while it hardly appears at all in the text of *Time Regained*, this is no doubt his way of inserting through this reminder an allusion to his own sense of design and thereby suggesting all that was most typical of Proust in his previous notion of film.

A TRANSFERENTIAL FORM OF ART

Clearly, for Ruiz, it is not a matter of illustrating Proust's text, but rather of using it to give film a Proustian style. And how does he do this? By breaking the false narrative coherence (that of a one-on-one intrigue based on the "central conflict") and

replacing it with a world of bifurcations, detours, and connections in time; by finding in the language of pictures both that feel of the palimpsest[6] whereby signs overlap one another without actually canceling each other, and that analogical depth which can bring out (through editing) the most remote feelings and perceptions; organizing the composition of the film around a musical model, with thematic variations, counterpoints, and distant echoes of patterns; and bringing continuity to what the chronological order might have disrupted, or, alternately, ellipses and violations into that which a realistic code would have homogenized. In other words, what is "Proustian" about this is not so much the tale (naturally Ruiz allows himself certain liberties, deletions, and additions in relation the text) as, in its strong sense, the form.

Consider, for instance, those fantastic sequences in which different temporal corridors suddenly seem to connect: the one in which Odette, who has become Madame de Forcheville, opens a door to the Guermantes' living room and finds the child narrator (many years before) holding his magic lantern, which projects its reflections not only onto the walls and objects, but also on the effigies of the upcoming reception; the one in which this same child narrator finds himself propelled into the future next to Saint-Loup in uniform, showing him pictures of the war; finally, the one that imprints himself onto Saint-Loup's funeral, where the narrator (adult) remembers their first meeting in Palbec, and where this flashback is in a way infused with signs from the future. Three undertakers (those from the funeral) in the setting of Palbec ceremoniously tip their hats; Saint-Loup gallops on horseback on the neighboring beach while the funeral procession carrying his own casket appears in the same scene. Each of these sequences does a fabulous job of concretizing this porosity of the temporalities that Proust turns into the subject and principle of a victorious depiction of Time.

This also explains the continuous use of the ellipsis by Ruiz, to which, through his artful editing and, especially his decision to avoid the shortcuts of dissolves, he conveys a quasi-structural scope: simultaneously blending his style with the radical discontinuity between the sequences (the jump cut) and the diffracted continuity between the signs it projects (obviously, a mediocre director would have done the opposite). This produces a double, paradoxical impression of fragmentation of fiction and reflection of narrative—whereby he once again connects with the traditional methods of film, one of the characteristic traits of Proust's art.

METAPHORS AND MEMORY PATTERNS

As I indicated, Proust places metaphors (in the broad sense: for him, this term includes the whole range of comparative figures) at the heart of his sense of fictional design. But the film medium is not well suited to this style.[7] Metaphorical visual reconciliations usually have a power of representation and fascination that end up surpassing their pure semantic value (just as, for instance, Sergei Eisenstein's *October*, with its proliferation of analogies, ends up coming across in a baroque, rather than a didactic style). Ruiz is quite aware of this (any visual metaphors in his previous films are a product of their strangeness or incongruity rather than their "meaning"). Thus, the decision in *Time Regained* to refuse to follow Proust's metaphorical design to the letter; or, more precisely, to remove the form of that design (it would be futile to look for visual equivalents to oral analogies) in order to better discern its function, produces the effects of double exposure, reveals the secret unity of perceptions or sensations that the passage of time has distanced, and interconnects a whole network of interdependent

connotations of the disparate elements of a misleading or evanescent reality or one bent on corruption.

What essentially "transposes" this function in Ruiz's film is this telescoping of universes and the transfer of signs to which I alluded earlier. More precisely, these are the patterns of linkages (or "memory patterns") that are found in the most heterogeneous sequences, and which end up connecting with the musical model of composition applied in Proust's writings.[8] This could take the form of pure repetitions (Odette's arrival at the party and Madame Verdurin's comment about it: a repeated, or "echoed" scene); or that of recurring objects, settings, constantly being moved and reassigned to various scenes without this, by itself, creating any unity (the roses and statues); or that of repetition (always in the musical sense) of a same sentence, attributed to two different characters in two segments of the story separated by several years ("I have better plans" are the words used by Morel to reject Charlus, who has invited him to spend the night, and they are the ones we'll find again much later coming from Odette's lips when she refuses a similar wish expressed by the Duke de Guermantes).

Possibly the most dazzling sequence in this arrangement of transferred signs is the one that transposes the famous episode in which the sensation of the irregular cobbled courtyard of the Hotel de Guermantes brings the narrator back to the buried memory of a holiday in Venice, where he had once experienced a similar sensation in the Basilica of San Marco: Ruiz shows us the individual tripping, steadying himself, as if frozen on the verge of falling, before the camera whisks us off to Venice, using several frames for the purpose, and then brings us back to "the present," where the narrator regains his balance and resumes his walk. But near him we notice a few pigeons, as though brought back through time (from the reminiscence). This is a fabulous visual stroke of inspiration, in which all it takes is a few displaced signs to suggest the intricacy of temporality and the manner in which the present can reactivate the past—the very domain of the Proustian experience.

One of the themes (missing from Proust's book) that is particularly pervasive is that of the statue of the *Venus Callipyge*, which appears repeatedly in various sizes, as though crossing over the most disparate spaces and times. Yet, in the end, this theme is one of the rare ones to be both symbolic and functional. It condenses the allusion to the world of Sodom (the image of the naked, proffered buttocks): the conflict between appearance and the hidden truth (seen from the front, the statue is a "shy" figure, hiding her breasts; seen from behind, she shamelessly displays the full glory of her buttocks): the fragmentation and layering of the truth, which implies that the truth has to be captured from several angles at once (if we want to really "see" the statue, we have to tear ourselves away from the frontal view and walk around it). In a sense, this represents an index of the art of Proust's storytelling in terms of a perfectly metaphoric sign.

THE CHARACTERS

Nothing is more difficult to restore in the language of film than Proust's concept of the characters. Not only because, in the novel, their images are progressively built up and unveiled to reveal aspects that are unclear and uncertain, but also because they seem to be impervious to any "realistic" representation. These characters are, first and foremost, contradictory and ambiguous:[9] Charlus is both the prince of the Faubourg Saint Germain and a masochistic client of Jupien's brothel; Morel is both

a worldly, well-respected musician and an unscrupulous bully; Saint-Loup is both Rachel's lover and Morel's suitor, etc. Their coherence becomes precarious, and there are changes, echoes, and transfers among them (the older Bloch "becomes" Bloch the father, Saint-Loup is Swann's distant reflection). But they also seem to evolve differently, as though time did not affect them all in the same way. In the final episode of "The Masked Ball," some of them (the Duc de Guermantes, Madame Verdurin, Monsieur de Cambremer) have become unrecognizable, whereas some of the others (such as Odette, who is "naturalized,"as though frozen in a previous picture) have barely changed at all. Finally, the effect of time means they had to be captured beyond their immediate photographic appearance, in the shift of time: "We had to see them both with the eyes and the memories," writes Proust.[10]

There are many challenges there for a director, and Ruiz has to be commended for having dealt superbly well with this disruption of the classical notion (homogeneous, stable) of the "character." First, through the casting, where each actor (Catherine Deneuve as Odette, John Malkovich as Charlus, Marie-France Pisier as Madame Verdurin, Vincent Perez as Morel, etc.) is capable of fully personifying the essential ambiguity of each role.[11] In the end, the choice of stars and famous actors ends up creating, for viewers, the same effect of "memory" perception as in the novel: for them, essentially, it is not so much the characters who superpose elements of their previous successive "states" as the actors themselves (Saint-Loup's dubious virility is an irresistible reminder of some of Pascal Greggory's parts in the theater or Chéreau's films; Charlus's blend of vice and insolent lucidity is a reminder of Malkovich's interpretation of Valmont in Stephen Frears's *Dangerous Liaisons*, etc.): as though Ruiz had borrowed a specifically cinematographic effect (the manner in which each actor evokes memories of his or her past parts) to rediscover, but in another place, the palimpsest effect at play in Proust's story.

As for the variable geometric metamorphoses affecting the characters in *Time Regained*, Ruiz has attempted to produce the equivalent in film by repeatedly changing his approach. He spectacularly accentuates some of them (Charlus's physical deterioration after his attack) and downplays others (when Odette walks into the Guermantes' salon, she is almost the same as the "lady in pink" whom the narrator-as-a-child met at his uncle's); he also uses impromptu substitutions, which are almost hallucinatory and seem to reflect, as in certain fantasy novels, the eruption of a parallel time dimension (the appearance, in this same salon, of the grotesquely aged faces of Gilberte and Madame Verdurin before they recapture their earlier image as soon as the disoriented narrator recognizes them). This leaves only the delicate problem of the presentation of the narrator, whose status, in the novel, is extremely ambiguous—particularly inasmuch as the traditional distinction between the subject of the storytelling (the one telling the story) and the subject of the story (the novel's character) is being constantly blurred. Ruiz's way of restoring the complex interplay of the different instances that make up "Marcel" was not only to personify him through four actors of different ages corresponding to the various stages of the character (the child in Combray, the adolescent in Ralbec, the adult narrator at the time that the events in *Time Regained* are unfolding, and the author nearing the end of his life, when he retells his work), but also to have them meet on occasion and talk, or have them appear together in the same scene, as though, in order to produce the same effect of uncertainty, a pronounced fragmentation of his presentation had to respond to the moving and indecisive status of the narrator in the novel. All this, incidentally, connects with the deconstructivist

principle at play in all of Ruiz's previous films (*Three Lives and Only One Death [Trois vies et une seule mort]* is a good example), but also seems to connect with the actual definition that would have been given to the character in Proust's art of the novel: "A multi-faceted figure whose final incoherence is but the partial sum of excessive coherences."[12]

SECOND-RATE FIDELITY

It is easy to imagine that Proust's followers, already convinced that the medium of film can only defile such a sacred text,[13] will inevitably be scandalized by the few alterations that the film brings to the book: the dismissal of a few secondary characters (Prichot, Norpois) and episodes (Perma's disgrace), while on the other hand another character, a fleeting figure in the novel, has a much bigger part to play in the film (Madame de Farcy) and a few scenes are simply added (Gilberte and the broken cup). We must also remember that this is a film that involves certain specific constraints (if none other than the timing and casting) which, in and of themselves, make total fidelity impossible, and that in the end, none of these small liberties take away from the core message, even when, from the point of view of the medium of film, they are not fully justified. If Ruiz, for instance, "overplays" the importance of Madame de Farcy's interventions, it is only to give the core theme of the disruption in the old hierarchies, the discounting of precedence and genealogies, its full prominence by removing it from the commentary and assigning it to this character, which gives the party at the Princesse de Guermantes's an opportunity to disclose a shift in the whole social order just as effectively as could have been done by a corruption of the bodies.

A far more disturbing issue, of course, is the one presented throughout the lengthy theoretical and aesthetic discourse thrown by Proust into the midst of *Time Regained*, through which the narrator realizes that only a work of art can perpetuate the realities evoked through the fleeting associations of recollection and turn this experience into the subject of a book designed to conquer time. It goes without saying that such a general, abstract exposé, in which Proust gives us a detailed account of his "art of the novel," essentially cannot be filmed. Yet, Ruiz's response to this added challenge is absolutely amazing. It does not involve exposing this theory (neither in bits nor voice-overs) but rather just coming right out and applying it in the film itself, giving it a concrete expression. Hence the decision to use, instead of the flashbacks explicitly called for by the text of *Time Regained*, frequent incursions into certain essential episodes in previous books (recalling the holidays in Balbec, memories of the first meetings with Saint-Loup, Odette and Charlus, reminders of Albertine's ambiguity and the narrator's torment when faced with the possibility of lies or concealments, etc.). In a way, Ruiz grafts new ramifications to the story in his film: a way of giving concrete expression to "looking through memory," as postulated by Proust, and at the same time helping viewers find their way around the backdrop of such an expansive story. To put it succinctly, what Proust's text states, Ruiz's film does.

THE BAROQUE

Finally, Ruiz has to be given credit for having avoided all the traps of an accepted, stereotyped "adaptation." No dissolves, no special music to signal flashbacks: only jump cuts between passages from one sequence to the next (the play of superpositions and the echoes between temporalities express themselves through signs conjured within the frames rather than through the addition of outside rhetoric). Nor

are there any indiscreet reminiscences: where it would have been easy to rely on the grand Viscount's feast in the sequence of "The Masked Ball," or a Fassbinder-style climate for Jupien's brothel, Ruiz instead gives us a piece of art, if not stripped, at least barren of all emphasis and pathos, which is much closer to the type of clinical lucidity that also characterizes Proust's text.

But perhaps most outstanding is the way in which Ruiz manages to transpose Proust's text into what is, paradoxically, most literary about it. I am referring to this most typical Proustian form of sentence: long, sinewy, off-center, packed with incidents, expansions, overlapping subplots. This sentence is neither "precious" nor gratuitous, but is eminently suited to the manner in which Proust mixes universes, shines the light on secret situations, short-circuits sensations, overlaps spaces and times associated with them.[14] Yet Ruiz, with astounding skill, has found the right balance of this sentence through the camera's own movements, to the point where one could then correctly refer to a Ruizian cinematographic "sentence." Lengthy scene sequences that are off-center (they are not at all focused on "following" a character or an action) and constantly confronted by a reality that is, itself, interspersed with incessant movement, changes in perspective; a permanently moving, turning, and undulating camera, whose movement at every instant surpasses the classical functions of panoramic filming (in this case, it is not a matter of exhaustively capturing a static setting, but rather of dissipating the view of a dynamic and multifaceted one) such as the angles of shots (which are not so much designed to confer a point of view upon the characters as to create an impression of instability and dizziness).

Whence, in Ruiz's films, a few sequences that are and will forever remain anthological: for instance, the first, in which the camera, after focusing on the author on his deathbed, starts meandering around him, showing objects or decorations in his room, and loops back to what has already been seen, only to show a few changes (the objects themselves or their proportions), as though the film "sentence" had mysteriously transformed what it was supposed to record. There is also the one in which the narrator, during the war, finds himself at one of those café-concerts where the first film showings used to take place (in this case, a war documentary), and where an erratic camera, after having swept the area, comes to focus on the narrator, who suddenly appears to be swept up sideways, in a movement resembling a counter-dive, but that we quickly see, contrary to any "realism," as being an actual ascendance of the character itself, on a backdrop of projected images, as if tearing itself away from the weight and the world of documentary representation. And that of the final concert, where a type of heavy swell of the camera, echoing that of the music, penetrates the audience before we, once again, see that the lateral movement of the rows of guests is being superimposed (while accentuating it) on the camera's reverse movement, giving the obscure impression that this whole worldly assembly is slipping away, being cast adrift in terms of what could be its physical composition or its social position. And, finally, that of the dinner at the Goncourts', where the camera, as though inebriated, can't stop spinning on its two axes, unbalancing our vision while at the same time snapping us up into its panoramic whirlpool, thereby creating a cinematographic anamorphosis that is best suited to the very substance of the text being transposed herein (the famous "pastiche").

This visual game of instabilities, twists, whorls, superimposed or intertwined opposing flows, naturally suggests an openly baroque quality—to which Proust's art could legitimately also be connected. And that is doubtless how a real stylistic

similarity emerges between the arts of film and novel. This being the very one that makes Ruiz's *Time Regained* a reply to the challenges issued by Proust's writing rather than its futile "illustration." In other words: more than a film adaptation of Proust, a cinematographically Proustian film.

1. See what Milan Kundera has to say about this in *Testaments Betrayed* (New York: HarperCollins, 1995).

2. See Gilles Deleuze, *Proust et les signes* (Paris: Presses universitaires de France, 1976).

3. Marcel Proust, *Le Temps retrouvé*, in *A la recherche du temps perdu*, Edition Pléiade, vol. 3, p. 895.

4. Ibid., pp. 882–83.

5. Ibid., p. 885.

6. See Gérard Genette, "Proust palimpseste," in *Figures* (Paris: Editions du Seuil, 1966–72).

7. Certain visual connections can have the effect of poetic images (in Luis Buñuel's *Un chien andalou*, the thin cloud that passes in front of the moon resembles a razor slicing an eye)—but this remains the exception.

8. I am borrowing the notion of "memory patterns" from Pierre Boulez, in his analysis of Alban Berg's treatment of the *Grande Forme*, which he sets radically apart from the Wagnerian system of the *Leitmotiv*.

9. What Roland Barthes interpreted as a generalization of the figure of "inversion" ("Une idée de recherche," in *Le Bruissement de la langue* (Paris: Editions du Seuil, 1984).

10. See note 3, p. 929.

11. It should be noted that the supporting actors (Chiara Mastroianni, Melvil Poupaud, Edith Scob, Ingrid Caven, and Arielle Dombasle) perfectly restore this aspect of ambiguity or secret backdrops. The only reservation about this casting might be the unfortunate choice of Emmanuelle Béart for the part of Gilberte: the actress, who is clearly unable to portray anything other than the highly sensitive always-on-the-verge-of-tears woman, loads the character with an incongruous pathos and totally fails to restore its complexity. We can always dream about what Isabelle Huppert would have done with this role.

12. Genette, op. cit. See also Julia Kristeva, *Time and Sense: Proust and the Experience of Literature* (New York: Columbia University Press, 1996), especially the chapter entitled "Surimpressionism."

13. Just think back to the defamation campaign launched, in particular by Angelo Rinaldi, against Ruiz's film even before it was completed and before anyone had since a single frame.

14. See Kristeva, op. cit., the chapter entitled "La Phrase de Proust."

No. 463, September 1999

Time Regained (Le Temps retrouvé). 1999. France/Italy. Directed by Raúl Ruiz. Written by Gilles Taurand, based on *Remembrance of Things Past* by Marcel Proust. Produced by Paulo Branco. Cinematography by Ricardo Aronovich. Film editing by Denise de Casabianca. Music by Jorge Arriagada. With Catherine Deneuve (Odette), Emmanuelle Béart (Gilberte), Vincent Perez (Morel), John Malkovich (Charlus), Pascal Greggory (Saint-Loup), Marcello Mazzarella (Narrator), Marie-France Pisier (Madame Verdurin), Chiara Mastroianni (Albertine), and Arielle Dombasle (Madame de Farcy). In French. 158 min.

Trustees of The Museum of Modern Art

Published in conjunction with the exhibition *Positif Champions: Fifty Years of Cinema,*
at The Gramercy Theatre, organized by Michel Ciment and Laurence Kardish,
under the auspices of The Museum of Modern Art, New York, December 5, 2002–
January 31, 2003.

Produced by the Department of Publications
The Museum of Modern Art, New York

Edited by Joanne Greenspun
Designed by Gina Rossi
Text translated by Kenneth Larose, with contributions from
Carole Dolan, Creighton Douglas, Joan Levesque, and Katalin Poor
Production by Christina Grillo
Printed and bound by Editoriale Bortolazzi-Stei, S.R.L., Verona
Printed on 120gsm Tauro Offset

Published by The Museum of Modern Art
11 West 53 Street, New York, New York 10019
(www.moma.org)

Distributed in the United States and Canada by D.A.P., New York
Distributed outside the United States and Canada by Thames & Hudson Ltd., London

Library of Congress Control Number: 2002113812
ISBN: 0-87070-688-8

Printed in Italy

Cover: Detail from Stanley Kubrick's *A Clockwork Orange*

Frontispiece: Joel Coen's *Fargo* and Agnès Varda's *Cleo from 5 to 7*